The
Artist
Outsider

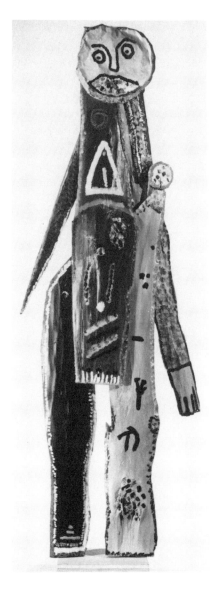

The Artist Outsider

Creativity and
the Boundaries
of Culture

**Edited by
Michael D. Hall and
Eugene W. Metcalf, Jr.**
with Roger Cardinal

SMITHSONIAN INSTITUTION PRESS

WASHINGTON AND LONDON

"Crossing into Uncommon Grounds" by Lucy R. Lippard was originally written for the 1993 catalog *Common Ground/Uncommon Vision: The Michael and Julie Hall Collection of American Folk Art at the Milwaukee Art Museum* and is reprinted here with permission.

"Folk Sculpture without Folk" by Daniel Robbins was first published in the 1976 catalog *Folk Sculpture U.S.A.* and appers here with permission of the Brooklyn Museum.

"Rebels, Mystics, and Outcasts: The Romantic Artist Outsider" by Joanne Cubbs copyright © 1993 by the John Michael Kohler Arts Center is excerpted from an earlier essay written for a book on major environmental works by self-taught Wisconsin artists to be published by the John Michael Kohler Arts Center, Sheboygan, Wisconsin. The essay is included in this volume with permission.

"Jahan Maka: Symbolist on the Precambrian Shield" by Michael D. Hall is adapted from a piece first published in *Jahan Maka: Retrospective* copyright © 1988 by the Dunlop Art Gallery, Regina, Saskatchewan, Canada, and is reprinted here with permission.

"The Reception of New, Unusual, and Difficult Art" by Constance Perin is a revised version of an essay written for *The Prinzhorn Collection* copyright © 1984 by the Krannert Art Museum and appears here with permission.

"The History and Prehistory of the Artists' House in Gugging" by Leo Navratil was first published in German as part of the 1990 volume *Von einer Welt zu'r Andern. Kunst von Aussenseitern im Dialog*, Dumont Buchverlag, Cologne. The English translation appears here with permission.

"Elijah Pierce, Woodcarver: Doves and Pain in Life Fulfilled" by Gerald L. Davis was first written for *Elijah Pierce: Woodcarver* copyright © 1992 by the Columbus Museum of Art and is reprinted here in revised form with permission.

Designed by Kathleen Sims.

ISBN 1-56098-334-5 (cloth)
 1-56098-335-3 (paper)

Library of Congress Catalog Card Number 93-84474

Library of Congress Cataloging-in-Publication Data and British Library Cataloging-in-Publication Data are available.

Manufactured in the United States of America
98 97 96 95 94 5 4 3 2 1

∞ The paper used in this publication meets the minimum requirements of the American National Standard for Permanence of Paper for Printed Library Materials Z39.48-1984.

For permission to reproduce illustrations appearing in this book, please correspond directly with the owners of the works, as noted in the illustration credits. The Smithsonian Institution Press does not retain reproduction rights for these illustrations individually or maintain a file of addresses for illustration sources.

Cover image: Detail of 8.4, *The Pope* by Jahan Maka, page 132.

CONTENTS

Acknowledgments xi

Introduction xii

PART I: THE OUTSIDER IN AESTHETIC PERSPECTIVE

HISTORY AND THEORY

1 **Crossing into Uncommon Grounds**

Lucy R. Lippard **2**

2 **Toward an Outsider Aesthetic**

Roger Cardinal **20**

3 **Folk Sculpture without Folk**

Daniel Robbins **44**

4 **An Anti-Museum: The Collection de l'Art Brut in Lausanne**

Michel Thévoz **62**

5 **Rebels, Mystics, and Outcasts: The Romantic Artist Outsider**

Joanne Cubbs **76**

ARTISTS AND THEIR WORK

6 **The Merry-Go-Round of Pierre Avezard: A Masterpiece of French Outsider Art**

Laurent Danchin **96**

7 **Bounded in a Nutshell: Reflections on the Work of Martin Ramírez**

David Maclagan **114**

8 **Jahan Maka: Symbolist on the Precambrian Shield**

Michael D. Hall **124**

9 **Folk Art and Outsider Art: A Folklorist's Perspective**

Charles G. Zug III **144**

10 **The Snake in the Garden**

Richard Nonas **162**

PART II: THE OUTSIDER IN SOCIAL PERSPECTIVE

HISTORY AND THEORY

11 **The Reception of New, Unusual, and Difficult Art**

Constance Perin **172**

12 **The History and Prehistory of the Artists' House in Gugging**

Leo Navratil **198**

13 **From Domination to Desire: Insiders and Outsider Art**

Eugene W. Metcalf, Jr. **212**

14 **French Clinical Psychiatry and the Art of the Untrained Mentally Ill**

Mark Gisbourne **228**

15 **Outside Outsider Art**

Kenneth L. Ames **252**

ARTISTS AND THEIR WORK

16 **Mistaken Identities: Meret Oppenheim**

Maureen P. Sherlock **276**

17 **Elijah Pierce, Woodcarver: Doves and Pain in Life Fulfilled**

Gerald L. Davis **290**

18 **How Do You Get Inside the Art of Outsiders?**

Michael Owen Jones **312**

19 **Outside in the City: Street Performers in New York's Washington Square Park**

Sally Harrison-Pepper **332**

Notes on the Contributors 348

To
Collin and Rane
Justin and Taylor

ACKNOWLEDGMENTS

A 1989 exhibition and symposium on outsider art environments in North Carolina generated the original conversation from which the idea for this book evolved. The exhibition's co-curator, Roger Manley, gave early impetus and direction to the development of this volume. Brad Taylor read the first draft proposal for the book and offered editorial assistance. John Michael Vlach reviewed the completed outline and gave counsel on some of the pitfalls that can attend the discussion of outsiders and their art. Lynda Roscoe Hartigan critiqued sample texts and helped focus the project toward publication.

Smithsonian Institution Press editor Amy Pastan enthusiastically promoted the manuscript and then shepherded it through various phases of preparation and production. Her support and editorial skill were invaluable. Cheryl Anderson, also at the press, made sure that the many details otherwise overlooked did not fall between the cracks.

We would also like to thank the contributors to the volume. Their work has challenged and redefined the understanding of the artist outsider and thus the conception of this book.

Finally, this project would not have been possible without the generous collaboration of Roger Cardinal. He suggested the European contributors, edited some of their essays, and with his wife, Agnès, translated into English a number of the essays. As a scholar and friend, Roger steadfastly supported the idea of this book as an exchange of a wide variety of provocative, and often conflicting, viewpoints. His patience, good-will, and hard work were critical to the success of this volume.

INTRODUCTION

The decades of the 1970s and 1980s witnessed an unprecedented rise of interest in art produced by people presumed to be cultural "outsiders." Folk art, the art of the insane, art brut, art by self-taught makers, women's art, and the arts of numerous ethnic groups—all captured the popular imagination. This book presents the first general collection of critical essays on the subject of art and its outsiders. Since the current conversation on the artist outsider is a trans-Atlantic one, this book contains essays by both European and American authors whose writings demonstrate how the study of the artist outsider can become a focus for the larger study of creativity, marginality, art, and culture. In Europe much of the debate on the artist outsider focuses on what was originally known as art brut, and more recently as outsider art—the art of obsessive visionaries or the patients of mental institutions. In the United States, outsider art has been understood more broadly than in Europe and has often been popularly conflated with folk art, ethnic art, and many other gestures produced by various outsider groups and individuals. Consequently, the essays herein focus both on outsider art and on a variety of other art forms which have together recently defined and popularized the idea of the artist outsider as it has affected the changing shape of western art.

All societies create a group identity which is established in relation to some designated "other." The cultural self is thus clarified, measured, and understood when members of a society compare themselves to those they perceive as outside their group. In 1949 Simone de Beauvoir wrote: "The category of the OTHER is as primordial as consciousness itself. In the most primitive societies, in the most ancient mythologies, one finds the expression of a duality—that of the Self and Other. . . .

No group ever sets itself up as the One without at once setting up the Other over against itself." [1]

To make the unknown known, and to protect the self, most cultures classify and collect the signs by which they know their others. Widely displayed, these signs mark the boundaries of culture and preserve the nature of the cultural self. They demonstrate to cultural insiders who they are by reminding them of who and what they are not.

Twentieth-century western assertions of the cultural self have been particularly fixated on otherness. In the interest of defining their own art, modern westerners have unrelentingly studied and collected the art of "others." Many varieties of such arts have been appropriated and assimilated in order to give form to the insider dialogue that has generated the evolving modernist aesthetic. In the early decades of this century Picasso, Paul Klee, and André Breton all measured their achievements against those of groups they knew as others—tribal carvers, children, and naives. In the 1920s and 1930s American artists, curators, and collectors discovered homegrown outsiders in the form of the "folk" and initiated the avid, ongoing interest in folk art. In the 1950s the French artist Jean Dubuffet identified artistic otherness in works he called *Art brut,* which he gathered from patients in mental asylums and from various self-taught makers he identified as visionaries. In the 1970s British critic Roger Cardinal popularized art brut in the English-speaking world as *outsider art,* and shortly thereafter, especially in the United States, this term came to apply to many different kinds of art created apart from mainstream traditions. Indeed, throughout the history of modern art, the avant-garde itself has long asserted its own artistic otherness. As a consequence, the bohemian modern artist has been typecast as a cultural outsider from the time of Courbet to the present.

Several early studies have discussed primitive art, folk art, and modern art as the art of outsiders. In 1938 Robert Goldwater's *Primitivism in Modern Art* considered the impact of tribal art on the early Cubists and Expressionists. In 1942 Sidney Janis, in his book *They Taught Themselves,* argued that the work of self-taught, folk, and popular painters should be viewed as an outsider challenge to the orthodox art world. Finally, Colin Wilson's 1956 book, *The Outsider,* examined Van Gogh and others as misunderstood artistic and literary outsider geniuses who shaped modern times. Recently the study of the artist outsider has acquired new energy and perspective with the direct linking of the outsider idea to the concept of the other. This has been especially evident in the study of primitivism with books like Sally Price's *Primitive Art in Civilized Places,* Marianna Torgovnick's *Gone Primitive,* and Susan Hiller's edited volume *The Myth of Primitivism.* In addition, particularly in books like *Mixed Blessings* by Lucy Lippard; *Out There,* edited by Russell Ferguson et al.; and *Woman, Native, Other* by Trinh T. Minh-ha, the concept of the other has been an important concern in the debate regarding issues of multiculturalism. [2]

This book proceeds from the premise that modern western culture has encouraged the classification of things made by people perceived as outsiders into two sys-

tems of inquiry, one that addresses the social meaning and value of such objects and another that considers the objects in aesthetic terms. The organization of this book, which follows this classification scheme, owes a debt to the work of historian of anthropology James Clifford. In his essay "On Collecting Art and Culture," Clifford discusses the interactive system in which westerners in the twentieth century have understood and categorized objects collected from nonwestern sources. In this system objects are classified as either "(scientific) cultural artifacts or as (aesthetic) works of art."[3] Ethnographic museums and art museums frequently display similar objects but contextualize them using different frames of reference. Objects thus interpreted are regularly trafficked back and forth between the world of artifacts and the world of art depending on the needs and dispositions of those studying them.

A perusal of recent writings on outsider art, folk art, and even contemporary fine art reveals that the system Clifford devised for his discussion of nonwestern art can be expanded to embrace the interpretations of many of the artistic gestures currently informed by the idea of the artist outsider. Although the distinctions between social and aesthetic systems of inquiry or meaning are never clearly drawn or immutably fixed—and objects as well as the discussions prompted by them can be a part of both systems—contemporary writings on outsiders and their art may be broadly categorized in terms of their social or aesthetic agendas. Thus the essays in this volume have been grouped in two parts: the first examines the aesthetic perspectives that underlie the ideology of the artist outsider, and the second emphasizes a social interpretation of outsiders and their art. Each of these parts is further subdivided into two sections, the first of which presents essays focused on theoretical, philosophical, and historical issues and the second of which presents case studies, or essays on specific artists and their work. In this way each half of the book provides both a wide-angle and a close-up view of the artist outsider.

The first section of the book opens with five critical essays. In the first of these essays, Lucy R. Lippard sets an open-ended tone for the book and establishes a major theme of this section, the problems of artistic classification. Musing on the nature and meaning of four objects which sit near her desk—objects which "run a gamut of outsiderness" and might variously be classified as folk, fine, craft, ethnic, or outsider—Lippard considers the ways in which such categories can obfuscate artifactual meaning. The next essay, by Roger Cardinal, reevaluates the term *outsider art*—a term which the author himself coined in the 1970s. Cardinal attempts to sketch new criteria for defining and aesthetically evaluating "a wider application of the term 'Outsider Art.'" Following this, in a seminal essay published in 1976, Daniel Robbins examines one of the most popular forms of American outsider art, American folk art. Arguing that the distinctions between folk art and other arts are not as clear as we believe they are, Robbins traces and investigates the history and mythology that popularized folk art as an American icon. The next essay, by Michel Thévoz, presents a history of the discovery, collecting, and promotion of art brut. Thévoz describes how art brut can be distinguished from other more socially connected art

forms, and how the burgeoning market for outsider art has influenced the production and nature of art brut. In the final essay of this section, Joanne Cubbs traces the history and philosophical development of the idea of the artist outsider from the time of its popular emergence in nineteenth-century Romanticism through its continued presence in the world of contemporary art. Cubbs provides a historical and philosophical context for the issues raised by the other authors with whom she shares the first segment of the book.

The next section focuses on the impact of artistic definitions on the work and lives of particular artists. Although the work of these artists has been variously classified as folk art, fine art, and outsider art, it is all informed by the idea of the artist outsider in ways which encourage reevaluation of the artistic terms in which this work is commonly understood. In the first of these discussions, Laurent Danchin introduces the French environment-maker Pierre Avezard and his fantastic merry-go-round. Danchin compares Avezard's work to other examples of environmental and kinetic art in both the United States and Europe, and considers it in terms of the definitions of art brut, outsider art, folk art, and popular art. Next, David Maclagan studies the enigmatic work of the Mexican American schizophrenic artist Martin Ramírez. Suggesting that art has no obligation to communicate with its audience, Maclagan argues that to be more fully comprehended the art of Ramírez needs to be reinterpreted in terms of the irony it brings to the idea of art as communication. In the third case study, Michael D. Hall offers an inspection of the art of the Lithuanian-Canadian artist Jahan Maka. Hall attempts to break down the barriers that generally exclude the art of self-taught artists from popular art history and suggests that the best language available for a discussion of work like that of Jahan Maka is the language of the fine arts. The fourth essay, by Charles G. Zug III, compares and contrasts the work of a traditional potter and a visionary stone carver. Zug establishes the criteria he uses to distinguish a folk artist from an outsider artist and then constructs the aesthetic framework within which the work of his two subjects can be understood and appreciated. Finally, in the last essay of this section, Richard Nonas argues that art cannot be contained by categorizing it with adjectives like outsider, folk, primitive, feminist, or conceptual. Such practices, he says, destroy the power of art—a power he believes is inherently tied to art's indefinable otherness.

The essays presented in the first section of the second part of the book focus on historical, political, and philosophical issues affecting the social meaning of the idea of the artist outsider. Here various writers explore the way in which that idea reflects and structures social relationships and ideology. In the first essay, written in 1985 and expanded for this volume, Constance Perin considers the cultural and biological factors which influence the reception of new and unusual art. To illustrate these influences, she analyzes the critical responses to the European and American tours of the Prinzhorn Collection of psychotic art, which was exhibited during the 1980s. The second essay, by Leo Navratil, recounts the history and development of his involvement as a psychiatrist with the art of his patients and with the founding of

the famous Artists' House at the Gugging psychiatric clinic near Vienna. The third essay in this section, by Eugene W. Metcalf, Jr., analyzes the social use and meaning of outsider art as a form of cultural inversion. Metcalf argues that like the art of primitives, outsider art is an artifactual category whose meaning is imposed from the inside and supports as normative the values of the group that has the power to impose its aesthetic definitions on society. In the next essay Mark Gisbourne discusses how the French view of the art of the mentally ill changed from one in which works were viewed as psychotic curiosities to one in which they were appreciated as art. In tracing this history, Gisbourne discusses changing medical views of madness and the development of clinical psychiatry. The last essay in this section, by Kenneth L. Ames, assesses art as an exercise in power. Examining outsider art in terms of its political and social dimensions, Ames argues that the mystification of any art (whether outsider, folk, or abstract) is a dangerous activity which promotes and perpetuates a dehumanizing conception of the things modern westerners have chosen to call art.

The case studies in the last section of the book consider the impact of the social construction of the idea of the artist outsider on the lives and work of particular artists. In the first of these studies, Maureen P. Sherlock constructs what she describes as a "meditation" on the Surrealist artist Meret Oppenheim. Sherlock speculates on how the artistic, political, and sexist forces of western culture and art world patriarchy not only determined Oppenheim's reception as an artist but indelibly shaped her art and her view of herself. The next essay, by Gerald L. Davis, considers the life and art of the African-American woodcarver, Elijah Pierce. According to Davis, despite the fact that Pierce's art has been called "isolate," Pierce himself was anything but an outsider. Davis establishes Pierce as an artist whose art and life were deeply rooted in his African-American community. The third essay in this section, by Michael Owen Jones, is both a critical inquiry and a case study. Beginning with a consideration and critique of the similarities and differences in the ways folklorists and proponents of outsider art approach their subjects as others, Jones concludes by examining two artistic activities, chair making and the decorating of an office work space. The last essay in this section suggests that issues related to the artist outsider are of concern in the performing, as well as the visual, arts. Focusing on street performers in New York's Washington Square Park, Sally Harrison-Pepper shows how their activities are influenced by, and can be understood in terms of, many of the issues discussed elsewhere in this book. Harrison-Pepper argues that the success of many street performers depends on their ability to represent themselves as outsiders.

Certainly many of the essays presented here could have been situated differently within the book's binary format, for they counterpoise both social and aesthetic issues. Similarly, some of the pieces grouped in either the theoretical or case study subsections could be translocated, since art exists both as an idea and as a physical production. In the broadest sense the best critical discourse rarely fits into tidy slots. More specifically, the difficulty of placing these essays within an organizational frame

bears witness to the fact that the contemporary study of the artist outsider is complex, even contradictory at times, because it inquires into both the nature of art and the shifting relationships of art, creativity, and culture.

The authors in this volume variously discuss art as aesthetic expression, political turf, clinical data, a marker of community, a functional artifact, and a sign of personal identity. Yet despite their differences of opinion, the contributors all suggest that art and artists play important roles in the creation and maintenance of our society's understanding of itself. The idea of the outsider comes into being as a construct for discovering and testing the boundaries of cultural experience. Similarly, the idea of the artist outsider provides an interpretive framework for speculating on the nature of art and the role of creativity in western culture. By examining various manifestations of the idea of the artist outsider, this book demonstrates how an interdisciplinary investigation of art practice and theory can clarify and enrich our understanding of the contemporary world.

Michael D. Hall
Eugene W. Metcalf, Jr.

NOTES

1. Simone de Beauvoir, *The Second Sex,* trans. and ed. H. M. Parshley (New York: Vintage Books, 1974), xix.

2. Robert Goldwater, *Primitivism in Modern Art* (New York: Random House, 1938); Sidney Janis, *They Taught Themselves: American Primitive Painters in the Twentieth Century* (New York: Dial, 1942); Colin Wilson, *The Outsider* (New York: Dell Publishing Co., 1956); Sally Price, *Primitive Art in Civilized Places* (Chicago and London: University of Chicago Press, 1989); Marianna Torgovnick, *Gone Primitive: Savage Intellects, Modern Lives* (Chicago and London: University of Chicago Press, 1990); Susan Hiller, ed., *The Myth of Primitivism* (London: Routledge, 1991); Lucy Lippard, *Mixed Blessings: New Art in a Multicultural America* (New York: Pantheon Books, 1990); Russell Ferguson et al., eds. *Out There: Marginalization and Contemporary Cultures* (Cambridge, Mass. and New York: MIT Press and New Museum of Contemporary Art, 1990); Trinh T. Minh-ha, *Woman, Native, Other: Writing Postcoloniality and Feminism* (Bloomington: Indiana University Press, 1989).

3. James Clifford, "On Collecting Art and Culture," in *The Predicament of Culture: Twentieth-Century Ethnography, Literature, and Art* (Cambridge: Harvard University Press, 1988), 222.

PART I

THE OUTSIDER IN AESTHETIC PERSPECTIVE

HISTORY AND THEORY

CROSSING INTO UNCOMMON GROUNDS

Lucy R. Lippard

I live in layers of familiar objects, some made by well-known and some by unknown artists, while others, equally exquisite, are created by nature alone. One of my favorites is a human/nature collaboration, a circular root snake that kicks around on the crowded bookshelves above my desk. It irritates me that I can't remember where I got this handsome object—a flea market, a junk store, or perhaps it was a gift, years ago. It is about four inches high. The wood is black and hard with a natural patina. It curves twice, then the head turns back toward its triple tail, which resembles three new and finely writhing snakes born of the stronger body. A small knot in the wood forms a kind of topknot or headdress behind the eyes. Winding three times around, it could be a bracelet for a hand smaller than mine. One eye is a tiny lump in the smooth, dark wood, and the only human-made emphasis is the other eye and a groove carved for its delicate mouth. It is fragile, graceful, and tough. It feels as though it could be African American, from the South, where I was raised for several childhood years, ignorant of the spirits around me [1.1]. But it could also be from some other continent, the intricate curling branch of some plant I've never seen. Although I was once trained as an art historian, and now and then feel a tinge of curiosity, I don't ultimately care where it comes from and I've never gotten around to showing it to anyone who might know. Its beauty and resilience reassure me; it belongs to some place where little distinction is made between "natural" and artificial, a place where humans and nature are not antitheses, where continuity between the two realms is taken for granted. I like to think that the root called and some artist responded, with a single word. Was the artist woman or man? Brown or pink? Here or there? Sooner or later I may know more about the snake's origins. Will it matter?

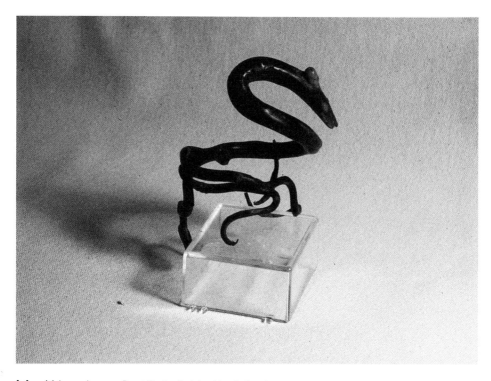

1.1. Maker unknown. Root Snake, height 4 in. Collection of Lucy Lippard. Photo by Jerry Kearns.

What if it turns out to be something I'm not supposed to have? Something unknowable? To whom should I return it?

A second object from my daily life: Bessie Harvey's *Rider,* also made of roots. Although I have never met the artist, I have seen a lot of her work over the years and finally found one I could afford in North Carolina. A wide-eyed black figure, whose horns are also hands holding the reins, does not control the runaway nightmare it rides. The steed has a giraffe-like neck, several horns, buck teeth, and eyes like its rider. The rider could be the artist, any artist, being carried away into unsuspected, desired, or dreaded realms. Harvey, an African American woman from a small town in Tennessee, had seen the images since childhood, but began to bring them out of the wood and roots only after she had raised eleven children [Pl. 1]. Her materials call out to become her visions. "It's somethin' like a torment," she has said. "Just about everything I touch is Africa . . . and I must claim some of that spirit and soul" (Harvey, 1989: 270). Robert Farris Thompson, citing Harvey's "formal plenitude," says she "vibrates" her wood with the addition of paint, sparkling glass, and foil. He also notes that her figures can be regarded as incarnations of *bisimbi,* powerful local spirits in the Kongo that are twisted like roots: "Forked branches, held to be remarkable counters of the presence of the spirit, are such a strong element of the Kongo

religion in Cuba that the faith has come to be termed *palo* (stick, twig, branch from the forest)" (Thompson, 1989A: 42).

A third object near my desk—a tiny armadillo skull, its mosaic scales painted in orange, turquoise, black—once had a life of its own on a Texas prairie. It was resurrected, and given new eyes—a shell and an agate, "for seeing in all directions"—by Cherokee artist Jimmie Durham, who is self- and family-taught as a carver and school-taught as an "artist." "A 'savage' can't, or won't, make 'fine art,'" he says. "Back home we have old people who have the most amazing power—it shines and vibrates, and I think that it comes from their goodness and generosity of spirit. . . . I'd like to achieve that. When it comes time to die—if one can say to the shit, 'haha, shit, I won!'" (Durham, 1991).

And one last piece close to me: an old dark wooden plane that was given to Peter Gourfain by an old man he befriended in Brooklyn. He then transformed its surfaces with a rich frieze of Romanesque-like figures that seem to be rising up in revolt against their confinement [1.2]. The tool, already venerable, already a handsome object, has been given a second life as "art." The artist, whose training and sophistication is extensive, but who has always been able to keep his feet on the "common ground," has recalled or responded to preindustrial roots.

These four objects, found and altered by artists, run a gamut of "outsiderness." Harvey, Durham, and probably snake-maker qualify (problematically) as outsiders because they are people of color, whereas Gourfain, the white male, has been a formal and political resister against (and at times within) the mainstream. But only snake-maker and Harvey qualify as "outsider artists" if art-world definitions are applied, and Harvey has now exhibited so often in "high art" venues, an argument could be made for her having escaped the fold and become a "black artist," waiting like so many of her African American colleagues to cross the artificial border into just plain "artist." Durham, whose "savage post-modernism" is a protest against the exclusion of Native American production from "universal" art, is trying to carve out a place where the two can coincide. Gourfain—committed to social change through left politics, teacher at both art schools and senior centers—moved years ago from "inside" minimalism to "outside" maximal art; he scorns the commercial milieu even as he sometimes makes a living as an artist. Snake-maker, who may be long gone, doesn't care what s/he is called.

The term "outsider" art, fairly new and already discredited, is as confusing as the range of works it tries to incorporate. These artists are "outside" of what? Their own social contexts? Sometimes. The mainstream? Usually. In fact, these people, like some of the best artists who function within the art world, are really insiders. They are outcasts only because those who live in their head tend to be ignored in a society that primarily decorates the pocket and the outer self. Their isolation is actually a perceived but unacknowledged class difference. From an existential position, they are no more isolated than most modern souls. So it is a matter, once again, of an

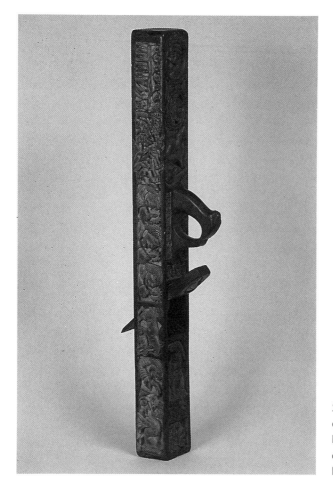

1.2. Peter Gourfain. *Michael Stewart—Remember,* 1986, carved wood carpenter joiner, length 28 in., width 4 in. Private collection. Photo courtesy Ann Nathan Gallery.

ethnocentric society's negative naming process, based on what is not rather than what is; the margins are defined by the center. (Black writers on black folk art are few.)

The "high-cultural bias" with which folk artists of color are viewed is itself a problem of context—not just the white-walled elegance in which a painted tin bucket or beaded watchband or carved religious figure may be set off, but the surrounding, pervasive, invasive social constructions of art which influence the folk artist as well as the fine artist of any color. When and if the categories blow away, we will be able to go back and look at the work of each artist in real particularity, in terms of her or his life, place, family, community, education, influences, beliefs, values, and the longings and visions that never entirely transcend the specific, the "ties that bind" us to the earth. While it is true, as African American poet Estella Conwill Majozo says, "we're all breathing each others' breaths" (Majozo 1991), we breathe from different places. According to art dealer and "folk art" scholar Randall Morris: "Entire bodies

of work have disappeared from our knowledge banks because the art establishment did not have the right word to describe it. Environments both sacred and secular are destroyed every week because their importance in this universe has never been understood. . . . We are the outsiders. We are dominating and invading entire ways of life and giving them our names. By naming it we think we own it" (Morris, 1990).

I prefer the terms vernacular or home-made or self-taught, though of course all good art is to some extent self-taught and the studio is home to many, just as home is the studio to many. "Perhaps if we started seeing the homes of the Southern artists as studios," says Randall Morris, "we would stop treating them as factories" (Morris 1990). This statement recalls feminism in the early seventies, when women artists, often lacking the big white lofts where men worked, demanded that kitchens, bedrooms, and card tables be seen as studios. Perceived as well as actual context determines how the product is seen.

It seems both inane and inevitable that I have already opened that can of worms I had meant to let alone: What is folk art and what isn't? I am torn, as I write for the first time at any length on vernacular art, between the scholar's temptation to name, to divide and divide again, and a contrary urge to decategorize forever. Who are the folk? Can we ignore the Nazi connotations of the word? Who is the "common wo/man"? Yet the ground is shifting even as we try to pin down the categorizations. And in the field of ethnic aspirations, naming is of extraordinary importance. Since all definitions of art itself tend to be intellectually pretentious, romantically vacuous, or wishful thinking, I yearn, probably naively, for a day when the categories will disappear and unconfined experience will become paramount. Destruction of irrelevant and misleading nomenclatures shouldn't affect the way the objects are seen, but we have learned enough about representation over the last decade to recognize the way vocabulary constructs the hierarchies on which the market and imposed notions of "quality" are based.

Like most people whose lives are committed to looking, I have always been pleased by serendipitous encounters with vernacular art. But I have been forced to confront this growing pleasure more directly in the last fifteen or so years in which I have become jaded by the art scene and often disaffected by the "fine" art that used to affect me deeply. The absence of meaning in many of the most beautifully made or cleverly stylized objects within the art world has sent me—and others—back to what I emotionally, if not intellectually, perceive as the sources of creativity. This return need not mean a regression to the kind of estheticizing that has characterized past study of "folk art." On the contrary, perhaps by expanding—going further out on both sides of the formalist-contextual debate—some actual common ground can be discovered. Strategies might include unexpected collaborations and dialogues decontextualized by moving out of the art worlds and into less-rarefied territories.

The range of complex situations displayed in the four objects around my desk is not that rare. While the "art world mainstreams" (there are several of them, which overlap in the market) still hold the center, the so-called margins are occupied by a

great diversity of art and artists and have been the most interesting place to Look and See for well over a decade. Some of this divergence, and rebellion against market control and categorization, began in the early seventies with the feminist movement's rehabilitation of so-called craft mediums, from fiber arts and quilting to china painting, hobby arts, even baking. Fourteen years ago I wrote that perhaps only in a feminist art world "will there be a chance for the 'fine' arts, the 'minor' arts, 'crafts,' and hobby circuits to meet and to develop an *art of making* with a new and revitalized communicative function . . . [when] our visions are sufficiently cleared to see *all* the arts of making as equal products of a creative impulse which is as socially determined as it is personally necessary" (Lippard, 1984: 105).

Through the 1970s and 1980s, the sources, content, and materials of new art continued to expand, but the contexts usually remained inside the art world. On the margins, however, a "new genre" public art, often involving performance, was developing out there in the world itself, where the audience or participants—true "outsiders"—became part of the mix, the form, the artist's work. As it expands the view of art itself, this kind of avant-garde community art indirectly expands my view of vernacular art. Deliberate mixtures, even confusions, of "high" and "low" cultures invaded the fine-art context in collective forms like Group Material's shows (such as *Arroz con Mango,* in which each inhabitant of the gallery's block contributed her/his own favorite "art object"), Judy Baca's and Tim Rollins's work with underprivileged kids, Suzanne Lacy's communally constructed performances with older women, John Malpede's Los Angeles Poverty Department work with homeless people, and many others.

By the mid-eighties a second tributary met the mainstream—the presence of an increasing number of innovative and culturally rooted artists of color. From the dual directions of conservative nostalgia and radical challenges to conventional history, the idea of personal and political roots has inspired a great number of contemporary artists. While some have warned against the dangers of "getting tangled up in roots," others have felt the call of real or imagined homelands. Today, for instance, David Hammons's African-inspired street (and gallery) art that pays homage to black vernacular art is welcomed into the art world. Faith Ringgold's quilt stories and Joyce Scott's beaded sculptures—both skills learned from their sewing mothers—are finally also considered high, or "inside" art. At the same time, as Randall Morris points out, biography is more important than esthetics in the evaluation of vernacular art; the artists have to be poor, crazy, criminalized, non-white, uneducated, young, old (Morris, 1990). A recent exhibition organized by the Southeastern Center for Contemporary Art, "Next Generation: Southern Black Aesthetic," admirably incorporates vernacular artists Hawkins Bolden and Lonnie Holley (whose work is arguably the best in the show). In the catalogue's biographical section, only these two artists are described by paragraphs about their lives, rather than their careers; the "professional" artists are represented by long resumes listing exhibitions and honors. Such inclusion, if not yet seamless, is a step in the right direction. But it is unlikely

that black vernacular artists, like their professional counterparts, will often be able to make the leap over "black art" and into "art." One reason is that vernacular artists are rarely given the chance to speak for themselves. Interviews and artists' statements are hard to find.

Eugene Metcalf has written that the Harlem Renaissance marked first-time white support for black arts, while at the same time there was "a hardening of caste lines and a resurgence of racism resulting in bloody riots and the rebirth of organizations like the Ku Klux Klan." This sounds very familiar today as the right wing attacks all moves toward multicultural cooperation as divisive threats to state unity. Similarly Metcalf again writes on the 1920s:

> The new popular stereotypes of black primitivism were remarkably similar to the old racist stereotypes of black self-indulgence and irresponsibility. Before the 1920s blacks were condemned for being childlike and shiftless. After the war they were applauded for being spontaneous and free. The image had not become more accurate; rather, white society's view of itself had changed, and whites now used blacks to justify their own rebellion against the discontents of civilization. . . . Generally, it was hard to tell the difference between the derision and the praise (Metcalf, 1983: 277).

Today white people remain the gatekeepers. Whenever we pick and choose from other cultures, we are validating values and tastes that may not be shared by those who made the art. We tend to select that which either validates our own values or, at best, that which provides intellectual challenges to our assumptions.

Commercially, the main thing that separates "folk art" and "black art" is that southern African American artists don't usually have agents; their work is netted though "sharecropping" situations, in which, according to Morris, "all their output is picked up for relatively small stipends by agents and pickers and then farmed out at huge markups around the country. . . . And to this day no one has called the concept racist in public" (Morris, 1990). The same, of course, can be said of Appalachian, Native American, and Latino craftspeople, whose work is intended for fairs, churches, flea markets, or airports.

According to Eugene Metcalf definitions of art are highly "political." The fact that most vernacular artists don't give a damn which kind of artist they are called shouldn't negate the weight of this devaluation process. The makers of things *are* often pleased that they are perceived as *artists,* aware, like the rest of us, of monetary benefits and prestige accompanying that glorified position. It is romantic to think that in this day and age "folk artists" can be rigidly separated from the values of the society all of us live in. That used to be the myth about artists in general, that they somehow escaped their social context and were freer than the rest of us, above it all or below it all. Poverty separates in other ways. To consider context is to consider class and economics. There is a pervasive and paternalistic tendency, even among the most progressive onlookers, to assume that folk art is spoiled by contact with the

(true) outside, that sophistication will destroy rather than enrich "authentic" vernacular output. (And sometimes this is true, as it is true for high artists who lose their way.)

Have things really changed since Holger Cahill wrote in 1932, "Folk art cannot be valued as highly as the work of our greatest painters and sculptors, but it is certainly entitled to a place in the history of American art" (Cahill, 1932: 14)? This is the kind of guarded reception so-called multicultural art has received in some quarters since the late 1980s. The confrontations, co-optations, and conflicts that have characterized the meeting of margins and mainstream in recent years have been seen as primarily transformative by some (myself included) and as primarily assimilational by others. The latter view has been expressed by critic Donald Kuspit, with a certain realism tinged by a certain cynicism:

> The appropriation of the marginal by the mainstream is dialectical in that the marginal is legitimated by the mainstream and the mainstream acquires the aura of authenticity and integrity supposedly innate to the marginal. . . . Once appropriated by the avant garde, the artifacts that embody marginality slowly but surely become mainstream, eventually acquiring the status of high art even though they were initially valued because they had nothing to do with its conventions. In its turn the avant garde acquires the exotic look of being at the limit of civilization . . . that marginal art affords. (Kuspit, 1991: 34)

Since the 1960s, an underground battle has been waged over the extent to which art and life can and should merge. Kuspit concludes that marginal artists, once assimilated into the mainstream, become "minor artists," in part because objects too closely entwined with the real world are not accepted as art, and the nameless makers of folk art have long been defenseless against such charges. They are named in and out of categories at the will of those who love their products and those who exploit them (often the same people). This is only the case, however, when the process of naming from above overcomes direct experience.

The incorporation of vernacular art into the art world parallels the process of assimilation in the history of the United States. The same problems abound. While on one hand it is important to recognize that vernacular art is "as good as" fine art and should therefore have the right (I use political terms deliberately) to be seen equally often and in equal circumstances, on the other hand, differences submerged are no longer differences, and cultural autonomy goes down the drain.

All folk art (although that by people of color is assumed to be doubly "primitive") has long played the role of the "other" for a hierarchical dominant culture that is in fact a nonculture. Those who maintain a sense of culture are oddly envied by those who have bought into the "cultureless" dominant culture, even when, or perhaps because, they live in unenviable economic circumstances. It is culture—often a euphemism for class—that separates middle-class and avant-garde art from vernacu-

lar art. We white people in the United States tend to see ourselves as without culture, without past, whereas we see vernacular art (like Native American art) as permanently located in the past, despite the fact that it often looks to the future with a certain visionary optimism. James Pierce, an artist and teacher who lives in Kentucky and Maine, a longtime supporter of outsider artists, has noted wryly that "socialized and inhibited university-trained artists . . . pursue the work of these natural artists as they would their own lost youth and innocence" (Pierce, 1979). Georg Lukacs's notion of a "transcendental homelessness" that characterizes the modern Western mind has been summed up by Marianna Torgovnick as "secular but yearning for the sacred, ironic but yearning for the absolute, individualistic but yearning for the wholeness of community, asking questions but receiving no answers, fragmented but yearning for 'immanent totality'" (Torgovnick, 1990: 188). From the security of educated whiteness it can be difficult to realize that change is not change unless it crosses the board.

In a splendid diatribe about everything that's wrong with the context in which folk art is held captive, Randall Morris says that outsider/self-taught art has

> little or no contextualization into the art world at large; and worst of all it has become a secret hiding place for the last bastions of cultural elitism, imperialism and out-and-out racism. . . . We seem to need to believe that the "noble savage" still exists. We need to believe it so badly that we will even cut off part of our own everyday world and exoticize it to create an "other" we can collect, embellish with theory, and still seek to control. (Morris, 1990)

This is a crisis for the white collector, critic, and audience as much as it is a crisis for those who are misnamed. This is not to say, however, that naming is the sole cure, that we will ever understand everything about each other. The vitality of the intercultural process is maintained by difference. New alliances, new mixtures, are being formed in contemporary art, and the (relatively) unself-conscious creativity of vernacular art seems a good place to look for them. The mixture of kitsch and commitment, synthesis and sincerity, is typical of the new hybrid art, which may be born of cultural specificity but ends up living in the domain of cultural generality— a national, even global, common ground. Instead of seeing "folk art" as potential high art and separating it from its uncommon ground, why not see its deep roots as something that can be emulated (rather than ripped off) by high art?

Vernacular art is simultaneously strange (mysterious) and universal, terms that sound contradictory but are simply expressive of an integrated dualism that surfaces in much of the writing about it. To whom is such art strange? To whom is it familiar? In view of the power (and empowerment) embodied in so much vernacular art, it is appalling that the term *primitive* is still used to describe the products of the self-taught, albeit less and less frequently and often in face-saving quotation marks. It is a word that acts like an ecological indicator to our own art environment, a word that

is especially objectionable when applied to the vernacular art of people of color. Paraphrasing Jean-Jacques Rousseau and Claude Lévi-Strauss, Marianna Torgovnick writes that there are no authentic primitives, no nature-culture dualism, because "all cultures construct natures." For Euro-Americans, she says, "to study the primitive brings us always back to ourselves, which we reveal in the act of defining the Other" (Torgovnick, 1990: 11).

If any white writer manages to ignore the concept of the Other, it is Robert Farris Thompson, whose twenty-five years of work on the African sources of African American art blithely approaches utilitarian objects, yard art, vernacular art, and "high art" with equal scholarly fervor. He has demonstrated how vernacular art acts "upon black artists like an invisible academy, reminding them who they are and where they came from, an alternative classical tradition" (Thompson, 1989B: 131). But I am struck by the ambivalence that characterizes so much writing on "folk art." Perhaps it is endemic to scholarship to be torn between categorization and imagination. Randall Morris calls for art historians and folklorists to combine efforts toward a "fascinating examination . . . of the process that begins with a folk cultural product and ends as a work of individual genius." At the same time, he says he is personally "glad to hear that Frank Jones is not in the same category as an applehead doll. . . . There is no line drawn between illustration and art. Royal Robertson and Grandma Moses romp in the same Elysian fields even though they never had and never will have anything in common" (Morris, 1990).

Similarly ambivalent and sometimes contradictory distinctions (or, more harshly, "nitpicking") characterize even the best academic writings on the subject. Eugene Metcalf, in a ground-breaking article written almost a decade ago, "Black Art, Folk Art, and Social Control," makes similarly ambivalent distinctions between "black art" and "folk art" while criticizing Jane Livingston for identifying folk art as "an esthetic paradoxically based in a deeply communal culture, while springing from the hands of a relatively few, physically isolated, individuals" (Livingston, 1982: 11). Metcalf took exception to her perception of that work as "neither folk art nor fine," but in so doing, he created his own contradictions. "Folk art," he argued, is communal, and "black art" is the occupation of isolated, individual African American artists. The "much more independent and improvisatory" aspects of such artists should deliver them into what I see as the equally confining category of "black art." ("Black art" is by definition still separated from "art," that is, "white art.") An artist like James Hampton (whose *Throne of the Third Heaven* was in Livingston's Corcoran show), wrote Metcalf, is not a "folk artist," making art that functions as a connection to society or tradition, but a "high artist," drawn "apart into a private universe" (Metcalf, 1983: 283). I'd argue that a "high artist" is defined, not just romantically by her or his isolation, but by the commercial hierarchies that affect the art once it leaves the studio.

"Real black folk art," such as baskets, gravestones, and musical instruments, writes Metcalf, is overlooked or dismissed, whereas social and esthetic status is con-

ferred upon the idiosyncratic works that resemble mainstream art and can be connected to various modernist movements. "Pushed into categories that do not fit it and stigmatized by a questionable—possibly pejorative—aesthetic that does not describe it, this black art is celebrated precisely for what it is not. Its truly unique qualities become, therefore, more difficult to understand and value" (Metcalf, 1983: 288, 287).

Knowing as little as I do about the history of the naming of folk art, I am not clear about why it took so long to include a large number of black artists "even" in a folk art context. Was their art seen as a stepping-stone to high art and therefore an invasive tactic by the masses to storm the palaces of art? Metcalf identifies, and perhaps exaggerates, a xenophobia within the art market that implies just that.

> One of the ways by which the notion of folk art preserves the status and power of the leisure class is by serving as a dumping ground for unusual forms of expression that might challenge the artistic and social status quo. Produced by artists uncommitted to the high-art tradition and the values and society that support it, these works pose a potential social threat. This art is at times the product of a world view antagonistic to the leisure class. To admit that it is as complex and significant as academic art suggests the validation not only of the art itself but of the culture, the attitude, and the people it represents as well. (Metcalf, 1983: 287)

With the introduction of many more African American artists toward the center, things have changed since that article was written, and Metcalf himself may well have rethought some of his more finely shaved definitions. But the problem of individual versus communal remains a red herring, furthering the kind of either/or thinking that characterizes the art world in almost every aspect of its existence. Metcalf says that to neglect a sense of community is to deny the very essence of folk culture. If that's so, then all the more reason to erase the categories. In many cases, the focal point is not so much community as place, or memory of place. In addition, an individual can express communal beliefs and longings even if s/he is "isolated," and even if s/he is wallowing in the art context. However, the chances of these beliefs and longings being identified in the sterile commercial context are not great.

Theoretical insistence on the distinction between high art and folk art, while demanded by current methodologies, can be insidious and double-edged. On one hand, it is crucial to acknowledge the invisible ways in which social control is abetted under the guise of esthetic standards. In the battle around "quality," these machinations operate still more dangerously within the fine-art world itself in regard to artists of color and other groups struggling to release information and emotions from unfamiliar territory. On the other hand, it is important to convince those who mediate art that quality is relative rather than absolute, differing among communities and cultures. The binary naming process itself—"folk art" versus "real art"—is inevitably imposed from above and beyond the world of the practitioners.

Lonnie Holley, the extraordinary self-taught artist from Birmingham, Alabama, speaks from a place that transcends external definitions:

> Time, for me, works like a door. You have to go through time in order to be in it. It seems like one big cycle from within, like a spring. You start at the innermost part of the spring and you move outward as you grow. And, as you grow, this materialistic body which is flesh, takes its place and acts; then it falls back to the beginning to recreate itself. . . . This is what the Spirit have gave me: Man was supposed to know all about the things that had been created on earth, from one time period all the way to another. . . . Time is standing still if one is not moving in it; and, if one is moving in it, time moves so fast that we cannot keep up with it.
>
> So I'm sure that everything that has happened; all the ancestors that have had to pass away in order for the earth to be as it is, they was playing a part, like I'm playing a part in life today, just living and creating. Then I'll fade away and kind of fertilize the soil around my children. (Holley, 1989: 63)

We increasingly recognize the link between the professional artist and the "outside world" and the ways both are unnaturally confined in a narrow concept of art which permits even white male artists to understand alienation. Truly new art of all kinds brings new information into the incestuous isolation native to high art. Once inside however, it tends to be redesigned. As Michel Thévoz has said in a discussion of *art brut*, "like Orpheus, who by looking at her, killed the woman he loved, western culture seems doomed to destroy any other form of expression by the mere fact of taking advantage of it" (Thévoz, 1976: 14).

So-called folk artists tend to be more relaxed than so-called fine artists about crossing back and forth over the borders between life and art, and about the idea that both art objects and art making have healing powers. "Art as therapy" is denigrated in the art-world market because it is seen (perversely) as a denial of the incredible amount of hard work it takes to be an artist in this society. Nevertheless, the best artists, like traditional shamans, consciously and unconsciously take risks for the common good outside of the circumscribed boundaries of professionalism—boundaries set for a politely "outrageous" art that sits safely in galleries and museums, usually revealing little but the surfaces of the modern malaise. A good deal of the most interesting art found today in galleries and museums has been influenced by the strength of objects made for religious, political, or therapeutic reasons. Ralph Griffin, for instance, finds his roots in water, associates water-shaped wood with antiquity and power, unconscious embodiments of Kongo religion (Thompson, 1989A: 47), and adds the global colors of shamanic vision. "I go to the stream, I read the roots in the water, laying in clear water. There's a miracle in that water, running cross them logs since the flood of Noah. . . . This is the water from that time. And the logs look like Old Experience Ages. . . . I paint it red, black and white to put a bit of vision on the root" (Griffin, 1989: 48).

The dilemma posed (and accepted by writers about folk art rather than by the

artists themselves) is still one of ghetto versus assimilation, autonomy versus co-optation. There are still a thousand questions to answer and they will spawn others. Is the power and spirit of a work made from roots found in the Tennessee woods permanently or temporarily (or not at all) stolen when it is exhibited in a foreign milieu and exposed to misunderstanding eyes? Do objects ripped from their contexts become "merely" beautiful, their richness forever impaired? Or is that power latent, waiting until a Robert Farris Thompson, or a new group of young artists who can see through glass cases, comes along to open the windows?

In fine art, the everyday is for the most part dismissed (except in still lifes and portraits, and even then, formal values tend to overwhelm the quotidian information). In vernacular art, the everyday is the container of meaning, of the political and spiritual currents that spark life itself. I suspect that few vernacular artists have bothered their heads about their alienation from the dominant culture. (And the indifference is mutual.) "Visions or dreams are generally highly personal experiences; to become legitimate parts of a folk esthetic they must be shown to be responsive to communal dictates," writes Metcalf (Metcalf, 1983: 282). Community is too narrowly defined here. The visionary process does not only occur "within strong traditional cultures." The emphasis on memory, place, dreams, and visions provides an unrecognized common ground between vernacular and high art. In popular opinion, all artists are assumed to work on this spiritual level, even though many do not. William Ferris says that domestic arts frame the artist's culture "into recognizable units," providing a way of coping with daily life and memories, and that the images emerging from the dreams of southern African American artists often "follow patterns consistent with each other and with traditional Afro-American folk art through which the artist recreates images of his [sic] past, and this dimension of Afro-American experience helps explain how artists hundreds of miles apart can create similar images and even use the same language to describe their 'futures'" (Ferris, 1975: 116). Fantasies of Africa are often built upon psychic insights and memories. Storytelling and narrative art guarantee continuity, which is what so many of us in this society have lost.

The rules for "folk art" appear to shift when Latino or especially Native American art is being discussed. Aside from the *retablos, bultos,* and *santos* of the Southwest, Latino folk art—ironwork, cement work, the yard art of *capillas* and *nichos*—is often relegated to the "crafts" or "utilitarian" category, whereas walking sticks made by both white and African American artists are, for some reason, permitted into the sculpture salons. Nowhere are these arbitrary distinctions more obvious than in the history of Native American art.

In the early part of the century, ethnographic collections were summarily divided between art and artifact, between art museums and natural history museums. The division itself was part of a grudging acknowledgment of "quality" in "savage" esthetics. Curiously, one rarely sees "Native American folk art"—or rather, one sees it but not under the rubric. Ironically some Native American art represents one area

where the boundaries between folk and fine art are crossed, although not necessarily for the right reasons. Even while some Native American religious art from the past has been elevated to high art, Indian "folk art" is seen as an imitation of a functional past art. Indian artists have been confined by their markets, although in the last few decades, some—like some "folk" artists—have escaped into the avant-garde. An area unexplored as far as I know is the vernacular art of the black Indian in the Southeast, where mutual influences in quilting and beadwork, for instance, have crossed between the two cultures.

Given the false distinctions between utilitarian object and "useless" art that haunt the vernacular arts in all communities, I particularly admire two recent "folk art" compendiums: the Texas Folklife Center's *Art Among Us/Arte entre nosotros*, Pat Jasper and Kay Turner's investigation of Mexican-American vernacular art in San Antonio, and *We Came to Where We Were Supposed to Be*, the 1984 exhibition of Idaho folk art curated by Steve Siporin. (The title is a quote from the Shoshone-Paiute on the Duck Valley Reservation.) *Art Among Us* includes cement park sculpture, wrought-iron ornament and furniture, religious shrines, wood carvings, musical instruments, religious shrines and paraphernalia, murals, yard art, signage, and grave decorations. *We Came to Where We Were Supposed to Be* has an even broader range, encompassing the work of Coeur d'Alenes, Nez Perces, and Shoshones, along with that of Mexican-American, Basque, Finnish-American, and Mormon communities. Their products include buckaroo saddles, quilts, rugs, parfleches, belts, embroideries, waxflower ornaments, cradleboards, wagon-wheel fences, whittled fans, baskets, mailboxes, miniature machines, tools, fishing flies, and branding irons as well as the more conventionally accepted whirligigs, sculptures, and pictures.

Such an expansive approach harks back to the Native American and rural Latino tradition of inseparable life, religion, land, and politics—a tradition that also constitutes a possible model for our future. *We Came to Where We Were Supposed to Be* is a grass-roots history of Idaho, and as such it doesn't divide the people who live there. As Siporin says, they don't often "express a sense of self so rashly as to declare themselves 'artists.' They consider themselves housewives, ranchers, or blacksmiths whose art is part of their work and leisure" (Siporin, 1984: 3).

The audience for these arts may often be a "consumer," but the relationship is more integrated than that of buyer and seller in the art world. Community-based cultural values produce these objects, but like so-called outsider art, they maintain their value beyond that context. Jasper and Turner talk about "esthetic loyalty" and cite Clifford Geertz's suggestion that traditional art forms and cultural realities are interwoven, simultaneously creating each other. "This idea of art *creating* community cultural realities challenges our usual notion of art—especially folk art—as a static reflection of societal values. It allows us to see that Mexican American folk art in San Antonio exemplifies the very way in which art-making may constitute strategies for affirming and recreating loyalties in the family, the neighborhood, and the community at large" (Jasper and Turner, 1986: 10).

So can't we see all of these very different arts (and I haven't touched on many, such as those made by the ill, the old, prisoners, or from an Asian American tradition) as a series of interfaces between urban and rural, old and new, this and that culture, art and not-art? As multiculturalism mixes it up on the art scene, barriers between disciplines, mediums, and hierarchies are falling too.

ACKNOWLEDGMENT

This essay is a revised version of an essay that originally appeared in *Common Ground/Uncommon Vision: The Michael and Julie Hall Collection of American Folk Art at the Milwaukee Art Museum* (The Milwaukee Art Museum, 1993).

BIBLIOGRAPHY

Cahill, Holger. 1932. "Folk Art." *Art Digest* 15 December.

Durham, Jimmie. 1991. Letter to the author.

Ferris, William. 1975. "Visions in Afro-American Folk Art: The Sculpture of James Thomas." *Journal of American Folklore*, Vol. 88.

Griffin, Ralph. 1989. Quoted in "The Circle and the Branch: Renascent Kongo-American Art" by Robert Farris Thompson. In *Another Face of the Diamond: Pathways through the Black Atlantic South*. New York: INTAR Latin American Gallery.

Harvey, Bessie. 1989. "Bessie Harvey." In *Black Art: Ancestral Legacy. The African Impulse in African-American Art*. Dallas: Dallas Museum of Art.

Holley, Lonnie. 1989. "Lonnie Holley." In *Another Face of the Diamond: Pathways through the Black Atlantic South*. New York: INTAR Latin American Gallery.

Jasper, Pat, and Kay Turner. 1986. *Art Among Us/Arte entre nosotros*. San Antonio: San Antonio Museum Association.

Kuspit, Donald. 1991. "The Appropriation of Marginal Art in the 1980's." *American Art* (Winter–Spring).

Lippard, Lucy R. 1984. "Making Something from Nothing (Toward a Definition of Women's 'Hobby Art')." In *Get the Message?* New York: E. P. Dutton.

Livingston, Jane. 1982. "What It Is." In *Black Folk Art in America, 1930–1980*, by Jane Livingston and John Beardsley. Jackson: University Press of Mississippi.

Majozo, Estella Conwill. 1991. Comments at "Mapping the Terrain" conference, Oakland, California, November.

Metcalf, Eugene W. Jr. 1983. "Black Art, Folk Art, and Social Control." *Winterthur Portfolio* Vol. 19, no. 4.

Morris, Randall. 1990. "A Question of Authenticity." Unpublished manuscript, New York.

Pierce, James. 1979. *Unschooled Talent*. Owensboro, Maine: Owensboro
Museum of Fine Arts.

Siporin, Steve. 1984. "Introduction." *We Came to Where We Were Supposed to Be*. Idaho:
Idaho Commission on the Arts.

Thévoz, Michel. 1976. *Art Brut*. New York: Rizzoli.

Thompson, Robert Farris. 1989A. "The Circle and the Branch: Renascent Kongo-American
Art." In *Another Face of the Diamond: Pathways through the Black Atlantic South*. New
York: INTAR Latin American Gallery.

———. 1989B. "The Song That Named the Land." In *Black Art: Ancestral
Legacy, the African Impulse in African-American Art*. Dallas: Dallas Museum
of Art.

Torgovnick, Marianna. 1990. *Gone Primitive*. Chicago: University of Chicago Press.

2

TOWARD AN OUTSIDER AESTHETIC

Roger Cardinal

Although a whole century has gone by since Henri Rousseau emerged as our first paradigm of untutored creativity, the task of sorting out those categories of art which flourish outside the academic mainstream remains inseparable from a sense of crisis, as dealers and collectors trumpet and agitate, and commentators obsessively check that their powder is dry and their criteria razor-sharp. But why should the simple business of classification still be so controversial? Can we not reach agreement about definitions and move on to the quieter, subtler discussion of purely aesthetic matters?

In my own case, I must confess that, in approaching the question of categorization, I have often drawn a metaphoric sword, as if to tackle an issue fraught with risk and dense with hidden implications. Somehow the mere phrase "Outsider Art" seems to stimulate an expenditure of nervous energy. A glance at catalogue prefaces from across the world shows how frequently apologists blow up a storm in their opening paragraph. Typically, they unleash a passionate polemic against cultural preconceptions, adopting the intellectual weaponry of a Jean Dubuffet. Alternatively, they may chant a list of synonyms—grass roots, isolate, marginal, maverick, offshore, primal, from scratch, way out, the art that has no name—calculated to flip the noninitiate into a mental spin. Then again, they may, to similar effect, coin one glamorous label, invariably ill defined and volatile in its connotations. Laurent Danchin has observed how, in the francophone world, the opening of practically every exhibition or museum of Outsider Art has been marked by the ritual minting of a new-fangled term so that, in the wake of Dubuffet's classic *Art brut*, we are each time obliged to check out the exact exchange rate for *Art-hors-les-normes, Les Singuliers de l'art, Art*

autre, Art en marge, Aracine, Art cru, Indomptés de l'art, Création franche, and so forth.

At one level, what Didi Barrett wittily dubs "term warfare" reflects a laudable instinct not to take other people's secondhand slogans on trust.[1] At another level, it may be symptomatic of an obscure complex of feelings, including the embarrassment at being seen to define and display a passion which a majority may perceive as unusual, even illicit. Perhaps what all the competing labels reveal is not so much the intrinsic qualities of the art itself as the disarray of its partisans; alluding to an unfathomable, almost taboo pleasure, the promoters of Outsider Art want simultaneously to share it with others and to cloak it in mystery.

At yet another level, it might be thought that such bickering over terms betrays a basic fear of genuine critical dialogue, which can only really flourish where there is agreement on a fixed nomenclature. My own feeling is that we ought by now to be impatient of turmoil; we need to sort things out with clarity: to identify just what this art *is* and why we place value upon it. To this end, I propose in what follows to stick to the single term "Outsider Art."[2] I am aware that this somewhat slick formula has attracted criticism—some shrewd, some silly—and that it is unlikely to be accepted as a neutral category for some time.[3] My justification for using it is simply pragmatic: Outsider Art has by now achieved wide currency in the anglophone world as an equivalent to and, as I shall argue, an extension of, Jean Dubuffet's original notion of Art Brut. Moreover, since I do define my terms, I can at least claim not to be guilty of bamboozling anyone with fancy rhetoric. In a turbulent situation, it is vital that we signal our intentions and allegiances as clearly as we can.[4]

What I am attempting here is to sketch the appropriate contemporary criteria for defining and evaluating Outsider Art. In order to do so, I am obliged to refer back to Dubuffet's earlier polemics, although I think it important not to stick slavishly to his historical positions, which, for all their undoubted influence, are in need of reappraisal. I see the priority as being to decide which concepts are of most relevance to the tasks of identifying the works being produced *today* as well as those from the past. Further, my ambition is to link the question of a working taxonomy of Outsider Art to that of its aesthetic impact. For it seems to me desirable not only that we decide which kind of art we wish to address, but also that we start to assess the responses it provokes.

Before offering a considered definition of Outsider Art, I want first to insist that Dubuffet's original notion of Art Brut was itself an evolutionary one. Indeed, his conception passed through at least three stages: at first a hazy intuition, it solidified into a rigorous set of criteria before finally becoming a more flexible and congenial yardstick.

When Dubuffet began his legendary searches in Switzerland in 1945—in passing, we might recall that his earliest revelation concerning extracultural art dates back to 1923, when he came across an album of mediumistic drawings—he seems

to have been motivated by a desire to prove a thesis, namely, that such a thing as authentic creativity *could* come into being outside what he saw as the impregnable walls of an elitist art world. A point-by-point definition of Art Brut did not seem necessary at the outset, something which in 1947 he cheerily admits, implying that to avoid spelling out one's terms might even be a proof of integrity: "It is surely not my business to formulate what Art Brut is. To define something—indeed even to isolate it—is to damage it a good deal. It comes close to destroying it." [5]

The fact is, of course, that Dubuffet *did* have a very sharp eye for the things he prized, and the official appeal he made in 1948 to the psychiatric profession begins to lay bare his criteria by way of an emphasis on the notion of stylistic originality, along with its corollary, creative independence from the supposed conformities of Cultural Art.[6] A year later, on the occasion of the first major public showing of his Collection de l'Art Brut, Dubuffet launched his most ornate definition in the manifesto "Art Brut in Preference to the Cultural Arts." Here an acerbic downgrading of the establishment values of museum and gallery serves to inflect a definition through contrast; given that Cultural Art is so narrow and infertile, he argues, one is surely impelled to admire its opposite, Art Brut, as the superior alternative.

> What we mean by this term is work produced by people immune to artistic culture in which there is little or no trace of mimicry (as is invariably the case with intellectuals); so that such creators owe everything—their subject-matter, their choice of materials, their modes of transcription, their rhythms and styles of drawing, and so on—to their own resources rather than to the stereotypes of artistic tradition or fashion. Here we are witness to the artistic operation in its pristine form, something unadulterated, something reinvented from scratch at all stages by its maker, who draws solely upon his private impulses.[7]

This classic passage constitutes the central knot in a web of associations which Dubuffet was to weave throughout his voluminous correspondence in order to fix his conception of Art Brut or Outsider Art; it is in relation to the essentials of this cumulative definition that I shall shortly draw up my own analysis.

At a third stage of reflection, Dubuffet was to modify his theory quite significantly. By the late 1950s, it had dawned on him that his stipulations were too rigid to be practical, and that some concession was needed. A slight embarrassment about having to adjust his position may be inferred from the way he uses metaphors to explain himself: Art Brut is now presented as a *pole,* an unattainable point at the antipodes to cultural conformity; and then as a *wind,* a waft of fresh air which inspires creative originality. "It would be good to think of Art Brut rather as a pole, or as a wind which blows with variable strength and which, in most instances, is not the only wind to be blowing." [8] Read in conjunction, the two metaphors evoke an allegorical journey of discovery in which a vessel in arctic waters ardently seeks an

impossible absolute; what is essential is that authentic creativity is deemed to be measurable by the power of the inspiration which propels it and by its orientation toward an ideal standard.

Christian Delacampagne has argued that these notions are implicitly tied to the specific and seemingly unimpeachable case of Adolf Wölfli, the Swiss psychotic artist who was one of Dubuffet's first discoveries and whose name crops up as the touchstone whenever Dubuffet needs to instil rigor in his evaluations.[9] Of course, the grounds for Wölfli's sanctification as an untutored genius are common knowledge. First, everyone agrees that he made marvelous pictures of great singularity, evidence that, in his case, a gale-force wind must have been blowing directly toward the Art Brut pole! Second, Wölfli was manifestly uncultivated; he was an uneducated farmhand and a social misfit, and his sexual misconduct at the age of thirty-one led to his institutionalization within a mental hospital for the rest of his life. Yet what really delighted Dubuffet about Wölfli's biography was, I surmise, not just that he was an out-and-out madman from the golden age of creative insanity, but that he had absolutely no art training, no contact with the art world, no professional vanity. Thanks to these notions, Wölfli was established in Dubuffet's eyes as an irrefutable paradigm.

There is about Dubuffet's appraisal a certain aura of partiality, and I shall want to return to the Wölfli case below. For the moment, let me simply stress the overt criteria which are in play here. What Dubuffet is proposing is certainly a method for differentiating between artworks; but what is special about it is that, far from relying on such intrinsic or aesthetic properties as form, style, and technique, it instead highlights extrinsic facts having to do with the creative posture, the personality, and even the case history of their maker. From a traditional aesthetic viewpoint, this might seem a very blurred way to want to look at things, and some will deplore this. All the same, a concern with persons has by now become an inescapable factor in any discussion of Outsider Art, and it would seem pointless to try to complain at this juncture. Let us therefore move on, consciously noting that the discourse around Outsider Art has by now legitimated an approach concerned not just with the artifacts proper but also with the creative activity which underlies their formation and in turn, and unabashedly, with the mental and social context out of which the creative impulse emerges in the first place. This is to accept that the pursuit of an "Outsider aesthetic" will imply a widening of focus beyond orthodox aesthetic limits (though at the end of the twentieth century this is, to be sure, no longer much of a heresy).

My own view is that Dubuffet's middle-period criteria, those which are strictest and sharpest and, of course, best known, paradoxically served the cause of Art Brut less well than his initial blithe intuitiveness or his later flexibility and relativism. I want to suggest that in at least two major instances, a stubborn commitment to his own most rigid principles forced him into regrettable discriminations. In the cases of Soutter and Chaissac, one sees him adjudicating in ways which make his standards seem suspect.

Louis Soutter was the maker of undoubtedly striking nonacademic works, the fruit of a psychological crisis late in his career. In other circumstances, his dazzling ink sketches and finger paintings would have attracted Dubuffet's unqualified enthusiasm had there not been the ticklish detail that the first part of Soutter's life had been that of a conventionally successful musician and artist [2.1]. Accordingly, Soutter was deemed to be culturally compromised and he failed to qualify for entry into the Collection de l'Art Brut.[10] Gaston Chaissac, for his part, was an untrained maker of drawings and objects whom in 1946 Dubuffet unhesitatingly hailed as an authentic author of works of Art Brut. Yet although Chaissac was never appreciably to alter his approach to the creative process, Dubuffet later reversed his opinion and cast out from the Collection each and every work donated by Chaissac, justifying his action by reference to Chaissac's link with the Paris intelligentsia and his alleged cultural opportunism [2.2].

I am, I hope, not alone in thinking it an enormous pity that two creators of such calibre should fall foul of a mere technicality. Are these not instances where it might have been sensible to bend the rules? Here, precisely, the absolutism of Dubuffet's

2.1. Louis Soutter. *Echoes of Distress*, n.d., black ink on paper, 14¾ in. × 19 in. Collection de l'Art Brut, Lausanne, Switzerland.

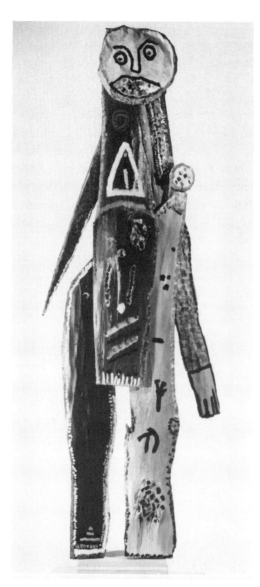

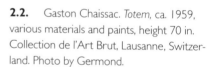

2.2. Gaston Chaissac. *Totem,* ca. 1959, various materials and paints, height 70 in. Collection de l'Art Brut, Lausanne, Switzerland. Photo by Germond.

classic, second position allows no room for compensation, whereas one could argue that his third, more flexible position might have ratified these two cases as ones in which the creative wind had certainly blown strong, even if a fraction erratically.

Michel Thévoz describes elsewhere in this book how it was that the problematic items which for decades Dubuffet assigned to a nondescript Annex Collection were at last able to resurface under the flag of "Neuve Invention," a borderline category whose standards are more generous in that they condone an element of formal training or of access to the domains of public exhibition and commercial profit. Yet though I am delighted to see Soutter, Chaissac, and many others emerge at last into

the daylight in Lausanne, I have my reservations as to the probity and necessity of this act of taxonomic reshuffling. It seems to me very odd, for example, that the work of Ignacio Carles-Tolrà should for many years have resided happily within the main Collection de l'Art Brut—no less than 256 items are listed in its 1971 catalogue, almost a record in itself!—only to gravitate thereafter, without public explanation, into the Annex Collection and thence into the Neuve Invention overspill. It is true that Carles-Tolrà can be shown to have enjoyed a few shows in commercial galleries; but then so did Scottie Wilson, and so have Michel Nedjar and Ted Gordon, who all three continue to figure on the Art Brut roll of honor. I should have thought that, whether or not the criteria of Neuve Invention are valid in themselves, they are certainly susceptible of being unevenly applied, and may on these grounds be deemed faulty.[11]

In his preface to the 1988 *Neuve Invention* catalogue, Michel Thévoz is at pains to defend Dubuffet, referring to the "taxonomic vicissitudes" which necessitated "the up-dating of a notion which has varied with the evolution of artistic production itself."[12] Now, it might well be objected that it is not individual artworks which change but rather people's perceptions of them, and that what Dubuffet and Thévoz have ended up doing is to mark out a defensive buffer zone around Art Brut, adding to the problems of taxonomy rather than diminishing them, and setting up what is in effect a two-tier and even elitist distinction between "first-class" and "second-class" Outsiders. This, I submit, is as unsatisfactory in principle as it is in practice.

My present sense is that the fast-growing body of creative work coming to light in North America, France, and elsewhere urgently needs to be addressed in ways more responsive and responsible than the classic criteria allow. To insist on applying outdated rules could mean vaunting one's critical consistency while in fact missing the boat of change. I am beginning to perceive that the more realistic strategy is to modify the definition before it cracks under the strain. I don't know whether we should vote for a restrictive definition of Art Brut as being uniquely the copyrighted label of the Lausanne collection, but I *am* sure we need to countenance a wider application of the term "Outsider Art"—indeed, we are under the considerable pressure of an expanding usage on three continents which cannot be halted by mere critical fiat. I make this statement in the full recognition that to loosen a definition means to risk blunting its capacity to discriminate; but on the other hand, a definition so inflexible and sharp that nobody dares to apply it any more will in any case go to rust!

Rather than pursue a localized European quarrel in which undercurrents of caprice and personal taste are inevitably implicated, I propose now to shift ground, retaining those elements of Dubuffet's original thinking which still seem relevant, in order to address Outsider Art in wider terms, both as a general concept and as an acknowledged international phenomenon. Let me accelerate this widening of focus by citing two very recent definitions which demonstrate that I am not alone in adhering to a contemporary conception of Outsider Art that is indebted, yet not subservient, to Dubuffet's original thinking. It is, I think, significant that I am able to invoke

two such apologists as the American Roger Manley and the Swiss Paolo Bianchi, who, in manifesting a reciprocal interest in Outsider Art as it has emerged on separate continents, are seeking to extend and to update Dubuffet's critical model.

Here is how Manley recently defined Outsider Art:

> This art has been created by ordinary individuals who are not part of the art world and who, initially at least, often have no conception of themselves as artists or of their creations as art. This last aspect is one of the most radical (in the truest sense of the word) aspects of the potent, evocative, provocative, intensely personal, unselfconscious, expressive, enigmatic, obsessive, vital, disquieting, brutal, subtle, exotic, close-to-the-ground, challenging art labeled as "outsider." [13]

Bianchi's statement reads thus:

> With the Outsider, we are dealing with a sensitized artistic type whose feelings, thoughts, work and life are shattered by contact with the reality of the dominant majority; yet he is able to escape from the ruling customs and the dominant view of the world in so far as he takes a stand on the issue of his otherness, setting himself up in contradistinction to other people, to that which is normal and orderly, and foregrounding his status as pariah. He avoids being classified as a curious comic entertainer, as a fool or a droll, by cultivating a willful isolation, a separateness, or an unconscious going-to-ground. [14]

While smiling at certain touches of hyperbole which still seem *de rigueur*, I would want to defend such definitions insofar as they not only identify an "artistic type" but also point positively toward an appropriate critical response. Let me underline the ideas at issue here and argue for their relevance to the processes of defining, collecting, and appreciating Outsider Art in today's world.

I have suggested that the broad terms of Dubuffet's aesthetic vision remain valid in the sense that, as enthusiasts of Outsider Art, we ascribe virtue not only to inherent properties of the material artifact but also to its maker's creative posture. I do believe that an emphasis on *process* rather than on *product* remains fundamental and that it should be considered a defensible option for the critic, despite the problems it brings in its train. One practical drawback is that we can rarely aspire to sufficient intimacy with a given creator as to be able to attest to his or her characteristic mode of engagement in the artistic procedures of visualizing, projecting, transcribing, elaborating, consolidating, modifying, and so forth. Not all Outsiders have made speeches about what they actually go through when they are at work, and this is why—from an understandable yet not altogether justifiable desire to fill in the gaps—we often find ourselves digging out ancillary information from anecdotal sources, building up a stock of data concerning social behavior, psychological condition, and so on. The danger is that we may end up exaggerating Bianchi's model and mythi-

fying the Outsider as a creature of beguiling paradox—heroic dissident, illiterate sage, ornery moralist, deranged rationalist, untutored perfectionist.[15] (It can also happen that we come across work produced by a supposed but nameless Outsider—the Philadelphia Wireman, for instance—which, merely because it is "orphaned," we uncritically pull under our rubric, and then unjustifiably attribute to its maker a lifestyle commensurate with that of Bianchi's splendid pariah. Where classification is based only upon idle conjecture, we move, critically speaking, onto very thin ice. How should we feel if, after all, the Wireman turned out to be a mischievous professional artist?)

My considered position is that, while I accept that extra-aesthetic considerations can be a revealing supplement to our understanding of artistic process, they are definitely the weak link in the actual definition of Outsider Art. They undermine its plausibility as being at least to some degree an *aesthetic* category and, as is now beginning to occur in the practical field, make it possible for a work to be credited with a low or a high rating in the art market on biographical evidence alone—evidence often as spurious as it is sensational.

On the other hand, I do not intend to retreat to the purist position which insists on severing art from an originating context altogether. Instead, what I would like to propose as the priority for discussion is the creative process proper, to the extent that this can be differentiated from the creator's broader biography. What guidelines might be established to help us focus upon the shaping impulse manifested within Outsider Art?

Traditionally, the Outsider has been described as producing his or her work in response to some unusually strong internal impulse, spontaneous and unprogrammed and, as Manley suggests, having no specifically artistic character. Such an impulse might be equated simply with the urge to articulate a pressing idea, feeling, or corpus of experiences. There is evidence that old age is a common precondition for the creative outburst, as Thévoz contends elsewhere in this book; again, it may be that a personal trauma is a frequent catalyst, as Manley observes.[16]

(In passing, it may be noted that such considerations tend to corroborate Dubuffet's determination to outlaw all specimens of Child Art from the Art Brut canon, on the grounds that, for all their seeming spontaneity and ignorance of artistic models, children necessarily lack the experiential momentum and depth that lends Art Brut its characteristic density.[17] This sort of argument could ratify our positive evaluation of, say, the childlike images of Bill Traylor, who began drawing at the age of 85. On the other hand, the startling imagery produced by the autistic child Nadia between the ages of three and seven should make us hesitate to countersign a legalistic ruling concerning the Outsider's age.[18] What surely counts is *artistic* maturity; automatically to reject a creator for being too young smacks of bureaucratic chicanery.)

Let me at this juncture hazard a tenet of my own, drawing on the underlying principles implied in the above. I believe that a paramount factor in the critical defi-

nition of the creative Outsider is that *he or she should be possessed of an expressive impulse and should then externalize that impulse in an unmonitored way which defies conventional art-historical contextualization.*

I want to suggest that Dubuffet's trenchant criterion of "immunity to artistic culture" has still enough of a cutting edge to allow us to make clear and instructive divisions between the province of Outsider Art and that of its neighbors. I think it makes excellent sense to invoke just this criterion in order to distinguish Outsider Art from Folk Art as the latter term is understood in Europe, that is, from the art of those who, whether or not they actually remain nameless, subordinate their ego to a collective culture or a long-established model or tradition. A respect for norms can be seen reflected in the work of rural potters, wood carvers, weavers, and the like, along with countless other examples of creative work which in turn touch upon what are sometimes classified as traditional crafts, or again Popular Art.[19]

It is well known that both Folk Art and Popular Art rely a good deal on nonfigurative patterning built up of scrupulously repeated motifs; but where such ornamentation occurs in Outsider Art, as for example in the drawings of Frank Jones, it is, on the whole, appreciably more intense and obsessional, and these qualities carry us beyond prettiness toward something more compelling and claustrophobic [Pl. 2]. Such a difference in impact can, I believe, be demonstrated, at least in relative terms, and is potentially an excellent basis for an aesthetic, that is to say work-specific, distinction.

The issue of figurative representation raises a separate criterial point. Within Folk Art and Popular Art, we can observe a tolerance of, if not a preference for, mimesis. But whereas these arts tend to stylize and to stereotype, thus distancing themselves from realism, Naive Art can be taken to imply an ambition to transmit recognizable, naturalistic configurations, whether they derive from existing pictorial sources such as engravings or postcards (Ernst Damitz, Emerik Feješ), or are based on real-life scenes (Germain Tessier, Nikifor), or embody imagined scenes which, albeit chimerical, are depicted in the realistic mode or something approaching it (Matija Skurjeni, Ivan Rabuzin, Drossos P. Skyllas). By contrast, the typical Outsider is one who deliberately or instinctively *shuns* realism, and generates images which court description in such terms as "distorted," "caricatural," or "strangified"; the drawings of Gaston Duf and Joseph Yoakum exemplify this trend.

Admittedly it would be wrong to attribute virtue to a style on the sole ground that it defies the supposed pictorial "norm" of perspectival naturalism.[20] What is awkward about Dubuffet's celebration of the "antimimetic" tendency is that it confuses formal training in the fine arts with a defense of the naturalistic, as if art schools were historically frozen at some point long before Cubism. I think it undeniable that not all academic artists paint mimetically; nor, for that matter, do all teachers impart such draconian rules as to inhibit their pupils' idiosyncrasies and capacity for innovation.

Notwithstanding, we do still find certain connoisseurs of Outsiderdom de-

fending tooth and nail the principle that authenticity means never having set foot inside an art school nor having been exposed to critical comment. I have argued above that this extremist criterion is crudely inadequate in the case of Soutter, whose later work so magnificently supersedes his earlier orthodoxy. And while our conception of Outsider Art would become pointless if it did not carry an expectation of a high degree of innovation and creative independence, I submit that it no longer makes sense to belabor the stipulation of *utter* pictorial innocence.

Among several recent protests concerning the crudity of that stipulation is that of Gary Schwindler, who reminds us that the very idea of creative autonomy has itself become problematic: "What constitutes the condition of being self-taught? Rarely can any person escape some form of social 'instruction,' and that conditioning necessarily impinges upon and affects the production of cultural objects we designate 'art.'"[21] In turn, Laurent Danchin contends that the notion of imperviousness to visual influences is now a dead letter; our technological society has reached a point where it is unthinkable that anyone should reach maturity without extensive exposure to images transmitted by the educational system and the media.[22]

I must agree that the days are over when Outsider Art could be described as "an art without precedent or tradition."[23] It has indeed become common practice among recent commentators to underscore this insight and show up the idealism of Dubuffet's demands, though one suspects that his veneration of "the admirable Wölfli" was already tinged with nostalgia and the sense that we would never see his like again. What is less often emphasized is that, even in this exceptional case, there are distinct traces of visual and cultural influences to reckon with. Though clearly at odds with late twentieth-century urban culture, the culture of the farming communities in the canton of Bern in the 1870s was nevertheless still a culture, and undoubtedly supplied Wölfli with many conceptual and pictorial stimuli. It was not necessary for Wölfli to attend an art school or visit galleries in order to absorb some basic precepts of representation; for example, his early portrayals of buildings show a grasp of perspective, and suggest direct borrowings from engravings of Swiss towns. The evidence of his collage pictures is that he was exposed to pictorial advertisements and to engravings and photogravures from magazines like *Über Land und Meer;* several of his works exhibit an ironic complicity with such imagery (though it would be farfetched, I think, to invoke a parallel with Pop Art and recuperate Wölfli as a cultural sophisticate after all!). We know that his musical compositions reflect at least the rudiments of conventional notation as well as the rhythms of Swiss folk song and military marches (Wölfli was an army recruit in 1883 and 1884).[24] Some time ago Julius von Ries noted the analogy between Wölfli's masked faces and the owl pattern found on ceramics made at Heimberg, near Bern, and spoke generally of a folk-based style.[25] I suggest that even a cursory scanning of the peasant arts of late nineteenth-century Switzerland will prompt persuasive analogies in respect to stylized figures and geometric patterning (including the chains of repeated motifs, and the device of multiple framing) [2.3]. At least one of Wölfli's drawings echoes the typical format of a target

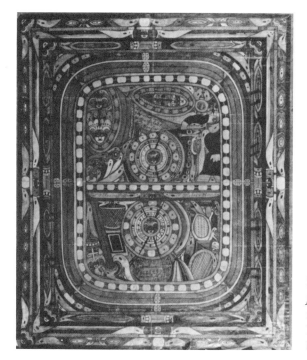

2.3. Adolf Wölfli. *Collection of Objects Brought Back from Travels,* Christmas 1920, color pencils on paper, 31 ½ in. × 37¾ in. Collection de l'Art Brut, Lausanne, Switzerland.

painted for a rural shooting contest, and the designs he did upon the Waldau asylum ceiling, and the screen and wardrobes he decorated, transmit an overall "folkloric" effect entirely redolent of cultural imprinting. Finally it is indisputable that Wölfli's texts, for all their delirious content, are rooted in the syntax and vocabulary of the Bernese dialect, and that his handwriting corresponds to the typical script of his era.

It would be idly sadistic to destroy the credibility of Dubuffet's finest example; in a sense, "tout le monde a très bien compris." We *do* know what he was getting at, and the reservations I have voiced will hardly undermine our evaluation of Wölfli as a most remarkable inventor. All the same, we must accept that even here it is still a matter of degree; so that if we are truly to assess the import of such a creative effort, we must jettison the myth that the Outsider can simply step outside of history. Equally I think we should challenge Dubuffet's tacit privileging of "low" over "high" culture. For on what grounds should we judge Wölfli to be significantly more "immune to culture" than, say, Soutter or the artists of Neuve Invention? Why—if indeed we are truly in search of originality—should we be prepared to gloss over clear traces of peasant culture while recoiling from any hint of bourgeois culture? I suggest it is time to return Dubuffet's private war with Cultural Art to its own historical slot and instead envisage Outsider Art as that which, so far as this is feasible, acts out a resistance to cultural stereotyping of *any* sort.

However, one aspect of Dubuffet's prejudice is worth preserving. He was, I be-

lieve, entirely right to contend that creativity alters its character once the creator is made aware of the expectations or aesthetic standards of other people. We have seen that Manley styles the Outsider as one who often has no conception of his or her work *as* art, whereas those artists who are exposed to the attentions of others, whether supportive or critical—not to mention those who are subsidized or commissioned—tend to find that the creative process is inhibited, or at least unfolds with less fluency and self-assurance.

In theory, it might seem that the limit-case of the polar Outsider must be that of the autistic who wholeheartedly renounces *any* sort of contact. I make use of the clinical term figuratively so as to indicate a stance of extreme distance from the ordinary conditions of dialogue; what attracts us about the Outsider artwork is indeed more often its autistic *air* than any evidence of literal autism. Examples of extreme self-engrossment abound in the archives of Art Brut. Among my favorite enigmas are the tiny drawings of Jean Mar, about whose outer and inner life next to nothing is known and whose work seems to emanate from a state of perfect solipsism [2.4]. The pictorial production of that textbook Outsider Martin Ramírez—schizophrenic, mute, locked up for decades—can similarly be seen as the external record of an enigmatic discourse that once took place within an estranged consciousness. Yet whatever the degree of withdrawal in the making, there seems always to be some element of self-exposure about the document, not least because, as David Maclagan observes, "an actual created work, as opposed to the *fantasy* of one, is not really private; it is 'out there' in the world," and is thus available to our scrutiny.[26] More positively, I would suggest that what I have called an autistic air is nothing less than a distinctive intensity, and that it is this intensity—a quality manifest within the artwork itself, at the level of style—which catches our attention, inspires our fascination, and quickens our sense of an Outsider aesthetic.

As for a determined, codifiable *style,* I take it that it is illogical to try to elicit a finite set of conventions for the Outsider. That which resists orthodoxy and compounds singularity must surely be peculiar to the individual and the unrepeatable occasion. Outsider Art can no more be a style than a school.[27] This theoretical precept needs a little adjustment, however, for it can only hold true to the extent that Outsider Art gravitates toward a pole which we have already seen to lie beyond effective reach. Indeed, if we insisted on envisaging Outsider Art as consisting of as many styles as there are individual creators, this would imply that no Outsider Art collection could have visual coherence; this is, I believe, simply not the case. Moreover, I suspect that, even within this elective domain of the disparate and the unique, there are some undeniable constants. Once again, I feel we are justified in modifying theory in the light of the actual works we encounter. Thus I would identify as recurrent features of Outsider Art certain modes of dense ornamentation, compulsively repeated patterns, metamorphic accumulations; an appearance of instinctive though wayward symmetry; configurations which occupy an equivocal ground *in between* the figurative and the decorative; other configurations which hesitate between repre-

2.4. Jean Mar. *King and Queen Take a Walk*, ca. 1908, pencil on paper, 10 in. × 6 in. Collection de l'Art Brut, Lausanne, Switzerland (formerly Collection of Professor Charles Ladame).

sentation and an enigmatic calligraphy, or which seek the perfect blending of image and word. Certain favorite subjects, such as the totemic self-portrait, have been putatively linked with the mental state of the creators concerned. There have been attempts to generalize about a "schizophrenic style," just as there have been commentaries on the typical features of artworks derived from the mediumistic trance.[28]

A secondary consideration is that stylistic affinities will tend to emerge wherever individuals share even an attenuated culture. Initially grouped on criteria of racial and social allegiance, certain black visionary creators in the American South have been compared in terms of their patterns and motifs; there has been speculation about a common source in an archetypal repertoire of "Africanisms."[29] Relying slightly less on visual parallels, Michael D. Hall considers the environmentalists Fred Smith, S. P. Dinsmoor, and Simon Rodia (all from different parts of the United States), and identifies common qualities, at once homely and heroic, which are characteristic of these "monument makers."[30] Such speculation might encourage us to treat the formula "Outsider Art" as a generalization within which, as time goes by, we should expect to situate further clear subcategories. Indeed, the groupings implied by terms like "black visionaries" or "monument makers" are, I suspect, already recognized in practice, so that all that remains is for there to be collective agreement on a sober terminology, linked to commonsensical criteria.

A third explanation for stylistic coincidence in Outsider Art is purely pragmatic. Where Outsiders have access only to relatively unsophisticated materials, their works will tend to look alike for the banal reason that they are made out of the same things. Hence the incidence in Outsider Art collections of monsters carved out of misshapen

wood unsuitable for carpentry (Bogosav Živković, Miles Carpenter), and of mosaics built up from broken ceramics (Grandma Prisbrey, Raymond Isidore); or the family likeness of drawings from European mental hospitals before the First World War, when crayons and wrapping paper were often the only accessible materials. We might, conversely, take note how the provision of uniform sheets of high-quality paper and bright felt-tip pens has imparted a rather less attractive uniformity to the products of art therapy workshops throughout the Western world. The flagrant exceptions to this rule are the maverick styles of the Gugging group, described by Leo Navratil elsewhere in this book, and the work of certain outstanding mentally handicapped artists, such as Jean-Marie Heyligen and Charly Keyen in Belgium, or Klaus Peter Schubert, Joachim Hepler, and Jörg Thiel in Germany.[31]

Having hinted at the futility of a classification informed only by the vagaries of biographical and anecdotal detail, and having pointed toward an alternative emphasis which would equate Outsider Art with a special sort of creative posture and certain concomitant confluences of style, I want finally to press for something like an "Outsider aesthetic" by insisting that, in the final analysis, the evidence which carries most weight is that provided by the works themselves. In this connection we may experience something a little unusual, though perhaps not altogether surprising, in that our taxonomic reflex is found to coincide with our aesthetic response, when, confronting the artwork, we recognize it as Outsider Art at the very moment we submit to its visual allure.

I indicated earlier that it is typical of Outsider works to be dense and hermetic. It is because they share perceptible qualities of complexity and intensity that I would feel justified in juxtaposing works as diverse in origin as the pictorial compositions of Adolf Wölfli, Frank Jones, Dragutin Jurak, Raphaël Lonné, or Minnie Evans, the crazy mechanisms of François Monchâtre or Vollis Simpson, the labyrinthine environments of Clarence Schmidt or Armand Schulthess [2.5]. What is most telling about such works is their total air of assertiveness, which seems intolerant of anything less than our fullest attention. Now, assuming that we do indeed respond, with what exactly do we make contact?

I am not sure how daring it is to suppose that the appeal of certain artworks might lie in their capacity to inspire a fantasy of participation whereby the viewer imagines joining in the very processes of their making. This speculation could hardly apply to works in the classical mode in which the principle of *ars est celare artem* tends to discredit any reminder of material fabrication. On the other hand, it could be argued that a preponderance of Outsider works bear frank testimony to their own expressive means and that, in assessing them, we would be well advised to admit this testimony. While it is true that romantic exaggeration can falsely color our reading, we can feel justified in assuming that many Outsiders experience creativity in terms of ecstasy, jubilation, engrossment, frenzy, vision, delirium, possession, and the like. Might it not be plausible for the viewer to seek to emulate such feelings, at least to a degree?

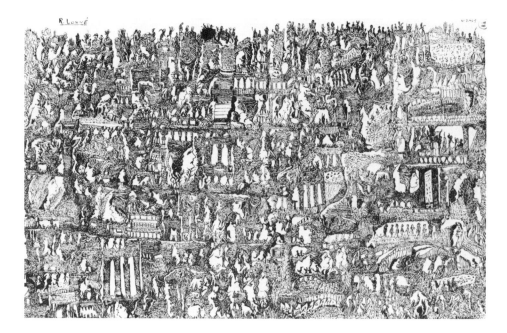

2.5. Raphaël Lonné. Untitled drawing, 1963, ink on paper, 13 in. × 20 in. Collection de l'Art Brut, Lausanne, Switzerland. Photo by Pierre Battistolo.

This empathetic mode of response becomes especially attractive when one considers the factor of *serial proliferation,* so characteristic of the more compulsive Outsiders. Here it is that, to hazard a paradox, quality arises out of sheer quantity. I have found, leafing through piles and piles of mediumistic drawings by artists like Madge Gill or Laure Pigeon [2.6], that the simple fact of scanning such accumulations over a period induces hypnotic side effects; the effort to focus on individual configurations, repeatedly made, actually induces a bemusement, my own secondary enactment of the artist's originating trance. If it is at all possible to generalize from this experience, might it not be the case that the whole aesthetic adventure of Outsider Art resides in its invitation to share in a creative process, indistinguishably both that which led to the work's original construction and now its climax in the event of construal taking place within the receptive viewer? Far from the work remaining autistic, it may be that expression and understanding were never so intimately linked as here.

This approach has the advantage of being congruent with the stipulations I discussed earlier concerning the work's relative resistance to artistic antecedents, as well as its status as a documentation of subjectivity. Outsiders, we may now suppose, develop a close relation to their work because they perceive it to be the visible embodiment of internal, psychological processes of self-exploration; the work of art can constitute a declaration of psychic independence. As Henri Raynal remarks, speaking of the spirit paintings of Augustin Lesage, "The euphoria of the artist derives from

2.6. Laure Pigeon. Untitled drawing, 2 August 1935, blue ink on drawing paper, 9½ in. × 12½ in. Collection de l'Art Brut, Lausanne, Switzerland.

the facility with which he moves about within a milieu which is by definition homogeneous, since it has sprung fully from himself." [32] For us in turn to enter that milieu means that we must adopt a certain caution, so as not to violate it. If Outsider Art comes into being through an intense investment of the private self, it follows that, as we gain access to it, we have the responsibility not to treat it flippantly or patronizingly.

Yet, it may be objected, surely not all creators are so secretive and thin-skinned? What of those Outsiders who seem only too eager to march into the limelight and press their work upon a public? Here we might be tempted to reply that Outsiders who do court publicity are ill advised to set themselves at risk; their naive self-exposure ought perhaps to be followed by solicitous quarantine.[33] However, such an attitude can all too easily smack of condescension, and I feel it is wrong to treat Outsider Art in the sentimental way that Naive Art, Child Art, and the Art of the Handicapped are so often treated: "Tread softly: these people know not what they do and require special handling." What Outsider Art surely asks for is a wholehearted, robust response whereby we meet it with our own sensibility fully adjusted to the moral seriousness of the occasion. When August Walla courts attention by

means of strident capital letters daubed on trees or pavement, or when Lee Godie annexes the steps of Chicago's Art Institute as an exhibition space, their actions may be less discreet than those of many other Outsiders, but they are no less admirable as challenges to conformity [2.7]. I believe that the intention behind their gestures of self-assertion can be perfectly easily distinguished from the motives of the run-of-the-mill *arriviste* jostling for a place in the queue for fame. We should take care not to exclude such boisterous creators from the Outsider canon on the grounds they have somehow compromised their "autism." Rather, they are to be valued for exposing academic proprieties; jesters in a world of sobriety, they point to a wonderful Otherness which only the repressed find embarrassing.

All the same, what the true lover of Outsider Art should really be looking for is more than a polemical gesture or a reenactment of Dubuffet's anticultural positions. It is still up to the artwork itself to transmit a subtler message behind an outward flamboyance. Once we look more closely, we may discern that which in the work conveys an individuality and therefore also a vulnerability, and we may also discern that which transcends its private discourse. Then it is that the work's Otherness modulates into familiarity, then it is that we share that thrill of which Jane Livingston speaks when, selecting material for an exhibition of Black American Folk Art, she felt "a sensation of convulsive recognition, as though one had seen these images before." [34]

I am conscious that I have sketched a rather demanding aesthetic of participation, one which relies on an exceptional marshalling of resources, both intellectual

2.7. Lee Godie. Untitled drawing, ca. 1984, pen, watercolor, varnish on canvas, 26 in.× 27 in. Carl Hammer Gallery, Chicago.

and emotional, in an engagement with inner impulse which goes markedly further than what one is ordinarily inclined to contemplate in the normal museum or gallery setting. Yet only by entering into something approaching the creative trance I have evoked can one hope for a fruitful dialogue with the work. When it happens, vulnerable oneself, one will echo and honor the vulnerability of the Outsider, and discover in this reciprocity a basis of human understanding and, as a bonus, a surge of feeling which is the aesthetic experience par excellence. The concentration, dynamic momentum, and sheer expenditure of time which are necessary in order for Outsider Art to accede to the status of the Beautiful (or, more strictly, the aesthetically compelling) may be seen as guarantees of its authenticity. It is that radical flavor of secrecy *slowly* becoming openness, of individuality *slowly* becoming community, which guarantees aesthetic integrity, communicating an eerie beauty born of a tension between our unsettlement and our simultaneous sense of reaching back, nostalgically, to a place we somehow remember.

NOTES

1. Didi Barrett, *Muffled Voices: Folk Artists in Contemporary America* (New York: Museum of American Folk Art/Paine Webber Art Gallery, 1986), 4. See also Michel Ragon, preface to *La Fabuloserie. Art hors-les-normes* (Dicy, France: La Fabuloserie, 1983), 6; Jean-Louis Lanoux, "La Valse des étiquettes," in *Les Jardiniers de la mémoire* (Bègles: Site de la Création franche, 1990), 10; and Laurent Danchin, "Y a-t-il un marché pour l'Art Brut?" *Artension*, no. 29 (November 1991): 7–12.

2. The coinage dates from 1972, when Jenny Towndrow, of Studio Vista Publishers, London, proposed the book title *Outsider Art* as a more palatable equivalent in English to the French *Art brut*. In Czechoslovakia, a certain rigor had been introduced by the late 1960s by the critic Štefan Tkáč, author of *Slovenske insitné umenie* (1966). His term *insitné umenie* (rather unsatisfactorily rendered as "insite art") carries the attractive connotations of the Latin root *insitus,* meaning "innate," "not inculcated," "original" (see Štefan Tkáč, "Introduction," in *Insita*, no. 1 [1972]: 14). In 1974, Vladimir Maleković proposed the term *Primal Art* and wrote a most stimulating chapter on its implications (see "The Nature of Primal Art," in his *Croatian Naive Art* [Zagreb: Grafički zavod Hrvatske, 1974], 11–86). However, theoretical clarity does not always guarantee discrimination in practice, as witness the selections for the Bratislava Triennale of Insite Art, where Outsider Art jostles next to what I would prefer to call Naive Art, and Folk or Peasant Art.

3. It often takes decades for an impromptu label to be accepted as a dispassionate technical term. Within anglophone cultures, the French formula Art Nouveau is nowadays uncontroversial, and Art Déco has achieved almost global acceptance. I surmise that Art Brut, being hardly more difficult to spell or pronounce, has enjoyed less favor with Anglo-Saxons because they identify it so closely with Dubuffet and see it as more a war cry than a concept.

4. I cannot grapple here with the many cases of informed critical dissent which shed light on the phenomenon of nontutored or nonacademic creativity. In North America, battle lines are still drawn between those loyal to the notion of Folk Art and those who see Outsider Art

as a distinct subset of that broader category, if not a category in its own right. There is evidence that vested interests, ideological and financial, have distorted what would otherwise be a tidier academic debate. I applaud the good sense of writers like Michael Bonesteel, who differentiates with clarity between Outsider Art, Naive Art, and Folk Art (see his "Outsider Art: Modernism's Parallel Aesthetic," in *Maurice Legrand Lesueur Sullins: Paintings, 1970–1986* [Springfield: Illinois State Museum, 1988], 1–2). We can still learn a lot from such classic controversies as the 1951 quarrel in which André Breton attacked Dubuffet for his unwarranted extension of the purview of Art Brut beyond the confines of psychotic art; or from the stubborn purism of an Anatole Jakovsky, the world authority on Naive Art, who for years fought to protect his artistic heroes from all association with Art Brut, despite the fact that his pantheon includes creators like Séraphine Louis, Camille Renault, Joseph Crépin, Gaston Chaissac, and Raymond Isidore, each of whom might qualify as an Outsider in a contemporary assessment (see Anatole Jakovsky, *Les Peintres naïfs* [Paris: Bibliothèque des Arts, 1956]; and Jakovsky, *Dämonen und Wunder: Eine Darstellung der naiven Plastik* [Cologne: DuMont Schauberg, 1963]).

5. Jean Dubuffet, "L'Art brut," in *Prospectus et tous écrits suivants* (Paris: Gallimard, 1967), 1:175. I have always enjoyed the breezy common sense of Dubuffet's quip later in the same text: "L'art brut c'est l'art brut et tout le monde a très bien compris" (176), which might be transliterated as "Art Brut is nothing more nor less than Art Brut, surely anyone can see that much!" Admittedly, the phrase might be taken as a sign of petulant insecurity rather than of a higher sagacity.

6. See Jean Dubuffet, "A Word about the Company of Raw Art," in *Asphyxiating Culture and Other Writings* (New York: Four Walls Eight Windows, 1988), 109–112.

7. Jean Dubuffet, "L'Art brut préféré aux arts culturels" (1949), in *L'Homme du commun à l'ouvrage* (Paris: Gallimard, 1973), 91–92 (my translation).

8. Jean Dubuffet, *Prospectus et tous écrits suivants* (Paris: Gallimard, 1967), 1:515. The implication that there may be other winds blowing opens up the interesting perspective of a plurality of simultaneous influences, though Dubuffet declines to enlarge on this.

9. See Christian Delacampagne, *Outsiders: Fous, naïfs et voyants dans la peinture moderne (1880–1960)* (Paris: Mengès, 1989), 126. Featured anonymously in Prinzhorn's book in 1922, Wölfli had previously been celebrated by name in that no less pioneering work, Walter Morgenthaler's *Ein Geisteskranker als Künstler* of 1921. Dubuffet had access to this book at the time of his Swiss searches and arranged for its translation into French in 1964. Curiously, Dubuffet's own Art Brut writings contain little specific comment on Wölfli, though the latter's work was displayed at the Foyer de l'Art Brut in Paris as early as 1948. In recent years, of course, Wölfli has been so widely acclaimed in Europe and North America as to have earned the undisputed title of World Champ of Outsider Art, much in the way that Henri Rousseau is an All-Time Great of Naive Art.

10. Dubuffet made some amends in his 1970 text "Louis Soutter," where he proposes a scale for measuring cultural independence which places Soutter much higher than Van Gogh, though not so high as Wölfli (see "Louis Soutter," in *L'Homme du commun à l'ouvrage*, [Paris: Gallimard, 1973], 437–439). That there is a case for accusing Dubuffet of inconsistency is shown by the example of Simone Marye, whose late drawings, conditioned by psychosis, so excited Dubuffet that he ignored the fact she had once been a professional sculptor and maker of Cultural Art.

11. I might add the observation that no less than seven of the names listed in Lausanne's *Neuve Invention* catalogue also turn up in the catalogue of the Aracine Museum of Art Brut, which expressly claims allegiance to Dubuffet's criteria (see *L'Aracine* [Neuilly-sur-Marne: Musée d'Art Brut, 1988]). (This institution further problematizes the issue of cultural independence in that it was itself founded by three Outsider artists.) Other collections such as La Fabuloserie at Dicy in France and the Outsider Archive in London similarly find themselves transgressing Dubuffet's code in practice while defending it in principle.

12. Michel Thévoz, *Neuve Invention: Collection d'oeuvres apparentées à l'Art brut* (Lausanne: Publications de la Collection de l'Art brut, 1988), 8.

13. Roger Manley, *Signs and Wonders: Outsider Art inside North Carolina* (Raleigh: North Carolina Museum of Art, 1989), ix.

14. Paolo Bianchi, "Bild und Seele," in *Kunstforum*, no. 101 (June 1989): 71–72.

15. Ted Gioia makes much the same point regarding the suspect information we swallow about the jazz soloist, so often stereotyped as an impromptu genius whose music is the by-product of an extravagant life-style. The parallels with Outsiderdom are intriguing, as when, for instance, Gioia speaks of jazz enthusiasts equating good jazz with visceral energy and unrestrained spontaneity alone, ignoring all dimension of acquired technique (see *The Imperfect Art: Reflections on Jazz and Modern Culture* [New York: Oxford University Press, 1988], 48).

16. Manley, *Signs and Wonders*, 9.

17. See Jean Dubuffet, "Petites ailes" (1965), in *L'Homme du commun à l'ouvrage* (Paris: Gallimard, 1973), 221–224.

18. On Nadia's remarkable work, see Lorna Selfe, *Nadia: A Case of Extraordinary Drawing Ability in an Autistic Child* (London: Academic Press, 1977) and Roger Cardinal, "Drawing without Words: The Case of Nadia," *Comparison* (Winter 1979): 3–21.

19. I take this last to designate a broad area of nonacademic art more or less associated with working-class creation and appreciation, as in fairground painting, amateur commercial signs, automobile decoration, and the like. The term is commonly associated with postindustrial and urban societies. The distinction I would make between it and Outsider Art could be demonstrated by a visit to the excellent Musée National des Arts et Traditions populaires in Paris, where I believe there is not a single object anybody would want to ascribe to an Outsider.

20. In an article attacking the conservatism of those art therapists who ignore everything that is not explicitly shown (i.e., figuratively represented) in their clients' pictures, David Maclagan argues for a more subtle approach to the reading of fantasy images, which can inhabit that considerable territory in between the figurative and the nonfigurative. See David Maclagan, "Fantasy and the Figurative," in *Pictures at an Exhibition: Selected Essays on Art and Art Therapy*, ed. Andrea Gilroy and Tessa Dalley (London: Routledge, 1989), 35–42.

21. Gary Schwindler, *Interface: Outsiders and Insiders* (Ohio University-Athens, 1986), 4.

22. See Philippe Rivière and Laurent Danchin, *La Métamorphose des médias* (Paris: La Manufacture, 1989).

23. Such was the subtitle of the "Outsiders" exhibition which Victor Musgrave and I

organized in London in 1979. While that formula now seems callow and outdated, I should say in our defense that an explicit aim of our selection was to highlight issues of classification, inclusion, and exclusion. In featuring artists like the architect Alain Bourbonnais and the former writer Denise Aubertin, we sought to draw attention to borderline cases in which creativity had flourished *despite* the creator's culturally marked background; the attempt to shake off a dominant culture is, in itself, entirely praiseworthy (see *Outsiders: An Art without Precedent or Tradition* [London: Arts Council of Great Britain, 1979], 24). And a good while before he thought up the Neuve Invention category, Dubuffet had formulated the maxim that "in the end, it is more fruitful to refuse and contest culture than to simply lack culture" (*Asphyxiating Culture*, 93).

24. The playability of Wölfli's musical compositions is assessed by Peter Streiff and Kjell Keller in "Adolf Wölfli, Composer," in *Adolf Wölfli* (Bern: Adolf Wölfli Foundation, 1976), 81–89.

25. See Julius von Ries, *Über das Dämonisch-Sinnliche und den Ursprung der ornamentalen Kunst des Geisteskranken Adolf Wölfli* (Bern: Haupt, 1946).

26. David Maclagan, "From the Outside In," in *In Another World: Outsider Art from Europe and America* (London: The South Bank Centre, 1987), 17.

27. As Dubuffet reiterated toward the end of his life: "It must be remembered that I applied the term 'Art Brut' to the entirety of those productions which have no point of origin in Cultural Art. There is no such thing as an Art Brut possessing its own characteristics: there are simply innumerable forms of art of which each has its own distinct character, their one common denominator being their basis in criteria completely at odds with those of Cultural Art" (Jean Dubuffet, *Bâtons rompus* [Paris: Editions de Minuit, 1986], 72–73). This statement supports the distinction between Outsider Art and Naive Art, insofar as the latter *does* admit the phenomenon of the stylistically uniform group or school, as witness the so-called Hlebine School in Yugoslavia, where untutored rural artists living in close proximity have developed a clear family likeness (and come close to a formulaic tourist art).

28. On the schizophrenic style, see, for instance, Alfred Bader and Leo Navratil, *Zwischen Wahn und Wirklichkeit: Kunst-Psychose-Kreativität* (Lucerne: Bucher, 1976). On the mediumistic style, see Roger Cardinal, "The Art of Entrancement: European Mediumistic Art in the Outsider Domain," *Raw Vision*, no. 2 (Winter 1989/90): 22–31. If such shared styles are indeed verifiable, and if they elude explanation in terms of orthodox cultural models, they may point to the existence of psychological and indeed physiological constants within certain creative states, thereby confirming my thesis that Outsider Art might best be defined by reference to the peculiar intensity of the art-making processes which underlie it.

29. See, for instance, Maude Southwell Wahlman, "Africanisms in Afro-American Visionary Arts," in *Baking in the Sun: Visionary Images from the South* (Lafayette: University of Southwestern Louisiana, 1987), 28–43; Alvia J. Wardlaw, ed., *Black Art, Ancestral Legacy: The African Impulse in African-American Art* (Dallas: Dallas Museum of Art, 1990); and Sharon D. Koota, "Cosmograms and Cryptic Writings: 'Africanisms' in the Art of Minnie Evans," *Clarion* 15, no. 3 (Summer 1991): 48–52.

30. Michael D. Hall, "Memory and Mortar: Fred Smith's Wisconsin Concrete Park," in *Stereoscopic Perspective: Reflections on American Fine and Folk Art* (Ann Arbor: UMI Research Press, 1988), 173–184. Hall is, of course, still working within the terminology of "Folk Art" as understood in North America, but I suspect his thinking here is compatible with mine.

31. On the art of the handicapped, see Luc Boulangé, ed., *Art et handicap mental* (Liège: Edition CREAHM, 1987); Werner Pöschel, ed., *Mitteilungen, Bilder und Zeichen aus Bethel* (Bielefeld: Bethel-Verlag, 1991); *Künstler aus Stetten*, vol. 2 (Kernen: Anstalt Stetten, 1991); and David Henley, "Artistic Giftedness in the Multiply Handicapped," in *Advances in Art Therapy*, ed. H. Wadeso (New York: John Wiley, 1989), 240–272.

32. Henri Raynal, "Un Art premier," *Critique*, no. 258 (November 1968): 975.

33. Alain Bourbonnais once proposed a mandatory period of occultation after each large-scale public display of Outsider Art (see his "Celebration and Occultation," in *Outsiders: An Art without Precedent or Tradition*, 17–19).

34. Jane Livingston, "What It Is," in *Black Folk Art in America, 1930–1980* (Jackson: University Press of Mississippi, 1982), 23.

3

FOLK SCULPTURE
WITHOUT FOLK

Daniel Robbins

One of the most influential but muddled aspects of American art history emerged about 1930 with the general acceptance of folk art as art. During the twenties, occasional museum exhibitions had explored this new realm with growing confidence in its validity. But the most telling signal of folk art's arrival in the art public's consciousness was the opening, in September 1931, of the American Folk Art Gallery, established under the wing of The Downtown Gallery. The establishment of "a kind of laboratory devoted altogether to American folk expression in the Fine Arts"[1] indicated the existence of a market, the most certain sign that a taste initially fostered by artists and their friends had been accepted by a wider circle.

One explanation for the rise in awareness of folk art lies in the sentiment, growing throughout the twenties, that the naive, the peasant, the savage, unspoiled by the corrupting factors of modern civilization—especially factory standardization and depersonalization—naturally produced work of innate value. When the Brooklyn Museum presented an early exhibition of Congo art in April 1923, the *New York Times* critic wrote of the magnetic appeal of this little-known art "to a small group of enthusiasts" who saw in it the source of a new progressive movement in the art of the white man. "Their reason for thinking it progressive is, to speak quite seriously, their knowledge of the limitations of the Negro mind, of the fact that the Negro mind beyond a certain point rejects instruction, is inaccessible to scholarship, remains primitive and therefore keeps basic ideas which are not frittered away by the invasion of the supplementary, superficial and extraneous."[2] (The contemptible, racist assumptions about blacks in this review have been discarded. Is there any reason to assume that they should be applicable to folk artists elsewhere?) Straightforward

expression, instinctively attained, undestroyed by civilization's complexity, was the order of the time, either for those who thought it beautiful or for those who found it repellent. Advocates thought this force would rejuvenate our own art, whereas scoffers found such unadulterated concentration of feeling abhorrent precisely because it lacked refinement, a quality they regarded as fundamental to fine art.

During the last half century it has become increasingly commonplace to view the recognition of America's folk heritage as a consequence of the alteration of aesthetic values caused—indeed imposed—by the gradual acceptance of modern art. The discovery of African and Oceanic art by Picasso and Matisse was followed a little later by the discovery of American folk painting and sculpture by Robert Laurent and Elie Nadelman. For a time these several modes of art (primitive, folk, modern) appeared to be related in a fundamental way.

Beyond the admiration of modern artists, there were a number of reasons why the works of artists such as Rousseau, the art of primitive people, and American folk art were all identified as crucially important in the early thirties. The imagined community among all primitive art—a community that extended to include the work of children, lunatics, and subconscious man, as well as the work of people from the most diverse cultures in distant times and once remote places—was born, in part, as a reaction to the virulent controversy excited by modern art. Detractors of modern art asserted that it was *not* art, that all modern tendencies were equally degenerate, that direct and simple feeling was inappropriate to the accumulated culture and refinement of centuries of tradition.[3] The defense against these coarse charges slipped into an easy admiration for the honesty, sincerity, and universal expressiveness of all that was attacked. The appeal of such simplicity was understandably great, especially at a time when high art in modern sculpture was dominated by the idea that force and communication of individual personality could be achieved through "direct" attack. Works were sanctified that seemed to hark back to periods when vision was fresh or to stages in life when conventions had not yet corroded personal spontaneity. Vigor and raw strength came to be identified with meaningful invention, and the two were frequently confused.

It can be said with sympathy and certainty that, about 1930, unfamiliarity and even hostility to the new artistic values led both defenders and apologists to blur important and crucial distinctions. Robert Goldwater's *Primitivism in Modern Art,* written in 1936 and first published in 1938 under the title *Primitivism in Modern Painting,* brought intellectual order into an area that previously could only be described as chaotic. Prior to its publication, writers on art made positive identifications among primitive art of all types and between the striving of modern artists and primitive art. This confusion was most often manifested in the gross equation of honesty or sincerity of expression with the unfamiliar forms possessed of such direct force. Goldwater's study cut across the blur by carving out the intellectual and historical categories that describe distinct arts produced in different contexts and by situat-

ing the growth of the whole concept of primitivism within modern Western art history.[4]

Since 1938 serious historical study has discovered a set of traditions and concerns out of which the artist created for a community for almost every category of art once lumped together as primitive; only in the realm of folk art has research not yet yielded a similar pattern. It seems that the level of our understanding of American folk art, particularly sculpture, has remained very much as it was when it first achieved popularity. Judging from some recent publications,[5] even the tenor of current appreciation of American folk sculpture is couched in a language astonishingly similar to that of forty or fifty years ago.

This language and the concepts that form the structure of its grammar are based on an erroneous identification of the aesthetic values and the appearance of certain works by modern artists with those of folk artists. It fails to take into account the complexities inherent in the production of each kind of art and is especially neglectful of the careful study of folk art. This attitude is summarized in the constantly repeated litany that the art produced by "truly American folk: everyday people out of ordinary life, city and suburban and small town and country folk" is "unaffected by the mainstream of professional art—its trained artists, trends, intentions, theories, and developments"[6] [3.1].

What is it that has so curiously retarded the study, although not the appreciation, of American folk art? Even the study of folk crafts has advanced far beyond the level where it is considered the result of the untutored or purely instinctual expression of simple and naive people. Studies such as those of John T. Kirk[7] demonstrate the relationship between high-style and country furniture, and research has advanced the precision with which we can date a piece and our ability to pinpoint its regional origin, not only by reference to the sources of its forms in Europe (where the same process has also been a matter of careful study recently).

Why, then, is folk art relatively untouched by both traditional and new scholarship?[8] There are at least two reasons, each complex, and both related to the larger question of the definition of current and past art. The first is the continued attractiveness of the democratic notion that simple and untutored folk can create work that rivals in value the self-conscious production of highly trained and sophisticated artists. The second is the still-growing power of the idea that interested society can stamp its own artistic values upon almost any kind of object, that each man who approaches life as an artist will find art and will find it to the extent that he himself is creative. This is an extension, and perhaps a particularly American extension, of a special contribution to modernism that is focused in the work and attitude of Marcel Duchamp: the found object.

The democratic attitude that crystallized so long ago and fused all forms of primitive art into one unsophisticated but expressive lump made connections between all forms of the art of primitive people and those of American folk art. It justified these relationships in the modern artist's admiration for Henri Rousseau,

3.1. Edgar Tolson. *Expulsion,* 1970, carved and painted wood, height 24 in., length 23 in., depth 11¾ in. Private collection.

the modern primitive, the first and still-quintessential example of an artist of quality and intensity who was presumed to have developed entirely outside the conventions of what was then considered high art.

A brief discussion of Rousseau's place in the rise of primitivism gives some indication of the errors to which folk art enthusiasts have long been prone. In 1935 Goldwater wrote that "the enthusiasm for the work of Henri Rousseau and the other misnamed Sunday painters was based on the naive quality found or imagined in these productions. But these realists of the imagination were far from creating instinctively." Rather, they were creating "out of a tradition and for a community."[9] In *Primitivism in Modern Art,* he wrote that "true Folk art is almost always anonymous, at least it is always part of, understood by and reabsorbed into the environment that produced it."[10] Do Rousseau and his work fit these criteria?[11]

Rousseau's work was the result of his intentions rather than a "collective conscience." By dint of perseverance, unremitting work, and a sense of art's importance, Rousseau "perfected a means which we take to have completely suited his purpose." But had he more means, he would have served his purpose better, and the consonance

between the technique and the ideals that pleased the modern viewer might not have been so satisfactory had Rousseau really been able to paint like Bouguereau. For the early admirers of Rousseau, there was a subtle irony in the disparity between his imperfect means and the high-art ends he had in mind. The sophisticated public enjoyed seeing the high ends unconsciously satirized by the slight jolt between the almost polished technique and the ideals, enjoyed the idea that the high ideals were uncritically accepted, with the corresponding implication that such ideals—those of Bouguereau—could only be accepted by the naive.

Of course, beyond the readily intelligible high-art intentions, the details of Rousseau's iconography and symbolism were personal, "deriving from experiences apart from a close familiarity or knowledge of the conventions of the ideology he wished to express." Rousseau is a genuinely interesting artist within strict limitations, because although his ambitions were high, the content of his art is considerably less high than he thought. It stands in relation to academic idealism in the same ratio as his technique does to the canons of academic realism in which he believed. We encounter here another constant and deeply moving characteristic of the naive artist: Rousseau's belief in the importance of painting in his own life, his "unself-conscious acceptance" of the value of art in the life of the community. This is the only unself-conscious aspect of Rousseau's work. Everything else—the ideals and the means—was derived from the conventions of high art.

Furthermore, Rousseau's community was that of European civilization, not of the men and women who lived in his *quartier* and had their own isolated and special sensibilities. There is no reference to any particular set of social or intellectual values that embody such things as the difficulties of material life, coarse or sordid surroundings, or toil. One cannot (although many tried in the twenties and thirties[12]) make of Rousseau an artist whose work was part of, understood by, and reabsorbed by the environment that produced him. His work can only be understood and appreciated in its double relationship to the high art of his time that he himself took as example and to those artists who, departing from it, chose him as a kind of mascot.

Since the thirties, Rousseau's art has been subject to the same methods of scrutiny developed and once reserved for the more conventional symbols of individual genius in Western culture. His compositions and themes have been analyzed and traced to their sources.[13] His continued importance for purposes of discussing the larger question of folk art is the astonishing persistence of the notion that he (or Clarence Schmidt or Simon Rodia or Edgar Tolson) was the living synthesis of an anonymous multitude of humble artisans, from sign and house painters to the decorators of traveling shows; that he (and they) represents the vision of the common people; that through him, mysteriously without the intervention of guides from the instructed classes, the common people have found plastic and permanent form[14] [3.2].

A far more sophisticated and enduring approach to the accommodation of primitivism (including folk art) to civilized modern taste was put forward by James John-

3.2. Simon Rodia. The Watts Towers, Los Angeles, California, 1921–54, concrete, steel, ceramic, stone, glass, shell, and impressed found objects, maximum height 100 ft., 1/10 acre site. Photo by Michael D. Hall.

son Sweeney in his exhibition "Modern Primitives" at the Renaissance Society at the University of Chicago in the summer of 1931. Sweeney maintained that the community of the primitive is to be found in the "plastic relations of the design, with a subordination of the technical and naturalistic representational elements to them." The universality of plastic elements, Sweeney noted, is not—as popularly conceived—attributable to "untutored technique or even naïveté of viewpoint." It is in plastic relationships among elements of design that one finds the chief characteristic of those works that mark the first flourishing of all great art traditions and go by the name of primitive. Sweeney, who recognized the operation of tradition, relegated the "expressive" element to a secondary role and focused attention almost exclusively on the plastic or structural elements in design, often yielding concise descriptions of decorative motifs and carefully trying to distinguish decoration and plasticity from mere patternism.[15]

Following the Sweeney approach of the community of plastic relations, American folk art provided a tempting basis for demonstrating that the unschooled masses had an innate understanding of plastic or formal relationships and therefore might respond favorably to abstract art. Less vigorous, but more pervasive, was the view that contemporary production would be swept forward by the discovery of a tradition that demonstrated that art belonged to all the people.[16]

One of the most interesting aspects of the acceptance of modern art in the United States is the very special place within it that was assumed by American folk art. This had to do with the internal collapse of what had, up until the arrival of modern art, been regarded as high art. In view of this sudden foundering of values, a need developed to discover a tradition out of which one might explain the emergent triumphs of a *new* high art: modernism. This was the role thrust upon folk art. It furnished, almost overnight, an unbroken American tradition with a clear relationship to what was being done by leading American artists in the early thirties. The idea that folk art constituted a two-hundred-year-old unbroken tradition of all that was characteristically American appeared highly attractive. It provided a background "solidifying and enriching a nation's fund of tradition" and established "the sense of continuity so vital to the health of contemporary art in any era." [17]

The importance of this issue—the existence or definition of an American art—is underscored by the November 1931 *Creative Art,* which was entirely devoted to the new American Renaissance. Ten authorities discussed whether there was such a thing as American art, whether American painting and sculpture revealed a "native stamp." [18] These discussions reached no absolute consensus, but for those who sought a positive answer, folk art provided eloquent proof of a native tradition. Thus, at a time when abstract art was already being attacked from certain quarters as yet another decadent product of European civilization, the intertwining ingredients that exalted primitive folk expression were used to provide a basis as much for the new native regionalist school, developing in the wake of a revived distrust of internationalism, as for the universal community of people's expression based on purely plastic elements.

The upheaval caused by the penetration of modern art into the consciousness and lives of civilized Americans gradually caused another, also very young, "native" tradition to be widely regarded as a false start. Hudson River landscapes were put into attics, marble sculpture was hauled into cellars or junked. Museums traded Innesses for masters of popular realism. Nowhere was this abandonment of the older tradition more evident than in the eclipse of high sculpture in the Beaux Arts tradition. One of the most telling consequences of the removal of these objects from public consideration was its effect on the study of folk art. Placing the Beaux Arts tradition to one side removed the possibility of comparison, and folk art remained isolated from the high art traditions the abandoned forms represented.

Folk art had indeed triumphed. It was collected; it had a market; it even provided

a tradition for contending traditions; it was a source for whatever wanted proof on the contemporary scene. Advocates of universal abstraction and advocates of native expression drew equal inspiration and almost *ex cathedra* authority from its forms.

This balance, however, was brief. As modernism lengthened its own tradition, folk art was often seized upon by those who looked back toward a time of imagined simplicity, when every man was an artist and art was clearly relatable to a crafts-manlike impulse that people appreciated because they understood its requirements. Thus we find in the current revival of the idea of folk art, especially in the distinction made between folk art and folk craft,[19] the arguments of the thirties being repeated. There is an assumption that, because folk art remains connected to the "organic nature of things," it is sensuous, vitalistic, and the opposite of abstract art. The folk artist is made, once again, to report the state of nature in the absence of intellectu-alism; he is denied that fundamental link with society's continually evolving ideal of art. Like a serf chained to his land, the folk artist remains chained to the organic nature of things—as if there were an organic nature of things!

The fact that folk art is usually classed by type of object rather than by either style or theme makes entertaining reading but neglects a basic ingredient: folk art's relationship to other traditions. At a certain stage in cultural awareness—one which we have surely reached by now—these relationships can be observed without in any way diminishing the high regard and delight we continue to have for these images. It would be interesting and useful to know if any mid-nineteenth-century American equestrian statues stand between *Buffalo Bill* and his most ancient source, Marcus Aurelius. There is a well-known Lion Killer weather vane in Shelburne, Vermont, with an image that can be related to both Delacroix and Rubens. Horse-and-sulky weather vanes should be studied in relation to the widely circulated prints of Currier and Ives, just as the prints themselves need to be carefully examined in relationship to European sources. It will not detract from the charm and integrity of the late nineteenth-century copper vane depicting Admiral Farragut to note that there is a distinct relationship to the great memorial executed by Saint-Gaudens and erected in Madison Square in 1881.[20] Rather, in studying the resemblances between the two, one might arrive at a better, and surely a richer, idea of the accomplishments of the anonymous maker of the *Sea Captain*. An entire range of possibilities exists, worthy of serious exploration, but it must begin with careful comparison of the works [3.3].

If we begin to study folk art's styles and themes, influences will no doubt be found to flow both ways, not merely from high to folk. Doubtless the dates on many folk carvings will be changed, and our admiration for the ingenuity of the carvers may even increase when we realize the specific choices and conscious changes wrought in famous contemporary images. The relationship between, for example, the white-painted wood *Personification of Time,* dated 1825–1840, and the Victory figure in Saint-Gaudens's *General William Tecumseh Sherman* (1900) is too provoca-tive to go unnoticed.[21] The folk carving is thought to personify Time because of the hourglass held in her raised right hand, the hand that in the Victory figure only ges-

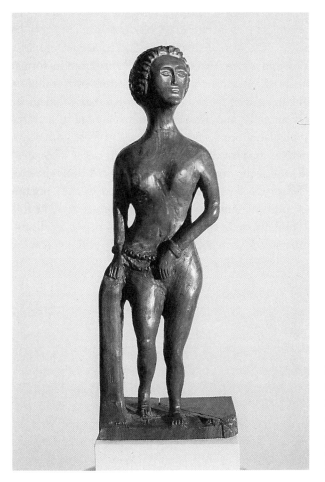

3.3. Everett Shook. *Figure in Chains,* ca. 1950 (after *The Greek Slave* by Hiram Powers, 1847), carved and varnished walnut, height 19 in., width 6¾ in., depth 3¾ in. Collection of Michael D. Hall.

tures "Make way!" Was the folk figure destined to decorate a hearse, as Bishop suggests? Since her left hand carries the palm of victory that is also present in Saint-Gaudens's work, might not the carver have wished to indicate victory over death? Furthermore, the essential movement of both figures is too pronounced not to suggest a fundamental formal relationship. It may be, of course, that both figures go to the same, as yet unidentified source. It seems more likely, however, that the folk piece is misdated by some sixty years and is a very sophisticated adaptation of the Saint-Gaudens. One thing is visually certain: *Personification of Time* was not carved by a naive artisan cut off from the tradition of high art.

When we turn to more recent folk sculpture, the problems are even more complex. In the years following the Newark Museum's famous 1931 exhibition, there was a positive flurry of discovery of naive painters, native Henri Rousseaus.[22] This was capped, perhaps, by Sidney Janis's remarkable activity in 1942, not only in the exhibitions he organized but also by publishing his book *They Taught Themselves.*[23]

Art historians and critics, perhaps inspired by serious studies of Rousseau's life,[24] attempted to distinguish a category of artists somewhat different from "folk." Certain artists were called "popular"[25] when it became increasingly difficult for art to be produced anonymously and theoretically impossible for any such production to be reabsorbed into the environment. The whole environment, having become critically self-conscious, could no longer reabsorb what had been discovered, set aside for aesthetic value, and finally bought and sold and exhibited in a context of high art. One need only look at the case of Grandma Moses to realize the problem. "The tradition she, a naive artist, wished to join was much closer to her own vision [than to that of Seraphine, Adolf Dietrich, or Rousseau, whose vision was linked with academic realism] but it was a folk tradition, already somewhat contaminated, and she herself was aesthetically self-conscious."[26]

At the end of the twentieth century, it is doubtful whether any folk tradition as described by Goldwater is left, even slightly contaminated. With the postwar boom in communications and media interest, is it possible that there are any "folk" left in America? Are any individuals or communities isolated or even insulated from a general culture? The manufacture and circulation of images through photographs, movies, television, and advertisements have only made technically complete what the massive discovery of folk art made a theoretical certainty as early as 1930. Mass communications have been so enormously productive of images that, by both quantity and electronic technique, they are literally reabsorbed in the invisibility of time, thus fulfilling on an unimagined scale and pace a primary condition of folk art. The images produced are anonymous because so omnipresent, understood—certainly!—and are reabsorbed because consciously forgotten in their overwhelming succession. Some artists—high artists like Roy Lichtenstein—have grasped the possibility that they could be artists for all the people. Lichtenstein most valiantly and wittily created the famous original color print portrait of Robert Kennedy for the cover of *Time*.[27] But this is the deliberate result of the often wished for, but seldom achieved, juncture of high art and popular interest. It is in no way an aspect of a cultural subset, as were the Shakers, Pennsylvania Dutch, different tribes of American Indians, or the Southwestern makers of *santos*.

The effort to persuade us that there is a true folk art today not only ignores the primary conditions of the transmission of visual ideas since at least 1950 but, by omission, makes a folk hero out of anyone who can resist the flood of material. But the artist who can take such material and invest it with civilized meaning, in the tradition of great and always self-conscious art, belongs to high art, even though he may deserve to be a hero of the people. Those who would see a modern folk art—apart from Lichtenstein, Johns, Warhol, Dine—still springing from "the organic nature of things" practice, in a quasi-refined manner, the discovery of found objects. The best current example is "Looking for Leonardo," the sophisticated text written by Bates Lowry, distinguished architectural historian and former museum director, to accompany the exhibition of the Bates and Isobel Lowry Collection of American

Folk and Naive Objects at the Taft Museum, Cincinnati, and the University of Iowa Museum of Art during the autumn and the Reading Public Museum during the spring of 1993.

Duchamp's presentation of found objects had its initial impetus, from 1913 to 1915, in his realization of the ironic consequences of the separation of content from pure form that grew among artists and their defenders early in our century. The democratic idea of making each collector an artist and each artist a collector parallels the slowly emerging consciousness that photography is art rather than mere reportage or an objective record of reality. Thus it is not accidental that much of the presentation of so-called contemporary folk art, or grass-roots art, or outsider art, consists of photo documentation of parts of extinct (destroyed) architectural-sculptural environments such as the one created by Clarence Schmidt at Woodstock, New York—an artists' colony since World War I. As Schmidt constructed his private vision, so it must be discovered by someone endowed with the capacity to find, to see its value, and to impose that vision on a willing part of society, the vastly enlarged community receptive to art.

All that is lacking in this attractive and genuinely moving effort is the similar discovery of the source behind the found object—a discovery complicated by the realities and techniques of visual information transmission. In the last twenty years, more people have seen a shadow of Michelangelo's accomplishment on the Sistine ceiling than have all the people who have lived since its creation. When we confront recently created objects of folk art, we may admire the objects, admire even more the artist's urge to pursue his vision obsessively for years and years. We should also admire the complex process of cultural diffusion that joins the isolated, untaught, or self-taught artist to the images and ideas of aesthetic innovators—the artists, past and present, who invented the images whose effectiveness is proven by the manner in which they reach these relatively innocent folk.

Can it be true that there are artists who "if they visit museums and enjoy the works . . . are not actually inspired by them," for the "restrictions of their lives leave them pure to paint (or carve) with total honesty"?[28] Total honesty is something that seekers of high art periodically search for. Perhaps they seek it in particularly simplistic terms when the techniques and meanings of those who invent images become so precious or ingrown that a fragment of audience sets out on a deliberate pilgrimage to find signs of art's enduring power and universality. In their finding, often powered by the seekers' belief that they are as sensitive and gifted as those whose creativity proclaims them artists, the process of selection itself has, of course, created the art form. Nonetheless, in every case there is the genuine effort on the part of the discovered artist (whether named or anonymous) to place between himself and his experience of life a "whole set of conventions, inhibitions, and acquired experiences." Robert Herbert wrote that "an artist cannot suddenly make up his mind to render what he sees and feels, for these acts are not neutral, nor simply acts of will and technique."[29] Every work of art, whether sophisticated or naive, involves the art of choos-

ing. In the past, we have accepted the capacity of human intelligence to be effectively self-taught in literature, philosophy, and other primarily verbal disciplines. In our contemporary world, with its wealth of readily available visual history, can we assume that the self-taught artist must be naive? That his choices are untutored or unconscious? That his intuition has not been filtered through both visual and verbal exposure or through intelligence?

Perhaps, without condescending, it is possible to find objects, buildings, whole environments constructed by artists who create with a large measure of intuition. But it is not possible to deny the operation of tradition, and the operative tradition through the present century is wholly in the self-consciousness of high art and its fascination, long ago played out, with nonculture. The discovery of often bizarre curiosities, so full of poetry, love, and history, sometimes so redolent of a tradition's decay, is an extension of the found object. That many contemporary or recent folk sculptors are discovered in towns like Taos, or Woodstock (Clarence Schmidt), or Springs (Albert Price) is a double function of the self-taught artist to be instructed and stimulated by his environment and to be "found" by the searchers in such colonies.

More interesting and pathetic is the occasional survival of a genuine, if faint, trace of what was once a continuous and separable tradition, such as Kachina dolls. By 1930 Kachina dolls were already reduced to the level of a tourist art, despite several attempted revivals by anthropologists beginning at the turn of the century. A Mickey Mouse Kachina,[30] although not without charm and rife with social implications, is a travesty of both Kachina tradition and Walt Disney. Faced with an abundance of identifiable images, the contemporary connoisseur of folk art must wonder how the artist came to encounter the art he is copying; he must wonder what moving relationship established a connection with visual material that led a man or woman to seek to place himself in that tradition.

Often the most arresting quality of the objects themselves is their medium and technique, sometimes as ingenious as the construction of a car sculpture entirely from bottle caps[31] or a human toastmaster, related to the traditional figure of Uncle Sam, from tin cans [3.4]. These bespeak the degree of sophistication of the maker and reveal the obsession of the hobbyist. But the forms themselves, and less often the techniques, bear a complex relationship to the forms of high and commercial art. The iconography of the most ambitious groups frequently reaches back to Christian themes that found their apogee in art prior to the nineteenth century. Why, one must wonder, is our more isolated nineteenth-century folk sculpture more secular than that of recent years? Perhaps the answer lies in the ready availability of reproductions of sixteenth-century paintings. Patrocina Barela, who carved so many biblical scenes with a pocket knife before his death in Taos in 1964, may never have learned to read or write, but he clearly knew how to look at pictures. He knew also how to distin-

3.4. Anonymous. *The Toast-master*, ca. 1900, fabricated and painted sheet metal with glass eyes, height 24 in., width 10½ in., found in the Chicago, Illinois, area. Collection of Estelle E. Friedman. Photo by Michael D. Hall.

guish the famous from the less renowned; his *Expulsion from the Garden* is derived from Michelangelo's *Fall of Man* on the Sistine ceiling.[32]

And what is the role of conscious irony in these presumably untutored works? Would Clarence Stringfield's 1973 *Bathing Beauty* [3.5] have been "found" had it been called Lady Wrestler? Would Jesse Howards's 1967 *Snow Shovel* have been found so interesting had Marcel Duchamp not found *his* snow shovel in 1915? We see a 1971 copy of Titian's *Rape of Europa* by a forty-eight-year-old prisoner; we see Angela Palladino, whose *Nude in the Grass*, 1967, is as much in debt to Matisse as ever was Max Weber; we see Frank Mazur, a highly individual pupil of Toshio Odate, but still a pupil; or "Driftwood" Charlie Kisling deriving his inspiration knowingly from pre-Columbian art, Mayan or Peruvian, imitating even the texture of volcanic tufa.[33] The common thread through all of these current derivations is the staggering range of available visual material and the total lack of a continuously operating tradition in so-called contemporary folk art. There can be no continuously operating tradition in a culture without folk.

Folk sculpture and painting in a culture without folk is selected by some collec-

3.5. Clarence Stringfield. *The Bathing Beauty,* 1973, carved and painted wood, height 54½ in., width 18 in. Collection of Estelle E. Friedman.

tors primarily on the basis of its irrelevance to or removal from the primary conditions or sensations of modern life. It is for this reason that anachronistic subjects, such as the religious parodies of Tolson or Miles Carpenter, are favored. Conversely, the strange marriages of high art themes with hobbyist techniques appeal to a sophisticated jaded taste in a way that may or may not have been intended by the artist. (The more intentional the strange union, the less "folk" the artist.) Among the many influences and relationships that have contributed to the formation of American folk art, we—collectors, dealers, curators, or historians—must add our own influence. Its cumulative effect all too frequently crosses the thin line separating patronage from corruption in modern society. It governs by both selection (which is remedial) and by influencing production (which is not), subsuming the folk roots of a tradition. Too often, meaning is submerged or discounted by formal values and our very appreciation (often profoundly condescending) permanently transforms not only the

society from which folk once emerged but the artifacts that were moving evidence of their existence.

ACKNOWLEDGMENT

This essay originally appeared in the bicentennial exhibition catalog *Folk Sculpture USA* (1976), edited by Herbert W. Hemphill. The exhibition was jointly organized by the Brooklyn Museum and the Los Angeles County Museum. With minor changes, the text printed here is essentially the same as that in the catalog.

NOTES

1. Edwin Alden Jewell, "American Primitives," *New York Times*, September 27, 1931.

2. "Africa," *New York Times*, April 15, 1923.

3. See an interesting exchange between Robert Macbeth and Alfred H. Barr, Jr., in "Art Notes," *New York Times*, March 22, 1931.

4. Robert Goldwater, *Primitivism in Modern Art*, rev. ed. (New York: Vintage Books, 1967), cited as Goldwater, 1967.

5. Robert Bishop, *American Folk Sculpture* (New York: E. P. Dutton & Co., 1974), cited as Bishop, 1974; Herbert W. Hemphill, Jr., and Julia Weissman, *Twentieth-Century American Folk Art and Artists* (New York: E. P. Dutton & Co., 1974), cited as Hemphill and Weissman, 1974; and Jean Lipman, *Provocative Parallels: Naive Early American/International Sophisticates* (New York: E. P. Dutton & Co., 1975).

6. Hemphill and Weissman, 1974, pp. 9, 10.

7. John T. Kirk, *Early American Furniture* (New York: Alfred A. Knopf, 1970); and John T. Kirk, *American Chairs: Queen Anne and Chippendale* (New York: Alfred A. Knopf, 1972).

8. One practical, although partial answer is found in the reluctance of most scholarly institutions to recognize the aesthetic quality of folk art, to encourage it as a valid subject for scholars.

9. Robert Goldwater, "An Approach to African Sculpture," *Parnassus*, May 1935.

10. Goldwater, 1967, p. 185, citing Zervos's observation that Rousseau's work was not truly popular because it was not the product of a collective conscience.

11. Ibid., pp. 178–92, esp. 185–90.

12. See, for example, Louise Gebhard Gann, "An Artist of the People," *International Studio*, July 1925.

13. See Dora Vallier, *Henri Rousseau* (Cologne, 1961); and Henri Certigny, *La Verite sur Le Douanier Rousseau* (Paris, 1961).

14. In "An Artist of the People," Gann said that "the craftsmen of the middle ages may have been his [Rousseau's] precursors, but he is the sole modern artist in whom there is no eclecticism, no influence. He is primitive in the sense that he is himself—isolated and ignorant."

15. See James Johnson Sweeney, *Modern Primitives* (Chicago: Renaissance Society at the University of Chicago, 1931); and Edwin Alden Jewell, "Modern Primitives in Renaissance Society Hall," *New York Times*, July 29, 1931.

16. Holger Cahill described folk sculpture as "an expression of the common people, and not of a small cultured class. Folk art usually has not much to do with the fashionable art of its period. It is never the product of art movements, but comes out of craft traditions plus that personal something of the rare craftsman who is an artist by nature if not by training. This art is not based on measurement or calculation but on feeling, and it rarely fits in with standards of realism. It goes straight to the fundamentals of art, rhythm, design, balance, proportion, which the folk artist feels instinctively" (Newark, New Jersey, Newark Museum, *Folk Sculpture*, October 1931).

17. Edwin Alden Jewell, "American Primitives," *New York Times*, October 25, 1931.

18. Carl Zigrosser, Robert Harshe, Julianna Force, E. A. Jewell, Douglas Haskell, B. D. Saklatwalla, Stephen Bourgeois, Guy Pène du Bois, and Malcolm Vaughan, "American Renaissance," *Creative Art*, November 1931.

19. Hemphill and Weissman, 1974, pp. 10–11, in a discussion based on quotations from Sir Herbert Read, *Art and Society* (London: Schocken Books, 1966).

20. See Bishop, 1974, fig. 109; and Wayne Craven, *Sculpture in America* (New York: Thomas Y. Crowell Company, 1968), fig. 11.1, cited as Craven, 1968.

21. Bishop, 1974, fig. 52; and Craven, 1968, fig. 11.6.

22. An article that slightly preceded the exhibition is a valuable reminder of the atmosphere of discovery in 1930 compared with that of 1975. "Many Americans have felt how sad it is that . . . the soul of our people cannot produce even the modest blossom of folk expression. They have become used to the idea that art, especially folk art, is something that flourishes only in far countries and that at home it is a dry stalk. But folk art has been produced in America for 200 years and more. It is being produced today, though on a rather small scale" (Holger Cahill, "Folk Art," *American Mercury*, September 1931).

23. Sidney Janis, *They Taught Themselves: American Primitive Painters in the Twentieth Century* (New York: Dial, 1942).

24. Christian Zervos, *Rousseau* (Paris, 1927), and Wilhelm Uhde, "Henri Rousseau et les Primitifs Modernes," *L'Amour de l'Art* 14, 1933.

25. See especially *Masters of Popular Painting: Modern Primitives of Europe and America* (New York: Museum of Modern Art, 1932).

26. Goldwater, 1967, p. 190.

27. See Henri Zerner, *The Graphic Art of Roy Lichtenstein* (Cambridge, Mass.: Fogg Art Museum, 1975), pp. 4, 13–14.

28. Hemphill and Weissman, 1974, p. 18.

29. Robert Herbert, *Barbizon Revisited* (Boston: Museum of Fine Arts, 1962), p. 13.

30. Hemphill and Weissman, 1974. p. 89. The Mickey Mouse Kachina is dated 1925 by Hemphill, but would seem to require a later date, since the first short Mickey Mouse cartoons came out in 1928.

31. Ibid., fig. 29.

32. Ibid., p. 126; and Frederick Hartt, *Michelangelo* (New York: Harry N. Abrams, 1965).

33. See Hemphill and Weissman, 1974, figs. 246, 251, 262, 296, 147, 146.

AN ANTI-MUSEUM

THE COLLECTION DE L'ART BRUT
IN LAUSANNE

Michel Thévoz

Translated by Roger Cardinal

Like all momentous events in the arts, the sudden and startling emergence of Art Brut may be understood as the fruit of a passionate encounter between the mind of an exceptional individual and the manifestations of a wider sensibility hitherto inarticulate and unnoticed. The genesis of the notion of Art Brut may be traced back to the extreme discomfort experienced early on by the French artist Jean Dubuffet; from the age of eighteen he had dreamt of someday becoming a painter, but he could feel only disgust for the artificial, elitist, venal, and publicity-seeking institutions set up to support the arts. Until the age of forty-two, Dubuffet felt trapped in a condition of creative paralysis caused by the discrepancy between his vision of art as a delirious, solitary, and highly idiosyncratic adventure, and the urbane rules and regulations which govern all public transactions in this domain. He was no less disturbed by the ponderousness of an artistic tradition whose apprenticeship he judged irrelevant, even harmful, and he was appalled by the noisy watchwords of the avant-garde, which seemed every bit as constrictive. As far as his personal career was concerned, Dubuffet was eventually to knuckle under to the inevitable paradox of being both cultured bourgeois and dedicated artist; he resolved to enter the system, albeit—as if to invoke the principle of the Trojan horse—adopting the role of the enemy who launches his attack from the inside.

This solution did not prevent Dubuffet from continuing to cherish his ideal of an art which has no conception of its parentage—in other words, an art free of the dictates of tradition or fashion, an art liberated from all social compromise, an art indifferent to the applause of initiates, an art which draws its strength from an impassioned way of thinking and an almost autistic inner necessity. Such is the definition

of Art Brut. Naturally, the insolent disregard of constraints implicit in such an exorbitant adventure of the imagination can have no truck with the promotional and commercial strategies which regulate the normal art world.

In this context it may seem curious to note that the most radical artistic revolutions of our century should have left intact those mechanisms which consecrate and commercialize the artistic endeavor, namely, the network of galleries and museums, and the circles of experts, critics, dealers, and collectors. Those artists who went furthest in destroying aesthetic stereotypes still managed to service this same apparatus, not tampering with its structure at all. Indeed, it would be odd if their docility toward the communication network were not mirrored in their actual works (for is it not the case that "the medium is the message"?). The art gallery, exactly like easel painting or the use of oil paint, is indissociable from a particular set of prescribed recipes. Only a mode of art making which is alien to the gallery system can hope to shake off that cultural inheritance which weighs so heavily upon the shoulders of professionals. This is why one should not be surprised to find that Art Brut is associated with social misfits: marginals, loners, anarchists, people propelled by deviant impulses which can even lead to their hospitalization as psychiatric patients.

Thus it was that Dubuffet fell in love with the wildflowers which he found blooming everywhere but inside the well-raked beds of Cultural Art, and delighted especially in finding them in corners where nobody else would have dreamt of looking—among illiterates rather than intellectuals, among the poor rather than the rich, among the old rather than the young, among women rather than men, and so on. Recognizing that he could have no pretensions himself to create works of Art Brut, Dubuffet became a collector, and did so at the very moment his own works were beginning to penetrate the art market and the museums. Measure for measure, perhaps he sensed that the time, the money, and, above all, the emotional energy he dedicated to "savage values" partook of an activity of dissent, thereby preventing his own adjustment to society from becoming too much of a compromise.

From 1945 on, Dubuffet began to seek out works corresponding to his peculiarly asocial and extremist conception of art. At that time he undertook a journey to Switzerland in the company of his friends, the writer Jean Paulhan and the painter René Auberjonois. His most telling discoveries were made in Swiss psychiatric hospitals and prisons—the discovery of Adolf Wölfli, of Aloïse, and of the Prisoner of Basle, not to mention the collection of psychotic art of the Geneva psychiatrist Professor Charles Ladame [Pl.3]. Thus, from the beginning, Art Brut was set under the sign of madness, in Dubuffet's eyes the quintessence of inventiveness. Indeed, what he considers to be pathological is not insanity but, instead, sanity and academic standards:

> I mean that not only are the mechanisms which govern madness just as visible within the sane (or supposedly sane) person but that in many cases they are the prolongation and ultimate flowering thereof. And in certain cases, its most admirable flowering. In-

deed, I believe that the West is entirely wrong to treat madness as something negative; it is my belief that madness is a positive value, a fertile and precious resource. To me, its influence seems not at all detrimental to the genius of our race, but on the contrary to be something invigorating and desirable. My sense is not that madness has reached epidemic proportions in our Western societies, but that, on the contrary, it is much too thin on the ground. (Dubuffet, 1951: 114)

In 1947, Dubuffet founded the Foyer de l'Art Brut, which he set up in the basement of the René Drouin Gallery on Place Vendôme in Paris. Here he arranged shows of work by Joseph Crépin (for which André Breton contributed an article), Aloïse, and Miguel Hernandez, among others. A year later, the Foyer was transferred to a pavilion loaned by the publishing firm of Gallimard, and the Compagnie de l'Art Brut (a nonprofit association) was launched with the participation of André Breton, Jean Paulhan, Charles Ratton, Henri Pierre Roche, and Michel Tapié.

At the initiative of Jean Dubuffet and the painter Slavko Kopac, who became permanent curator, exhibitions were organized, notably of work by Adolf Wölfli, Gironella, Aloïse, Heinrich Anton Müller, Jeanne Tripier, Auguste Forestier, and Miguel Hernandez. Thanks to these efforts and to numerous generous donations, the Collection began to take on solid proportions. In October and November of 1949, an exhibition was housed in the Drouin Gallery, taking up the whole of its available exhibition space and accommodating two hundred works by sixty-three creators. The catalogue contained Dubuffet's manifesto under the heading "L'Art Brut Préféré aux Arts Culturels" (Art Brut in Preference to the Cultural Arts), in which he enlarged upon his definition of Art Brut (Dubuffet, 1949: 87–93). In the next few years a series of modest albums were to appear, produced by amateur means by the authors themselves: Jean Dubuffet, Miguel Hernandez, Slavko Kopac, and Jean l'Anselme.

However, the space limitations in these premises—the use of which was by no means guaranteed to last—and the lack of personnel and of financial backing, along with a certain passivity on the part of the members of the Compagnie de l'Art Brut, impelled Dubuffet in 1951 to take up the offer of the painter Alfonso Ossorio to install the Collection in spacious premises in his residence at East Hampton, close to New York City. Prior to this, it had been decided to suspend all activity in France and to dissolve the association.

Dubuffet and others began collecting again in 1959, and this had the effect of enriching the Collection considerably. The year 1962 saw the Collection's return from America to Paris, after it had been the object of a show at the Cordier and Eckström Gallery in New York in February of that year. The new home of the Collection was to be a four-story house with fourteen rooms which Dubuffet had acquired on the Rue de Sèvres and converted into a conservation and research center, closed to the general public but open to especially interested visitors. Slavko Kopac was named curator. Furthermore, the Compagnie de l'Art Brut was reconstituted in July 1962 and would enroll a hundred or so members.

Activities were thus launched afresh, and resulted in significant acquisitions, both through purchases and donations. Further, a long-cherished publishing project at last materialized, in the form of periodic fascicles bearing the name *L'Art Brut;* the series now comprises seventeen volumes with monographs on each of the principal creators of Art Brut. Up until issue number eight the bulk of the texts were composed by Dubuffet himself. In April–June of 1967, a selection from the Collection—seven hundred works by seventy-five creators—was shown at an important exhibition at the Musée des Arts Décoratifs in Paris, with a catalogue preface by Dubuffet entitled "Place à l'Incivisme" (Make way for disobedience) (Dubuffet, 1967: 177–182). In 1971 there appeared the *Catalogue de la Collection de l'Art Brut*, listing 4,104 works by 133 artists (Publications de la Compagnie de l'Art Brut, 1971).

Growing anxious about the future of the Collection, Jean Dubuffet now resolved to seek out a body which would guarantee it permanent public status. Discussions ensued with the Swiss city of Lausanne and led to a formal agreement to hand over the Collection to the municipality, which in turn undertook to ensure its conservation, management, and permanent public display. To these ends, the city decided to make available the Château de Beaulieu, a fine town house dating from the eighteenth century [4.1]. When asked why he had made this choice, Dubuffet declared:

> Out of friendship. I was a very close friend of Paul Budry, Charles-Albert Cingria and Auberjonois. It was at the Waldau, where Wölfli was a patient, that I began my searches in 1945, and in Geneva where I came across the collection of drawings by patients belonging to Professor Ladame. Moreover it was in Lausanne that I came across Aloïse. The fact is that my enquiries have always met with more understanding and support in Switzerland, especially from doctors, than anywhere else. (Dubuffet, 1971: 22–23)

The Collection de l'Art Brut was officially inaugurated in its new premises in Lausanne on February 26, 1976. Rather than let the museum deteriorate into a mausoleum where works would remain embalmed and lifeless, a policy decision was made, in accordance with Dubuffet's own wishes, to animate it by adding to the holdings and through a varied program of temporary exhibitions. The Collection's accessibility to the public and the international notoriety it has gained have prompted collectors, sponsors, and psychiatrists to make important donations (notably of new pieces by Aloïse, Jules Doudin, Carlo, and Vojislav Jakic, and works by fresh discoveries like Samuel Failloubaz, Célestine, Johann Hauser, August Walla, Reinhold Metz, Josef Wittlich). In this way, the inventory of the Collection has, since its transfer to Lausanne, been extended by some ten thousand items. Jean Dubuffet continued to give moral and financial support right up until his death in 1985.

The decision to expand the Collection was not an easy one. At the time of the Collection's transfer to Lausanne in 1975, the issue of new acquisitions was openly considered. Given the impact of the media and mass communication—in other words, of mass conditioning—was it possible that individuals could still exist who

4.1. The Château de Beaulieu, Lausanne, Switzerland, home of the Collection de l'Art Brut. Photo by Erling Mandelmann.

were so idiosyncratic and independent as to be capable of constructing a personal mythology and pictorial idiom? Might not the Collection lose its strength through assimilating material of lesser and lesser quality?

The discussion was colored by one important fact: After 1950 the incidence of cases of Art Brut produced inside psychiatric hospitals had abruptly evaporated. The reason was quite obvious: the introduction of Largactyl and psychotropic drugs. Arguably, the development of psychopharmacology has had beneficial effects from the medical point of view; however, insofar as it has prevented all those deliriums and hallucinations which give rise to artistic inspiration, it has had a fatal impact on artistic creativity within the clinical context. Under the neuroleptic regime, patients have moved from a condition of exaltation or possession to one of drugged stupor.

And yet, it might be objected, artistic productivity was surely never so rampant in psychiatric hospitals as in the 1950s, thanks to the setting up of workshops devoted to art therapy, occupational therapy, and the like. Prior to that time, there had been active discouragement, not to say repression, of the symbolic expression of those who were still seen not as patients but rather as detainees. Admittedly, new psychotherapeutic strategies have given rise to an abundance of pictorial and sculptural productions, but only in the quantitative sense. In truth, the solicitous framework within which such activities take place has seriously undermined the spontane-

ity, the fervor, and the rebellious spirit which are the necessary constituents of true artistic invention. The making of art as a hygienic practice dissuades the potential creator from tackling anything novel, for it preempts all initiatives and orients them in a preordained direction toward an orthopedic goal. Just like sex, art forfeits its attraction once it is prescribed as a therapeutic exercise. In any case the evidence is there before us: Apart from the one spectacular exception of the Artists' House at Gugging in Austria—the success of which reflects, precisely, the artistic priorities of psychiatrists who nourish no therapeutic illusion—it must surely be recognized that nothing truly inventive ever comes out of the art therapy workshop. No doubt Dubuffet was right in asserting that the creators to whom he was drawn did not practice art so as to cure their madness but rather to stimulate it.

Thus, to return to the problem which faced the Collection in 1975, the prudent option seemed to be to call off all further expansion. But prudence was never Dubuffet's forte; he was always one to take a gamble. And his gamble paid off, for it has become clear that—despite the overwhelming impact of the chemical straitjacket within psychiatric hospitals, despite the development of the means of mass conditioning, despite social and mental normalization on a global scale—there do still exist, against the odds, a number of refractory individuals who cling obstinately to their singularity in the face of conformity. The examples of Josef Wittlich, Reinhold Metz, and Helmut N. in Germany, Willem Van Genk in Holland, and Vojislav Jakic in Yugoslavia are living proof that, in this era of mass communication, one can still find individuals capable of constructing a wholehearted philosophical, intellectual, and formal system which owes nothing to anyone else's input [4.2]. True, it would be wrong to claim that such creators are 100 percent "impervious to culture," in Dubuffet's phrase. What they do, though, is to misappropriate the cultural ingredients they encounter, discarding the orthodox recipes and operating in a spirit of happy-go-lucky improvisation, picking out just those elements which suit them and integrating these within entirely original and unpredictable combinations.

Another paradox which differentiates Art Brut from Cultural Art is as follows. The latter is associated with youth, which our society has erected as a supreme value, a radiant metaphor for invention, freedom, anticonformism. The young have a complete monopoly on society's tender concern, having become the object of the most extensive investments in social, educational, professional, and economic terms, as well as the ultimate target of all advertising. The young end up the victims of a program of militarization enacted through rock music, which dictates that they keep in step, through the imperatives of fashion, which force them to adopt a uniform, and by the assault of the media, which regulates their every thought. On the other hand, and in a way entirely at odds with what used to happen in traditional societies, the old have been progressively ignored and marginalized, demoted to the status of the lowliest in society, and even interned in what are more or less cozy concentration camps. All in all, the old have come to occupy the position once reserved for the insane; they are today's pariahs, and it is they, likewise, who have taken up the thread

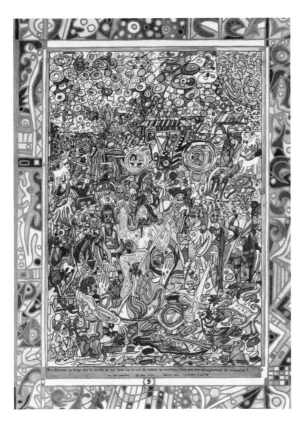

4.2. Reinhold Metz. *Don Quichotte, page 9 (Don Quixote, page 9),* 1977, watercolor and lacquer, 21 in. × 15½ in. Collection de l'Art Brut, Lausanne, Switzerland. Photo by Claude Bornand.

of Art Brut. Of course, the majority of old people react to their situation of dereliction with bitterness, and one can sympathize with that. Yet some seem to find that it rather suits them. Given that they have nothing more to gain and nothing more to lose, being absolved of all responsibility and free of all concern for what "people might say," they will, from time to time, strike out on their own, severing all social and mental ties and grappling with complex creative extravaganzas in which they alone participate. It is an impressive fact that creators like Gaston Teuscher, Alois Wey, and Hans Krüsi only discovered their vocation as artists after reaching retirement age [Pl. 4]. One has the impression that, from one day to the next, they picked up anew the thread of a childhood impetuosity which had been thwarted during their working lives, just as if, between the ages of ten and seventy, they had hung around waiting for a dull interlude to pass. Even within the field of Cultural Art, in spite of all the demagogic slogans we hear about youth, it has become quite obvious—as witness the recent stunning exhibitions devoted to the last years of Cézanne, Matisse, Klee, Picasso, and Dubuffet—that *the future belongs to the old.* Art Brut, at any rate, can be seen as peculiarly an art made by old people; it takes seven decades to turn into an anarchist.

As the theorist of Art Brut, Dubuffet was naturally preoccupied with the integrity of his Collection. Of course, it must be stressed that the polar concepts of Art Brut and Cultural Art constitute guidelines rather than watertight categories. One has to bear in mind that a given work is always *more or less* indebted to culture. A work can be classified as belonging to Cultural Art or to Art Brut depending on whether it veers toward one or the other of the two poles.

Yet, there are certain borderline cases that cannot be ignored. What I have in mind are those artists from cultivated backgrounds whose singularity is still channeled within a figurative tradition—artists of the order of Louis Soutter, Marguerite Burnat-Provins, or Mario Chichorro. I also have in mind certain creators who, in their lifetimes, were implicated in the art market, as were, for instance, Gaston Chaissac and Friedrich Schröder-Sonnenstern [4.3]. These were clearly artists of caliber; yet it was necessary to avoid their assimilation within the Collection proper if the category of Art Brut were not to risk being diluted, little by little, and gradually seeping indistinguishably into the category of art at large. Therefore, Dubuffet began by placing such half-and-half works in a special grouping he called the Annex Collection. Indeed, in the early stages, this proved to be a convenient place for relegating problem cases.

As it turned out, in the course of the 1970s these intermediary cases grew appreciably in number. More and more artists whose style was original though not entirely free of influences felt that they wanted to communicate their work to others, but they were inhibited from doing so by the specious nature of the training given in the art schools and above all by the rift between the fine-art network and genuine creativity. They found that far from stimulating invention and ensuring its transmission, the elitist system had an intimidating, dissuasive, and asphyxiating effect, one which kept artistic production confined within a cozy, artificial milieu, dominated by the obsession with what was in fashion, with whether or not one "belonged," and with the value system of the world of commerce. For a growing number of artists, therefore, the Annex Collection represented a way of bypassing establishment orthodoxy.

Jean Dubuffet always showed a lively interest in anything which the system could not stomach, and in time began to acquire works with the deliberate intention of adding them to the Annex Collection, which therefore gradually lost its negative function of simply storing the unclassifiable cases and instead took on a positive role. To confirm this new evaluative approach, Dubuffet resolved in 1982 to rename the Annex Collection "Neuve Invention" (Fresh invention) thereby designating those works which, though not characterized by the same radical distancing of mind as Art Brut, are nevertheless sufficiently independent of the fine-art system to constitute a challenge to the cultural institutions. The Neuve Invention Collection, which today boasts some five thousand works, is the object of separate displays in the museum, as well as of traveling exhibitions—in contradistinction to Art Brut itself, which, in keeping with Dubuffet's wishes, cannot be allowed to enter the cultural circuits of art promotion.

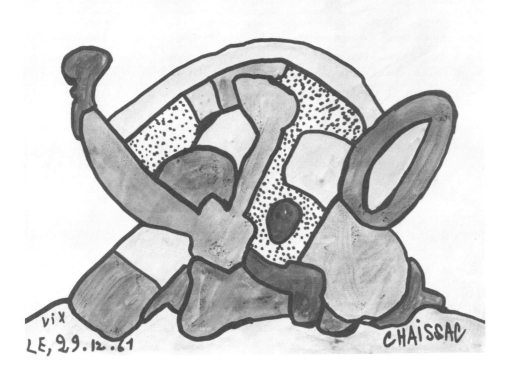

4.3. Gaston Chaissac. *Composition au Fond Rose Vif* (*Composition with bright pink background*), 1967, gouache, 19½ in. × 23½ in. Collection de l'Art Brut, Lausanne, Switzerland. Photo by Germond.

The emergence of this undisciplined art called "Neuve Invention," or perhaps "Outsider Art," which already has quite a high profile within the ordinary art market, gives cause for anxiety. Might not current fads in the art world, which for some time has been raving about anything which seems a tiny bit wild, induce the professional to engage in the deliberate and artificial manufacture of Art Brut? If so, how might one separate the authentic from the phoney and distinguish true Art Brut from its copies? The issue of authenticity, the practice of judging the work by its label or signature, is doubtless crucial to the way the art market operates, since it reflects the perceived value of the work. Collectors always seem to prefer a genuine Courbet of negligible quality to a phoney Courbet of high quality for reasons which are obviously financial rather than aesthetic. What they really like is to possess art, not to look at it. On the other hand, those who make Art Brut are not at all in awe of authenticity. Why, they are all mad, aren't they—that is to say, tricksters by definition? In other words, as makers, they let the cat out of the artistic bag and cheerfully admit that the whole business of art, which after all is based upon imagery, is nothing other than a vast enterprise of simulation. Every artist, insofar as he is a producer of

simulacra, is a forger. The sole distinction to be made is between the good and the bad forger. Thus when Courbet, toward the end of his life, began to pastiche his own work, as all painters do after all, he fell short of the standard of certain skillful forgers. Where then does authenticity lie?

Why not test the thing out for yourself? Why not have a go at making a work of phoney Art Brut? At the outset, you will certainly feel ham-fisted and lacking in authority (as happens with the "true" makers of Art Brut in their early works). However, once you engage fully in the process, you will inevitably find yourself getting more and more involved in this business of forgery, perhaps even to the point of neglecting everything else around you: your daily chores, your appointments, your professional and family obligations. You will run the risk of losing your job, your salary, and, in consequence, your partner's affections. You will end up with an altered personality, for you will have lost your ego, having come to realize that this, too, was only an image, a sham, the most pernicious of all simulacra. As Nietzsche put it, "Happy are the poor of spirit who contain not a single immortal soul but a thousand mortal souls!" In this way, as a compensation for the loss of a few social conveniences which are in truth no more than illusions anyway, you will come to experience the nomadic mentality and, above all, the sheer pleasure of making "genuine forgeries." Rather than produce counterfeit bank notes in the normal way, you will begin to issue your own personal currency, caring nothing for the value it might have on the market. What will happen next is that you will be invited into the museum of Art Brut by the front door, that is, as a creator and no longer as a passive visitor. In short, your mental health will be restored to the full! All roads lead to Rome, alas, bar that of madness, which is another way of saying total simulation. So this is the very road you need to follow if you want to create Art Brut—which, as we all know, lies at the antipodes of Rome.

Another question of the same sort: Has there not emerged a market for Art Brut which threatens to pervert, deform, or recuperate these artists? The field of what has been termed "Outsider Art" has certainly become commercialized. When I first became aware of this development, I naively supposed that people's financial interest in the field would stimulate fresh discoveries. But I have observed with consternation that, at least as far as Europe is concerned, gallery personnel place no faith in their own eyes or private responses, but instead look only for the label. And the label "Art Brut" implies being featured in the museum which bears this name. If Aloïse were to show up in a gallery today with a pile of her drawings, all the gallery director would do would be to check out whether her name appears on our list.

The idea is obviously absurd; there can be no Aloïse making the rounds of the galleries. It is the professional artists who tread this path. (Let it be said that one cannot really disapprove, if what they are seeking is to communicate and to sell their works.) On the other hand, true makers of Art Brut, by definition, recoil from any operation which seeks to integrate them within a system devoted to promoting and selling their work. In this connection, I would like to report a rather telling anecdote.

A few years back, I heard of a lady of seventy-five, living in a retirement home, who was producing the most flamboyant pieces of knitting. I arranged to visit her, whereupon the woman in charge of the establishment ushered me into the presence of a charming old lady completely engrossed in her work. A web of some twenty separate threads led down from her busy needles to a large work basket crammed with balls of wool. The knitter was improvising directly, with no preconceived program, summoning up images of stunning originality. Once I had informed her of the existence of the Collection de l'Art Brut, our conversation proceeded along the following lines:

"Your knitting is absolutely magnificent! Might I be allowed to put it on display in Lausanne?"

"My dear sir, what can you be thinking, these are not things to put on show in a museum! I'm just an old lady off her rocker who gets on with her knitting simply to help pass the time."

"Not only are these pieces of knitting worthy of being displayed, but with your permission, I should like to purchase some of them for the museum."

"No, I could never take money for such rubbish, that would be worse than stealing. In any case, there isn't anything you could take away, because I always unravel what I've been knitting as soon as I've finished, so that I can use the wool over again."

"But won't you at least allow me to take this one, which I see you've nearly finished, and then I'll buy you as many balls of wool as you want!"

"Certainly not, sir! Wool is far too expensive and you've no right to squander your money on such foolish extravagances."

I went off crestfallen. I can well imagine that this latter-day Penelope, who must have fashioned hundreds of sublime though short-lived masterpieces, has in the meantime died without leaving the slightest trace of her artistic prowess. She remained to the end the sole spectator of the works she knitted. She had discovered a creative project so inherently exalting and engrossing that, by comparison, the applause or even the attention of other people would have made not the slightest bit of difference.

Such is, in its extreme form, the attitude typical of makers of Art Brut with regard to what is commonly called "an artistic career." In their eyes, the essence of art is concentrated and accomplished within the act itself, in that jubilant adventure when they confront the sheet of paper, the canvas, the knitting needles. The creative hallucination breaks off like a film where the words THE END announce the shift back to lackluster reality. Surely it is obvious that if one were to try to introduce such people to the art market, one would only lead them to their doom, or, more likely, induce a wave of heart attacks among gallery directors.

So it is not that the art market is propelling Art Brut toward a crisis, but rather the other way round! And as far as we are concerned (by "we" I mean we functionaries who are interested in Art Brut with no thought of financial gain), the cash invested in this field has not actually changed things that much. All it has really done

is to launch a salutary challenge: to discover and to collect works before they become the object of a prohibitive valuation from whose profits, in any event, their makers will receive no more than a few crumbs; and to try to protect the vulnerable among them from the more aggressive buyers by reintroducing the convention of the pseudonym, as was once the practice in psychiatry, though for different reasons.

This said, speculation in the art trade has at least had the merit of administering a kind of counterproof; in this age of rampant privatization, it appears more than ever that the only status Art Brut can settle for is a public one and that it can only thrive within the inalienable collections of those museums which (for how much longer?) remain independent of the economic strictures of the marketplace. Does this mean that Art Brut should be considered an archaic relic of the precapitalist era, or that it represents the symbolic alternative we are all looking for? That is the question!

BIBLIOGRAPHY

1971. *Catalogue de la Collection de l'Art Brut.* Paris: Publications de la Compagnie de l'Art Brut.

Dubuffet, Jean. 1949. "L'Art Brut Préféré aux Arts Culturels." In *L'Homme du Commun à l'Ouvrage.* Paris: Gallimard, 1973.

———. 1951. "Honneur aux Valeurs Sauvages." In *L'Homme du Commun à l'Ouvrage.* Paris: Gallimard, 1973.

———. 1967. "Place à l'Incivisme." In *L'Homme du Commun à l'Ouvrage.* Paris: Gallimard, 1973.

———. 1971. Interview with Franck Jotterand. In *Gazette de Lausanne*, 22ff.

REBELS, MYSTICS, AND OUTCASTS

THE ROMANTIC ARTIST OUTSIDER

Joanne Cubbs

THE ARTIST AS OUTSIDER

The belief that artists are social outsiders or inspired individuals who transcend the boundaries of culture is the subject of much current debate. It is central to a contest between modern and postmodern critical sensibilities, between those who affirm art's transcendent, universal nature and those who characterize those ideals as mythic and negligent of particular social and cultural realities. This essay describes the origin of the belief in the artist outsider and charts its critical history.

Although rooted in countless myths and legends of earlier times, the view of artists as outsiders was first fully established, in Western culture, during the Romantic period. A major intellectual and popular movement of the late eighteenth and early nineteenth centuries, Romanticism embraced an artistic philosophy of escape, fantasy, reverie, and revolt.[1] It also preached a dissatisfaction with the mundane everyday world which it believed could only be redeemed through the mysterious transforming powers of the artist's individual imagination. Exiled from common social life by the myth of their unique creative vision, artists came to be viewed as isolates, rebels, and necessary outcasts from society.

Within Romantic ideology, artists assumed a number of roles that dramatized different aspects of their outsider nature. One role, for example, positioned the artist as a prophet and visionary responsible for the world's moral and spiritual enlightenment. Influenced by the long-held view that human creativity is a form of divine or supernatural inspiration, many Romantics believed that through the exercise of the

imagination artists were able to reenact the original creative activity which first gave rise to the world.

Another popular Romantic myth portrayed artists as rebels or adversaries of established culture. Contemptuous of social conventions, past aesthetic traditions, and cultural orthodoxies of any kind, this image of the artist outsider challenged the authority of the status quo. It was a role that would be best realized in the early twentieth century by the modern avant-garde, who channeled their dissatisfaction with the state of Western civilization into a succession of artistic movements and manifestos charged with the rhetoric of revolution.

To this outsider entourage of divine visionaries and spiritual redeemers, of social rebels and political insurgents, was added another artist species—the social misfit. Eccentric, idiosyncratic, naive, reclusive, and unwittingly nonconformist, this is the characterization which is today most frequently imposed upon the contemporary self-taught artist. Closely related to the idea of the eccentric artist was the most common stereotype of the Romantic outsider—the "crazy artist" or "mad poet." While Plato theorized that artists were possessed by a strange kind of "divine madness," the Romantics finally equated creativity with madness, asserting that insanity was an exemplary mode of genius and a heroic form of opposition to both social and artistic conformity. The Romantic ideal of the "mad genius" would prompt the Surrealists' interest in psychotic imagery, unconscious meaning, and the expressions of the irrational mind. It would also lead to Jean Dubuffet's now famous "discovery" of artists among the inmates of European insane asylums and to the many sensational tales of brooding poets, suicidal painters, and temperamental artists slowly driven to derangement that have continued to dominate the history and literature of Western culture.

Much standard art history from the last two centuries seems to be little more than a relentless recasting of the Romantic outsider theme. Although the actors change, the basic plots remain the same—story after story of daring formalist rebellion accompanied by flamboyant gestures of social defiance, countless excerpts from the melodramatic memoirs of misunderstood genius, and tragic accounts of artist poets consumed by their lonely creative quests. Believed to be naturally estranged from the society they in some way call into question, "real" artist outsiders are never fully appreciated or recognized. Isolated, ignored, and impoverished, they must struggle with indignant singleness of purpose to express the higher sensibilities, intense passions, and deeper torments commonly ascribed to them. Included among art history's favorite outsiders is the late eighteenth-century painter and poet William Blake. According to the popular Romantic text, Blake shunned the official patronage and academic standards of his time. Reportedly a misfit even among other artists, he entered the later years of his life unknown to the general public and facing extreme poverty. And in the end, his intense apocalyptic fantasies and fiery emotions earned him the accolades of troubled prophet, eccentric, and madman.

These historical dramatizations often make it difficult to distinguish reality from

fiction, but despite such exaggerated accounts, the outsider mythology is not simply a fable. It is a cultural belief system that has actively shaped the convictions, behavior, works, and lives of many modern and contemporary artists as well as the perceptions and expectations of the society that surrounds them. The most famous re-incarnation of the Romantic artist outsider was Vincent van Gogh, whose notorious artistic passions ended in the suicidal madness so often associated with the anguished creative spirit. In the mid-twentieth century, the archetypical image of the outsider was relocated in the popular legend of Abstract Expressionist painter Jackson Pol-lock, who forged a new outsider model combining his identity as an alienated artist outcast with the rugged individuality, frontier machismo, and Romantic pathos of the American cowboy. Among the more recent descendants of the Roman-tic artist outsider is German painter and self-proclaimed "alchemist" of his-tory Anselm Kiefer, whose enigmatic personality, arcane symbolism, and giant apocalyptic landscapes represent a late contemporary vision of art-world magic and heroicism.[2]

In addition to influencing cultural conceptions of artists and their relationship to society, Romanticism's outsider ideology also affected the nature of artistic pro-duction itself. As the activities of artists became further consigned to a place outside ordinary experience and beyond the bounds of normal social discourse, Romantic art and poetry increasingly abandoned their interest in everyday external reality for the remote and mysterious world of the inner self. This Romantic emphasis upon interiority and the self inspired the now very common tendency to eulogize art that is personal and eccentric, passionate and expressive, idiosyncratic and strange. While in the past much art may have overtly served the collective values and shared tradi-tions of the established social order, often reinforcing the dominant powers of church and state, it now claimed an allegiance only to the specters of the imagination, to the ideals of self-expression, and to a mythical realm of pure subjectivity held to be the magical province of creativity and genius.

Romanticism's interest in the mysterious inner world of the artist and poet was part of a larger fascination with feelings, passion, irrationality, and subjectivity that came to characterize the entire period. A change in sensibility that dominated much European thought from about 1790 to 1830, this turning inward is sometimes inter-preted by historians as a response to the crumbling of traditional social order and modern alienation brought about by the Industrial Revolution and the development of industrial states. Even more commonly, the Romantic movement has been re-garded as a reaction against the rationalist, empiricist, and materialist tendencies of the Enlightenment. But while Romanticism certainly represented a different con-sciousness, it might also be said to have been influenced by the rigorous questioning and humanist concerns that marked the predominant thought of the early eighteenth century, especially the Enlightenment emphasis upon individualism and the accom-panying political philosophy which proposed the right of all individuals to self-determination.

Romanticism emphasized to a dramatic extreme the concept of the individual as unique and independent. In particular, it asserted that the distinct nature of the individual could best be realized through the idiosyncratic expressions of the self. As a result, artists and poets became increasingly preoccupied with what might be described as the metaphysics of the self, an introverted universe of feelings and troubled subjectivity that often assumed the shape of strange and singular visions. Although these fantastic images conjured from within the private world of the self seemed to possess little relationship to reality, Romanticism argued that such visions were not mere fictions but rather representations of another kind of truth, evidence of a special knowledge obtained through the workings of the imagination.

THE ARTIST AS MYSTIC SEER

Belief in the imagination as a means of both creating and knowing dominated the discourse of Romanticism. Assuming a nearly mystical importance, the imaginative experience came to be viewed as a form of inspired understanding, one that super- seded ordinary intelligence. This Romantic epistemology, which positioned the imag- ination as the source or faculty of knowledge itself, led to the conclusion that the artist or poet possessed a kind of peculiar and privileged insight. Not only singled out by their unusual visions, artists were now also set apart by their unique ability to apprehend the real nature of things. For many Romantics, the feelings, passions, intuitions, and inner visions of the artist and poet were *alone* believed to be capable of revealing deeper truths, of discovering the realities beyond or embedded beneath the familiar, observable world.

The Romantic position which argued the epistemic authority of the imagination and the artist's central role in the act of knowing came to occupy a large body of critical and poetic writings. Among the most influential were the theoretical works of the German Romantics, particularly those of philosopher and metaphysician Friedrich Wilhelm Joseph von Schelling. Asserting a belief in the "obscure unknown power" of the artist's vision and in the transcendent nature of art itself, Schelling's writings serve as an important master text for the Romantic ideas that have contin- ued to govern many modern art-world beliefs and practices. They reveal, in particu- lar, the origin of Romanticism's outsider ideology within the larger history of West- ern philosophical discourse.[3]

In his writings, Schelling searched for a theory of knowledge in which the con- scious self could perceive the unconscious world, or in which the Ego might come to know Nature. Seeking to unite the free and conscious self with the involuntary forces of Nature, Schelling stated, "An intuition must be discoverable by which the ego is at once conscious and unconscious. . . . Only by way of such an intuition do we bring intelligence, as it were, wholly out of itself" (Schelling, 1800: 361).

In the end Schelling concluded that the only activity which could simultaneously engage both conscious and unconscious knowing was artistic creation. Through the powers of aesthetic intuition, Schelling believed, it is possible to traverse both conscious and unconscious worlds, to join the self with the vast and mysterious phenomenon of nature, and finally to understand the infinite and absolute principle underlying all reality. In his words, "It is as though in the rare persons who are, above all others, artists in the highest sense of the word, the immutable identity, on which all existence rests, has put off the raiment with which it clothes itself in others" (Schelling, 1800: 365).

Yet in representing "the infinite," art became characterized by a paradox—the belief, still prevalent today, that the highly subjective and idiosyncratic expressions of the individual artist also possess a universal significance and validity. This paradoxical view of art, which elevates the isolated and personal gestures of the artist to a universal principle, implies finally that the primary task of the poet is to reveal general truths or to convey some deep essential reality. Equating aesthetic self-expression with the quest for ultimate mysteries, Romanticism set the stage for the mystico-religious aspirations of much art to follow. Such cosmic ambitions inspired the works of Wassily Kandinsky, Piet Mondrian, Kasimir Malevich, and countless other early modernists who sought to evoke the Absolute through the metaphysical metaphors of pure abstract shape. In fact, many have now argued that abstract art itself evolved from artists' desires to represent spiritual beliefs that could not be expressed in conventional pictorial forms (Tuchman, 1986: 17). It was this strong mystical tendency in twentieth-century art which influenced countless other artists and their works, from the pantheistic images of Arthur Dove and Georgia O'Keeffe to the later abstract paintings of Jackson Pollock, Barnett Newman, Mark Rothko, Yves Klein, and Ad Reinhardt. Similar spiritual or metaphysical aspirations came to inform countless other expressions, including among many others, the shamanistic rituals and fetishistic objects of Joseph Beuys, the symbolic earthworks of Ana Mendieta, and the strange asceticism of John Cage, Robert Irwin, and much contemporary conceptual art. It is this same idea of art's crypto-religious nature that also underlies part of the art world's recent interest in the expressions of spiritual mediums, religious visionaries, and fundamentalist preachers who draw or paint.

But while Romanticism defined art as an absolute revelation or as an epiphany that transcends particular social and historical realities, it simultaneously argued that such mystical expressions are also historically significant. In one of the most familiar scenarios of Romanticism's outsider ideology, the artist's individual "drama of redemption" is "projected upon society" in order to transform it (Campbell, 1987: 182). Evoking the same form of transcendent historicism, Schelling and many of his contemporaries came to view the artist as a sort of agent for the Absolute in the world at large, especially as this cosmic force worked its providential powers upon the course of world history.

During the nineteenth century, history was viewed as a fundamentally linear process, a continuous movement forward to some final and awesome accomplishment. Schelling and many other philosophers of the time interpreted the goal of history as nothing less than the wholesale fulfillment of humanity, an epic form of self-realization brought about by the progressive unfolding of a universal spiritual consciousness, which Hegel referred to as the "Absolute Idea." In his influential writings, Hegel asserted that this ultimate and timeless identity curiously evolves or realizes itself within time (i.e., history), aided by the passions, exploits, and willful actions of certain historically significant characters (i.e., "world-historical individuals").[4] Like his friend and colleague Schelling, Hegel believed that great art embodies the Absolute and so assists the "world soul" in following the evolution of its own activity. As he more simply expressed, "The work of art brings us face to face with the eternal powers paramount in history" (Hegel, 1835: 390).

As the quest for the spiritual was joined with historical actuality, the artist came to be viewed as an actor within history. And the notion that art somehow "understands" the great inner directive of history led to the assumption that artists have a major part to play within world destiny. While Hegel said that art was just one means to advance the spiritual goal of history (superseded finally by the insights of religion and philosophy), Schelling argued that artistic genius alone was able to perceive and thereby join forces with the divine principle which continually imposes its designs upon the world. Schelling's views of art's unique spiritual nature and the artist's central role within the world's evolutionary scheme were ideas shared by many other Romantics of the period. In a now famous quotation, Percy Bysshe Shelley claimed that "poets are the true, unacknowledged legislators of the world" (Shelley, 1821: 188). In a long poem titled *Jerusalem, the Emanation of the Giant Albion*, Blake put forth a similar portrait of the artistic persona with his creation of the fictional character Los. Serving as symbol for the Imaginative Mind and as Blake's own alter ego, Los is a perennial seeker of spiritual truth and a cosmic protagonist charged with the responsibility of enlightening humanity and of finding ways to heal and redeem the universe. Inspired by such tasks, he assumes the identity of a blacksmith and goes on "to construct the city of the imagination and to form the tools of the world's salvation" (Boime, 1985: 114).

In what has perhaps come to be the best-known proclamation of the Romantic period, Blake once said:

> I must Create a World, or be enslav'd by another Man's.
>
> I will not Reason & Compare: my business is to Create.
>
> (Blake, 1804: 23)

With the idea that artists are figures of world-historical importance came the additional notion that these individuals possess the power to re-create the world at will. For the Romantics, the purpose of art was not to imitate reality but to transform it, and the means to effect this metaphysical magic was the imagination. Not merely a superstition, the Romantic belief that artists can simply imagine things into being evolved directly from mainstream idealist thought, a major movement in modern philosophy which was prefigured by Descartes' famous assertion that the world exists only as an elaboration of the human mind. According to idealist philosophy, the individual subjective consciousness is the foundation of all knowledge and therefore the source of all that we can understand as objective reality. A form of idealist thought, Romanticism similarly believed that because the existence of the world depends entirely on our perceptions, we can also reshape it through those visions.[5] Responding to critics of Romanticism who questioned the imagination's relationship to reality, Blake stated with great fervor: "Mental things are alone Real: what is call'd Corporeal, Nobody Knows of its Dwelling Place: It is in Fallacy, and its Existence an Imposture. Where is the Existence Out of Mind or Thought? Where is it but in the Mind of a Fool?" (Blake, 1810: 8).

In its most extreme expression, Romanticism might be described as a "magic progressive idealism," a belief in the metaphysical powers of the artist that were to "radiate outwards from poetry to transform the whole world" (Furst, 1976: 43, 44). Not subject to world events but able to create them, the Romantic artist became an author of history, an individual whose imaginative visions could shape not only poems and paintings but human destiny as well. It was this Romantic view of artists as world visionaries which inspired the modernist notion of the artistic avant-garde marching heroically ahead of the rest of society. Armed both with an irreverence for the past and with uncanny intuitions of the future, modern artists set out to lead history, to make manifest through their art the most advanced ideas, sensibilities, and tendencies of culture. Recounting an imaginary conversation between an artist and a scientist, the Utopian socialist Henri de Saint-Simon wrote in 1825: "It is we artists who will serve you as avant-garde: the power of the arts is in fact most immediate and most rapid: when we wish to spread new ideas among men, we inscribe them on marble or on canvas. . . . What a magnificent destiny for the arts is that of exercising a positive power over society, a truly priestly function, and of marching forcefully in the van of all the intellectual faculties" (Saint-Simon, 1825: 2).

Such impassioned proclamations of the avant-garde's noble mission fueled the agenda of many artists well into the second half of this century, but the influence of Romantic outsider ideology within more contemporary times is not so simply drawn. Today the concept of an artistic avant-garde as well as the underlying idea of historical progress itself have fallen out of intellectual favor. Discredited by the recent interrogations of postmodernism, the modernist belief in the truth of history and its sacred heroes now appears to be remarkably naive. During the last two decades, a significant part of the art world has come to adopt postmodernism's critical project,

working to "dismantle the monolithic myth of modernism" and its "oppressive progression of great ideas and great masters" (Wallis, 1984: xiii). In particular, the widespread borrowing of popular images and imitative tactics of appropriation and simulationist art have refuted the notions of authorship, originality, and genius upon which the outsider mythology of Romanticism and the cultural status of its progeny, the heroic modern artist, were founded. Now with the idea of the artist outsider placed under siege by the art world's questioning of its own myths, status, purpose, and power, it is curious to contemplate how and where this Romantic character has survived.

Despite critical efforts to demystify artistic practice, the rhetoric surrounding artists is still dominated by magical descriptions of mysterious inner vision, creative drives, expressive urges, innate sensibilities, messages from the unconscious, and pure subjectivity, and these imperatives of the imagination are still considered to place artists outside of society and its understandings. As contemporary art critic Donald Kuspit writes, "It is the desire [of artists] to enter the mainstream of societal communication itself that must be resisted, for it usurps inner necessity" (Kuspit, 1986: 314). Although few continue to truly believe in art's mystical reality or revelatory power, many attempt to reinvest it with enough sublime or enigmatic qualities to maintain at least the appearance of transcendence. Artists and their art are still frequently tragic and heroic, as demonstrated by the continued "high art" interest in giant canvases, grand existential themes, insolent male painters and sculptors, apocalyptic imagery, expressive painterliness, and personal angst. Most of all, the artist outsider is sustained within the marketplace, where mythic claims of uniqueness, originality, and one-of-a-kind genius serve an important promotional purpose and help to transform once-transgressive gestures into the class-coded, taste-bound trophies of a cultural elite.

Finally, while some try to destroy it and others strive to go on living it, still others attempt to preserve the image of the artist outsider in a place beyond the perceived boundaries of their own art world, or within that category of expression appropriately referred to as "outsider art." It is no coincidence that as many of the art world's Romantic beliefs now turn into critical doubt, the interest in the work of self-taught artists has intensified. Located far away from our pessimistic conversations about the death of originality and the end of authenticity, it is within their world that we can play out our nostalgic and reactionary yearnings for a return to the uncorrupted sources of creativity itself. It is within their world that we believe real outsiders might still be found.

THE OUTSIDER AS ARTIST

The discourse surrounding the works and lives of self-taught makers, or so-called Outsider Artists, is, in many ways, a perfect site for the reproduction of Romantic

outsider ideology. To begin, the individuals usually designated as Outsider Artists are ready-made outcasts conveniently drawn from the ranks of those already imagined to be on the margins of culture. Among the most qualified for induction into this art-world role are: social isolates and eccentrics, religious visionaries, and the inhabitants of mental hospitals, prisons, small rural towns, city slums, and the streets. The merely uneducated, the elderly, and the impoverished are sometimes candidates as well. The term "Outsider Art," now widely used to describe the creations of such untutored makers, was coined by British scholar Roger Cardinal in the early 1970s, but his writing and much of the subsequent commentary in the field have drawn inspiration from the earlier, impassioned beliefs of French artist Jean Dubuffet, who issued the following proclamation: "Tramps, obstinate visionaries soliloquising, brandishing not diplomas but sticks and crooks, they are the heroes of art, the saints of art" (Dubuffet, 1959: 7).

Recasting "schizophrenics, rogues, hermits, innocents, tramps and eccentrics" into the role of artist heroes, Outsider Art is the most extreme example of the Romantic tendency to conflate social and artistic nonconformity, to re-encode social marginality as a willful act of creative individualism. Often underlying this mythic transformation of the disenfranchised is the strong rhetoric of protest, a championing of the otherwise culturally and artistically dispossessed as well as an attack on the lifeless conformity and repressive moral authority of "high culture." By supporting Outsider Art (initially called Art Brut, or "raw art"), Dubuffet believed that he was opposing the tyranny of the established order and the system of official culture, which, he asserted, "asphyxiates" true creativity, denies the value of "the art of the common man," and becomes both a "weapon of caste" and a tool of Western imperialist oppression (Dubuffet, 1968: 10, 14).

In his search for self-taught creators who were free of influence from the academies of "learned" art and for unusual individuals who seemed to be immune to the more pernicious indoctrinations of Culture, Dubuffet found among such "obscure artists" the ideal emissaries for his anti-cultural sentiments and subversive beliefs. Although Dubuffet would have disclaimed the influence of any historical antecedents, his strident cultural protests derived from the tradition of Romanticism whose rebellious spirit and world-rejecting stance have fostered the still-frequent relationship between radical art and radical politics. But, in their subsequent commentaries, many contemporary proponents of Outsider Art often depoliticize such work. Transforming Dubuffet's cultural rebels into "aesthetic mavericks" and championing the cause of artistic, not social, liberties, they have turned raw art's cultural attacks into purely aesthetic protests. At the same time, they, like Dubuffet, maintain the insurgent rhetoric of Romanticism. Cardinal, for example, assigns to the authors of Outsider Art a "nonaligned creativity," an "anarchic" spirit, and "a refusal to accommodate to the practicalities of normal social life." In what might just as easily serve as a mission statement for the Romantic artist outsider, Cardinal also writes: "Outsider Art is a force in motion which contests the authority of the central establishment and

maintains a posture of dissidence in the face of the influences to which it is subject. . . . Alienation represents a chosen path leading to a position of deliberate differentness and hence of creative originality."[6]

Projecting the image of nonconformity and rebellion onto individuals whose lives and work may or may not contest cultural norms and artistic traditions, the discourse of Outsider Art imposes a false intentionality upon some makers, obscures the original subversive content of others, and finally asserts its own hegemony of meaning over those it views as culturally disempowered in a way that is similar to the system it protests. It is, after all, important to remember that, while espousing the works of the socially marginalized, the category of Outsider Art is itself the invention of an elite coterie, the totalizing enterprise of formally educated artists, collectors, critics, and dealers who often work to promote their own mythic beliefs, ideological agendas, and aesthetic self-interests. In many instances, Outsider Art is another manifestation of the common tendency within the art world to seek out and assimilate the marginalized as a means to reinforce and promote its own heretical or outsider posturing. Not surprisingly, the history of Outsider Art's "discovery" is really an account of its appropriation by the art world and its repositioning as an imaginative pawn within that world's ongoing aesthetic protests, iconoclastic struggles, and cultural debates.

For example, Dubuffet's early interest in Art Brut and the continued advocacy of that "genre" by the many European artists, critics, and collectors who followed him might be seen primarily as efforts to extend the agenda of the avant-garde, to find in the "raw" gestures of the untutored "an art without precedent or tradition" which, unbeknownst to its makers, would undermine the inherited "high" art practices that it has always been modernism's project to destroy.[7] Although those examples of Outsider Art capable of being recognized by the art world must necessarily coincide in some way with the already established formal directions and current aesthetic values of their "discoverers," the mythology that surrounds these works portrays them as radically different creations whose utter singularity serves to defy all past artistic conceptions.

In the United States, Outsider Art enthusiasts have aspired to similar avant-garde pretensions, as witnessed by the title for a recent touring exhibition of such works—"The Cutting Edge."[8] But the revitalized interest in self-taught artists that started to occur in America in the late 1960s and early 1970s might be attributed to other forces as well. Stirred up by that era's strident social activism and its call for the democratization of culture, by the then widespread rejection of established conventions, and by a new desire to embrace alternative canons of all kinds, a number of individuals within the art world began to seek out the otherwise unrecognized creations of unschooled painters, sculptors, and environment builders. Often their interest was part of a larger fascination with a wide variety of marginalized expressions that also included traditional folk art, craft, kitsch, popular art, roadside archi-

tecture, and countless other forms of vernacular culture with which Outsider Art is still sometimes associated. Together with these other emblems of unheralded or "oppositional" culture, the works of self-taught artists often came to serve as a grass-roots challenge to the representational systems of high modernism, or as an "art-is-everywhere" rebuttal to the pretentious claims and privileged productions of "fine art."

During the 1980s, the interest in Outsider Art continued to intensify, particularly as it became the hottest new commodity for neophyte collectors anxious to participate in that decade's voracious art market. Then, in February of 1992, a front-page story in the *Wall Street Journal* announced an event of which many were already aware. The headline proclaimed: "Outsider Art Is Suddenly the Rage among Art Insiders." Other reports in the popular press had similarly asserted: "The Eccentric Visions of Untrained Artists Are Taking the Art World by Storm," "The Outsiders Are In," and "Outsider Art: Visionary Artists Find an Eager Public." Art critics speculated in one article that "the surge in interest partly reflects a yearning for a return to artistic innocence." Elsewhere another scholar of Outsider Art responded: "[This art] answers a very deep need in the 20th century. People are tiring of oversophistication."[9]

Conjuring the familiar image of self-taught artists as simple, untrained, and ingenuous makers, many recent promoters of Outsider Art view this work as an antidote to the increasingly critical and theoretical tendencies of much contemporary "insider" art. Similar anti-intellectual protests against the obscurity and elitism of "official" art-world culture have always been a part of the rhetoric supporting Outsider Art. But today, as it poses itself against a new body of radical critical thoughts and practices that actively contest the Romantic values and ideals upon which it has been founded, the discourse of Outsider Art appears to be less of a protest and more of a fundamentalist revival, a re-entrenchment of those Romantic sentiments that continue to support the notion of original, unmediated expression and the belief in an art which is somehow able to "spring from pure invention." Characterizing self-taught artists as symbols of pure, uncorrupted creativity or "humanity before the fall," the metaphysics of Outsider Art and its Romantic restoration theology appropriately begin by invoking the themes of the Garden of Eden—purity, innocence, and unself-conscious Nature.

NATURE, PRIMITIVES, AND SELF-TAUGHT ARTISTS

· Instinctive and independent, they appear to tackle the business of making art as if it had never existed before they came along. What they make has a primal freshness; it is the product of an authentic impulse to create and is free of conscious artifice…. They bring us face to face with the raw process of creation.

—Roger Cardinal, 1979

Believing in the possibility of expressive innocence or in creators not yet corrupted by the sinful fruits of art-world knowledge, the discourse of Outsider Art represents western culture's latest dream of Arcadia and the image of simple peasants, noble savages, and virtuous, untutored natives still attuned to nature. Inhabitants of a cultural Eden, Outsider Artists embody the "raw vision" and elemental powers that issue from an imaginary communion with nature, a connection which is now otherwise believed to have been lost.

While central to the mystique of Outsider Art, nature plays a major metaphorical role in most other narratives of Romantic outsider ideology as well. The mythic antithesis of modern society, the idea of nature is often called upon to protest the ethical and spiritual corruption of society. It is the absolute symbol of modernism's quest for transcendent knowledge and regained spiritual wholeness. Finally, in many outsider scenarios, the artist becomes a kind of defector from civilization who seeks to renew a covenant with the natural world and with the spiritual forces believed to be found there. Within Romantic thought, nature is also commonly viewed as an analogue for the artistic self, the mirror image of the individual psyche and the very source of the artist's creative powers. Schelling claimed that the unconscious and spontaneous actions of nature informed all true art, which he summarily defined as the Ego in immediate identification with Nature. The belief that art is driven by "natural" impulses manifests itself further in the more contemporary valorization of works whose immediate expressionist gestures, strange random markings, or unfettered visceral images signify the violent, ambivalent, and unconscious powers associated with nature.

Reputed to be especially close to nature, Outsider Artists are subjects of the most dramatic accounts of its mysterious promptings and other obscure urgings from the unconscious. As a number of commentators write:

> Their works are the product of long, tortuous journeys into the depths of the human psyche, into the very sources of human creativity. Here uncontrollable forces give rise to strange, powerful artistic expressions which are often haunting and disquieting. (Farber, 1990: 7)

> There is a feeling that they stand not on the margins of art, but at its center, at the very verge of the sources of creativity whose enigmatic forces they ride like Apocalyptic horsemen without any desire to tame them. (Musgrave, 1979: 8)

> They invite us to take a journey into the "distant interior" from which we cannot return unscathed. (Thévoz, 1976: 13)

Often described in metaphors of a strange and mythic journey, this search within Outsider Art for those radical creative energies that exist beyond the boundaries of the rational world is nevertheless a familiar quest, for it recalls the larger obsession

within western culture for the "Primitive." Outsider Art is, in fact, another fantasia of Primitivist invention. Placed in dialectical opposition to the civilized world, the world of logic, language, and culture itself, the mysterious natural forces of the Primitive are believed to be located in most non-European peoples, in all rural "folks," in women (especially in their role as the feminine muse), and finally, in "crazy" self-taught artists.

It is with the mysterious creative and procreative powers of the Primitive that many Western artists have imaginatively sought to identify themselves. Jackson Pollock said, "I am Nature." Paul Gauguin said, "I am savage." He also said, "You will always find nourishing milk in the Primitive Arts." The art world's desire to rejuvenate itself through the Primitive began with the aesthetic appropriations of African and Oceanic cultural property and with other borrowings of the "exotic" for which Modernism has become so notorious. Outsider Art is the latest example of such "ethnographic collecting." Jean-Jacques Courtine, a contemporary proponent of Outsider Art, expresses the Primitivist sentiments underlying this continued colonization of the other:

> The turn of the century did witness a quest for otherness in representation being set in place, at the same time as a *thirst for origins* sought a return towards the first moments of esthetic consciousness. They wished to unearth, prior to the pictorial tradition, the virgin continent of the creative process caught in its infancy, in the purity of an intact origin, before culture could come and corrupt it. The discovery of Art Brut is a consequence of this desire: the art of madmen or of prisoners, of marginals or of recluses, of small children or of old people, was thought to bear the immaculate seal of beginnings. (Courtine, 1990: 40)

This myth of "beginnings" or the illusory search for the truly original is at the very center of the metaphysics of Outsider Art. Defined by their independence from the conventions or conformity of "academic art," the works of self-taught artists are, above all else, extolled for their uniqueness. Seeking to support this claim of originality, the writings on Outsider Art feature fantastic passages of formalist prose that marvel at the unusual creativity or intrinsic singularity of outsider expressions. The strange and ineffable aesthetic properties so assigned to Outsider Art soon dominate all other meaning as the already meager biographies of its makers are often turned into supporting tales of eccentricity and difference.

It is in this relentless fetishizing of difference, in the exaggerations of the work's perceived singularity, and in the exploitation of the maker's often real-life marginalization that the originality of Outsider Art is constructed. But even more sensational are the accounts of the magical process by which these expressions are believed to be created. Characterized as "an orphic journey to the depths of the human psyche" (Musgrave, 1979: 8) and described in countless other metaphors of interior sojourn or visionary transport, Outsider Art epitomizes the Romantic notion of creative

epiphany and the long tradition of art's prophetic or supernatural inspiration. For central to the texts on Outsider Art and to all discourses on originality is the belief in a moment of "pure spontaneous creativity," or sudden imaginative insight that transcends normal causality and external reality.

Viewed as a form of extracultural creativity, Outsider Art was initially seen as immune to significant artistic, social, cultural, and historical influences. Of course, the obvious fiction of this originary status did not go unchallenged, as now even the proponents of Outsider Art testify to the inexorable force of cultural cause and effect. But just beyond these concessions, there remains a metaphysics not fully deconstructed, a magical rhetoric that still asserts its mystical beliefs. Within the discourse of Outsider Art, private worlds of illusion continue to exist, creative visions issue from beyond the realms of ordinary experience, and the meaning of such expressions is still meant to elude much of our understanding.

In the end, Outsider Art serves as a contemporary construct through which western culture can continue to exercise its belief in the mysterious, ineffable, and transcendent nature of art itself. It is the most recent imaginary device through which the Romantic idea of the artist as outsider survives. Recalling the portentous claims of the Romantic visionaries and heroic avant-gardists, John Maizels, the editor of an international journal devoted to Outsider Art, states: "Too many people all around the world are now aware of the power and truth of Outsider Art for it to be ignored any more. . . . Its influence will be ever growing. It will act as a shining beacon for all artists and creators: the true way forward for human creativity" (Maizels, 1992: 3).

ACKNOWLEDGMENTS

This essay is excerpted from a larger text for an upcoming book documenting major environmental works by self-taught artists throughout the state of Wisconsin. The publication is being produced by the John Michael Kohler Arts Center in Sheboygan, Wisconsin, with funding from Kohler Foundation, Inc. In particular, I would like to acknowledge the continued support of Arts Center Director Ruth DeYoung Kohler, who has enabled the realization of this project and many other related exhibition and publication efforts, and inspired the site conservation work for which the Foundation is known. I also thank Eugene Metcalf for his many editorial comments and suggestions.

NOTES

1. Most texts on Romanticism caution against any attempts to define this broad cultural phenomenon too narrowly, and I enter the same caveat here. Among the many writings on the

subject, Colin Campbell's *The Romantic Ethic and the Spirit of Consumerism* was an important influence on my arguments.

2. Although some women have been viewed as "artist outsiders" (the name of Frida Kahlo, for example, is frequently invoked in discussions of this topic), it is important to note that the outsider myth is primarily a heroic male text which generally excludes any female protagonists, whom western culture has traditionally failed to recognize as its major artists, much less envisioned as its heroes.

3. Friedrich Schelling (1775–1854) is commonly recognized as the philosopher who best represented Romantic ideas and sensibilities. His first distinctive and most widely known work was published in 1800 and entitled *System des transzendentalen Idealismus* (System of Transcendental Idealism).

4. For the association of artists with Hegel's notion of "world-historical individuals," I am indebted to the writings of Thomas McEvilley. In particular, see his essay "The Case of Julian Schnabel," in *Julian Schnabel: Paintings 1975–1986* (London: Whitechapel, 1986).

5. The specific form of idealist philosophy referenced here might be more accurately described as "subjective idealism," an antirealist epistemology whose extreme subjectivism also underlies the propositions of Existentialism and Phenomenalism. In contrast, the "absolute idealism" of Hegel and others poses the individual, not as the ultimate arbiter of reality, but as an unwitting pawn of an Absolute mind, spirit, or "Idea," which is finally the primary force within the world. Within its various conceptions, Romanticism manifested both of these tendencies of idealist thought.

6. In a recent article, Cardinal writes, "Naturally, a creator so idiosyncratic may well turn out to be something of a *social* misfit, but, as I have said, the point is to see the Outsider as an essentially *aesthetic* maverick" (SPACES newsletter, no. 11 [Summer 1991]).

7. In 1968, Renato Poggioli, writing about the avant-garde, referred to their "favorite myth of the annihilation of all the past, precedent and tradition" (*The Theory of the Avant-Garde* [Cambridge: Harvard University Press, 1968], 47). In 1979, a major publication on Outsider Art with contributions by Victor Musgrave, Alain Bourbonnais, and Roger Cardinal was entitled *Outsiders: An Art without Precedent or Tradition* (London: Arts Council of Great Britain, 1979).

8. The exhibition "The Cutting Edge," which featured the Rosenack collection of "twentieth-century American folk art," was first shown at the Museum of American Folk Art in New York City from December 6, 1990, to March 10, 1991.

9. The various headlines referenced here appeared in the following newspapers: the *Wall Street Journal,* February 25, 1992; "Sunday Magazine," *Oakland Tribune,* June 30, 1991; and *Newsweek,* December 25, 1989. The "art critics" were cited anonymously in the article from the *Wall Street Journal.* The final statement used here is by John MacGregor, as quoted in the *Oakland Tribune* story, p. 9.

BIBLIOGRAPHY

Blake, William. 1810. "A Vision of the Last Judgement." Quoted in *The Romantic Imagination,* by C. M. Bowra. New York: Oxford University Press, 1961.

———. 1804. "Jerusalem." Quoted in *The Romantic Imagination*, by C. M. Bowra. New York: Oxford University Press, 1961.

Boime, Albert. June 1985. "William Blake's Graphic Imagery and the Industrial Revolution." *Arts Magazine* 59:107–119.

Campbell, Colin. 1987. *The Romantic Ethic and the Spirit of Modern Consumerism*. New York: Basil Blackwell.

Cardinal, Roger. 1972. *Outsider Art*. London: Studio Vista / New York: Praeger Publishers.

———. 1979. "Singular Visions." In *Outsiders: An Art without Precedent or Tradition*. London: Arts Council of Great Britain.

———. 1986. "An Art Without Labels." In *European Outsiders*. New York: Rosa Esman Gallery.

Courtine, Jean-Jacques. 1990. "Raw Bodies." In *Portraits from the Outside,* edited by Simon Carr, Betsey Wells Farber, Sam Farber, Allen S. Weiss. New York: Parsons School of Design Gallery.

Dubuffet, Jean. 1959. "Art Brut." In *Collection de L'Art Brut*. Lausanne: Collection de l'Art Brut, 1976.

———. 1968. "Asphyxiante Culture." In *Asphyxiating Culture and Other Writings*, translated by Carol Volk. New York: Four Walls Eight Windows, 1988.

Farber, Sam. 1990. "Portraits from the Outside: Figurative Expression in Outsider Art." In *Portraits from the Outside,* edited by Simon Carr, Betsey Wells Farber, Sam Farber, Allen S. Weiss. New York: Parsons School of Design Gallery.

Furst, Lilian R. 1976. *Romanticism*. London: Methuen & Company.

Hegel, Georg Wilhelm Friedrich. 1835. "The Philosophy of Fine Art." In *Philosophies of Art and Beauty: Selected Readings in Aesthetics from Plato to Heidegger,* edited by Albert Hofstadter and Richard Kuhns. Chicago: University of Chicago Press, 1976.

Kuspit, Donald. 1986. "Concerning the Spiritual in Contemporary Art." In *The Spiritual in Art: Abstract Painting, 1890–1985*. New York: Abbeville Press / Los Angeles: Los Angeles County Museum of Art.

Maizels, John. 1992. "Letters to the Editor." In *New Art Examiner,* September.

McEvilley, Thomas. 1986. "The Case of Julian Schnabel." In *Julian Schnabel: Paintings, 1975–1986*. London: Whitechapel.

Musgrave, Victor. 1979. "Preface." In *Outsiders: An Art without Precedent or Tradition*. London: Arts Council of Great Britain.

Saint-Simon, Henri de. 1825. "Opinions litteraires, philosophiques et industrielles." Cited in "The Invention of the Avant-Garde," in *The Politics of Vision: Essays on Nineteenth-Century Art and Society,* by Linda Nochlin. New York: Harper & Row, 1989.

Schelling, Friedrich. 1800. "System of Transcendental Idealism." In *Philosophies of Art and Beauty: Selected Readings in Aesthetics from Plato to Heidegger,* edited by Albert Hofstadter and Richard Kuhns. Chicago: University of Chicago Press, 1976.

Shelly, Percy Bysshe. 1821. "A Defence of Poetry." Quoted in Colin Campbell. *The Romantic Ethic and the Spirit of Modern Consumerism*. New York: Basil Blackwell, 1987.

Thévoz, Michel. 1976. "Some Considerations." In *Collection de L'Art Brut*. Lausanne: Collection de L'Art Brut.

Tuchman, Maurice. 1986. "Hidden Meanings in Abstract Art." In *The Spiritual in Art: Abstract Painting, 1890–1985*. New York: Abbeville Press / Los Angeles: Los Angeles County Museum of Art.

Wallis, Brian. 1984. "Introduction." In *Art after Modernism: Rethinking Representation*. New York: New Museum of Contemporary Art and David R. Godine.

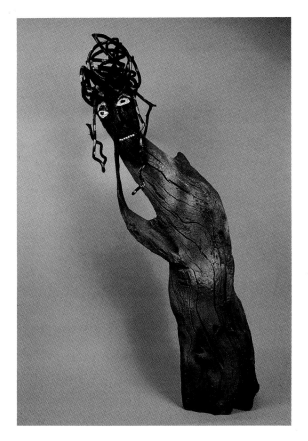

1 Bessie Harvey. *Sha Cha,* 1987, wood and mixed media, 57 in. × 14 in. × 12 in. Wendy Snyder Collection. Courtesy Cavin-Morris, Inc., New York.

2 Frank Jones. Untitled drawing, ca. 1968, color pencil on paper, 25½ in. × 30½ in. Collection of Ivan and Sharon Koota. Photo courtesy Janet Fleisher Gallery, Philadelphia.

3 Adolf Wölfli. *Saint Adolf portant des lunettes,* 1924, color pencil, 20 in. × 27 in. Collection de l'Art Brut, Lausanne, Switzerland.

4 Alois Wey. *Maisons (Houses),* 1977–1978, color pencil and silver and gold paint, 18 in. × 19 in. Collection de l'Art Brut, Lausanne, Switzerland. Photo by Germond.

5 Pierre Avezard's merry-go-round as it appeared in 1985, still at its original site. Wood, metal, found objects, and paint. Photo by Jean Paul Vidal.

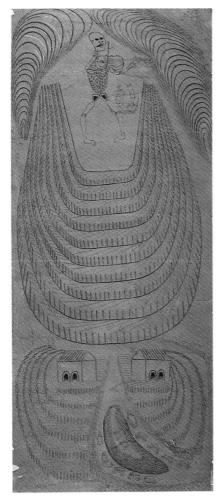

6 Martin Ramírez. Untitled, ca. 1950, pencil and mixed media on paper, 81 in. × 35 in. Courtesy Phyllis Kind Gallery, New York and Chicago.

7 Jahan Maka. *Four Rich Farmers and Two Young Girls Dancing at the Crossroads and the People Living in Between,* 1977, enamel and oil paint on canvas, 36 in. × 60 in. Collection of Joe and Susan Fafard, Regina, Saskatchewan, Canada. Courtesy Dunlop Art Gallery, Regina. Photo by Patricia Holdsworth, Regina.

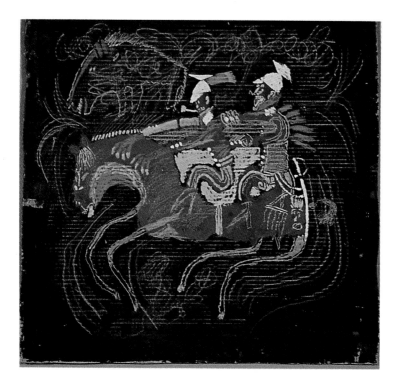

8 Jahan Maka. *Two German Soldiers,* n.d., oil pastel and enamel markers on corrugated cardboard, 27½ in. × 29 in. Private collection, Oxford, Ohio.

9 An assemblage of Raymond Coins's early creations in wood and stone. Late 1970s. Gallery Clinton Lindley, Ltd., Hillsborough, North Carolina.

10 Fritz Opitz. *The Artists' House,* 1983, pen and ink, wash, and body color; 12 in. × 16 in. Artists' House, Gugging Institute. Photo by Leo Navratil.

11 Elijah Pierce. *The Man That Was Born Blind Restored to Sight,* 1938, carved, assembled, and painted wood, height 23¼ in., length 11¹⁵⁄₁₆ in., depth 1⅛ in. Milwaukee Art Museum: The Michael and Julie Hall Collection of American Folk Art. Photo by John Nienhuis.

12 A chair similar to the Li'l Abner chair that Chester Cornett created in the spring of 1965. Maple, red oak, white oak, and white hickory, 55 in. × 36¾ in. wide at seat front. The Kentucky Museum Collection, Western Kentucky University, Bowling Green, Kentucky. Photo courtesy Diane Watkins.

ARTISTS AND THEIR WORK

THE MERRY-GO-ROUND OF PIERRE AVEZARD

A MASTERPIECE OF FRENCH OUTSIDER ART

Laurent Danchin

Translated by Pierre Danchin

I doubt whether the nightingale, having sung in the evening, would say: I have worked. My little watercolors have little to do with work either. They are rather songs, prayers, little tunes in color, that have given pleasure to many people. No more and no less.

—Hans Reichel (1892–1958)

The merry-go-round of Pierre Avezard, or Petit-Pierre, which is now located in France in the park of the Fabuloserie Museum at Dicy, Yonne—about sixty miles from its original site—is one of the most exceptional and moving examples of French Outsider Art.[1] Among folk-art environments, Art Brut gardens, and narrative parks of the *habitants-paysagistes*, it is unique in Europe, if not in the world.[2]

Having played a significant part in the preservation of this exceptional work, I intend to write about it from the point of view of neither an anthropologist nor an art historian, but as a writer who has struggled, on several occasions, to preserve such creations. My purpose is to note what one can learn from this example about Art Brut in general and folk-art environments in particular. For the merry-go-round of Petit-Pierre is also one of the few French environments of this type which has been saved.

For those who have not seen any photographs or motion pictures of the merry-go-round at Dicy, or who have not seen it in operation, let me describe it [Pl.5]. Visible from a distance, because of a wooden "Eiffel Tower" about sixty feet high which rises out of it, the merry-go-round is organized around a small yard. The yard is surrounded by low, flimsy buildings made of wood, wire netting, and corrugated

iron which remind one more of henhouses or garden sheds than actual buildings. Avezard's construction is an automatic machine run by a single electric motor which powers, over a surface of some one thousand square feet, a multitude of painted metal figures: vehicles and animals, roughly cut out of iron sheets, like the silent silhouettes of a shadow play. A miniature spectacle in which everything is on the move and seems to be alive, Avezard's work is characterized by its striking carousels of airplanes, linked to the metal spokes of a huge star, and by the huge horizontal wheel protected by a circular metal roofing which gives the carousel its name. The wheel is a roundabout of hanging figures—carts, cows, tanks, lorries, and rabbits beating drums—all of them on the move and articulated in a primitive way, like old-fashioned toys.

The name "merry-go-round" (which was chosen by the maker, according to an old inscription by him) is misleading and should only be understood as a kind of metaphor. For this is not, properly speaking, a merry-go-round, but rather a kinetic space, a kind of giant *tableau vivant* which the public is invited to enter, not in order to take part physically in the movement of the roundabout, but to see a spectacle developing in all directions—in front, behind, and in the sky above. It forms a kind of general summary of traditional peasant life, mixed with a naive evocation of the most advanced technological inventions of modernism.

Avezard's figures are grouped in small scenes built up under the shelter of appropriate scenery, and they move along all sorts of cables, trails, and rails, or they turn aloft in giddy carousels. These creatures are endlessly varied, and their poetic power is increased by the precarious nature of their motion and the materials of which they are made. As the airplanes turn in the sky, as an elevated train and cable car go back and forth endlessly, as (on his circular route) a cyclist eternally and vainly attempts to overtake a streetcar, we can see horses, trucks, and carts moving forward, hens pecking in a farmyard, and imaginary hay being loaded and unloaded. Combine harvesters, cranes, power shovels, bulldozers come alive. The forest ranger, a figure taller than the surrounding houses, sits at a table to drink a glass of wine. Men eating at home are seen through a window. A few couples are turning around, dancing at a county ball, and as a kind of humorous, slightly nostalgic signature, Avezard himself is represented, dancing alone with his cow.

All these things revolve, roll, walk, or topple in one direction and then another; they open and close to the sound of fairground music, which serves to conceal the squeakings of the mysterious, imaginative machinery as much as to suggest the festive atmosphere of a carnival. Obviously every movement is impelled by a series of mechanical devices, comparatively simple and not really numerous, though exploited here in an extremely varied and ingenious manner.

In the past, when it was at its original site at the farm of La Coinche in the Orléans countryside, the merry-go-round was operated by Avezard, who would start the engine which turned this diminutive world of rusty metal into a marvelous universe [6.1]. To get to this site, one first followed a long footpath, as straight as a

6.1. Pierre Avezard's merry-go-round (detail of original site). Photo by Jean Paul Vidal.

corridor hemmed in between a fence and the wall-like edge of a small wood. Crossing over a bridge, whose warped sheet-metal construction made an infernal noise that announced to Petit-Pierre the coming of visitors, one encountered flowers of painted metal in cement pots and small, slowly revolving wheels which gradually began to replace the natural flora. At last one came to a door of wire netting which led to a small gateway; then one entered the enclosed space of the yard, which appeared, on first impression, to be only a jumbled mass of wire and metal sheets.

Then one heard a noise to the left as an engine was started by Petit-Pierre sitting high at the top of a flight of steps in a kind of pilot's cabin [6.2]. He pulled some levers and, immediately, straps, cylinders, and pulleys began to revolve. Gradually, on all sides, everything began to move to the accompaniment of an old record player that produced the deafening carnival music.

From this single engine, relayed by an infinite number of camshafts, cogs, and bars, there sprang an illusion of activity produced by improbable drives and approximate frictions: Life itself had appeared. Then Avezard—hilarious—from the center of his universe, like a pilot at the helm of his ship, or rather like the driver of an engine, would press other levers to produce a series of gags intended to surprise his visitors: an airplane, turning into a bomber, would drop metal balls onto a metal

6.2. Pierre Avezard at the controls of the merry-go-round. Photo by Jean Paul Vidal.

sheet creating a horrendous noise; the electric cow would lift its tail, as the visitor was bending to read a small inscription, and drench the visitor in water. A final device, near the exit, would again soak those who delayed too long, thus making room for the next group of spectators.

The merry-go-round was devised as an organized circuit, precisely marked with all sorts of diminutive inscriptions written on white metal plates in a fine, round, school-like hand, and sprinkled with misspellings: "P. Avezard cowherd at La Coinche 1935–1958," "The ciren sounding, the planes begin bombing," "Look at the electric cow," "Look carefully at the man drink his glass of wine," "Look at the men eatings" [6.3]. Finally, inscribed on the white metal of a fake clock whose hands, as if gone mad, would turn at full speed: "See time how it passes." When the music of the record player finally stopped, Avezard himself, holding against his ear a kind of homemade metallic zither, gave to his visitors, as a farewell offering, "an air of music before exit."

All of this would be merely anecdotal and deserve no further discussion if it were, like those miniature villages built for the curiosity of the public by a do-it-yourself maker of perfect models, a mere popular entertainment, and if there did not

6.3. Under the big wheel of Avezard's merry-go-round. Photo by Jean Paul Vidal.

exist in the world of Pierre Avezard, through the very awkwardness of his style, a surprising unity, the sure evidence of much else. For far from being pure entertainment, Avezard's work results from a kind of secret obsession; it stands not for a vulgar pastime, but for the labor, the commitment, of a whole life. Above all, there issues from it a very rare quality, an authentic poetry, a deep and true sense of the marvelous, deriving from the close observation of the most trivial things of everyday life, but so far transcending anecdote that it reaches a sort of archetype as a real work of art.

"With self-taught artists, it often happens that their lives and their art become extensions of one another, intermingling and inseparable. There is not a great division between art and life. Something deep-felt wells up within such artists and manifests itself naturally as a song" (Bonesteel, 1988). These words in a catalogue to an exhibition of the drawings of Bill Traylor (1854–1947), a black Outsider Artist whose silhouettes, as if cut out from cloth or cardboard, somewhat evoke the simple art of Pierre Avezard, might just as well be applied to the creator of the merry-go-round, and to nearly all the known authors of folk-art environments.

But this type of reflection might also apply to *all* true artists, for authentic cre-

ators cannot easily be dissociated from their creations, which more or less function both as a projection and as an extension of their mental world and physical body. It is only because the processes mediating between man and work are, in the case of the more cultivated artists, more numerous and complex, that the relation seems, in their case, less direct than in that of less literate artists.

The work of a lifetime, the expression of a particular sensibility, the sum of an experience and a philosophy—the merry-go-round of Pierre Avezard, whose hundreds of figures depend on a simple engine operated by the maker, appears the perfect example of this type of work, as inseparable from its author as the shell of a snail or the web of a spider. It is as if the merry-go-round were a kind of organic extension of its maker: a kind of natural prosthesis, an envelope, a cocoon, or an armor, of which Avezard was at the same time the builder, the inhabitant, and the organizing brain. One needs only to have seen Avezard enter his environment, or rather resume possession of it, immediately detecting all its faults or weak points, then instinctively, with a confident gesture, mending it with the appropriate tool, to realize the almost animal strength of the link uniting him to his machinery. I was lucky enough to have visited Avezard's merry-go-round on several occasions when Avezard personally conducted its operation, and I was immediately struck by the unbelievable intimacy he had with his instrument. But there were several reasons for this, caused by particular details of his life.

Pierre Avezard was born in 1909, at Vienne-en-Val in the Loiret, the second child of a modest family. Avezard's father was a sand carrier, presumably for a brick factory; then he was a gamekeeper. He married rather late and had three children. The oldest, a girl, became a social worker, and the last son, an electrical mechanic, now works in an airplane factory. Pierre was congenitally handicapped, his face being heavily distorted. He could scarcely speak and was almost entirely deaf. With his single good eye and his crumpled ear, he might have looked frightening were it not for the mildness and kindness of his eye.

Indeed, Avezard was a person one might have thought had been created on purpose, to justify Dubuffet's prejudice in favor of the cowherd over the university professor. In the various articles which have been devoted to him, Avezard is usually referred to as deaf and mute. But, as I personally experienced a number of times, it was possible to communicate with him, provided one spoke slowly and loudly enough. Avezard could then mumble explanations which one soon managed to understand.

As a child, Petit-Pierre seems to have scarcely attended school; for, as one of his family told me, "Already at primary school people used to make fun of him." Thus Avezard was soon sent to work on farms which, in those days, were particularly isolated, so that he spent most of his life in the fields. An inscription on his roundabout states that he was a cowherd at La Coinche for twenty-three years, from 1935—when he was twenty-six—to 1958. Avezard was proud to assert that he was given the responsibility of looking after some fifty cows. Later, in the late 1950s,

his occupation changed, and he spent those years helping out, in various ways, on neighboring farms.

There are different stories about the origins of the merry-go-round. But they all refer to the early years at the farm at La Coinche, where, having become a cowherd and having been more kindly treated by his employers than by some former ones, Avezard at last found a kind of stability. An old inscription by him stated that the merry-go-round was "begun in 1937," two years after he had become employed. Other witnesses mention the early 1940s, the period of the war and of the German occupation, when, according to one story, Avezard's imagination was stimulated by his discovery of a plane crashed in a field. The sudden incursion of modern, civilized violence into the peaceful surroundings of the Orléans countryside was thus supposed to have inspired Avezard, in much the same way the Facteur Cheval had been inspired some sixty years earlier to build his obsessive "palace." [3] And soon after, it is said, Avezard began collecting old bits of iron, leather thongs, bits of rubber tires, nails, and cogwheels in order to make his first small articulated figures and devices. Whether this story is a legend created after the event or an authentic happening is hard to know. Yet what is certain is that Avezard's building began not on the small plot of ground on which he was later to build his merry-go-round, but in the cow shed where he used to live, along with other cowherds.

"Because the farmhands never stopped bothering him," Avezard's brother says,

> he fashioned a bed for himself under the main beam of the shed, and in order to stay undisturbed, he would pull up the ladder. He had built a crane and an airplane, which the crane loaded with beetroots. The plane would dart like an arrow to the other side of the shed where it threw a root to each cow. Avezard had also already built the round-about where the figures were located: the rabbit, the tanks, and the carts. Later he built a house for himself, a house made of earth with a corrugated iron roof and an oven. Following that, his employer told him: "I am going to have a house built for you; that way, you will have your own house."

This is how, thanks to the kindness of his employer, Avezard found himself at last free and independent, on a small plot of his own, a short distance from the farmhouse. I remember having seen a small panel on the merry-go-round on which he had written, "I have been here at the house of the roundabout since 1955." It was from this time that Avezard's work, which had been started on a small scale, developed to its final dimension, growing constantly as the years passed. Soon this work became a local curiosity, and people came to look and admire, generally on Sunday afternoons.

It is important to stress the generosity of Avezard's employer, who, by giving Avezard the use of the small plot, was instrumental in the final development of Avezard's work. Pierre's brother also played an important role in Avezard's development. "Each year," his brother told me, "I took him for a trip, and he derived a theme from it. When we came back from Belgium, he built the atomium. I also took him to

Biscarosse; he then built an oil pump. I had worked on the Concorde, so Pierre built one. I had shown him pictures of the Superfrelon helicopter; he made one. And the same for the Mont Blanc cable car. He was remarkably gifted at imitating things he saw."

According to several witnesses, Pierre Avezard possessed an almost photographic visual memory. For example, after observing a drawing of a centrifugal pump, he reproduced one. Together with his brother, as his brother tells it, Avezard "visited everything in Paris," but "it was not necessary to show him anything twice; what he saw was immediately recorded. Then he became impatient and wanted to go home." Indeed, Avezard felt it unpleasant to remain away from his environment for more than a few days, for it was this site that gave shape to his mechanical obsessions. Avezard was inspired by all the achievements of modern technology, whether great or small. For example, the Eiffel Tower he built at the merry-go-round is really too narrow and pointed because it was also influenced by a radio or television tower Avezard saw on one of his trips.

Much literature has been devoted to the link between Art Brut, or Outsider Art, and mental disease, and thus the art of the mentally handicapped is widely understood to be one of the essential sources of Outsider Art. In the case of Pierre Avezard, however, it is a *physical* handicap which has influenced his art. It is as if Avezard's native inventiveness was in some way focused by his handicap. Indeed, this is what the mother superior of the home for the aged where Avezard currently lives, has suggested. "In spite of his somewhat repulsive face," she has said, "he is very intelligent. If he had been able to go 'to the schools,' he would have 'made a genius.'"

Indeed, none of those who have visited the merry-go-round have ever doubted that the creator of this exceptional poetic universe was something of a genius. Nor have they doubted that, handicapped as he was, Avezard was constrained to find alternative ways to express and communicate his inventive impulses. The mere sight of Avezard's small, mute theater makes this obvious. Immured in the silence imposed on him from birth, Avezard had to invent a substitute language; the poet imagined ways to animate shapes, his own way of making them speak.

In the French tradition of Art Brut there is one example which, in a way, reminds one of Avezard—that of Emile Ratier (1894–1984), a peasant from the Lot region. When Ratier became blind at the time of his retirement, he devised a number of roughly hewn wooden machines, activated primarily by noisy pulleys and handles. Although Ratier was also handicapped, and this may help to explain his creation, Ratier's machines have nothing of the complexity of Avezard's construction. Above all, they do not appear to be a monument, a unique work, the poetic sum of an entire existence.[4]

Avezard was doubly marginalized. Not only was he a farmhand, one of the most deprived kinds of French workers, but he was also physically handicapped in a way which made him the butt of his fellows. Thus, from the beginning, Petit-Pierre was,

as a creator, in a more difficult position than Emile Ratier. An outcast among outcasts, Avezard represents the most extreme case of an Outsider.

Folk-art environments are numerous in France and can be divided into various kinds, according to the specific techniques or materials used to create them. Usually made of pieces of porcelain, crockery, or shells, the first type is mainly decorative. An example of this would be the Picassiette house in Chartres, the famous environment created by Raymond Isidore in a mosaic of broken plates. Other examples are the house of broken crockery of Raymond Vasseur at Louviers (Eure), the mosaic garden of Mr. Da Costa at Dives-sur-Mer (Calvados), and the many painted or illustrated houses like the Petit Paris of Marcel Dhièvre at Saint-Dizier (Haute-Marne) and the house of "Mr. G." at Nesles-la-Gilberde (Seine-et-Marne).

One can also find a large number of narrative gardens and sculpture parks like the gardens of Eden built by Camille Vidal and Camille Renault (the first now at La Fabuloserie and the second now long destroyed, although a few vestiges of it are preserved in the Aracine Museum at Neuilly-sur-Marne), as well as the Centaur Garden of Fernand Chatelain at Fyé, in the Sarthe (a site which is also in poor condition since the recent death of its maker).

In this second category one should also consider the more recently documented works, like the Jardin de Gabriel in the Charente-Maritime, the Jardin Zoologique of Emile Taugourdeau at Thorée-les-Pins in the Sarthe, and the many suburban gardens which are decorated by sculptures or various constructions. (One of the most interesting of these, constructed in the late 1940s, was that of Frédéric Seron at Pressoir-Prompt. This astonishing environment no longer exists but it was noted by photographer Robert Doisneau in his memoirs [Doisneau, 1989: 131–32].)[5]

According to Roger Cardinal, narrative gardens and sculpture parks seem rather exceptional in the British Isles, but they are not infrequently found in the United States (Cardinal, 1990, and Rosen, 1979). For example, there is the Old Trapper's Lodge of John Ehn in California, the Concrete Park of Fred Smith in Wisconsin, the garden of John Guidici, and even the Watts Towers. There are also the gardens of Eden like that of S. P. Dinsmoor in Lucas, Kansas, sites that are like oases of a do-it-yourself dream, places of memory and illustrated autobiographies, Noah's arks of the ancestral imagination reduced to diminutive proportions by the expansion of urban, industrial civilization.

When viewed separately, many Art Brut environments, like the sculptured rocks at Rothéneuf or the Village d'Art Préludien of Chomo in the forest of Fontainebleau, appear to be isolated instances, as unique as Cheval's Ideal Palace or Rodia's Watts Towers. But all these examples have one element in common. They are fixed, static—a characteristic linked to their construction techniques. In comparison, the merry-go-round of Pierre Avezard is unparalleled, at least in France, because of its kinetic features and the materials used. Of course, one can find, in all regions of the world,

numerous mechanical inventions which act as weather vanes, shop signs, or rooftops, whose purpose is to enliven the appearance of houses. The airplane, with or without its propeller, is a favorite theme. Similarly, trains, automobiles, tanks, rockets, cranes, lorries, tractors, ships, and the like are frequently found. But such elements usually appear separately or in small numbers at a given site as decoration for the garden, the gate, the mailbox, the roof, or the chimney of the house. Nowhere are they found in such teeming numbers as in Avezard's work, or linked together to constitute a whole universe.

If one wishes to compare, there are fairly frequent examples of artistic mechanical works which aim at simulating motion. Folk-art specialists even tell us that this is a typical characteristic of popular sculpture (Cuisenier, 1987: 251). But once again, never did their makers create so much, and the mechanical aspect usually makes up only a small part of the production. Or they are, like Ratier's machines, only separate pieces, each with its own mechanism, a sort of transposition of a child's toy, built for adults. For example, one might want to consider the "automaboules" (crazy cars) of Monchâtre, absurd machines which wheel about in a mockery of social rules, or even the small animated theaters of Auguste Sallé, discovered and preserved by Alain Bourbonnais. But one of the best comparisons with the work of Avezard is a strange and inspired environment in which motion was part of the creation: a composition of statues made up of glued pebbles and grouped in small scenes, some of which were animated by a motor, which Marcel Landreau, a former railway worker and pastry cook, had placed in the garden of his small house at Mantes-la-Ville near Paris. Now dismantled, this little universe has great poetic force. The most important group, or scene, represented a village wedding: about twenty couples, all made of assembled pebbles and disposed on a long series of steps in front of a large church made of the same material. In front there was a photographer, with his old-fashioned camera, who posed the young married couple. Other scenes included animated groups or individuals worked by remote control, such as a scene of a Fourteenth of July ball, an accordion player, and a hunting scene.

But even in the case of Landreau's work, the movement was very elementary and was added afterward as a sort of supplementary feature in which lifeless figures turned round and round on a turntable or merely moved their arms. Movement was not the chief characteristic, the guiding principle of Landreau's art; its poetry was found in something else, in the colors of the assembled stones and the naively expressive character of the faces of the figures. From a kinetic point of view, Landreau's work was nothing compared to the complex ingenuity of Avezard's roundabout, for the amount of movement involved makes all the difference.

The only other French example comparable with Avezard's was a real roundabout for children built in the 1950s and also recorded by Robert Doisneau. However, the utilitarian purpose of this construction made it different. This roundabout was built by a Monsieur Barre, a very suspicious man who was hostile to photogra-

phers, and it was put up every summer on the Place de la Mairie of the fourteenth *arrondissement* of Paris. "On drawing nearer," Doisneau writes:

> one discovered a crowd of subjects all made up—including the railway engine, the bus, the airplane, or the horse—of salvaged pieces of metal. As in the story of Cinderella, in which the pumpkin is turned into a coach by a good fairy, here it was the metamorphosis of the oilcan or the box of cakes. . . . The Facteur Cheval of fairground art, Monsieur Barre disappeared, his roundabout being sent to the scrap heap. Here is a masterwork which will always be missing in the Musée de l'Art Brut at Lausanne. (Doisneau, 1989: 85)

Of course, it is always possible to track down similarities or kinships, as if creators belonged to various families or sensibilities. For example, in the United States, to my knowledge, there are only two examples which might really compare kinetically with Avezard's: Romano Gabriel's fragile, artificial, animated garden made of wood scavenged from fruit and vegetable crates in Eureka, California, and Clark Coe's kinetic construction in Killingworth, Connecticut. Both environments are now destroyed, and only a few figures from the latter have survived, in particular, the famous "Girl Riding a Pig."

More recent, Avezard's merry-go-round is also more fortunate, having been saved by a museum. But this kind of environment, more fragile and short-lived than masterpieces of statuary or masonry, is usually fated to disappear with its creator. Have there been, here and there, other examples of this interesting type which have left no trace, even in photographs? This is quite possible. Indeed, apart from some literary descriptions, eyewitness accounts, and drawings and engravings, we can know nothing of the constructions which preceded the invention of the cinema (1895) or the camera (1839). However, I do not know if any systematic research has ever been undertaken to discover such early examples.

A masterpiece of marginal creation, or of *art pauvre* in its literal sense, the merry-go-round of Petit-Pierre poses, as do so many other works of this type, a difficult problem of classification, especially in France. Does it belong to Art Naïf, Art Brut, or Art Populaire, three categories which are radically separate in the French tradition? This problem of terminology, pointless in itself, and the solution to which does not alter the value and poetic impact of the merry-go-round, will allow me to show the limits of such categories, which do not readily suffer translation and are the cause of regrettable misunderstandings.

In France, Art Naïf is what belongs, particularly in painting, to the posterity of Douanier Rousseau. Art Brut (an extension of the art of the insane or of mediumistic creations, prison art, and the unusual works of self-taught, isolated artists) only legitimately designates the collection of the painter Jean Dubuffet and is defined by his

preferences. As for Art Populaire, contrary to the wider Anglo-Saxon meaning, in France this term mainly applies to the products of surviving traditional artisan trades or to art such as that in comic strips, aimed at a popular audience.[6]

If such categories appear in most cases relatively clearly defined, in a case like that of Avezard's merry-go-round one is led to wonder, since that kind of work can be seen to belong to all three categories. Thus, the more flexible notion of Outsider Art, used to designate the more individual, surprising, and inventive forms of popular creation, seems particularly apt to a French critic, because it allows him or her to avoid the insoluble problems of borderline cases.[7]

The merry-go-round of Petit-Pierre is undoubtedly *naïf*, because of the ingenuous style of its small figures, the do-it-yourself simplicity of its inventive machinery, and, above all, its narrative style and humor. We are not far, in such a case, from the charmingly fresh world of some authentic naive painters, whose paintings display a condensed version of their daily universe, the delightful modesty of their daily work or of their dreams.

From another point of view, the merry-go-round proves strange and disquieting because of the personality and muteness of its author, who for thirty years literally inhabited his own work, activating it himself and ritually greeting his visitors on his own territory. Thus the merry-go-round transcends ordinary naive art and becomes Art Brut because of its slightly absurd and harsh poetry, its generalized use of scrap materials, and the extreme, quasi-autistic solitude of its creator—in summary, because of the singular and obsessional nature of the whole enterprise. For, as is the case with all the authors of Art Brut, who create first of all because of an inward urge apart from any conscious influence, Avezard made his creation in the absence of any artistic reference outside himself. One would have had to visit the merry-go-round *in situ,* when Avezard was still in charge, in order to perceive, beyond the noisy music which probably aimed at concealing the handicap of silence and creating a festive appearance, a kind of a parody of a fair, a strangeness combined with an anguish caused by the mute figures wheeling round in a closed circuit, by the endlessly repeated motions: the cyclist riding after the bus, the small man coming out of the pigeon house, the endless and purposeless round of life.

As for the reference to folk arts and traditions, in the case of the merry-go-round one does not need to be a specialist to perceive that much is a revival, probably unconscious, of old trades like the making of weather vanes, painted iron signs, clock figures, sheet-metal toys, or even the mechanical targets at fairs in which the impact of a bullet opened a door or window of painted metal to reveal a small naive scene: a pub quarrel, a husband beating his wife, a country ball. This was essentially an art of the silhouette, like those made by artists who cut them out of black cards, an old trade similar to the art of pattern making. All of these processes have in common the same principle of the schematization of shapes and the use of symbols found in Punch and Judy characters or on rough posters or woodcuts.[8]

It would be only through a detailed inquiry about the Avezard family, and about

some of the local customs, that one could find out what Petit-Pierre actually learned from tradition. Did he go to fairs when he was a child? Had he an ancestor who was a maker of shop signs or of ironwork? Discovering this would enable one to find out about the sources of his work, but it would not solve the riddle of his genius. But if the merry-go-round can be linked to folk tradition, it is also for another reason: the social origin of its author and his culture and, above all, the type of public initially attracted to this work, an audience of "good folk" of the region who went with their families on Sunday outings.

It is sometimes asserted that Art Brut or Outsider Art does not care about communication with others.[9] This may be true in the case of the art of the mentally deficient, for Jules Leclerc and Aloïse used to hide their tapestries and drawings because they were afraid that their most intimate treasure might be destroyed or that they might be scorned. But they stopped these practices as soon as they felt truly loved and encouraged.

In the case of Avezard's merry-go-round, however, the social dimension appears essential from the outset and is manifested in two ways: first, through the narrative character of the work, which appears very frequently in folk art even when it is marginal, and, second, through the ritual of its display to the public. For the merry-go-round needed a particular *mise en scène* and Avezard had, for this reason, prepared the entrance to his domain in a highly professional way. He erected panels which told when the shows started, a narrow path with posters to direct visitors, an admission system and exit turnstile, and even a parking place for the many cars and buses which brought hundreds of visitors each Sunday. Like Germain Tessier, the "peintre du Terroir" of Pithiviers, who, in one of the rooms of the hotel he had built himself, organized his own museum, or like Scottie Wilson, who organized shows of his own work, Avezard dealt alone with his visitors for thirty years, and it was due to the spontaneous charisma of his work that over the years, and without advertising, he attracted thousands of spectators.

Since he could not speak to his visitors, with the kind of silent presence of a public employee, Avezard perfectly performed his Sunday mission, even going out after he had moved to the retirement hospital. Avezard worked at his merry-go-round as if he were performing a duty, although since he was himself the creator of his surprising display, he certainly found it gratifying to make it work. One could see his intense satisfaction and the almost paternal distance from which he observed the pleasure of his public.

Doubtless, at least in the beginning, Avezard began like every creator, by being moved and guided by a purely individual urge, and for his own personal satisfaction. "He did all that for himself alone," his brother maintained in a recent conversation. "He does not care about other people. Earlier there was no one there. He would write to us: 'I have done four, or seven, hours of merry-go-round.'" This was the retaliation of the solitary creator, and it reminds one of the strict definition of Art Brut or Outsider Art.

However, having rapidly become a slave to the success of his work, Avezard little by little assumed a true social responsibility. If we take into account the fundamentally ambivalent nature of the relationship of any artist with his or her public, we cannot exclude the social dimension from our examination of the work; nor should we overlook the keen sense of relationship to other people which characterizes the creative process in this case. Must we then conclude that Avezard's construction, and others like it, are no longer Art Brut or Outsider Art? Or must we adjust our definitions and acknowledge that the creators of this art *also* feel the need to reach a public, with the corresponding risks and disappointments, like all true artists?

After seeing many creators of this sort, I am struck by the presence in them of an urge to be recognized as pressing as that, for instance, of a singer or a musician whose relationship with the public is of a very strong, vital nature. If no one turns up to listen, what is there left for the artist? The artist no longer exists, in the strict meaning of the term. Of course, just as a flower is content with simply being, the singer may keep on singing, but the interest of the public—its astonishment, its emotion, its laughter is essential to the artist's recognition. And this is certainly, during all those hours of daily solitude over the weeks, months, and years, one of the fundamental motivations of creators: to anticipate the wonder of the public.

Is then someone like Pierre Avezard an artist? Can we really apply this nomenclature to him? I should like to close by quoting the last words of a small documentary film I made in 1987 with Raphaël Lonné, a mediumistic draughtsman discovered and encouraged by Dubuffet, who had, in his own way, the same ingenuousness and modesty of Petit-Pierre.

"Do you consider yourself an artist?" I had asked Lonné.

"I, an artist? No, an amateur."

"An amateur?"

And he quickly answered, "A creator, not an artist!"

These are nuances in language, but they have their own significance.[10]

NOTES

1. Avezard's merry-go-round was originally located on a very remote site, the farm of La Coinche in the territory of Fay-aux-Loges, a small village next to Jargeau, near Orléans, in the Loiret. After having been active for thirty years and having been seen by thousands of visitors, it ceased to function on August 25, 1985. Two years later, to prevent local vandalism, it was given to the late Alain Bourbonnais, the creator of the Musée de la Fabuloserie. Then it was dismantled, carried away, reconstructed, and repaired during 1988 and 1989, and finally inaugurated at its new site on August 26, 1989.

2. The concept of *habitant-paysagiste* comes from the French landscape architect Bernard Lassus, who, in 1962, founded the Centre de Recherche d'Ambiance (the Ambiance Research Center), which has documented more than one thousand decorated and ornamented gardens from working-class, suburban neighborhoods (Lassus, 1977).

3. In 1879, Ferdinand Cheval, known as "le Facteur Cheval," discovered what he would later refer to as his "pierre d'achoppement" (stumbling block): "It's a chalk stone. Worked by the waters and hardened by the strength of time, it becomes as hard as pebbles. It presents a sculpture as odd as it is impossible for man to imitate; it represents all species of animals, all species of caricatures. I told myself: Since nature wants to make the sculpture, I myself will make the masonry and the architecture." And for the next twenty-seven years, every evening after his work, Cheval toiled to create what was to become the Palais Idéal (Ideal Palace). With more than one hundred thousand visitors every year, the Ideal Palace was, in 1984, the most-visited monument in the Rhône-Alpes region. It was classified as a Monument Historique on September 23, 1969 (Jouve, Prévost, and Prévost, 1981).

4. Ratier's machines, also exhibited at the Fabuloserie, are on display in two other museums: the Collection de l'Art Brut in Lausanne and the Aracine Museum, at Neuilly-sur-Marne, in the Paris suburbs.

5. On all these environments one should consult the *Guide de la France Insolite* (Arz, 1990). It provides the addresses and visiting hours of more than sixty sites open to the public. See also "Environments in France" (1989).

6. On the classic definitions of Art Brut by Jean Dubuffet and the theoretical differences between Art Brut and children's art, naive art, and the art of primitives, see Thévoz (1975) and Danchin (1988: 229–304). As Allen S. Weiss recently stated in correspondence with Michel Thévoz: "It seems to me that the category of Art Brut is quite different in Europe from in the USA, because of the different paradigms which guide research on the two continents. In Europe, Art Brut has been considered mainly according to the category of art discovered in psychiatric hospitals, that is to say, according to a certain notion of 'madness.' In the USA, Art Brut-Outsider Art is usually presented as a sub-category of Folk Art" (Weiss, 1990:20). A notion like that of Outsider Art can escape not only the limits of this dichotomy but also the much-too-restrictive point of view of John MacGregor, who, in his recent works, purely and simply reduces Art Brut to the art of the insane (MacGregor, 1989). His point of view must surely seem unjustified to those who consider the full history of Dubuffet's collection. Even if its core were first derived from researches in mental hospitals, Dubuffet from the beginning wanted Art Brut to come out of the psychiatric ghetto. That is why he exhibited the works of truly insane creators like Aloïse or Wölfli alongside those of outsider, self-taught artists like Miguel Hernandez, Lonné, or Maisonneuve.

7. Since 1978 a new notion, more pliable and less definite than that of Art Brut, has become prevalent in France, to designate the most remarkable folk-art environments as well as the most original outsider creations: *art singulier* (singular art). The origin of this term is the title of an outstanding Paris exhibition, "Les Singuliers de l'Art" (*Les Singuliers de l'Art*, 1978). It is this notion of *art singulier* that would be the more appropriate equivalent in French to the concept of Outsider Art, not of Art Brut, which can seem rigid and restrictive. One should also stress that the notion of Outsider Art was launched by Roger Cardinal as early as 1972, three years before the publication of Michel Thévoz's survey of Art Brut in Geneva (Cardinal, 1972, Thévoz, 1975).

8. On the original site of the merry-go-round at La Coinche, thanks to a system devised to recover rainwater, there existed several pools and a stream of running water, where silhouettes of fake fishermen were fishing. Lined by flowers made of painted metal sheets, in their plastic pots filled with cement, this stream made the wheels of a series of small mills turn.

Hence, according to anthropologist Nadine Beauthéac in a survey of the merry-go-round, Avezard's work has to be related to the "hydraulic surprises" common in the gardening tradition of the sixteenth and seventeenth centuries (Beauthéac and Bouchart, 1982).

9. Such is the case of John MacGregor, who, having again in mind the art of the insane, recently wrote, "Commonly, there is no desire to share these things with anyone, and the images are kept secret, or are hidden" (MacGregor, 1990: 13). This kind of statement, unsuitable for most cases of Outsider Art or "singular art," springs from the prejudice reducing Art Brut to the art of the insane.

10. Since failing health has prevented his returning to his merry-go-round, Petit-Pierre seems to have no more interest in his creation. He found his only joy, in the last years of activity, in the season when he could receive his visitors. During those years a nun working at the place where he is now retired had confided in me: "He feels much better in summertime than in winter. The merry-go-round is everything in his life." A very pious person, Avezard seems to consider the survival of his work as superfluous, and he does not seem to care about what has happened to it since it has been inaugurated at a new site. In his retirement quarters, the only thing Avezard has been curious about is what has happened to his tools. Of the merry-go-round itself, he does not want to hear any more.

BIBLIOGRAPHY

Arz, Claude. 1990. *Guide de la France Insolite*. Paris: Hachette.

Beauthéac, Nadine, and François-Xavier Bouchart. 1982. *Jardins Fantastiques*. Paris: Editions du Moniteur.

Bonesteel, Michael. 1988. "Bill Traylor: Creativity and the Natural Artist." In *Bill Traylor Drawings,* edited by Kenneth C. Burkhart and Gregory G. Knight. Chicago: Chicago Public Library Cultural Center.

Cardinal, Roger. 1972. *Outsider Art*. London: Studio Vista.

———. 1990. "L'Art Brut et l'Angleterre." In *Déviance et Transgression dans la Littérature et les Arts Britanniques*. Bordeaux: Annales du Groupe d'Etudes et de Recherches Britanniques de l'Université de Bordeaux.

Cuisenier, Jean. 1987. *L'Art Populaire en France*. Paris: Arthaud.

Danchin, Laurent. 1988. *Jean Dubuffet*. Paris: Editions La Manufacture.

Doisneau, Robert. 1989. *A L'Imparfait de l'Objectif—Souvenirs et Portraits*. Paris: Pierre Belfond.

"Environments in France." 1989. *Spaces*, no. 10.

Jouve, Jean-Pierre, Claude Prévost, and Clovis Prévost. 1981. *Le Palais Idéal du Facteur Cheval: Quand le Songe Devient la Réalité*. Paris: Editions du Moniteur.

Lassus, Bernard. 1977. *Jardins Imaginaires*. Paris: Presses de la Connaissance.

Les Singuliers de l'Art. 1978. Paris: Musée d'Art Moderne de la Ville de Paris.

MacGregor, John, M. 1989. *The Discovery of the Art of the Insane*. Princeton: Princeton University Press.

————. 1990. "Marginal Outsiders: On the Edge of the Edge." In *Portraits from the Outside,* edited by Simon Carr, Betsey Wells Farber, Sam Farber, and Allen S. Weiss. Dalton, Mass.: Studley Press.

Rosen, Seymour. 1979. *In Celebration of Ourselves.* San Francisco: A California Living Book, published in association with the San Francisco Museum of Modern Art.

Thévoz, Michel. 1975. *L'Art Brut.* Geneva: Skira.

Weiss, Allen, S. 1990. "Art Brut Today: A Correspondence between Michel Thévoz and Allen S. Weiss." In *Portraits from the Outside,* edited by Simon Carr, Betsey Wells Farber, Sam Farber, and Allen S. Weiss. Dalton, Mass.: Studley Press.

7

BOUNDED IN A NUTSHELL

REFLECTIONS ON THE WORK OF MARTIN RAMÍREZ

David Maclagan

Of all the known examples of "psychotic art," the three hundred or so drawings created by Martin Ramírez between his "discovery" by Dr. Tarmo Pasto in about 1950 and his death in 1960 are among the most astonishing and enigmatic examples. It is hard to imagine a greater contrast between the clarity and imposing authority of the images, and the pathetic silence and degradation of their creator. Ramírez suffered a triple excommunication: He was a Mexican living in poverty and exile in the United States; he was a man who had seemingly abandoned speech at the age of thirty (in 1915 or thereabouts); and he was a long-term institutionalized mental patient with a diagnosis of chronic paranoid schizophrenia (his original admission was in 1935). Yet from within these concentric rings of cultural, social, and psychological alienation, there emerges, against all the odds (before Dr. Pasto rescued them, the drawings were swept up and destroyed at the end of each day), a body of works whose visual impact is dramatic and whose aesthetic force is immediately accessible. Their almost shocking power, coming from an artist with a background of such accumulated impotence and withdrawal, reminds me of Rilke's remarks about another psychotic artist, Adolf Wölfli: "It seems that the urge to order, which is the most persistent artistic force, is stimulated by two different interior circumstances: the feeling of excess and the total collapse within a human being, which again results in a state of excess" (Rilke, 1921). What sense are we to make of the fact that such superbly competent images were made by someone so radically removed from normal modes of communication with his fellow humans?

Part of the answer must lie in the whole vexed notion of communication and the problematic way in which it is applied to works of art. That a work of art should

be readily recognizable in representational terms, and that it should be understandable in terms of an established set of symbolic conventions is an idea that may appeal to conservative art historians or to critics who need to pigeonhole meanings, but it is one that has come under increasing suspicion. The whole notion that the artist is obliged to communicate, whether from subjective psychological need, or for the sake of a grudgingly recognized social responsibility, has become something like a ball and chain from which we need to cut loose. It is no coincidence that the label *psychotic art* appears at the same historical moment as major upheavals in the modernist landscape are taking place.[1] In both the psychotic and modernist contexts we find works that elude conventional understanding in their form and their content; but the eccentricity of the psychotic creator is disqualified in advance, whereas that of the avant-garde artist is not. However, this boundary is not impermeable. Just as *psychotic art* shifts from being a clinical, diagnostic label, whereby works created by psychotic patients are supposed to demonstrate their psychological disorder, to a more general descriptive or stylistic term, so the work of avant-garde artists is, in the period between the two world wars, occasionally stigmatized as showing symptoms of some kind of psychopathology.[2]

Hans Prinzhorn's comprehensive study of disordered forms of pictorial expression was the first text to deal with the remarkable convergence of modernist works of art and works created by schizophrenics in terms other than the naive assumption that formal disorder was necessarily or causally linked to mental disorder (Prinzhorn, 1922). Although his analyses of the deviations of psychotic art from representational, ornamental, or symbolic conventions tend to refer to a "configurative urge" that is compulsive and autonomous in its operation, he shows a sophisticated sensitivity to their aesthetic qualities that lifts them out of a merely diagnostic context. Several features of Prinzhorn's approach are still relevant to any discussion of "psychotic art." First of all, he deliberately chose to concentrate on those examples whose content was most obscure, or whose form was least conventional, so that their formal or stylistic characteristics could be more clearly isolated.[3] Second, he made the conventional assumption that a work of art should be intended by its creator to communicate or find some resonance in its audience, and psychotic art was therefore problematic because it allegedly failed to do so. Third, he asserted that the attempt to express pure psychic phenomena without recourse to traditional codes of representation or symbolism—a project that was explicit in some forms of modern art and implicit in schizophrenic art—was doomed to failure because the basis for any communication was lacking. Finally, as a consequence of these assumptions, Prinzhorn was driven to admit that the only reliable means of distinguishing between psychotic and avant-garde art was not on the basis of their formal attributes, but in relation to the circumstances under which they were produced; the schizophrenic created out of a "gruesome and inescapable fate," whereas the modern artist exercised some degree of choice or control.

In Prinzhorn's picture of psychosis, which we have inherited and which forms an

imaginal backdrop to Ramírez's work, there is a double confinement: the outward, institutional segregation and an inner, invisible imprisonment in a private world, a black hole of interiority. The imagery of collapse and implosion reinforces the fantasy either that whatever manages to reach us in the outside world must have been projected, not so much by an effort of the will as by some instinctual and compulsive force, or else that the artist's subjectivity has been driven so far in on itself that it becomes anonymous, no longer recognizable as such. This notion of madness as an involuntary submission to impersonal psychic forces leaves little room for there to be any other motivation behind the psychotic's withdrawal or for the fact that it might, perhaps, contain an element of refusal or ironic deviation. The strategies that someone as extremely alienated as Ramírez might already have resorted to—a mute deference, for example, or an ambiguous noncompetence that served to protect and intensify a hidden spring of resistance—would in effect be given an additional twist as a result of his being an institutionalized psychotic.[4]

As an extension of the traditional association between art and madness, our image of the psychotic artist is of someone who has gone further, and more irrevocably, beyond the bounds of normal communication than any other artist. This issue of communication is usually seen in terms of a willingness or unwillingness on the artist's part to share—hence the enormous resentment aroused by works whose difficulty or lack of explanatory support system makes it seem as though the artist is deliberately withholding something. But if psychotic art has an extra-intense aura of secrecy about it, it is not on account of its isolated situation; it is because the questioning of art's function as a conventional form of communication is found there in a peculiarly undecidable form. Many, if not most, artists are concerned with what lies at the edge of the readily communicable, and their need *not* to be understood— or, at least, not to be caught on the flypaper of the immediately recognizable—is just as important as their need to find some confirmation of their experience in others. If such obvious images as old cliches or stereotypes are used, they are often reframed or resituated so that their original significance is altered. Critical discourse does this explicitly, and a postmodernist style might do it through quotation or parody; but beyond these lies a less well signposted area where the status of such images is more ambiguous: the domain of irony. Irony is the idiom of the disadvantaged, of those who expect to be misunderstood, and in the one-sided perspective of psychiatry it is poignantly vulnerable. If paranoia is a perverse re-reading of the world in flagrantly subjective terms, then it casts an ironic shadow of self-effacement, in which our overlooking of this personal twist is a sort of secret victory for the patient, a triumphant defeat.

When Ramírez parades his heroic horsemen, when he puts figures of women literally on a pedestal (borrowing from both Mexican and North American stereotypes, as the occasional substitution of a collaged advertisement or poster image suggests), we are in no position to decide how far to take these apparent acts of homage at face value. If the animals in his pictures with their stylized poses and

7.1. Martin Ramírez. *El Soldado*, 1954, water color and wax crayon over pencil on machine woven paper, 29 in. × 36 ⅟16 in. Milwaukee Art Museum: The Michael and Julie Hall Collection of American Folk Art. Photo by John Nienhuis.

heraldic stance are as much reminiscent of Walt Disney as they are of Mexican popular art, if they sometimes seem to have a silent dignity or pathos that contrasts with the preoccupations of human beings, there is no way of finally deciphering their enigmatic gaze [7.1]. When a tortoise leads a long procession of cars into a tunnel, or an endless snaking train ends with a dragon-headed engine that seems to gawk at a female figure poised above a cavelike tunnel entrance, there is no clue as to what kind of humor might be at play. To go further: Are the frequent images of locomotives entering or exiting tunnels to be read only as unconscious sexual symbols? If a sultry dark-haired woman's head is collaged over the front of another train that winds its way out a typical Ramírez landscape, is this no more than a symbolic masculine response to an icon of the archetypal feminine? Ramírez's images deserve better than to be corralled into such narrow pens.

But the issue of secrecy or noncommunication strikes deeper than the level at which irony or other forms of disguise or misdirection might operate. At the invisible

core of much creative work, there is something that lies beyond any question of addressing others, and this is especially evident when we deal with forms of inscription other than language. When a musician is inhabited by an entire and simultaneous cross-section of composition, when a theoretical mathematician is possessed by certain topological transformations, when a painter is in the grip of the very field he is creating, there is something obscure at work: a solitary perseverance which we can only describe vaguely as "obsessional" or "antisocial." At all events, it elides the distinction between objective and subjective forms of knowledge on which the conventional notion of communication seems to depend. To say, as Octavio Paz does of Ramírez, that "the very act of drawing or painting is a rupture of autism, a communication, but a communication in code" (Paz, 1989: 20), is to telescope together the essentially solipsistic heart of creation and the fact that the resulting work paradoxically speaks to us, even though it is not necessarily addressed to us.[5] Ramírez's situation, with its dramatic combination of his unspeakable isolation and the imposing presence of his work, confronts us in a peculiarly intense and poignant way with the hiatus between what any work of art says and what it might have been meant to say. Whatever their starting point, whatever the unconscious influences woven into them, these images are a concentrated pictorial reiteration, almost like a visual mantra (in some cases the same motif is reproduced almost point for point), and they establish their own very powerful and specific gravity.

Gravity, with its powerful condensation of time and space, seems an appropriate metaphor for the most remarkable element in Ramírez's work: its extraordinary spatial rhythms. I can imagine tracing his contour lines, each one tautly, hypnotically divergent from the next, as being like treading an invisible tightrope, or like trying to keep upright when walking into a gale. The lines themselves progressively amplify the force, as though each step had to be made in the face of relentless pressure, and the slightest deviation might result in one's being carried away in an overwhelming current. These contours that converge but never quite meet, that dramatically shape space, shrinking and swelling it, are like elements from an atlas of imaginary landforms. The space is "landscape" with its cliffs and valleys, but with Ramírez the "map" does not refer to an external, pre-existent territory; it creates its own internal one. Yet these spatial metaphors refer to real experiences. Their lines both obey and direct expansions and contractions of mental space that are at the edge of a barely imaginable intensity.

Ramírez's pictorial vocabulary is deceptively simple; the imposing theatrical setting of many of his figures actually entails jumping some remarkable gaps. For example, the serried ranks of vertical lines that so often frame the central scene give only the illusion of interlocking with their horizontal counterparts; in fact, they are usually found in a kind of spatial dissonance or syncopation (unlike other drawings of his in which they read consistently, like piano keys) [7.2]. In other settings, such as a landscape, Ramírez simply juxtaposes perspectival discords—rather in the way that Thelonious Monk could bend a note—producing a shocking spatial contradic-

7.2. Martin Ramírez. Untitled (Train), ca. 1950, mixed media on paper, 17 in. × 32 in. Courtesy of Estelle E. Friedman.

tion that is nonetheless totally convincing. At his work's most dramatic, in his canyons and mesas, for example, the swoops and climaxes are spellbinding; sometimes he produces simultaneous ascending and descending visual glissandos, a kind of spatial delirium. These slow-motion explosions of volume have a hypnotic and captivating effect, and I wonder whether Ramírez, like many other visionary artists, was intoxicated by his own creations. After all, didn't Novalis say: "The greatest magician would be he who could so entrance himself that his magic would appear a strange, autonomous phenomenon to him. Could this not be our own situation?" (Novalis, 1989: 79).

From this perspective, the trains that career across Ramírez's landscape have something of the same feel about them: Whether heading straight down the track or winding sinuously around bends, they contribute to a similar sense of leaning into the curvature of space-time. Indeed, the tunnels and the swollen tumuli behind them, and the corridors of vacant space, *call for* these imaginary incursions; but their gravitational pull evokes something far more mysterious than a merely phallic penetration. There is a negative space in his work; the windows that open blankly onto infinite emptiness, the archways that draw us into an unutterable darkness, are like holes in the picture plane itself, absences that counterbalance the staggering volume of the positive forms. It is as though his images are strung between two extremes: the rearing and plunging topography of the overwhelming, the barely manageable excess, and a corresponding sinking into nothingness.

The figures in Ramírez's work can be read iconographically, as male and female emblems in a rhetoric of dominance and submission, as dramatis personae in the

rehearsal of various forms of power and authority, however knowing or ironic this display may be. But the space in which they are set is more radically metaphoric, and it is the most astounding feature of his creative world. That someone driven so far back in on himself should rebound with such force is extraordinary; yet the questions his work raises about the relationship of a work of art to communication, about the solitude at the core of creativity, and about the psychological feedback of pictorial imagery on its author are different only *in degree* from those raised by the work of almost any other artist [Pl. 6].

Whether it was psychosis, or the effects of long-term institutionalization, or some more gradual and obscure retreat on Ramírez's own part, his isolation, like that of many Outsiders, put him effectively beyond the reach of many of the circumstantial distractions of art. His work, stuffed under mattresses, hidden behind radiators, seems to have been created for no ulterior motive. Perhaps a particular extremity and intensity of imagery is only possible under conditions of prolonged concentration or absentmindedness that border on madness. Certainly many artists have what could be called a working relationship with madness: They know the relentless flux of invention that appears in hobbled form as doodling; the leapfrogging fugues of metamorphosis that, tamed, go under the guise of decoration; or the sudden gusts of psychic energy that are called inspiration. They know, even if only in a diluted or temporary form, states of mind that can best be described in the language of possession as trance or rapture; they also know, in crossing these thresholds, the awful seductions and the feeling, at once thrilling and alarming, of being *taken over.* I have worked with patients in psychotic states where this sense of being caught in between two worlds is terrifying, where the sheer condensation of imagery is fearfully fascinating and where the act of creation has something exorcistic or apotropaic about it. Again, Novalis comes to mind: "Madness and conjuring have much in common. A conjuror is an artist in madness" (Novalis, 1989: 79). As with many of his aphorisms, the terms can be exchanged as an extension of the metaphor: The artist conjures madness, the mad person's art is magic. Ramírez's work sits Sphinx-like in a desert of eerie vacancy, and the riddle it poses is beyond reason.

NOTES

1. I have dealt with this at greater length in "Methodical Madness," *Artscribe*, no. 32 (1981): 36–43.

2. Artists as different as Cézanne and Kandinsky were accorded this treatment. The notorious "Entartete Kunst" exhibition of 1937 simply presented a more systematic and comprehensive version of the same prejudices.

3. When a representative sample of five thousand items on which Prinzhorn had based his research was exhibited in 1980, a large number of them turned out to be very direct expressions of personal distress or of political, moral, or religious unorthodoxy ("Die Prinzhorn-

sammlung," in *Die Prinzhorn-sammlung*, ed. Hans Gercke and Inge Jarchov [Königstein/Tau-nus:Athenäum Verlag, 1980]).

4. In Wölfli's case the Waldau asylum can be said to have functioned as a kind of monastic insulation as a result of which he was free to concentrate on his creative work.

5. I have dealt with some aspects of this in "Solitude and Communication: Beyond the Doodle," *Raw Vision*, no. 3 (Summer 1990): 34–39.

BIBLIOGRAPHY

Novalis. 1989. *Pollen and Fragments*. Translated by A. Versluis. Grand Rapids, Mich.: Phanes Press.

Paz, Octavio. 1989. "Arte e Identidad." In *Martin Ramirez: Pintor Mexicano*. Mexico City: Fundacion Cultural Televisa.

Prinzhorn, Hans. 1922. *Bildnerei der Geisteskranken*. Berlin: Springer.

Rilke, Rainer Maria. Letter to Lou-Andreas Salome, September 10, 1921.

8

JAHAN MAKA

SYMBOLIST ON THE
PRECAMBRIAN
SHIELD

Michael D. Hall

The discovery and exhibition of the remarkable art of Jahan Maka simultaneously broadens and complicates recent art history. Maka's work, though uncontestably provocative and beautiful, is, nevertheless, problematic from a critical point of view. The pictures produced by Jahan Maka sharp-focus (better, perhaps, than those of any other contemporary self-taught artist) the problems that indigenous, contemporary, nonacademic art pose for the self-conscious modern and postmodern art community. If Maka and his art are to be taken seriously, old stereotypes about folk art (outsider art, naive art—pick any of the above) must go. Conversely, if Maka and his achievements are denied, modern visual culture is surely the poorer. To understand and appreciate Maka, we must inquire into the layered subjects of motive and meaning in art as well as into the social and aesthetic disposition of the modern temper, the ground that inevitably gives form and context to the art of any modern artist.

The problem of Maka is not new or unprecedented. One need only recall that at the very moment when the Post-Impressionists were celebrating the advent of modernism, a "Sunday painter" named Rousseau was stretching his Sundays out through the entire week to tend a fantasy garden he painted around an Eve who would become both handmaiden and serpent to the modern muse. It was as if modernism required Rousseau to complete itself. His art was conscripted to serve as the raw counterweight in a balance progressively tilting to the urbane, the sophisticated, and, above all, the new. The primitive became a leaven in all the recipes of the writers, artists, and thinkers who invented modern artistic fare. Rousseau's paintings found their first audience in the salon of the Société des Artistes Indépendants founded by Paul Signac. Robert Delaunay became an avid Rousseau collector early, as did many

other modern painters, notably, Kandinsky, Vuillard, Max Weber, and Picasso. The Douanier's work was celebrated in verse by poets Alfred Jarry and Stéphane Mallarmé and championed by such pioneer dealers as Paul Guillaume, Wilhelm Uhde, and Alfred Stieglitz. At his death, Rousseau's epitaph was penned by none other than Apollinaire and chiseled into immortality on his headstone by Constantin Brancusi.[1]

So, to Maka—Lithuanian immigrant, itinerant laborer, hard rock miner, painter—the dazzling irritant in us and among us, but not yet of us [8.1]. As in the case of Rousseau, Maka's talent was first recognized by the avant-garde art world. Trained curators and arts administrators awarded him his first award in a juried show. Leading contemporary Canadian painters became his first patrons. Galleries showcasing the cut and thrust of new art first offered his work to the public in both Winnipeg and Regina. The search for answers to the question "Why Maka?" begins with a look at his biography but quickly moves into broader speculations on the what and why of art today.

Maka was born in Lithuania in 1900. Through most of his youth, he lived on a farm in the small village of Svedasai. Around him he saw his country torn by war and conquest. Russians, Germans, and Poles alternately invaded and occupied his homeland. Dual impressions of a turbulent military history and a pastoral peasant life became indelibly imprinted on his imagination. In 1927, he left his farm and emigrated to Canada. He traveled and worked at various labor jobs through the western provinces for some thirteen years before settling in Manitoba in 1940. There he worked underground as a miner for over two decades, retiring in 1965 and taking up painting three years later. Maka made his home in Flin Flon, a small village situated on the vast fan-shaped Canadian Precambrian shield, a tundra-and-forest formation that covers most of central and western Canada. He died in 1987 after a somewhat prolonged illness.[2] Ironically, in Flin Flon, Maka rooted himself on the same 55th parallel of north latitude that cuts through the region of the great eastern European plain that had been his boyhood home.

Transplanted from one land of extremes and contrasts to another, Maka maintained some vital continuity in his life. It is tempting to speculate that the commonality of the topological, climatic, and geographic features surrounding his two homes on the same parallel was part of that continuity. Demonstrably, his stubborn retention of his Lithuanian heritage was. Through all his years as a Canadian, he sought out living situations that kept him in contact with other Lithuanian immigrants. He followed current events by reading newspapers printed in Lithuanian, and he resisted the process of acculturation at many junctures. When he took up painting, a life that was half a world and half a century behind him poignantly informed and inflected the pictorial images he would create.

Yet, were Maka's paintings merely nostalgic evocations of Lithuanian history and folk life, it is doubtful that they would have attracted their current following. This essay seeks to focus on the transcendent nature of this art and to discover the

the way art affects perception, especially in relation to the unconscious. A modern consensus finds the "primitive" symbolism in Chagall somehow compelling and durable. In our orientation, Chagall's symbolism is perceived as "the result of a natural, almost involuntary transfer that takes place between reality and imagination; that is, the realistic meaning of what he is painting acquires a transfigured and imaginative meaning."[7]

Jahan Maka now enters our art history as yet another balky eastern European symbolist who, in his best works, creates a visual poetry both imaginative in form and layered in meaning. Because his images are compelling, they cry out for a critical assessment. Such an undertaking, however, demands far more than the a priori application of the romantic-mythic folk- and outsider-art rhetoric that has formed the critical bias on Maka to date. Maka, for me, is a painter whose art revitalizes many of the ideas of the early Symbolists and reintroduces them (with a certain authority) into a contemporary art dialogue. As with Rousseau and Chagall, we seek to understand Maka's place in our cultural container.

Information on the development of Maka's work is a bit sketchy. Oral testimony establishes that he first began to draw and paint sometime about 1968. Not until ten years later, however, did anyone really begin to notice the artist and his work. Even then, patronage was sporadic, and very few works are known from the period 1968 to 1980. The few extant documented examples are typically simple and general in character. The artist that had lain dormant in Jahan Maka for over sixty years had not emerged full-blown. Just the opposite. The artist, Maka, developed through stages fully consistent with those Rudolf Arnheim and others have described as the stages that children pass through as their minds and perceptions mature to shape their efforts at pictorial representation. I hasten to point out that by citing Arnheim's work, I by no means suggest (as is often suggested in typical assumptions about "folk" artists) that an artist like Maka is in reality merely some kind of a late-blooming child. Rather I would assess Maka's art using Arnheim's conclusion that, in the realm of human perception, vision as experience "does not start from particulars, which are secondarily processed into abstraction by the intellect, but from generalities."[8]

Through Arnheim, we can properly account for the fact that the drawings from Maka's early sketchbooks are filled with marks that are more or less the generalized representations produced by all people first attempting to impart concepts and mental schemas to plastic form. Struggling to find images that would adequately represent his ideas, Maka produced an early body of work in which figures and animals (generally rendered frontally or in profile) are drawn on blank page grounds that are largely undifferentiated and noninformational [8.3]. Occasionally he injected a flattened image of an architectural structure, a tree, or a simple horizon line into a drawing as a background reference for his foreground figures. But there is little in these early works that anticipates the complex formal and expressive synthesis of symbols and images that Maka would achieve in his late mature style.

8.3. Jahan Maka. *Flin Flon Mayor,* n.d., wax crayon and ballpoint pen on paper, 12 in. × 10 in. Collection of the author. Photo by Patricia Holdsworth, Regina, Saskatchewan, Canada.

Middle-period Maka is transitional. The work from the early 1980s exhibits a certain restlessness. Pictures become more patterned. Scale shifts occur between various passages of the same composition. Backgrounds become active, often vying with foreground figures for our visual attention. Most important, it is in the middle period that Maka begins to build his pictures from multiple perspectives, including the aerial bird's-eye view. His visual schemes are no longer constructed from a conven-

tional orientation to the top and bottom of a page. Unhampered by gravity, his figures tumble and turn in a space newly informed by the interiorization of the artist's life and art experience. We can almost imagine Maka rotating the page on the work table before him in such a manner as to make what was once a side the bottom and then turning it again to make yet another bottom of that which was originally the top. His images begin to fan through his compositions, and his palette begins to become dense and rich [Pl. 7]. Increasingly attracted to interior images, Maka engages in the production of symbolic rather than "realistic" representations. In his middle period, he begins to creatively harness a new reaction growing within him—the reaction Jean Piaget, in a discussion of the transformation of imitation, calls the "deferred imitation of an absent model." [9] In so doing, Maka charts a course that will lead him, in the manner of the historic Symbolists, to focus his art on the evocation of absent realities.

The full synthesis of Maka's art came late. His most original and moving works were produced in the last three years of his life. All that he had lived and painted somehow came together and was poured across the surfaces of what I will describe as the "black pictures." These works were all rendered in chalk, crayon, and paint on large sheets of dark brown or black mat board. Though Maka may have worked on black paper as early as 1982, it was not until 1984 or 1985 that the large-format black paintings adequately expressed his epic symbolic vision. Against black and dark brown, Maka's vigorous marks in blue, yellow, and cream take on higher expressive intensity. On black, his rust reds and crimson purples pulse with mystery. In the black pictures, the artist achieved a condition of drama that seems to have suited his charged sense of memory and his distilled sense of the way simple anecdotes and complex myths intertwine.

The black pictures are remarkable because they are so realized. They are devoid of the fumbling that often distracts us in Maka's early representative and narrative works. They are clear and intense because they are products of a fully integrated consciousness in which thought and memory are one and in which imaged representation acquires a life of its own [8.4]. The black pictures are reflexive because they are the focus of Maka's complete psychic process—a process in which "there is a continual and continuous coming and going from the unconscious to consciousness." [10]

One of the most fascinating and yet troubling aspects of this coming and going has to do with the figurative and historic details that appear threaded through the deceptively abstract layers of line and color that give late Maka works their graphic impact. Soldiers that were only stick figures in earlier drawings begin to sport highly specific regimental insignias on their helmets and uniforms. Tanks and airplanes are suddenly marked with brigade and squadron emblems specific to the various military units that warred across Lithuania during Maka's youth. The accuracy and realism of this detail bring an informational component to Maka's late work that was largely absent in his earlier drawings.

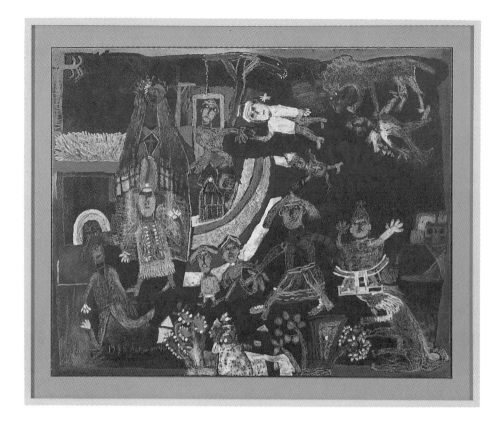

8.4. Jahan Maka. *The Pope,* 1985, oil pastel, acrylic, and enamel markers on canvas, 24 in. × 30¼ in. Collection of Joe and Susan Fafard, Regina, Saskatchewan, Canada. Courtesy Dunlop Art Gallery, Regina. Photo by Patricia Holdsworth, Regina.

It is in the late drawings that images of the Death's Head hussars first appear. The elite members of this crack Austro-German cavalry unit rode into battle wearing helmets distinctively marked with the image of a white skull. In other works, Maka identifies similarly colorful Prussian, Polish, and Russian fighting units. German foot guards sport helmets topped with a single spike, whereas lifeguards wear headgear crowned with the imperial eagle. Russian air squadrons fly the St. Andrew's cross, and Polish uhlans are recognized by their square-topped hats and by the pennons flying from their lances. The details of dress and the armorial insignias in the late drawings transform works that otherwise could be described as abstract pictorial musings into detailed social documents understandable, perhaps, only to students of history—particularly military history.[11]

One picture especially demonstrates this change [Pl. 8]. The piece is ostensibly a depiction of two soldiers riding tandem on a gaunt and overburdened war horse. Figures riding double are common in all of Maka's work. In the artist's early picto-

graphic style, however, this representation simply involved two generic human forms perched atop a generic horse form. There is much more in the late picture examined here. The inspection of a knowledgeable authority establishes that this drawing actually documents two German cavalry officers fleeing a battlefield. The figure in the saddle (as shown by the stripes on his uniform and the insignias on his hat) is low ranking. The man mounted up behind him is a senior officer who, having been un-horsed, is being taken from the field to be fitted with a new mount for the next charge.[12] How is it that Maka could recount such detail in works conjured up from a memory reaching back sixty years? Does the aging artist suddenly reveal himself to be one of those rare individuals possessing total visual recall? Or do pictures like the aforementioned argue that something new from an external source has imposed itself on the form and style of Maka's late work?

Research suggests that Maka's world changed significantly in the last several years of his life. His art, as a consequence, changed, too. In his last years Maka opened his work to the participation of others who to some extent re-formed and redirected the imagery in his drawings. As Maka became known to galleries and collectors, many in Flin Flon began to come around to watch him work. The Lithuanians in particular came together in Maka's home to share their memories of the past as the artist drew. Some, it seems, even picked up chalks and pencils and marked into the drawings. The drawings became communal productions generated (as one researcher noted) "around the table" as Maka and his friends reminisced, told stories, and drank.[13] The ethnic and historic content of the late works became amplified as a direct consequence of this collaboration. The input of others seems to have also challenged and enriched Maka's formal vocabulary, particularly his use of color.

It was not only Maka's Lithuanian peers who marked the black pictures. Several junior members of the Flin Flon community brought distinctive new energy to Maka's production. Foremost among these was Maka's godson Tony Allison, a young man who had studied art in school and who, more important, had a particular passion for European military lore. Thrilled by the stories he heard from Maka and the Flin Flon elders, Allison became a close friend to the artist and then became one of the original boosters who brought Maka's art to the collector communities of Winnipeg and Regina. The fact that Allison had an art background and also owned a collection of military memorabilia strongly suggests that he might have been the author of the precisely rendered sword hilts, epaulets, and helmets seen in the black pictures.[14] In this scenario, these details, then, did not come from Maka's memory but rather from the observations of someone with access to a resource of artifacts and texts that would bring specificity to the stories told by a group of aging immigrants pictorially reminiscing about a distant world.

Another of Maka's "helpers" was Maggie Lenderbeck, a young Native American woman who became a friend of the elderly Maka and who (by her own account) spent a great deal of time visiting with the artist and assisting him with his cooking and housekeeping. Lenderbeck states that frequently Maka would instruct her to

"color in" some of the flat background areas in his works. With broad strokes and sometimes with textured hatching she did as he bid, but she insists that Maka always told her what colors to use.[15] As to whether she and other collaborators interposed themselves in more creative and improvisational ways, we can only speculate. What is known, however, is that several (perhaps many) hands were at work giving a charged character to the marks and images in late Maka drawings. It is also clear that efforts to separate out the various marks in the works, and then to assign them to this hand or that, is almost impossible—and probably not important.

The late works became communal activities, transported from the realm of private recollection into a collaborative condition in which numerous individuals collaged their memories and aesthetic impulses into a body of shared visual narratives. Late Maka drawings, in the tradition of friendship quilts, became social documents as well as original works of art. Consequently, they moved from the world of aesthetics into the worlds of ethnography and material culture, where art becomes one with lore and artifacts. As things suspended between art and social science, late Maka drawings bring into question many of the beliefs that collectors, connoisseurs, and folklorists hold dear on the subject of art.

The fact that Maka and his art are problematic becomes clear when only a few obvious questions are asked. Is a Maka drawing real art, or merely a charming memory picture born of the therapeutic needs of an old man with time on his hands? If Maka was an artist, was his art rendered "impure" when his friends and admirers became a part of its making? What about artistic integrity? Was Maka, the outsider artist, compromised when he exchanged his role as a private image maker for that of a public catalyst bringing a community together to celebrate and salvage a folk history? Does the discovery of Maka enrich culture or does it simply fuel the folk-art myth that moderns have formulated to combat the neurasthenia they suffer living in the modern world? Finally, is the story of Jahan Maka less a story about art than it is a witness to the dishonesty and destructiveness of a greed-driven art market? The questions go on. In the end, they may perhaps be best addressed with the speculation that the Maka saga was only an instance of serendipity but one that has ironically inched a modern art world toward a recognition of the shortcomings and weaknesses of some of its most sacred stereotypes, including its definition of the thing it calls "art."

Maka's work doesn't fit the tidy categorizing schemes that distinguish between fine art, outsider art, and folk art. The community and tradition alive in the drawings seem to disqualify them from a fine-art paradigm in which only labors of alienated individuals following a personal muse can be called art. No one, however, ever suggested that the socially oriented murals produced by trained artists collaborating with apprentices are less than art. If outsider art is only that produced by psychotics and sociopaths, then Maka's work fails yet another test. Still, the obsessive "look" of the drawings seems oddly compatible with the most private visionary gestures made by so-called outsiders. Finally, given the bold originality of Maka's mark mak-

ing, it is easy to argue that it in no way fits a folk-art model, in which only gestures generated in tradition and then conventionalized over time by makers sharing a homogeneous and continuous culture can be called "folk." Yet the ethnicity in Maka's art is that of a durable (no matter how translocated) folk society, and the transgenerational collaboration that helped shape the late drawings speaks from, and answers back to, the traditions and history of a vital and self-aware folk community. Maka's art, in the end, is curiously synthetic. Its form derives from a highly individual and innovative imagination; its content derives from a rich and persistent communal experience. Maka's art forces the idea of art back to its latency. It forces us to look beyond the contemporary art world and beyond the world of folklore studies to a prehistoric time when art, storytelling, and artifacts were all made one on the walls of the caves of southern France.

In the late works, Maka filled black voids with charged and brilliant colors. He discovered (in a process that enfolded the inspirations and marks of his collaborators) the power that colors and symbols can bring to the art of visual storytelling. In a 1985 work entitled *German Soldiers watch as an Officer shots Rut's goats and sheepdog. Rut runs away to join the Sumski Hussars,* Maka ostensibly narrates a story from his past [8.5]. Visually, however, we have another story. Figures, wagons, houses, and plant forms dance across the page. Layered over them, two soldiers (one with a drawn pistol) and a pair of snarling beasts alternately take center stage. The soldiers in imperial military regalia, the leaping jackal-cat, and the ruffed lion-horse symbolize the brutal, depersonalized, and fearsome forces that war unleashes on the land. Order breaks down; Maka's background depicts both man and nature caught up in a maelstrom. Maka's apocalypse is as evocative as Rousseau's great *War* and in many ways stands comparisons to Picasso's fearsome *Guernica*. Through the power and persuasion of its colors and symbols, the story of *Rut* grips our senses.

Maka came from a culture that retained much of its tradition through the repeated telling of stories and the recounting of myths. Thus, it is reasonable that his mature art would draw on the storyteller's ability to build images through both symbolic and metaphoric means. The artist Tony Allison, who often brought Maka paints and other supplies, recalls that Maka once badgered him to bring him "the color of air." [16] Maka's need to find and use the color of air signals his desire to find tangible ways of representing the unseeable and the intangible; in short, it bears witness to the symbolist turn of his artistic mind. Whether he was depicting events from Canada's present or Lithuania's past, Maka distilled and amalgamated incidents and stories into symbolic pictorial structures. [17]

As a symbolist, Maka fits into a fine arts lineage. Historic Symbolism emerged from the same ferment that led Freud to advance his theories on dreams and the workings of the unconscious. As Freud turned his attention to the problem of the human psyche, many late-nineteenth-century artists had already attempted to understand the role of the subconscious as a determinant in art making. Clustered around Paul Gauguin, a group of painters identifying themselves as the Symbolists began to

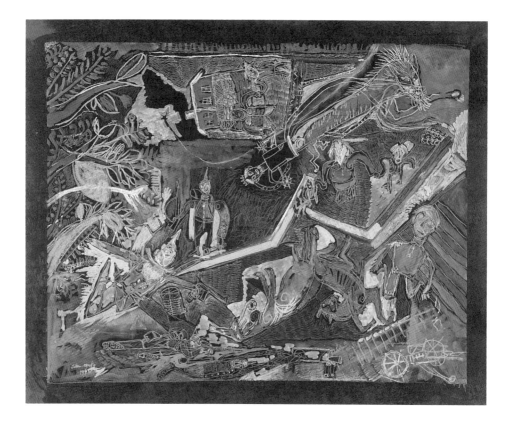

8.5. Jahan Maka. *German Soldiers watch as an Officer shots Rut's goats and sheepdog. Rut runs away to join the Sumski Hussars "Svedessus 1914,"* ca. 1985, chalk, color pencil, and metallic markers on mat board, 32 in. × 45 in. Private collection, Regina, Saskatchewan, Canada. Courtesy Dunlop Art Gallery, Regina. Photo by Patricia Holdsworth, Regina.

formulate an aesthetic in which "the work of art is not expressive but representative, a correlative *for* feeling and not an expression *of* feeling." [18] This Symbolist idea was originally propounded in literary circles, but Gauguin and his followers quickly adapted it to the visual arts. They argued that "the observer is not so much expected to have a purely visual response to the painting, but is rather required to piece together from the evidence available some not entirely obvious narrative." [19] Gauguin particularly concerned himself with the evocative and symbolic power of color. Articulating the philosophical idealism of 1886, the Symbolist poet Gustav Kahn stated, "Our art's essential aim is to objectify the subjective (the exteriorization of the idea), instead of subjectifying the objective (nature seen through a temperament)." [20] With this goal, the Symbolist painters set their concerns quite apart from those of other artists in the period, especially those of the Impressionists.

Early Symbolist theory subsequently found indirect support in the writings of

numerous psychologists who came after Freud. Carl Jung held that symbols and symbolisms were general in nature, and he sought to associate them with primitive language and thought. Jung's fascination with the primitive and the mythic in the early twentieth century was, in many ways, not unlike that of Gauguin in the late nineteenth. In the 1930s and 1940s, Jung's Swiss countryman, Jean Piaget, gathered what he believed to be scientifically supportable information on the role of symbols in human psychology. Systematically studying the development of thought and behavior in children, Piaget concluded that "the 'condensation' of the symbol . . . expresses the assimilation of situations and is thus a kind of generalisation. Just as there can be no generalisation without abstraction, so in the symbol there cannot be condensation without displacement, since in the realm of images and affective assimilations displacement corresponds to abstraction in the realm of thought." [21] Piaget's studies ratified what the early Symbolist writers and painters had intuited, namely, that symbols as condensations of experience are general rather than specific. His findings suggested (by extension) that an artist incorporating symbols in an image had already assimilated and displaced some experience and thus might well be creating the "correlative for feeling" that was the Symbolist ideal.

Why is it important to discuss Maka as a symbolist? The question is well asked. Certainly it would be easier to place him in the contemporary outsider container and brand him visionary or naive. It is a thoroughly modern habit for us to regard marginalized artists as a breed unto themselves and to wrap their art with an affection that disguises the arrogance of the intellectual elite that first created the myth of the primitive. The modernist myth of primitivism should by now be understood as an ongoing exercise in intellectual imperialism. Reacting against the problems of their technological world, modernists "discovered" an unspoiled and manageable world in the cultures of peoples they labeled as primitive, ethnic, or folk. They also found their lost Eden in the thought and behavior they attributed to those believed to be uninhibited by (or cut off from) culture—children, the insane, and prisoners. Subsequently, they boxed all the artistic gestures of these groups in a single container of acclaim that became modernism's dream of the primitive.

Out of needs and fears, we moderns have given ourselves a way to use, commercialize, and, ironically, dismiss the art produced by the "others" we find in the world. We consume it as an escape from (rather than a road to) our own art. *Primitive* has become our present synonym for fresh, honest, spontaneous, and authentic in a rubric system where *sophisticated* or even *modern* has come to connote soiled, corrupt, inhibited, slick, or perverted. Maka fits our primitivist model perfectly. As an ethnic, a peasant, and an unschooled provincial, he is the ideal outsider. His art can be (and has been) described as coming "straight from the heart." [22] His creativity can be discussed as raw expressivity, and his pictures can be intellectually coddled to death by a public that needs them primarily as signs that the "simple" and "honest" does still exist in some art today, as signs that art is not all a product of the strategies and schemes of New York charlatans and promoters.

How limiting! Maka and his art deserve more. Though we could accept the fact that the symbolism in Maka probably developed autogenously, it is still present—realized and powerful. Though Maka most likely had no knowledge of Gauguin and the other historic Symbolists, it is still germane and challenging to discuss the color and symbols in his work in terms of the ideas and images the Symbolists brought to an understanding of art that is still provocative today. Jahan Maka discussed seriously as a symbolist changes the current dialogue on primitives, outsiders, and self-taught artists. Maka as a symbolist drives a wedge into an art history that serves several vested systems of power and control. Maka's thoroughly symbolist work attacks the sloppy and patronizing arguments that all too often force the creative gestures of marginalized artists to reside forever outside the aesthetic and intellectual center we call the mainstream.

For proof that a powerful and original symbolism informs Maka's art we need only examine the war horse images in his pictures. These images are symbolic by every definition Piaget ever formulated. In drawing after drawing, war horses emerge as the visual condensations that become the abstractions, or "displacements," associated with symbolic imagery. Inquiring into Maka's art, one finds three different war horse symbols.[23] All three stand in marked contrast to the farm horse representations found there also. Maka's farm horses seem to have almost no symbolic import. Along with cows and chickens they seem to simply make up the domestic barnyard menagerie that the artist uses to portray Lithuanian peasant life. But the war horses are something else. They are decidedly horses of a different color.

Of the three war horse symbols that can be found in Maka's work, the most prevalent (and perhaps the most powerful) is the assertive, or lunging, horse [8.6]. This form is Maka's symbol for mechanized war. The lunging horse charges with its head down, straining at its reins at a full gallop. The form of the lunging horse is usually overlaid with the shape of an equally menacing rider armed with a lance or a machine gun. Man and beast meld into one. The lunging horse as war machine (or siege engine) is Maka's correlative for uncaring, uncontrollable destruction, the fury of war unleashed on the land. Like the horse in Rousseau's *War*, Maka's lunging horse is an angel of death.

Maka's second war horse symbol takes the form of a belligerent, or balking, horse [8.7]. This horse with its outstretched forelegs refuses the urgings of its rider and halts itself in its own tracks. The balking horse as a base, dumb animal becomes Maka's condensation of all things disrupted and thwarted. The balking horse is the stolid, unmanageable brute mind that strips war of conscience and thought. Maka's last horse, curiously like the horse in Picasso's *Guernica*, is the dying horse [8.8]. Rearing and plunging with feet thrashing, the dying horse is the symbol of fear and horror. The dying horse is a grotesque and distorted thing—a victim and a scream. The dying horse objectifies Maka's subjective experience of dread, terror, and loss. It distills one artist's personal experience of war and becomes a symbol for a harmony of life irreparably broken and coldly discarded.

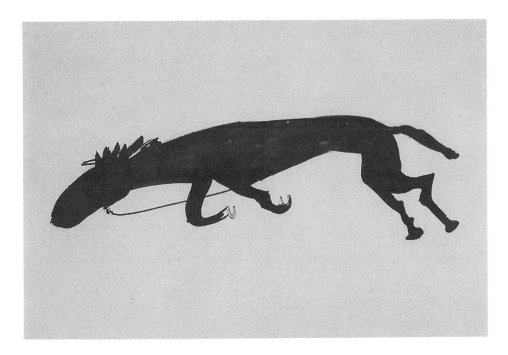

8.6. Symbol: The lunging horse (composite image). Illustration by the author.

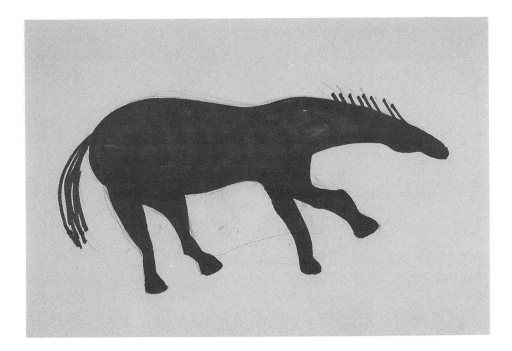

8.7. Symbol: The balking horse (composite image). Illustration by the author.

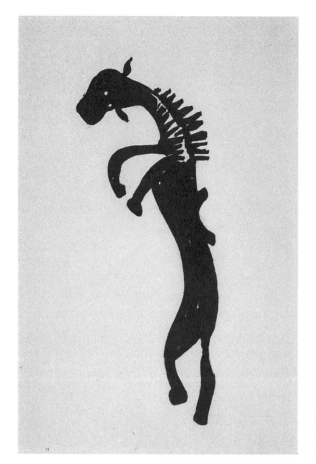

8.8. Symbol: The dying horse (composite image). Illustration by the author.

To place Maka inside rather than outside our cultural container is the only cogent way to discuss him as an artist, for art and aesthetics themselves are sociocultural constructs. Only by stripping Maka of the outsider handicap and releasing him from the primitivist box (a box only pretending at this point to be a container) can we usefully compare his work to that of Chagall, Picasso, or even the premier "outsider" symbolist, Henri Rousseau. Such comparisons force us to accept Maka's art on its own terms—terms perhaps not clear until the work is given a critical base that accepts rather than withholds. The acceptance of any art is an active engagement in which a culture grapples intellectually, visually, and spiritually with whatever the artists in its midst create. Maka's best works challenge us to grapple with many things. Maka as an outsider offers little that enriches our art culture, but Maka in the mainstream becomes a bright Aurora flashing above the town of Flin Flon and far beyond the forests and tundra of Canada's great Precambrian shield.

ACKNOWLEDGMENT

This essay is adapted from an essay that originally appeared in *Jahan Maka: Retrospective* (Regina, Saskatchewan, Canada: Dunlop Art Gallery, 1988).

NOTES

1. See Carolyn Lanchner and William Rubin, eds., *Henri Rousseau* (New York: Museum of Modern Art, 1984).

2. See Helen Marzolf, ed., *Jahan Maka: Retrospective* (Regina, Saskatchewan, Canada: Dunlop Art Gallery, 1988), pp. 17–19.

3. Donald Kuspit, "Suffer the Little Children To Come Unto Me: Twentieth-Century Folk Art," in Russell Bowman, ed., *American Folk Art: The Herbert Waide Hemphill, Jr., Collection* (Milwaukee: Milwaukee Art Museum, 1981), p. 44.

4. James Johnson Sweeney, *Marc Chagall* (New York: Simon & Schuster, 1946), p. 7.

5. Ibid., p. 7.

6. Cathy Schaffter, "Flin Flonner Mines His Talents," *Winnipeg Tribune,* June 6, 1978, p. 45.

7. Andre Pieyre de Mandiargues, *Chagall* (New York: Leon Amiel, 1974), p. 97.

8. Rudolf Arnheim, *Art and Visual Perception: A Psychology of the Creative Eye* (Berkeley and Los Angeles: University of California Press, 1957), p. 130.

9. Jean Piaget, *Dreams and Imitation in Childhood*, trans. C. Gattegno and F. M. Hodgson (New York: W. W. Norton and Co., 1962), p. 67.

10. Ibid., p. 172.

11. An interview by the author with Professor George Stein, Oxford, Ohio, May 1991. Stein currently teaches political science at the Air War College at Maxwell Air Force Base, Alabama. At the time of the interview, he spent three hours reviewing almost one hundred slides of Maka's work. His inspections revealed many specific details incorporated into the drawings, and his conclusion was that there is, indeed, a complex and accurate history woven through Maka's visual narratives.

12. Ibid.

13. Helen Marzolf, director, Dunlop Art Gallery, Regina, in conversation with the author, spring 1992. Marzolf has written the only biographical information published to date on Jahan Maka. Her field research in Flin Flon brought to light much information on the collaborative aspect of Maka's late work.

14. David Thauberger, artist and collector, in conversation with the author, Regina, Canada, spring 1992. Thauberger had occasion to speak with Tony Allison several times during the Maka exhibition in Regina in 1989. These conversations established Allison's interest in (and familiarity with) military memorabilia.

15. Susan Whitney, director of an art gallery that exhibits the work of contemporary Canadian artists (including Jahan Maka), in conversation with the author, at the Susan Whitney Gallery, Regina, Canada, spring 1992. Whitney spent some time in Flin Flon during 1992 discussing Maka and his work with Maggie Lenderbeck. In the course of these encounters Lenderbeck described her participation in the drawings and indicated (when shown photos of various late works) the marks that had come from her own hand.

16. Tony Allison to Helen Marzolf, assistant curator, Dunlop Art Gallery, Regina, Saskatchewan, Canada, August 1988.

17. Ibid.

18. Herbert Read, *A Concise History of Modern Painting* (New York: Praeger Publishers, 1975), p. 46.

19. Maly and Dietfried Gerhardus, *Symbolism and Art Nouveau* (Oxford: Phaidon Press, 1979), p. 25.

20. Robert Goldwater, *Symbolism* (New York: Harper and Row, 1979), p. 1.

21. Piaget, *Dreams and Imitation in Childhood*, p. 210.

22. Pat Zanger, " 'Incredible' Maka paints straight from the heart," *Winnipeg Free Press*, June 5, 1978, p. 21.

23. The identification and subsequent interpretation of the war horse symbols in Maka's drawings came as the author carefully examined several dozen of the artist's war theme drawings between 1988 and 1992. At least ten symbols (some more conventional and obvious than others) came to light in the course of this examination. The interpretation of the war horse symbols presented here is wholly supported by the autobiographical and historical information seen in the works and described by Tony Allison (note 16), Helen Marzolf (note 13), and Professor George Stein (note 11).

9

FOLK ART AND OUTSIDER ART

A FOLKLORIST'S PERSPECTIVE

To a folklorist, the very notion of outsider art would appear to have little meaning. For the art studied by folklorists—folk art—is insider art, the art of the community, an art that "comes mostly from the central values of a society rather than its fringe elements" (Vlach, 1986: 16). Frequently, however, artists who have little to do with communal traditions or values are labeled as folk artists. Prominent examples range from the legendary memory painter, Grandma Moses, to the builder of the Watts Towers, Simon Rodia, to the flamboyant preacher and visionary, Howard Finster. All are unquestionably artists, but their work is too personal, too eclectic, too idiosyncratic to qualify as folk art. In each case, these artists worked alone, without any local mentors to guide them, to tell them what forms to paint or sculpt or what tools to use to make them. In each case, they devised their oeuvre by drawing on a unique agglomeration of inspirations and resources.

This tendency to lump together all manner of nonacademic artists under the banner of folk art goes back to the early years of this century. Artists, collectors, and museums began studying and exhibiting "the art of the common man": limner portraits, landscapes, mourning pictures, fraktur, calligraphy, weather vanes, decoys, stove plates, toys.[1] For lack of a better term, *folk art* served well enough to unify these diverse objects, that is, until the late 1960s, when American folklorists entered the field. Goaded into the study of material culture by scholars such as Don Yoder and Henry Glassie, folklorists began to examine the social and cultural nature of folk art and to challenge old assumptions and definitions. The result was "term warfare" (Barrett, 1986: 4), a sometimes acrid but ultimately healthy debate that has proven fruitful in combining aesthetic and ethnographic approaches to folk art and artists.[2]

145

In particular, this ferment has gradually generated the term *outsider art,* to encompass the extraordinary, singular creations of a Moses or a Rodia or a Finster.

This essay is an attempt to explore some of the essential differences in the lives and work of folk artists and outsider artists. To avoid abstraction, I begin with biographies of two men whom I have known for about fifteen years. Burlon Craig is a potter; he has turned and burned alkaline-glazed stoneware in the Catawba Valley region of North Carolina for sixty-three of his seventy-seven years. Raymond Coins worked as a tobacco farmer near Pilot Mountain, North Carolina, until his retirement at sixty-six; then he suddenly began carving large numbers of animals, human figures, tableaux, even dreams, out of rock and wood. To me, these two men represent the quintessential folk and outsider artist, respectively. Out of necessity, I have given more attention to Coins, because the development of his career is so unusual.

Burlon Craig was born on April 21, 1914, and lived with his family on a small farm in Catawba County, about a mile north of his present location. His father was a farmer, carpenter, and preacher, and so, alongside his nine brothers and one sister, Burlon spent much of his youth working in the fields or doing other chores essential to farm life. He also attended the local school, which he didn't particularly like, but just a short distance away he discovered something of real interest—the pottery shop of Lawrence Leonard. While just a first-grader, Burl recalls, "we'd run off from school and go down and watch Will Bass turn—from the old Ridge Academy schoolhouse down there. . . . We got an hour then at noon, let out an hour at school, you know, why I'd go down there. And sometimes I'd run off and go down there, watching them turn. That fascinated me" (Craig, 16 Dec. 1978). Lawrence Leonard and Will Bass were not the only potters that young Burl Craig could "study." There were more than half a dozen shops in the immediate vicinity, all producing alkaline-glazed stoneware and carrying on a tradition that began in the late eighteenth or early nineteenth century.[3]

Although early absorbed in the potter's art, Burlon did not get his hands into clay until he was about fourteen. He was cutting cordwood on his father's farm when he was approached by veteran potter Jim Lynn. "One day I was down in the woods there cutting wood, and he wanted to know if I wouldn't go in with him now, as partners, in the pottery business. I said, 'How do you want to work that, Jim?' He said, 'Well,' said, 'I'll give you half the profit. . . . I'll do the turning till you learn.' And says, 'We'll use this wood!'" (21 Aug. 1981). Even though he knew Jim really coveted his woodpile, Burlon recognized the value of this proposal. "I said, 'Now, I'll do this, Jim, I'll try it. And if I'm not able to turn something or make a little money out of it by next spring, cotton planting time, I'll have to stop and help my daddy farm.' And by the next spring, I was turning out some saleable stuff. I wasn't the best turner in the world, but, you know, I was setting my stuff out with him, with Jim, and selling it—two-gallon jars, three-gallon churns, stuff like that" (16 Dec. 1978).

After his apprenticeship with Jim Lynn, Burlon worked throughout the 1930s

as a journeyman at potteries all across the region. Sometimes he turned for another potter at the going rate of two cents a gallon. At other times, he formed a partnership and rented an unused shop. By thus working with many different men, he learned the full repertory of forms and gained a broad competence in all phases of the potter's work. After a stint in the navy in World War II, Burlon and his wife Irene purchased potter Harvey Reinhardt's home, shop, and kiln for thirty-five hundred dollars. Except for a stint in a furniture factory in Long Beach, Burlon has made pottery continuously since 1945 [9.1]. Today he is the master potter of the Catawba Valley tradition and now teaches others, among them his son Donald, granddaughter Regina, and two highly skilled local potters, Charlie Lisk and Kim Ellington. Buyers now literally fight to get one of his pieces at a kiln opening, and he has received wide national recognition and numerous awards. In 1984 the National Endowment for the Arts presented him with its prestigious National Heritage Fellowship for authenticity, excellence, and significance in the folk arts.

Raymond Coins has also achieved considerable fame, but his path has been far less predictable than that of Burlon Craig. Raymond was born near Stuart, Virginia, not far above the North Carolina line, on January 28, 1904. When he was ten, the family moved south into the Pilot Mountain area, where he continues to live today. One of thirteen children, he helped his father raise corn, wheat, and tobacco. They never owned their own land, but they "did have enough to eat. Never did save nothing, never did accumulate nothing" (Coins, 14 Sept. 1989). Like Burlon, Raymond saw little virtue in going to school and dropped out by the seventh grade. "I didn't consider it necessary," he explains. "I didn't have to have an education, I didn't think" (7 Aug. 1978).

With little schooling, Raymond faced a life of hard work, but he was prepared for it. As a teenager, he hired out to other farmers to earn money for his family. Once he walked home after a year's work for another man with a ten-dollar bill in his pocket. After he married his wife, Ruby, in 1926, they moved from farm to farm. Raymond remembers scything and tying wheat all day: "I'd get two bushels a day, and my wife would get a bushel a time. We'd make three bushels" (7 Aug. 1978). Mostly, he farmed, but he also worked in a sawmill and a furniture factory in High Point. Occasionally, he did some gravedigging, and later in life he worked on the sales floor of a number of tobacco warehouses. By 1940 he and Ruby had saved up enough money to buy thirty acres and a house; gradually they increased the size of their farm to well over one hundred acres. Their current home sits atop a ridge with a fine view of rolling green fields and forests.

When he retired in 1970, Raymond Coins seemed like anyone else in his neighborhood, just another hard-working farmer ready to relax and enjoy the fruits of his labors with his family and friends. But there was nothing ordinary or typical in the artistic explosion that soon followed [9.2]. The roots of Raymond's second career are not entirely clear, but many of them do extend back into earlier life.

Even at five years old, he recalls, "I was really interested in collecting stuff, and

9.1. Burlon Craig trimming a five-gallon jar on his treadle wheel, 1982.

I'd put it in that box. Find any odd piece—just anything that was odd I'd put it in that box. . . . Had me a lock on it" (7 Aug. 1978). The box long ago disappeared, but he continued searching for arrowheads and other artifacts, some of which he sold, in fields and river bottoms. He also enjoyed attending estate auctions, where he purchased large quantities of old tools and furniture that he later resold out of his barns. "One time I collected just about everything that was used back in, way back in the old times. Dated plumb on back, one hundred years back" (15 Dec. 1978). Collecting old or unusual objects was a lifetime passion. With the newfound freedom of retirement, Raymond began to make his own artifacts and antiques.

The catalytic event behind Raymond's art occurred well before his retirement, possibly during the 1950s. He and his close friend Harvey Lynch were out priming tobacco together, when Harvey's son picked up the head of an old Indian tomahawk. Fascinated by the find, Raymond paid the boy fifty cents for it and kept it for many years. Eventually, "that old antique man begged me out of it. I didn't know no better right at that time" (12 July 1988). Angry at himself for selling his prize, Raymond

9.2. Raymond Coins chiseling a rock slab in his backyard, 1989.

carved a few tomahawks of his own out of the local soapstone. "I'd spread a hickory stick, put it in there, and tie a leather string around it." One day, he goes on, "I carried one of my tomahawks to Pilot Mountain, Wilson's, they run a cafe up there at that time. And I sold it to him for five dollars; that was big money. And he said he kept it for about six months or something like that and sold it for a hundred dollars. So I got started," Raymond laughs, "and then I just give away a fortune!" (28 June 1989).

While Coins was farming, he had little spare time and so contented himself with carving an occasional tomahawk or Indian bowl. Once retired, he was free to let his imagination run. Next, he recalls, "I started cutting doll babies. And then I cut everything—you mention something I didn't cut on a rock" (28 June 1989). The "doll-babies"—with their flat, stylized heads and torsos hewn from slabs of gray soapstone—caused quite a commotion when they first appeared [9.3]. Indeed, as Roger Manley observes, they have "a time-worn patina that detaches the work from recent history; like Easter Island heads or Cro-Magnon effigies, the work looks as if it could be thousands of years old" (Manley, 1989: 78). I well recall several proud antique dealers passing them around among scholars and archaeologists. Without question they appeared ancient, and with their somewhat African features, they evoked much speculation that they must have been made by slaves before the Civil

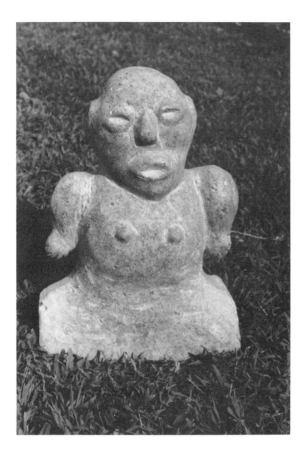

War. The earliest ones were about six inches tall and were made as "paperweights" for presents to some local doctors (7 Aug. 1978). However, as Raymond located larger pieces of stone, they grew in magnitude, some standing well over two feet tall and weighing hundreds of pounds. He also began cutting tableaux on flat surfaces, scenes such as the Crucifixion, or Adam and Eve, or a house with a large sun shining above it. About the mid-1980s, he began hammering out dreams on slabs—dreams such as his walk through the valley of the dry bones [9.4]. And all along, there have been countless animals carved in both wood and stone—alligators, bears, mules, dogs, hyenas, possums, turkeys, cats, owls, fish, turtles, frogs, snakes [9.5]. Most were fashioned directly from nature, though he admits he borrowed a children's book on animals from his granddaughter Rocky to help with more exotic creatures like a walrus or an octopus.[4] His largest creation was a rock lizard that weighed about one thousand pounds and required five men to lift it into a truck.

Like Burlon Craig, Raymond has received considerable recognition. His carvings have been on display at the Sawtooth Center for Visual Design in Winston-Salem, the Paine Webber Art Gallery in New York City (Barrett, 1986: 15), the High Museum in

9.4. Raymond Coins. *The Valley of the Dry Bones,* a dream depicting Coins and Preacher (who baptized him) walking through the valley. After a long journey, they heard the gospel sound, and all the skeletons rose up as people reborn. 1986, 16½ in.

Atlanta, the North Carolina Museum of Art in Raleigh (Manley, 1989: 30–1, 76–8), and as part of numerous other exhibitions (*Baking in the Sun,* 1987: 130–1). Buyers from all parts of the country have driven the steep and dusty road that leads to the top of the ridge where the Coins live to meet him and purchase a cedar mule or a rock-carved dream. For those unwilling to make this trek, his work is carried by many galleries. A recent issue of the *Clarion* contains a full-page ad by the American Primitive Gallery of New York City, with illustrations of stone carvings of the Crucifixion and a dream of a journey in which Coins wrestles with a snake (*Clarion,* 1990: 19). On the very next page is a color illustration of a doll baby, offered for sale by Gilley's Gallery of Baton Rouge, Louisiana. Clearly, Raymond has had an extraordinary second career, one that would have seemed unthinkable at the time of his retirement from tobacco farming [Pl. 9].

I have juxtaposed the lives and achievements of Burlon Craig and Raymond Coins in order to illustrate that they learned their art in very different ways at very different times. Burlon typifies the folk artist; he acquired his knowledge and skills through a long-standing, informally transmitted, regional tradition. Raymond is the outsider artist; granted he drew on his earlier experiences, but his artistic impulse

9.5. Raymond Coins. *Dog, Bust,* and *Owl* carved from a single cedar tree cut down on the property, 1978, height (dog) 34⅜ in. and (bust) 26½ in. and length 28½ in.

came from deep within and is intensely personal in form, execution, and meaning. Let me expand on these essential differences.

To begin, the folk artist usually encounters his calling very early in life. Burlon was raised in a community of potters; by the first grade he was already watching how Will Bass centered his clay and pulled up the walls of big churns and jugs. Had he been born into a clay clan, Burlon would have been hard at work as a small child, digging clay, grinding glazes, preparing balls for the wheel, and lugging the wares out of the shop and into the kiln and out again. As it was, he earned small amounts of money cutting wood for the local kilns or bringing in one of his mules to power a clay mill. Then, at the young age of fourteen he began his life's work under the tutelage of his neighbor Jim Lynn.

By contrast, outsider artists normally emerge at a much later stage of life. As Roger Manley explains, their "life stories frequently reveal traumatic events that threw them onto their own resources and triggered responses that led to art making: the loss of a job through illness, injury, or retirement; the death of a spouse or elderly parent; religious doubt; social ostracism; imprisonment. These events precipitate their transformation from 'ordinary' farmers, loggers, or textile workers into artists as well" (Manley, 1989: 9). Raymond had little time for carving rocks or trees until his mid-sixties. To have done so would have been frivolous when there were children

to raise, crops to harvest, animals to tend. With his retirement from such an active life, he felt a sense of emptiness, a loss of purpose and continuity, and so turned his old tools to new uses. In fact, he declares, "I ain't never retired. . . . I just quit growing tobacco. I work harder now than I used to, I think" (12 July 1988).

Essentially, the folk artist begins early in life because he has an already existing tradition to shape his work and give it meaning. Like all other potters, Burlon began by turning small, simple, open-mouthed wares like milk crocks and jars. Gradually, Jim Lynn helped him master more complex forms like the jug in ever larger sizes up to five gallons and more. A tradition offers many guideposts, but it should not be regarded as stifling innovation or creativity. Burlon, indeed, has had to alter his repertory quite extensively over the last fifteen years as his clientele has shifted from the local community to collectors (Zug, 1989). In addition, he feels a tremendous responsibility to pass on the Catawba Valley alkaline glaze to the next generation. Hence, his great delight is that his son Donald has recently decided to be a full-time potter. "I believe he's going to make it. I hope he does. I'd like to—I know that I'm not going to be able to do it forever—and I'd like for him to carry on right here. If he does, I'll fix it so he can have this shop as long as he wants it" (20 July 1990).

The outsider artist works under no such obligation. I have never once heard Raymond mention anyone else in connection with his art. Instead of working through a well-defined tradition, his path is more existential; he gradually invents his own art, both what it is and how to do it. This is not to say that his work is totally inexplicable. Raymond's lifelong passion for collecting old or unusual objects has been an important shaping force, as was his farm work. From erecting log barns to constructing simple tables or cupboards, he learned to use the tools—axes, saws, chisels, sanders, files, knives—that would later serve to hew out his visions in cedar or soapstone. As for his dreams, they stem directly from his long standing as a Primitive Baptist. Such revelations, explains Brett Sutton, are "the product of an individual member's spiritual experience and an emblem of his participation in the church" (Sutton, 1990: 203). Raymond himself explains their importance. When members "don't live up to the rule of the Primitive Baptists, they'll exclude them. . . . And so, when something'd come before the church, us deacons, . . . we was supposed to deal on it. And then the moderator's supposed to just moderate it. And if I couldn't make up my mind now what I ought to do, . . . I'd dream what to do. And then when I'd do the church work, I was clear" (14 Sept. 1989). Altogether then, it is possible to recognize some of the individual influences on Raymond's work, but they commingle to form a unique configuration. Since there is no shared tradition, he feels no need, as Burlon does, to pass on his art to others.[5]

Working within a communal tradition, the folk artist produces familiar and useful objects—in Burlon's case, jars, jugs, milk crocks, churns, pitchers, and so forth [9.6]. These are made for sale and usually go for a clearly established price, which, in the case of pottery, is according to the size or capacity of the pot. The outsider artist, on the other hand, may show a surprising indifference to the prospect

9.6. Burlon Craig admiring a recently fired kilnful of alkaline-glazed stoneware, 1978.

of selling his work. Again and again I have heard Raymond insist: "I started as a hobby. I didn't even start to make money, . . . didn't even think about making money." Then he adds with a laugh, "Ain't made too much!" (12 July 1988). While he appreciates the money he receives—to continue to earn an income is to affirm one's self-worth and independence—it is by no means essential to his desire to work. In fact, it is not too much to say that the process of making art is far more important to him than the finished product.[6] This appears to be a heretical concept in a consumer-oriented society, but Raymond articulates his obsession with carving very clearly.

> I can't set still. I look at television, maybe the news, I don't look at television much. I read the paper, and I get tired of reading the paper. And me and her [Ruby] can't talk all the time. . . . And in the wintertime I can spread me a plastic down on the porch and get me a little rock. And I go out there at seven o'clock. And it's *bedtime* before I know it. When I'm a-working on it, it don't nary a thing come on my mind, disturb me, not *nothing!* . . . And I might look at my watch and be ten o'clock, and didn't think I'd been out there ten minutes. . . . That's when I love to make them. That's when I love to work (28 June 1989).

In short, it is the act of creation that matters most to Raymond, not the resulting work of art.

9.7. Raymond Coins and walnut friend, 1989, 62 in.

As his popularity has grown, Raymond has found it increasingly difficult to cope with his customers' orders for specific pieces. "It puts pressure on me," he explains, "because as I was getting ready, something ready for you, I can't do as good a job." Feeling pressured by other people's choices and deadlines, Raymond finally decided that "I wasn't going to take no orders at all. . . . And I said, 'When I want to make something, I'm going to make it. I'm going to set it out here.' And I said, 'When you call me, I'll tell you what I got made.'" In short, Raymond has preserved his integrity by making what he wants, not what others order [9.7]. In addition, he has little interest in replicating objects. "If you was to give me an order for four or five, I'm not even as interested in it. I just can't do as good" (14 Sept. 1989). All of this contrasts markedly with a folk artist like Burl Craig, who must respond to his customers' needs and repeat the same essential form thousands of times over. While he, too, expresses a similar passion for pulling up large, bulbous forms on his treadle wheel, he never forgets that his ultimate purpose is to produce a saleable pot.

Raymond's refusal to respond to the requests of his customers raises the ultimate

question of the artist's relationship to his community. Burlon's wares have always been part of everyday life; his neighbors understand the subtle differences between a churn and a storage jar, and they know how to use all the forms he cuts off his wheel. Even today, some will gather when he burns the kiln, and help feed the pine slabs into the firebox. In a small way, then, Burlon's friends may even participate in the process.

The work of the outsider artist, on the other hand, is generally more personal than communal; it tends to be exotic rather than commonplace. Raymond makes this point very clear when he affirms that he was "always interested in something, in anything that was unusual" (28 June 1989). Again, "my desire is to make something I haven't already made" (12 July 1988). Because he works primarily for his own pleasure rather than the needs of the community, his art often baffles or amazes. To compensate, Raymond has learned to explain the meaning of his creations. "Well, I try to give everybody a record. Just like now if you wanted to buy that, I'd rather tell you and then you set it down. And then you know what you got. And I love to cut my dreams, and I can back them up with the Bible. But you see now, if I don't give them a record of it, they buy it, they wouldn't know what they had" (14 Sept. 1989).

The need for a "record," as Raymond puts it, to explain the significance of a work of outsider art, is best illustrated by his all-time favorite carving, the Rock House Church (Manley, 1989: 77) [9.8]. Cut on a massive stele that is almost four feet tall, it depicts, from top to bottom: the Crucifixion, a gable roof over a preacher standing in a pulpit, a communion table with thirteen figures behind it, and at the bottom, the steps and porch at the entrance of the church. Inscribed at the bottom left is IN•GOD / WE•TRUST; and then to the right of the porch is ROCK HOUSE /CHURCHE 1889 / R•COINS MEMBER / 44 YEARS / ELDER FLETCHER / BEASLEY MODRATER / 34 YEARS.

To a casual observer, the sculpture appeals because of its mass, its powerful symmetry, and its puzzling elements of Christian symbolism. But with Raymond's help it takes on much richer meaning. When it was exhibited at the North Carolina Museum of Art in 1989, Raymond was only too pleased to narrate the full record to curator David Steele. "Steele was tickled to death—he didn't understand it. . . . See, I cut the church and the communion table. And I told I had served as deacon thirty-some years at that time. And I cut that on the sides. . . . Man, he thought more of it when he found out about it" (14 Sept. 1989). Once understood, the stone urges the viewer to enter at the bottom and then move upward through the church, past the communion table and the preacher, and finally, to the looming figure of Christ at the top. Thus, the stone both commemorates the Primitive Baptist church that Raymond has attended for more than half a century, and illustrates his own personal spiritual journey toward faith and transcendence.

The previous discussion of the lives and work of Burlon Craig and Raymond Coins should make clear that the outsider artist is not some social misfit living on the fringes of society. The adjective "outsider" points only to the nature of the art, not the person creating it. To my knowledge, Burlon Craig and Raymond Coins have

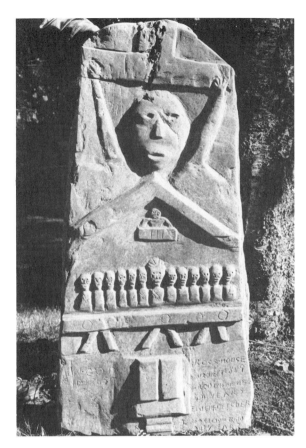

9.8. Raymond Coins. *The Rock House Church,* ca. 1981, stone, 44 in. Photo courtesy Roger Manley.

never met, but were they to do so, they would have much to share. Both men were raised in large families that derived their livelihood directly from the land. Both learned the virtues of self-sufficiency and hard work; "everything you done," Raymond reflects, "you just had to do it with a man's strength" (15 Dec. 1988). Both worked in sawmills and furniture factories to supplement their incomes, and both farmed and raised cash crops: cotton, corn, and stoneware for Burlon, tobacco for Raymond. What distinguishes the two men as a folk and an outsider artist is their art—in particular, the timing of their artistic careers, the presence or absence of a guiding tradition, the relative importance of product or process, and the understanding of their work within their communities.

Earlier definitions of folk art, as suggested at the beginning of this essay, would have subsumed the work of Burlon, Raymond, and numerous other types of artists. "The [older] concept of folk art," explains Jane Kallir, "is one of negation. It is a catchall category for misfits—wallflowers at the dance of Western civilization" (Kallir, 1981: 8). In this sense, folk art is un-fine art, or not-art, or not real art, anyway.

One hopes that today such elitist perceptions are a thing of the past, so that the various categories of nonacademic art can be judged on their own merits, not as pale reflections or failures of "fine" art.

The following, admittedly simple diagram suggests three distinct types of nonacademic art.

To the left, the school and factory stand as the major institutions of popular art. Objects such as calligraphic drawings and theorem paintings, or drop-forged weather vanes and mass-produced Hitchcock chairs, evolved from books and blueprints, formal classes and assembly lines. In general, they lack the variation, the regionality, or the control of the individual maker, all of which characterize the work of the folk artist.[7] To the right side of the diagram is folk art, which springs from an informally transmitted, craft-based or religious tradition (for example, decoys and quilts, santos and grave markers). And finally, suspended in the middle is outsider art, which, as shown, develops largely independent of any tradition, whether academic, popular, or folk.

Burlon Craig and Raymond Coins work on today, oblivious to all this theorizing. Burlon continues to make the old Catawba Valley alkaline glaze, though his work has changed somewhat over the last fifteen years. He still uses the same tools and makes the same forms, but there is a much greater decorative emphasis now, with a strong demand for face vessels and multicolored swirl ware. Raymond continues making animals, doll babies, and dreams while also seeking the odd or unusual. On a recent visit I found him carving a stone image of himself and his good friend Harvey Lynch sitting in front of a pile of tobacco. His inspiration was a photograph of the two of them as young men that had recently appeared in the *Winston-Salem Journal*. Both Burlon and Raymond know exactly what they are doing and are in the enviable position of being able to sell all they can make. And each still feels that electric jolt of pleasure when he gets one just right, whether it be a smoothly curved, richly textured storage jar or a gray stone homage to the Primitive Baptist faith.

1. This often repeated phrase comes from Holger Cahill's important exhibition and catalogue, *American Folk Art: The Art of the Common Man in America, 1750–1900,* which appeared in 1932.

2. For the results of two interdisciplinary conferences on folk art, the "shoot out" at Winterthur (1977) and the meeting at the Library of Congress (1983), see Quimby and Swank (1980), and Vlach and Bronner (1986).

3. For a fuller consideration of the Catawba Valley tradition, see Zug, *Turners and Burners* (1986: chap. 3).

4. Rocky's book was Jane Werner Watson's *Animal Dictionary* (Racine: Golden Press, 1976) and cost forty-nine cents.

5. The outsider artist, of course, may initiate a new tradition. One who appears to have done just that is the late Felipe Archuleta of Tesuque, New Mexico. See Wecter (1986), and Everts-Boehm and DeBouzek (1991).

6. For a more extended discussion of product and process, see Kathleen Condon's article on North Carolina chainsaw carver Clyde Jones (1990).

7. There are most certainly gray areas here, such as a parochial Amish school or a small machine shop.

BIBLIOGRAPHY

1987. *Baking in the Sun: Visionary Images from the South.* Lafayette: University Art Museum, University of Southwestern Louisiana.

Barrett, Didi. 1986. *Muffled Voices: Folk Artists in Contemporary America.* New York: Museum of American Folk Art and the Paine Webber Group, Inc.

Cahill, Holger. 1932. *American Folk Art: The Art of the Common Man in America, 1750–1900.* New York: The Museum of Modern Art.

Clarion 15, no. 3 (1990): 19, 20.

Condon, Kathleen. 1990. "'Learnin' Though': Environmental Art as Creative Process." In *Arts in Earnest: North Carolina Folklife,* edited by Daniel W. Patterson and Charles G. Zug, III. Durham: Duke University Press, 179–91.

Everts-Boehm, Dana, and Jeanette DeBouzek. 1991. "New Mexico Hispano Animal Carving in Context." *Clarion* 16, no. 2: 34–40.

Glassie, Henry. 1968. *Pattern in the Material Folk Culture of the Eastern United States.* Philadelphia: University of Pennsylvania Press.

Kallir, Jane. 1981. *The Folk Art Tradition: Naive Painting in Europe and the United States.* New York: Viking Press.

Manley, Roger. 1989. *Signs and Wonders: Outsider Art Inside North Carolina.* Raleigh: North Carolina Museum of Art.

Quimby, Ian M. G., and Scott T. Swank, eds. 1980. *Perspectives on American Folk Art.* Winterthur: The Henry Francis du Pont Winterthur Museum.

Sutton, Brett. 1990. "In the Good Old Way: Primitive Baptist Tradition in An Age of Change." In *Arts in Earnest: North Carolina Folklife,* edited by Daniel W. Patterson and Charles G. Zug, III. Durham: Duke University Press, 195–215.

Vlach, John Michael. 1986. " 'Properly Speaking': The Need for Plain Talk About Folk Art." In *Folk Art and Art Worlds,* edited by John Michael Vlach and Simon J. Bronner. Ann Arbor: UMI Research Press, 13–26.

Vlach, John Michael, and Simon J. Bronner, eds. 1986. *Folk Art and Art Worlds.* Ann Arbor: UMI Research Press.

Wecter, Elizabeth. 1986. "Animal Carvers of New Mexico." *Clarion,* Winter: 22–31.

Yoder, Don. 1963. The Folklife Studies Movement." *Pennsylvania Folklife* 13: 43–56.

Zug, Charles G., III. 1989. " 'New' Pots for Old: Burlon Craig's Strategy for Success." In *Folklife Annual, 88–89,* edited by James Hardin and Alan Jabbour. Washington: Library of Congress, 126–137.

———. 1986. *Turners and Burners: The Folk Potters of North Carolina.* Chapel Hill: University of North Carolina Press.

INTERVIEWS

Coins, Willie Raymond. Tape-recorded interviews with the author. Pilot Mountain, North Carolina, 7 Aug. 1978, 15 Dec. 1978, 12 July 1988, 28 June 1989, 14 Sept. 1989.

Craig, Burlon B. Tape-recorded interviews with the author. Henry, North Carolina, 16 Dec. 1978, 21 Aug. 1981, 20 July 1990.

10

THE SNAKE IN THE GARDEN

Richard Nonas

IMAGINARY SNAKES IN REAL GARDENS

Outsider-art, art-brut, folk-art, or primitive-art: The sloppy and reflexive distinctions invoked in the descriptive half of those hyphenated terms are not what worry me; the uncritical use of the substantive half is what does.

There is now a particular kind of provincialism, of narrowness, involved in those uses of the word *art*. Not the old place-specific provincialisms of New York or Paris or Berlin, but rather another and equally provincial need to limit the scope and power of art itself, to fold art into a larger category more instructive and uplifting than art, to make it an example of something more important than art, to make it didactic, to make it our visual aid for lectures on topics other than art. What we seem to seek is disjointed, compartmentalized, categorized art, hyphenated expansionist art, whose aim is to undermine and redefine art by the simple expedient of making it into something else. But not just folk-art, outsider-art and primitive-art do that; such categories as modern-art and postmodern-art and women's-art and conceptual-art obfuscate the power and independence of art in the same way.

All art is in danger of becoming the art-part of something else. The old philistine questions about modern art, "What is it supposed to be?" and "What does it mean?," are answered by pointing to the hyphenated category to which that art has been assigned. Art is, indeed, clarified for us in that way, but it is cleansed of its ambiguity, too. Art is assigned the power of expedient use, the power of intellectual closure, the power to present neat packages of social, political, or emotional belief. Emphasis is switched from noun to adjective. Art becomes a secondary marker of

163

ideology, a political poster. It becomes the shorthand summary of our pretensions, our advertisement for the lives we think the rest of us should want to live. But in the process, the special communicative power of art is actually destroyed. *And that is what we want to happen.* Art hyphenated becomes an illustration. Art meant to break categories is used to establish them. And the hyphen, written or unwritten, is how we make that happen. The hyphen is how we control art's central statement. It is how we domesticate the inevitable *otherness* of art itself.

For the essence of art has always, everywhere, been its unpredictability, its position outside our usual range of experience and explanation. Art is always an outside to the inside of everyday life. It is never ordinary; that is what we mean by separating it out, what we mean by calling it art. Art is everywhere differentiated from the rest of human communication, separated exactly by the disjunction and ambiguity of its own essential breaking of the rules of language. Disjunction and ambiguity are its defining characteristics, the shocks to the system of culture that allow art—force it—to speak and be heard differently. Yet the turnabout gesture of hyphenization enforces the subjugation of art to specific nonart projects. It is a narrowing and hardening of art's crucial openness. It is a denial of art's strange centrality, its separateness, its self-contained completeness. It is the way we intentionally limit the "outside" function of art, the way we force it to work for us at the expense of its most unique function as art. For hyphenization is the weakening of what is most important about art: its shocking ability to subvert the very conceptual boundaries with which we bind the world.

Art's indefinable otherness—its wholeness and thereness—has always been its point and weapon, the paradoxical proof of both its radical discontinuity and its other, ultimately conservative, role as a cultural safety valve. That functional ambiguity is, in itself, art's basic cultural importance. Ambiguity is the strength which underlies and propels whatever specific meaning art may be made to carry. That expansive self-doubling power is always art's most meaningful message. Art is the actual acknowledgment (and not, as is often said, the denial) of the chaos we know surrounds us. Art is what ties us to a world beyond us. That is art's difference from what we call either craft or design. Art is the way we puncture our own complacency; craft is the way we simply enhance it. Craft is our righteous pride in human skill; art is the equally human hubris of over-reaching will. Art is culture's uneasy acknowledgment of an outside always there within itself, an outside already found within. It is the way we stab impending, impinging confusion into our immediate life.

Art is the way we trick ourselves into *more*. Not into change or improvement, but simply into more. More for the sake of more. More as the edge of possibility. More as mystery. More as hope. More as the shifting boundary of both human culture and specific culture. Not better, but more. More because we cannot live without more. More as the meaning of being human. Not more of some specific thing, of money or love or freedom or energy or silence or even life. Just more, just generalized and unrealizable more. Art is the way we torture ourselves with unreachable dreams,

the way we do not forget them. Art is the way we acknowledge our awful dreams of more. And hyphenization is how we explain them away.

Let me be clear. I am talking about all artists and all art. I am talking about all culture, the beliefs and behaviors shared in any human group. I am talking about the place and meaning of art in culture, any culture. I am talking about the ways in which the very idea of art and artist are used by a culture to explain, understand, and shape the world—our world and also the unknown worlds of people different from us. I am talking about the utility of art anywhere and everywhere. And I am speaking from the point of view of both the artist I now am, and the anthropologist I once was—an artist and anthropologist who has seen the meaning and being of even his own work changed radically, from place to place and time to time even within his own culture. I am speaking as an artist who knows that the meaning of his work changes in terms of the external needs of society itself—what society at that moment defends or denies or destroys or builds. I am speaking as an artist who pushes against that, fights against it, conspires to force his work around it, yet is affected by it still. And I am speaking as an artist whose work is actually changed and sometimes even destroyed by that pressure.

For we measure art against our own cultural dreams of meaningful life, our particular dreams of more. We measure it against our dreams of an art that can itself make lives meaningful, an art that can explain old lives away, an art that can suck the outside world back in for us to use, an art that can change our world by answering it back, by forcing it back to just those ideas we at that moment need. We measure art against a dream of art that can absorb anything by translating it into another language altogether: the language of meaningful things—the only language ambiguous enough to transcend the limitations of language itself, and therefore human culture itself.

And as the anthropologist I used to be, I argue that those dreams of art's encompassing use drive art in all cultures—that, and not the aesthetics or style of the art object itself, nor its immediate literal or even symbolic meaning, though many in our culture would deny that, too. Each piece of art everywhere is an attempt at some actual dream of more, dreamt not just by artists but by the audience as well. Each piece is a particular representative of that dream, an embodiment of its life-enhancing power. For there can be no art without an audience. The power of art is embodied in the special communication between artist and audience that the art object initiates. The audience is the necessary inside to art's outside. *The audience, I mean to say, completes the fact of art.*

Art is culture's strongest acknowledgment of an incalculably important social bond, a bond of shared unease. Art is the continual reweaving of outside hope into inside doubt. And that is why there is art in every culture we know. Art exists everywhere because it is the most direct institutionalized way out for both artist and audience and, thus, by extension, for society itself—a safe and available way out from the immediate ideological, intellectual, psychological, and linguistic structure of cul-

ture. Art is a way out of each culture's narrow surety of the way the world is and must be—the very surety that all culture exists to enforce. It is a way out of the predictability, I mean, of the culturally defined categories that art challenges yet inevitably (and even intentionally) goes on to reinforce. Art is always that shaky and fallible *transaction* by which we ambiguously acknowledge an outside, then pull ourselves back to safety again.

But safe or not, the artist always speaks from outside. He is one of society's "outsiders." That is the artist's job, the only platform he is granted. The power of art, its strangely ambiguous force, depends on that starting point. The yes-no doubling of social reality by art is what is important and unique about it. Art is our culturally sanctioned method of having it both ways, our back-and-forth realization that culture is arbitrarily given and freely chosen, too.

That is true not only of the art made and used within a single cultural tradition, but also of the art displaced, uprooted, from one living context to another. The audience's use of an object as art is crucial in either case. The way in which both familiar and exotic objects are made into our art by us, the way they are shaped, defined, and, in the process, literally reinvented by the audience determines which dreams of both art and life that art will illuminate. Artists and their audiences always find the art they dream of—the exotic art, the traditional art, as well as the contemporary art they need; it is the art they need to tell them what they wish to hear at that moment about themselves and the world. We invent our own traditions, even ancient or exotic ones, which draw the lines we wish to see drawn, the lines between our own shifting contemporary notions of inside and out. We build the art that challenges, that crosses and recrosses, exactly those lines that are then appropriate to the message, the dream we want to dream.

Art has always been used that way, used, I mean, to test, to set, and to justify the margins that shape our dreams, and through those dreams our lives. Art exists in human culture to accomplish that cultural doubling, that testing, changing, and, at the same moment, reinforcing of basic boundaries between outside and in, between permanence and change, between culture and nature. Art is the way we acknowledge our belief that we can indeed shift those lines, reset them ourselves and thereby change our world without actually destroying it. It is the way we, artist and audience, constantly remake the categories of a world too complex to grasp as a whole. Art is the most generalized, most abstract, least linguified way we can do that. It is probably the safest way, too. But it is the most insidious way as well, for it is, in its ambiguity, the most unpredictable.

Art is our attempt at a human way out—out of language, out of our own constant contextual control. Art is our acknowledgment of the frightening limitations of all language and culture. Art is the way we acknowledge the paradox of a world opening and then closing again. Art is the way we point to human limitations, the way we confront them. Art is our acknowledgment of the impossible existence of

alien nature in an already human world. And art is our ambivalent acknowledgment of the inside's inevitable destruction of the outside. Art is our leap at the silence outside ourselves, the silence of distance and difference. It is our doomed attempt to build a substitute and unnatural silence of the inside. Art is man's futile dream of human silence. Art is the silence of our dreams.

All art inevitably starts with an outside and an outsider, not just those hyphenated art categories that focus their attention on the nonart social or political fact of marginality. For all art stands aloof. And all audiences don't. All art is an outsider's art; all art is made of exotic dreams—dreams of alternatives we can use to judge and measure the world. It is not important whether the outside or outsider is depicted accurately. Art does not deal in facts. It does not illustrate reality. It creates reality. Ethnographic or historical truth is rarely the point of art. The point of art is its edgy acknowledgment of the inevitable limitations of cultural reality. Yet that function can, of course, be undermined. It can be distorted by forcing art back from its confrontation with culture's edge. Art can be denied by pulling it too quickly down to specific, illustrative use. Some uses of art, I mean to say, some uses of the "more" of art, are actually meant to limit, to destroy art's central power of transcendence.

The idea of a separate category of Outsider-Art, I believe, does just that. It concerns itself more with the normative and conditioned message of the hyphen than with the power and immediacy of art. It makes artists and their art into illustrations. Its aims are the opposite of art's aim. The propagation of the old noble-savage, holy-fool myth of natural superiority is more important to the idea of a separate Outsider-Art than is the art the term encompasses. The art itself is subordinated to an ideological argument. The idea of a separate Outsider-Art is committed to a concept, not to a context. Its main accomplishment is the very peculiar one of having designated one skewed version of someone else's reality as the central critique of our own. Which has, I believe, very little to do with the art or the artists brought together by the name "outsider."

REAL SNAKES IN IMAGINARY GARDENS

Art is always a cultural category, a cultural definition, not something defined by a particular artist, audience, or critic (though their views will affect the way the definition may change over time). The cultural category of art is itself changeable and imprecise. But it is *there*. It is artificial, an abstraction, yet real. Its reality is proven by the fact that people struggle desperately against it. That is, they start from it.

Art starts out being whatever a culture says it is. That is the only possible starting point, our only interesting starting point. It is the only platform from which we, artists and audience, can possibly jump. Yet we all want to deny it. We need the certainty of our own moral positions. We want the clarity of virtue. We want, that

is, the justification of an aesthetic and social morality that separates us from those norms of the society we mean to criticize. So we start from our own already discovered truth. We do not question; we preach.

But what, then, is the role of art in society? What is it that makes the whole enterprise of art morally real, that makes it culturally and thus humanly significant, and that makes it matter in a more than self-indulgent way? If the role of art in society is, as I have claimed, the acknowledgment of an inevitable human unease with the limitations of culture, what happens to that role when we become accustomed to, and enamored of, that unease? What happens when unease of art itself becomes easy? What happens, that is, when we simply accept art's spoken or unspoken criticism? What happens when the outside of art begins to feel like *home*, becomes inside and no longer out?

What happens, I think, is that the cultural power of art slips away. It slips away just at the moment we too easily accept it. It shifts when it becomes too familiar, when we no longer distrust it, when we no longer acknowledge our distrust of it, of its unpredictable power, and our unease in the presence of its confusions and confrontations, our discomfort in its inside-outside tension, our distrust of art as art.

For we should, in fact, distrust art. Artists should distrust their own work. Distrust is the acknowledgment of what art actually is, of art's outside edge, of art's structural thrill. Distrust is what allows art to function as art. It is what creates art's cultural force. Distrust is what fuels art's particular power over us. It is the recognition of art's ability to move us and change us (if only temporarily and in small ways). Distrust is our most immediate way to admit art's difference from the rest of life, to signify its confusing and sometimes frightening importance to us. Distrust is the way we mark the distance out to, and away from, our dreams. The domestication of art— the familiarization and instrumentalization and trust of art—leads to, and even defines, what I have called hyphenization; for it leads to and defines the strangely suicidal strategy of using art as something other than art, using it as the stylized illustration of something else. Using it, I mean, as the denial of art.

Openness to art makes no sense to me at all, except as an attempt to destroy art. I can find no other way to think about that. I must, it seems to me, distrust the very idea of art. I must distrust the mark, the seal, the imprimatur of art. I must distrust the pretensions of art. I must distrust art's answers. I must distrust the questions art asks. I must distrust the people who speak for art. I must distrust the name and the name giver of art. I must distrust the message and messenger. I must distrust my own need for art. I must distrust my own readiness to find and credit art. I must distrust my constant use of art, my need to speak and write about it. I must distrust art and everything around it. Art threatens me and is meant to threaten me. Distrust is my defense. Yet, distrust is also my most intimate connection to that threatening outside. Distrust is the closest I can come to meeting art on its own aggressive terms.

But I fear art as well as distrusting it. I also love to fear it. And that, too, is part

of the inside-outside paradox that culture builds into art. I deeply and lovingly distrust all the art I know. I fear and distrust even the art that moves me most, the art, that is, whose making and being is *finished* immediately, the art of the instantaneous presence of changeable things, of objects as objects in a present and immediate world—things unified precisely by their mysterious ability to instantaneously transcend their pasts, to instantaneously undermine and deny even their own parts. I fear and distrust the art that is the suppression, or even destruction, of everything it affects, the art that is the tyranny of its own changed boundaries (wherever those boundaries fall in the new world it has made), the art that is the paradox of juxtaposed part-less parts instantly transformed into larger part-less wholes, the art that immediately coalesces into unique and flashing single thing-ness, that jumps to newborn separateness. I distrust and fear the art I myself want most to make: the art that is immediately and wholly there, the art that means its specific world by instantaneously becoming it, the art that does not grow, but simply appears, shuddering like a knife stabbed into wood [10.1 and 10.2].

10.1. Richard Nonas. *Dniee* "All the arts derive from / This ur-act of making, / Private to the artist: / Makers' life are spent / Striving in their chosen / Medium to produce a / De-narcissus-ized en- / during excrement," (from *Geography of the House* by W. H. Auden), 1988, steel, length 26 ft., width 15 ft., height 2 ft. Ace Gallery, Los Angeles. Photo by Richard Nonas.

10.2. Richard Nonas. *Lucifer Landing (Real Snake in Imaginary Garden),* 1989, stone, height 4 ft., width 35 ft., length 135 ft. Cranbrook Academy of Art, Bloomfield Hills, Michigan. Photo courtesy Hill Gallery, Birmingham, Michigan.

But I must tell you that I also distrust and fear the art I most disdain: art based on theatricality, archetype, or the evocation of nature; art that emphasizes process, duration, or growth; art that attempts the primitive or the sacred; art meant to act a role; art that does not silence the theater of its own creation; art that plays to an audience; art that needs a text. But I tell you now, more than anything else, I distrust and fear the art that worships art, that denies the function of art, that transforms another person's living world into an architectural detail or edifying decoration—the kind of art that submits itself to the tyranny of its hyphenated name.

PART II

THE OUTSIDER IN SOCIAL PERSPECTIVE

HISTORY AND THEORY

THE RECEPTION OF NEW, UNUSUAL, AND DIFFICULT ART

Constance Perin

Viewing works of art whose references are obscure, we cannot be sure of what their makers intended to convey of their experience, history, and beliefs. We can be sure only of our own responses to them. Although our individual biographies outline the stories we can tell, the details are suggested by our milieu, especially by professional critics, curators, and artists themselves. Their readings often supply lay people with their first if not ultimate comprehension of ambiguous work. Critics, too, rely on colleagues for their orientation to new, unusual, and difficult art. For example, several years ago when the Museum of Modern Art in New York City was closed for renovation, the *New Yorker*'s critic was trying to place certain new paintings as "art" or "not-art," and he yearningly observed that "everyone misses MOMA's presence at the center of things, offering information and historical perspective" (Tomkins, 1983: 82–83).

Concepts and experiences both of art and life shape professional beholders' interpretations of what they see. These decide whether the art's reception is friendly or hostile. Unmistakably, modern art, if not the target of active hostility and avoidance, may be totally neglected, first by critics, then by the public. "The Impressionists certainly did not make it easy for people to understand their artistic ideas," Arnold Hauser observes, "but in what a bad way the art appreciation of the public must have been to allow such great, honest and peaceable artists as Monet, Renoir and Pissarro almost to starve" (Hauser, 1951: 176).

The resistance people have to new ideas in general, I propose, is little different from the initial lack of appreciation for the Impressionists' "artistic ideas." The colorful language in which Arnold Hauser recounts responses to "new, unusual and diffi-

cult art" in fact accurately reports well-observed patterns in cultural and biological responses to novelty and ambiguity:

> High, serious, uncompromising art has a disturbing effect, often distressing and torturing; popular art, on the other hand, wants to soothe, distract us from the painful problems of existence, and instead of inspiring us to activity and exertion, criticism and self-examination, moves us on the contrary to passivity and self-satisfaction. . . . The chances of success of important works are lessened by the fact that the new, the unusual, and the difficult have of themselves a disturbing effect upon an uneducated and not especially artistically experienced audience and move them to take up a negative position. (Hauser, 1983: 582)

Even a sophisticated critical cadre can be hostage to similar responses. At Dubuffet's second major exhibition in May 1946, "These forty-eight paintings alarmed the public by their imagery of cruel irony (few people realized how funny they were) and by their use of crude materials. In the best Dada tradition, paintings were slashed by infuriated spectators. Many of the critics were wildly antagonistic and, in fact, nothing had so outraged the Paris art world in a great many years" (Selz, 1962: 20).

When primitive artifacts were exhibited forty years earlier in Paris, they

> came as a great affront to the public. . . . To imagine how any art could actually hurt feelings or cause outrage is difficult now. . . . My notion is that "Negro" art (as it was also called) entered the art world as a sort of speech in this grand conversation; or, to use Stendahl's more striking phrase, it was like a pistol shot in church. . . . As "primitive" art objects entered public consciousness (through the agency of artists), they re-positioned other objects, causing dislocation and disequilibrium of these other objects. Andre Breton cried (championing Easter Island carvings), "Greece never existed!" This was dis-placement. He shocked and frightened "the public" and the emotions generated took many years to die down. (McNamara 1982: 1, 5)

Nor are artists themselves immune: Braque and other painters first reacted little differently to Picasso's work. "The traditional stylistic features of painting were so thoroughly violated that their orientation toward painting was no longer applicable. Rather than permit themselves to be disoriented, they denied Picasso's work admission into their category of painting and consequently into their category of art" (Peckham, 1965: 80). In our time, the work in the Prinzhorn Collection, by being both art and the product of psychotic patients, can evoke a similarly intense denial among professional observers of art.

Why do these powerful responses occur? Drawing on aspects of cultural and biological anthropology may help to explain how the reception of art resembles responses to other experiences of cultural and social innovation. Itself a part of our social surround, art lives through the same meanings by which our personal, social, and cultural experiences are motivated. And art, like literature, asks us to consider

meanings afresh, warning us that those by which we habitually understand our experiences also may need to be reconsidered. It is this prospect that can be unwelcome.

In the reception of "the new, the unusual and the difficult," our species' biological responses are also important: These are autonomic responses of fear and anxiety evoked by art's "violations" of or even variations upon familiar, comfortable meanings. Once grasping the neurophysiological processes of response to novelty and ambiguity in some detail, we may better understand why professionals and lay people arrive at the kinds of interpretation and criticism they do.

After a brief account of the biological and semantic relationship of novelty to fear, I discuss critics' responses to the European and American tours of parts of the Prinzhorn Collection during the 1980s. Next I examine the reasons why many perceive a relationship between the artistry of the mentally ill and that of primitives, outsiders, and Surrealists. I conclude by proposing that to understand art by means of its reception is another route into understanding the culture producing it.

FINDING AND LOSING MEANING

Art lives inside of issues central to personal, social, and cultural experience, and when works bring new perspectives to bear on these issues, we are asked to reconsider our usual interpretations of them. We can ignore the request (and neglect the art) or we can respond to it and find ourselves unsettled, sometimes pleasurably, sometimes painfully. Art participates in "the organization and reorganization of experience . . . the making and remaking of our worlds," says the philosopher Nelson Goodman, who sees, however, none of the darker sides to these "reformations" of experience:

> What we see in a museum may profoundly affect what we see when we leave; and this is as true for nonrepresentational as for representational works. As I have put it elsewhere, our worlds are no less powerfully informed by the patterns and feelings of abstract works than by a literal Chardin still-life or an allegorical Birth of Venus. After we spend an hour or so at one or another exhibition of abstract painting, everything tends to square off into geometric patches or swirl in circles or weave into textural arabesques, to sharpen into black and white or vibrate with new color consonances and dissonances. In turn, what we see when we leave the museum may appreciably affect what we see when we return. Works work when, by stimulating inquisitive looking, sharpening perception, raising visual intelligence, widening perspectives, bringing out new connections and contrasts, and marking off neglected significant kinds, they participate in the organization and reorganization of experience, in the making and remaking of our worlds. If that sounds grandiloquent, I must insist that I am not romanticizing or rhapsodizing here, not talking of ecstasy or rapture or the miraculous or the visionary, but calling attention to down-to-earth facts abundantly attested by observation, by able writers on art, and by psychological experiment. The myths of the innocent eye, the insular intel-

lect, the mindless emotion are obsolete. Sensation and perception and feeling and reason are all facets of cognition, and they affect and are affected by each other. Works work when they inform vision; inform not by supplying information but by forming or re-forming or transforming vision; vision not as confined to ocular perception but as understanding in general. (Goodman, 1983: 11)

To find our feelings about and our vision of "our worlds" "transformed" and "re-formed" is to experience upheaval of familiar understandings, styles, norms, and the meanings these support. Is this not the very "seduction and danger" of art that Plato banished from the ideal republic? (Hauser, 1983: 308). The fact is that human beings resist and fear transforming their "understandings" as much as they may welcome it. To understand that resistance and fear, it is necessary first to understand why familiar meanings are essential to us and tenaciously held.

Every experience of novelty and ambiguity challenges our abilities to make it meaningful. Until we do, we are unsure of how to act and of what to expect. Until we are sure, we experience unease, tension, anxiety, fear, sometimes panic. Our ability to tolerate ambiguity is singularly limited, yet so is our capacity to find meanings. Only in the realm of the arts, as we reflect on facets carved with deliberate ambiguity, have we become accustomed to welcome it—and there, it takes continual practice and the special assistance of teachers, critics, docents, and catalogues. Studying poetry, literature, music, and the visual arts trains us to celebrate ambiguities. They call on our negative capability, John Keats termed it—"when man is capable of being in uncertainties, Mysteries, doubts without any irritable reaching after fact and reason—so strong is the human bent for sharp, positive definition. Irritation is the least of the visceral feelings ambiguity, uncertainty, and the confusions of novelty prompt. Out of fear, we vanquish ambiguities, as though they were a plague.

How humans are constituted biologically accounts for the strategies we use to do so. Those strategies have much to do with the ideas through which we constitute the clarities and meanings we act on, for it is these ideas that novelty and ambiguity threaten. Shared meanings are as important to survival as every other resource within an ecological niche, and if the ideas animating them are threatened, so are they.

Like finely articulated spines, meaning systems are backbones to acting: Slipping a single disc realigns meanings, weakening our ability to act on them. When this happens a sequence of neurophysiological responses we call fear and distress is set in motion. All mammals have these responses, but, uniquely, humans transform them into social disdain, disvalue, disparagement, abuse, stigmatizing, prejudice, and avoidance. These are social manifestations of the autonomic distancing and resistance we call fear.

Why can threats to meanings evoke responses no less intense than threats to survival? How we make meanings is key. Because our constructions of social and cultural worlds are wholly dependent upon meanings, they cannot be accounted for with the same methods that account for the realities of stars, atoms, and genes. To

natural scientists, each object in nature has an intrinsic, inherent essence which it is their work to distinguish from every other—oil from water, elms from oaks, salmon from perch. Their taxonomies are to be grounded in verifiable or disprovable differences among essences. To cultural scientists, underlying systems of ideas, beliefs, and values generate our lived-in worlds and what we make of matter and materials; that is the hermeneutic premise. Finding the connections between signs and the ideas they stand for to the members of any given group is the work of semiotics (from *semeion*, Greek for "sign"). Not essences, nor classes, but filaments—those connections out of which webs of meanings are spun are the subjects of cultural inquiry. Its search for signs starts by ploughing semantic fields in which each term bears a relationship to every other, each a "fragment of a system" through which the complete system can be "envisaged."

> Where ordinary logic talks of classes the logic of relatives talks of systems. A system is a set of objects comprising all that stand to one another in a group of connected relations. Induction according to ordinary logic rises from the contemplation of a sample of a class [of objects] to that of the whole class; but according to the logic of relatives it rises from the contemplation of a fragment of a system to the envisagement of the complete system. (Peirce, in Singer, 1978: 210)

The position of one fragment puts us in mind of its connections to others; by contrast, ordinary logic sends us searching for a closed class in which to include it.

I call the "connected relations" in a system of meaning "predicates": These are the silent concepts on which we predicate our choices and our actions. Smiling and frowning, for example: Our system of facial expressions uses these physical signs to express our predicates Approval and Disapproval. American conventions allow that a smile stands for Approval or Understanding, and a frown, Disapproval or Doubt. Each is again a fragment embedded in a still larger semantic field, so that we may not know what a person's smile means and know thereby how to respond, unless we have also seen his smirk, which members of this culture are likely to read as a sign of Conceit, or grin, Triumph; or simper, Self-indulgence; or sneer, Ridicule; or leer, Lust. If any one sign is ambiguous, we are confused about our appropriate response. (These predicates—Approval, Conceit, Triumph—themselves connect the fragments of other semantic fields: *Meaning* is labyrinth.)

When we see the painting of a face whose features are distorted and do not find these customary signs, we are in the dark about how to respond. The distortions may turn our attention to the signs we expected, which we would not otherwise think twice about. The anatomical distortions prevalent in the works of those who are mentally ill and those who speak consciously in the idiom of gross distortion (Bacon and Giacometti, for example) put us on the alert, and, like the more subtle exaggerations of classical art, they may lead us to see our taken-for-granted understandings in new light. All visual art relies on some degree of distortion, in fact, to arrest our

attention and lead us to think anew about the predicates we may associate with their subjects.

Our systems of meaning are such systems of predicates. By the thousands they tunnel beneath the surfaces of everyday life. Making our actions possible, they make our world meaningful. Until we can envisage the place of a fragment—whether an action, event, person, idea—within a familiar structure of predicates, we are puzzled about how to act and react. In providing the felt coherence of daily life, meaning systems define our equilibrium, cultural and biological. Novelty and ambiguity upset it.

Comfort and coherence take priority neurophysiologically: With freezing and flight responses, the brain autonomically permits us *to continue to act on the basis of what already has meaning.* When unable to flee, we will tend to "fight," to express hostility in one form or another. Or we carve out clarity by standing fast and not making room for what is new: Resistance and denial are "freezing" responses to whatever we see as discrepant to the meaning systems we live through. Instead of accommodating what is unfamiliar, the brain's strategy is to keep clear what is already clear to us with an array of responses for keeping ambiguity and its uncertainties at bay.

Neurophysiologically, these responses are as autonomous as breathing. The degree of difference between what is known and what is unfamiliar defines the intensity of the response: Small differences the brain experiences as pleasurable stimulation; large differences, as fearful. The profound effects of art and all that it may do to change our "understanding in general," as Goodman puts it, we do not, then, experience only benignly or positively.

The neurophysiology of fear suggests that biologically we are constituted to learn and not to learn simultaneously. The brain seems to be inherently limited in its capacity both to integrate ambiguity, discrepancy, and novelty above some threshold and to relink the chain of associations they break into (Gray, 1971, 1982; Hebb, 1946, 1955). Whatever it perceives to be novel, discrepant, and strange, the brain responds to with behaviors of pain, frustration, and fear, which are functionally and physiologically equivalent. The brain's physiology sets the limits: Equilibrium is the brain's ideal state (some call it a basic "drive"), and motor behaviors of avoidance and immobility are mammals' main strategies for maintaining it (Hebb, 1946; Brehm and Cohen, 1962: 224–225).

Fear is "learned" in the sense that "other things have been learned first." For example, human infants exhibit "stranger fear" not at birth, but only after the brain develops its "match-mismatch" capacity (Hebb, 1946: 244; Konner, 1982: 223). Furthermore, the number of meaning systems ("belief systems," "world views," "mind sets," "tapes") the brain keeps in working memory seems to be limited, so that much else can be perceived as novel. Gradually, as we learn, less is novel, of course. But fear of novelty diminishes as humans mature for another reason: We

gain the ability to read cues of potentially unfamiliar, frustrating, and disrupting experiences, the better to avoid them in the first place (Hebb, 1955: 256).

Humans' responses are under the control, therefore, not of what is new and unknown but of what is already known. An established commitment to a course of action, to a set of beliefs, to the meaning systems of a group, to those perceptual configurations we call "classical" and to the expectation of a "golden mean"—these constitute equilibrium. Its degree of disruption calibrates pleasure or pain. Mild fear and frustration can be pleasurable, as when learning or playing games and viewing art and hearing music not too "far out" from a golden mean.

Because the human brain relies on visual stimuli more than any others, art takes its privileged place in both pleasure and distress. "Changing the way we look at things" as the mission of art will succeed only if the change is not too great, if it can pass the censorship of our habits of looking. So it is that the very "deviations" and "discontinuities" that are the hallmarks of art can be painful for some audiences and supremely pleasurable for others, depending on their aesthetic experience.

Where there is discomfort, we are prone to transfer it to its stimulus. Resistance, avoidance, hostility, disparagement, and stigmatization are some of the judgments that our fear response takes; delight, pleasure, and inspiration are judgments that "just enough" disequilibration arouses. Discomfort with ambiguity, strangers, novel information, new experiences—and unusual and avant-garde art—is not a response to these per se, however, but to the meaning systems they invade. We take novelty as a sign that, to assimilate it, the predicates now providing us with reliable meanings will be realigned and uncertain. We fear that this realignment will impair our ability to act and to predict the actions of others. Only then do these signs become objects of distress, in one degree or another, and to them we transfer discomfort in the form of resistance and hostility. These are the processes that fashion our "bad ways," as Hauser puts it, of appreciating artistic and many other kinds of innovation.

Restating the history of art as a history of intentional "discontinuities" or, in the terms of this biology of meaning, discrepancies from what was once familiar and meaningful, Morse Peckham suggests that human beings actively seek out limited discontinuities as "rehearsal" for the jolts to our expectations life inexorably presents. "Art is rehearsal for those real situations in which it is vital for our survival to endure cognitive tension. . . . Art is the reinforcement of the capacity to endure disorientation so that a real and significant problem may emerge. Art is the exposure to the tensions and problems of a false world so that man may endure exposing himself to the tensions and problems of the real world" (Peckham, 1965: 314). That people seem more likely to experience the discontinuities of art than to accept social and cultural change suggests that it is less painful to rehearse than to revise meaning systems.

Music's "variations" and "deviations" from familiar "style systems" account for its impact (Meyer, 1956: 54, 289). In music, the "customary or expected progres-

sion of sounds can be considered as a norm, which from a stylistic point of view it is; and alteration in the expected progression can be considered as a deviation. Hence deviations can be regarded as emotional or affective stimuli" (Meyer, 1956: 32). This biology of meaning accounts for that well-observed sequence of events and, as well, for the tiny audiences for modern music.

To manage the tension between familiarity and novelty is an important calling of critics and historians; they smooth novelty's path by situating it against the familiar works it plays off of, to reduce our resistance. Museums' tape tours and publications intensify aesthetic experience by relating it to our other experiences, and, at the same time, they protect us from the unpleasure of too much unfamiliarity and dissonance.

RECEPTION BY EUROPEAN AND UNITED STATES CRITICS

Critics' responses to the first traveling exhibitions of the Prinzhorn Collection within the past decade reveal some of the dynamics of the human encounter with novelty and ambiguity. I find in them the twin threads of distancing and resistance. The European tour in 1980 and 1981 included Heidelberg, Hamburg, Stuttgart, Berlin, and Munich, and, in Switzerland, Basel. A selection from the collection toured the United States in 1984 and 1985, shown only at university museums: Krannert Art Museum at the University of Illinois-Champaign/Urbana; the Lowe Art Museum at the University of Miami in Coral Gables; the David and Alfred Smart Gallery of the University of Chicago; and the Herbert E. Johnson Museum of Art, Cornell University. (All translations of the comments of German and Swiss critics and all comments of American critics are paraphrased or transformed into composites unless otherwise noted.)

Woven into these critics' shock, praise, wonder, delight, and bafflement are three motifs that show how little control even professional interpreters have over their distancing responses. Critics themselves may sometimes be aware of these issues: One European critic sees the collection's history as itself a metaphor for the insanity the normal person is so distanced from. He regrets that this most important collection had been left uncatalogued and neglected in the attic of a distant hospital and was never dealt with as art would be in a museum.

The first motif I find in comments of European critics: While the aesthetic qualities and evocative powers of these works are much remarked upon, critics tend not to discuss them in the same terms of analysis and comparison as they would use for "serious" works. Although critics see the works as fantastic treasures and truly autonomous new kinds of art, and praise the stitcheries and collages, they do not also discuss salient qualities such as the handling of color and line, a theme we might expect to find in appraisals of the works of noninstitutionalized artists.

That these are pictures that will follow us into our sleep, as one critic put it, is

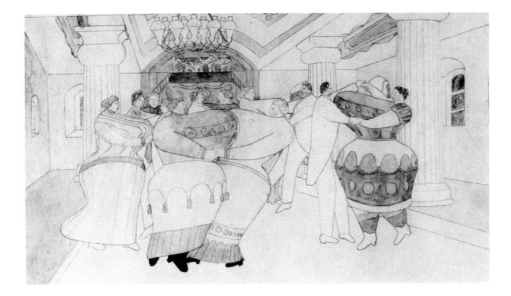

11.1. Gustav Sievers. *Dance* (22), pencil, pen, and watercolor on paper, height 7¼ in., length 10⅝ in. Prinzhorn Collection, Psychiatric Clinic, University of Heidelberg, Germany. Photo courtesy Krannert Art Museum.

the hope of every artist. But we hear little more about the feelings these images stir in the critics. Surprising pictures, they say, which impress us with strangeness, eeriness, ambiguity. They reveal a power of spontaneous expression with an extraordinary directness and authenticity admired by the protagonists of art brut, we are also told. Yet, instead of elaborating on aesthetic sources of these powerful effects, critics' attention shifts instead to the artists' psychopathology. Critics thus bar their works from consideration in critical discourse about matters such as color, light, and composition that are customary in explaining those effects.

We are not, then, to receive the powers of these works in the same terms as we do those that are allowed into that system of meaning we designate "the fine arts." Weaving "insane art" into the same system of meaning by which the fine arts are interpreted, the critics imply, will threaten it. For one critic, viewing the world of the mentally ill is, borrowing an image of Freud's, like taking a trip in a totally closed carriage moving through a park of wild and menacing animals; the glass separates and protects us so that we experience this art as something quite other. Critics seem to avoid coming to terms with the spontaneous distress those images may elicit in their own labyrinths of meanings, both aesthetic and experiential.

A second motif is a recurring call for biographical material about each artist-patient, to provide concordances to the meanings of their images. So personal and so individual are these works that it would be embarrassing, if not immoral, to char-

acterize them from an aesthetic point of view, critics say. I see this as a quest for familiarity; in others' lives there will be experiences we can recognize, and knowing their details will enable us to trace out the art's otherwise opaque associations and implications.

But do we look to the biographies of designated artists whose work captivates and puzzles us? No. When designated artists represent the irrationalities, contradictions, indeed insanities, of our supposedly rational world, we do not depend on their life credentials as a condition of responding. Having had their images fitted into a developmental line in various aesthetic systems, these artists receive critical immunity. Because the works of the insane are deemed to follow no such line, they are doubly discrepant. Trying to understand this paradox, critics say that Prinzhorn himself was able to recognize the accomplishments of these patients only because, having a happy acquaintance with the new art of his time, he had already defamiliarized himself (I would put it) vis à vis classical traditions.

Finally, European critics acknowledge the shattering impact of these works and in the next breath dispatch them to the consulting room or to the academy. This exhibition, some say, belongs not in an art museum but in a university. Viewers must not take the exhibition as sensational, but as a key to be used carefully for the medical insights and questions it can help to resolve. The exhibition offers aesthetic information, of course, and medical enlightenment as well, in the opportunity to make detailed comparisons between the elements of style of healthy and ill creators. In this variation on the motif of resistance, critics objectify and devalue these works as "medical records." (Prinzhorn specifically disavowed the diagnostic value of these works; his central concern was with the ways they might illuminate general properties of the psyche and its "configurative process," defined as those forming and shaping capabilities that even severe mental illness does not debilitate.)

For European critics, the emotional impact of the art of the Prinzhorn Collection resonates with that of Expressionism, Surrealism, and art brut because it echoes nuances of great modern art. They do not, however, comment on the anachronism. The art may evoke the same feelings as serious art does, but for these critics, knowing that these artists are insane, the artistry of the mentally ill belongs more in the consulting room than in the realm of serious art.

Turning now to the comments of critics in the United States: One motif is their dilution of the force of the collection. By drawing parallels with "much of the art in vogue today," in terms of its "repetition, serializing, obsessiveness," they use the present to defuse the impact of what they have distanced into the past.

> The purity and unexpected imagery of its works continue to have urgency to artists now. . . . But [in contrast to its impact in its early years] the collection also looks very different in 1985. After R. D. Laing, Michel Foucault and a sustained, ongoing struggle to establish voices for those who had previously been silenced or repressed, after a century in which irrationality, breaking rules and cultivating extreme states of mind have

become so commonplace that they are themselves rules and conventions, the Prinzhorn Collection looks a good deal more tame. With their spatial dislocations, large heads and vast anxiety and panic, the works now seem almost mainstream. (Brenson, 1985: H27)

From our perspective it is difficult to get the same charge out of these works that must have electrified the surrealists 60 years ago, although some people today may get a kind of voyeuristic thrill out of, presumptively, peeping into the minds of madmen. (Moehl, 1985: 66)

American critics struggle with the clinical issues the collection raises in several ways. One is to quote experts in psychiatry and art history who explain how and why the works are and are not art. These works, critics say, are often eerie hallucinations, worthy of study for those interested in the deviant pathways of the mind. Even as strange creations, they remain art, capable of affecting us deeply and unable to be dismissed as mere products of derangement. But why this art is moving or even why it is strange—through what arrangements of form, color, line, subject—we are left to imagine. In this clinicization, I see resistance not only to experiencing the art in aesthetic systems of meanings, but to analyzing it as well.

Critics evoke the madness and suicide among artists throughout history as one way of situating these unfamiliar works in familiar territory; they name Goya, Gorky, Pascin, Munch, Rothko, and Van Gogh, among others, as having lived on, if not crossing and recrossing, the borderline of sanity. They may be thus "tainted" but they are nevertheless "talented."

Finally, only the poet John Ashbery comments on the medicalizing of the works. Writing in *Newsweek,* he notes that the collection is appearing only in university museums. (It is a fact that several art museums had chosen not to house it during the tour, one that Brenson makes only a slight gesture toward: "It is unfortunate that the exhibition did not come to New York City" [Brenson, 1985: H30].)

Coming in the midst of a vogue for would-be "sick" art whose conviction often seems dubious at best, the Prinzhorn collection is a shocker: it's like suddenly encountering a real wolf after having one's ears numbed by cries of wolf. . . . [T]his show has got to be one of the most exciting anywhere at present. The fact that it is confined to a few university art galleries is significant: major museums are no doubt more comfortable offering watery approximations of this apocalyptic imagery than the raw alcohol of the real thing. (Ashbery, 1985: 61)

Romanticizing as a distancing strategy is also commented on, and although not subscribed to, these remarks illustrate how difficult it is to give up.

It is now harder to romanticize outsider art and impossible to believe that the art of children and the mentally ill holds a key to a lost Eden of human wholeness and unmedi-

11.2. Adolph Nesper. Untitled (628), pencil on cardboard, height 11½ in., length 17 in. Prinzhorn Collection, Psychiatric Clinic, University of Heidelberg, Germany. Photo courtesy Krannert Art Museum.

ated expression, the Prinzhorn Collection nevertheless remains remarkable. Its works are radically honest and ceaselessly inventive. (Brenson, 1985: H27)

Even the most casual observer of contemporary art is aware by now that the expressionist comet has made one of its periodic rendezvous with the planet earth, unleashing all manner of spooks, demons and hobgoblins on a delighted and receptive public. . . . A drawing of an open, upraised hand with an eye gazing impassively from the tip of one finger, it could serve both as an invitation and a warning to the viewer. For the lure of this work is strong, but so is the terror of the unanswerable riddles it proposes. (Ashbery, 1985: 61, 63)

American critics thus struggle with the question of whether the works in the Prinzhorn Collection are art and their makers artists. Although it had been "hoped and believed that through the cracks of their disordered minds might pour forth revelations" about the origin and nature of human creativity, it "is up to the individual viewer to decide" (Moehl, 1985: 66).

Situating the works in the period when they were made, between 1880 and 1920, "when there was an unprecedented curiosity about human experience that functioned outside the established conventions of the industrial world," Brenson refers to Gauguin in Tahiti and to Ensor, who "peeled off the surface of domestic life

and found suspicion and delusion." Pursuing the outsider theme further, Brenson says:

> As different as the works are in style, they share certain characteristics. They are not self-conscious. There is no sense that the images went through any process of planning or verbalization before they poured onto canvas or paper. Part of what makes the collection so moving is that a deep need to communicate is invariably combined with a conviction that no one was going to look or listen. We constantly feel the presence of the outside world in these works, but rarely as a reality independent of the patient and almost always an inaccessible and unresponsive power. (Brenson, 1985: H27)

Brenson's half-page review in a Sunday edition of the *New York Times* carries the headline, "The Need to Communicate in a World That Does Not Listen." In suggesting that "sane" art making is a social act in which these patients could not participate, Brenson is himself convinced that they lived "with a conviction that no one was going to look or listen." Can we presume that? Is this the critic's own resistance in play, believing that he is only voyeur and not intentionally being drawn into their pain and, not often acknowledged in these reviews, into their wit and their wisdom? "There's a difference, of course, between the willed fantasies of sophisticated artists and the compulsive expressions of sequestered mental patients," comments John Ashbery. "As Prinzhorn puts it, 'the loneliest artist still remains in contact with humanity, even if only through desire and longing. . . . The schizophrenic, on the other hand, is detached from humanity, and by definition is neither willing nor able to re-establish contact with it. If he were, he would be healed'" (Ashbery, 1985: 61). Or is it *our* unwillingness to establish contact with the content of the art, which, after all, according to just about every review, packs an emotional wallop?

The unwillingness goes hand in hand with gestures of admiration. "The Prinzhorn show is not an easy one to absorb. In the end there is an impenetrable quality to the work that puzzles and tantalizes. To say the least, this is like no other exhibition of folk, outsider, insider, or isolate art, and it is unlikely that a show with the same power and impact will come along soon" (*Folk Art Finder* 1985: 5). Why do critics reveal little about their difficulties in "absorbing" the works or about their reasons for feeling puzzled, terrorized, and intrigued?

The content of these artists' concerns is also closed off. The content is said to reveal only "psychological essences" but not cultural and social commentary. "The authenticity of much modern art—that is, our belief in it—depends on a largely unexamined article of faith: that the artist's gestures, as revealed in paintings and drawings, for example, somehow reveal an inner psychological essence. The Prinzhorn Collection provided early and powerfully convincing evidence for such a belief" (Lyon, 1985: 22). Yet the contents of many images parallel those of Goya, Daumier, Toulouse-Lautrec, Picasso, Saul Steinberg. Psychologizing the content keeps us from acknowledging the truth and justice of not only these artists' social perceptions but, in that process, our own as well.

Critics, historians, and artists call on several perspectives in approaching the art of the mentally ill. Anthropologically and psychologically, they view it as evidence for the species' "primitive," or nonlogical, mind; socially, they place it as "outsider art"; and aesthetically, they associate it specifically with Surrealism. These are also additional manifestations of distancing and resistance, I suggest. Moreover, these readings imply our culture's understandings of civilization, of reason, of "insider art," and of realism.

"The folk—as producers of works of art, in contrast to the artist who consciously plans—belong in the same category as the child, the primitive, the psychopath and the animals. All these beings who work instinctively are mere vehicles that are not the drivers of their talent" (Hauser, 1983: 574). This bespeaks a system of meaning in which intentional, conscious Planning and Control—that is, Reason—distinguish "artists" from "producers," just as they distinguish adults from children, civilized from primitive peoples, the sane from the insane—and humans from animals. Reason, Intention, and Control are predicates more important perhaps than any others by which Western civilization constitutes both meaning and value in the human domain.

Anxious distancing has a long history in Western thought about "primitive" peoples. Until just a few decades ago nonliterate peoples had been classified by an implicitly disparaging evolutionary scheme in which "lower" and "higher" characterized the human species and the varieties of human societies. Western civilization stood at the apex of an implied scale of "social fitness." We know now that no matter their time in history, all humans are equally members of the same species and that "simple" and "complex" are sufficient to distinguish between types of social structure. Yet even those terms are inadequate. The variegated meaning systems through which the hundreds of human groups live are invariably intricate, ingenious, and difficult to translate into our own (limited) conceptual repertoire; "simple" continues to mislead.

"Primitive" is often, then, an epithet that serves to distance us from our fellows. To replace this sense of an "outsidership" of "primitive" people with an appreciation of the far plainer facts of human otherness and similarity, we need to enter empathetically into ethnographic representations of the beliefs and practical routines of exotic peoples. But where "primitive art" is showcased, we are likely to see artifacts with little reference to their contexts and cosmologies and unlikely to read any warnings that these works must be situated to be understood as more than mute specimens.

Sometimes museum curators promote exoticism, remoteness, and outsidership. The leaflet distributed at the 1984 exhibition "Primitivism in 20th Century Art: Affinity of the Tribal and the Modern" at the Museum of Modern Art announces:

Our exhibition . . . focuses not on the origins and intrinsic meanings of tribal objects themselves, but on the ways these objects were understood and appreciated by modern artists. The artists who first recognized the power of tribal art generally did not know its sources or purposes. They sensed meanings through intuitive response to the objects, often with a creative misunderstanding of their forms and functions.

In a telling misprint, the booklet goes on to say:

The impact of tribal art on Western culture first honors the great inventive powers of the tribal artists; their objects have transcended the contests [sic] of their own societies, demolishing Western presumptions linking human potential to technological progress. It also honors the modern artists who subverted their own received traditions in order to touch the force of things radically unfamiliar.

"Contexts" is misspelled as well as misapprehended.

Having dispensed with information about contexts of belief, ecology, and practice from which "primitive" artists took inspiration and gave these artifacts their life, this exhibition concerns itself solely with abstracted "affinities" of line, mass, and form in "technological," not semantic, translation. Missing from the exhibition's running commentary is the "force" of *concepts*, whether unfamiliar or familiar. For it is the meaning systems embedded in ritual and social contexts that give primitive art its vital and compelling aesthetic energies. The booklet puts these works at even further remove: "Nothing in Western (or Eastern) art prepared modern artists for the otherness of tribal art. Yet they were moved by it, and we are too, precisely because we see something of ourselves in it—a part of ourselves that Western culture had been unwilling to admit, not to say image, before the twentieth century." Yet none of the exhibition's many commentaries uses primitive art's content or context to suggest just what it is of ourselves that we see in it—our experiences of life's cycles or of the sacred, for example.

That alien aura around "primitive art" is put there by Western civilization's preoccupation with maintaining comfort and equilibrium (the homeostasis of the familiar). On home ground, these sculptures, masks, body paintings, headdresses, weavings, architecture, and spatial arrangements serve and symbolize their makers' daily social worlds. Like ours, these worlds are structured through myriad meaning systems. Because our knowledge of most preliterate societies depends on reports made in "the ethnographic present"—the slice of time the anthropologist spent in them— their origins and histories remain mostly matters for speculation. Being without history is not, however, the same as being without context. Yet beyond specialist circles, "primitive art" is not likely to be deciphered through its contexts, which, there can be no mistake about it, make the art; for where the contexts tatter, the art also comes apart. Until we understand those contexts, by grasping (as best we can) the predicates constituting the systems of meaning within which the works were originally pro-

11.3. Oskar Herzberg. *Dancing Pair* (3954), watercolor, color pencil, and pencil on paper, height 13¼ in., length 8⅜ in. Prinzhorn Collection, Psychiatric Clinic, University of Heidelberg, Germany. Photo courtesy Krannert Art Museum.

duced, we apprehend little more about "primitive art" than its formal qualities and technical energies. As many "avant-gardes" await as there are non-Western cosmologies. Is it because these other systems of meaning are founded on predicates likely to call ours into drastic question that we keep our distance by leaving them unknown?

Even in anthropology, Other peoples, surprisingly enough, remain a challenge that has also been resolved by distancing them temporally with evolutionary notions. They are, of course, entirely contemporaneous with the field-workers living among them. Anthropologists find with "exasperating predictability" that a well-read public has learned to rely on anthropology to help it keep its distance. "I am surely not the only anthropologist who, when he identifies himself as such to his neighbor, barber or physician, conjures up visions of a distant past. When popular opinion identifies all anthropologists as handlers of bones and stones it is not in error: it grasps the essential role of anthropology as a provider of temporal distance" (Fabian, 1983: 30).

In Johannes Fabian's fine ethnography of this distancing within anthropology,

he documents the many ways that, in the terms of this discussion, this discipline deals with the stress of encompassing unfamiliar systems of meaning and conduct. As deeply as anthropologists are able to immerse themselves and absorb differing meanings, they do go home again to live within the meaning systems that yield their life, their equilibrium. But this distancing role that Fabian characterizes as our professional "illness" and "a festering epistemological sore," I instead see as our way of coming to terms with unacknowledged human limitation. For while it may be the anthropologist's creed that "nothing human is foreign to us," we do not also promise to remain unaffected.

The psychological makeup of primitive peoples is also believed to rely more on "primary processes" than "secondary," as is the psychology of schizophrenics, children, and, many have had it, artists and women. The "primary process" of the brain, as Freud named it, is our capacity for dreaming, for untutored, diffuse thinking, and for perceiving uncomplicated similarities. (At his first lectures, audiences fled.) This "primitive" constituent is gradually dominated by a "secondary process" of learning and habituation to concepts and images and, in our case, Western systems of deduction, induction, and causality. People lacking these secondary capacities of foresight and inference we regard as helpless and dependent. Children gradually gain these capacities; schizophrenics lose them. But cross-cultural studies of cognitive processes strongly suggest that there is no cultural group that "wholly lacks a basic process such as abstraction, or inferential reasoning or categorization" (Cole and Scribner, 1974: 193). These capacities may be only differentially stressed, depending on the social context and the kinds of situations a people habitually deals with.

In preliterate peoples' myths and classifications of nature and social experience, Claude Lévi-Strauss claims to have established the presence of another kind of logic, a "science of the concrete" by which unlettered peoples acquire, remember, and transmit knowledge by relying on their experience with material qualities such as color, sound, size, taste. From these they develop elaborate series of analogies, homologies, and metaphors (much as literate people do) through which they rotate their understandings from one domain of life into every other. Do these same processes enter into the configurative capacity evident in schizophrenic art? Discussing the complex, totemic classifications of preliterate peoples, Lévi-Strauss asserts:

> We must therefore alter our traditional picture of this primitiveness. The "savage" has certainly never borne any resemblance either to that creature barely emerged from an animal condition and still a prey to his needs and instincts who has so often been imagined nor to that consciousness governed by emotions and lost in a maze of confusion and [magical] participation. The examples given [of totemic classification] are evidence of thought which is experienced in all the exercises of speculation and resembles that of the naturalists and alchemists of antiquity and the middle ages: Galen, Pliny, Hermes, Trismegistus, Albertus Magnus. . . . From this point of view "totemic" classifications are probably closer than they look to the plant emblem systems of the Greeks and Ro-

mans, which were expressed by means of wreaths of olive, oak, laurel, wild celery, etc., or again to that practised by the medieval church where the choire was strewn with hay, rushes, ivy or sand according to the festival. (Lévi-Strauss, 1962: 42)

We are closer than we have liked to think to the "primitive mind."

"Outsider art" is the second perspective through which critics make their readings of the art of the mentally ill. This characterization is inherently paradoxical: Serious artists certainly do volunteer themselves for outsidership, yet this role is falsified once we have heard who they are. By the time we see their works, others, making place for them in the art market and museums, have seamed them back into society. Not only that, these "outsiders" tend to find one another and merge into movements—the Chicago Imagists, for example, our homegrown fantasists, "outsiders" to the First City (Schulze, 1972).

Their membership in a social universe of shared meanings differentiates normal artists from schizophrenic artists. That is the decisive difference for Prinzhorn.

> It is essential to all art to seek resonance in other men, to be understood as it is intended. The certainty of such resonance supports every artist and nourishes his creative urge. The confidence that "the world" will at least someday happily accept what the misunderstood artist, though filled with contempt for it, creates, lies behind even the most distorted, negative attitude toward the public. Given this outlook on the world, the loneliest artist still remains in contact with humanity, even if only through desire and longing, and the desire for this contact speaks to us out of all pictures by normal people. The schizophrenic, on the other hand, is detached from humanity, and by definition is neither willing nor able to reestablish contact with it. If he were he would be healed. We sense in our pictures the complete autistic isolation and the gruesome solipsism which far exceeds the limits of psychopathic alienation, and believe that in it we have found the essence of schizophrenic configuration. (Prinzhorn, 1972: 266)

It is neither reason nor consciousness, then, which divides schizophrenic works from those of serious art, but rather the "consistency" and "integration" of "a superior conception" which the artist intends to convey *in the belief that an audience exists to receive it*. In understanding serious art as expressing a search for "resonance" in others, which schizophrenics are by definition incapable of, Prinzhorn asserts his criterion for all that would be considered art: that it is supremely social.

For having unconsciously and unintentionally manipulated space, form, and color, among other artistic processes that preoccupy artists and historians of art, the works in the Prinzhorn Collection are considered to be outside the meaning system of "the fine arts," which is to say, the one that artists and critics live through. But the placement of these works is less clear in terms of their aesthetic and emotional effects. To consider them as being intentionally "outsider art" I find a cruel romanticism, prima facie evidence of resistance to their powerful and distressing visions. Involuntary debilitation is not a willful act of anarchy.

Last, critics, historians, and artists associate the artistry of the mentally ill with Surrealism, Dada, fantasy art, and romanticism. All, they say, are engaged in breaking down sharp distinctions between reality and dreams. Surrealism parallels the anthropological enterprise, in fact, being engaged in "a continuous play of the familiar and the strange." Ethnographies reveal that for any predicate or custom of ours, says James Clifford, a historian of anthropology, there is "always an exotic alternative, a possible juxtaposition or incongruity. Below (psychologically) and beyond (geographically) any ordinary reality there [exists] another reality" (Clifford, 1981: 542). In giving voice to the signs of silent predicates, Surrealists suggest that

> beneath the dull veneer of the real [there is] the possibility of another, more miraculous world based on radically different principles. . . . The Surrealists frequent the Marche aux Puces, the vast flea market of Paris, where one could rediscover the artifacts of culture, scrambled and rearranged. With luck one could bring home some bizarre or unexpected object, a work of Art with nowhere to go . . . objects . . . stripped of their functional context. . . . Surrealism is ethnography's secret sharer—for better or worse—in the description, analysis, and extension of the grounds of twentieth-century expression and meaning. (Clifford, 1981: 542–543)

In manipulating such ordinary things, artists rearrange our systems of covert predicates, our cultural premises. In dreams we expect juxtapositions and incongruities, but not in waking life. In drawing attention to these premises and predicates, Surrealists and schizophrenic artists lead us to recognize that we, too, sometimes call them into question. Being human and uniquely endowed with intuition, insight, and the capacity to imagine alternatives, we can do no other than to exercise them. To recover the equilibrium they can upset and to distance from their distressing consequences, our culture places higher value on "reality" and on the faculty of reason that is said to allow us to know it.

For when Reason's priority is challenged by Feeling, Intuition, Insight, and Imagination, distress can afflict both humanists and scientists. Even scientists studying diverse and unusual human behaviors which require their empathy and self-awareness may instead anxiously remove themselves "from the fellowship of mankind" and join "the cult of objectivity" (Devereux, 1968: 154). "The more anxiety a phenomenon arouses, the less man seems capable of observing it correctly, of thinking about it objectively and of evolving adequate methods for its description, understanding, control and prediction" (3). The more anxiety, the more distance.

In fact, Surrealism only appears to have left reason behind. To read Dubuffet, whose work was more directly inspired by the Prinzhorn Collection than that of any other artist, is to learn how thoroughly reasoned artistic conceptions can be. First speaking of landscapes he once made—"a vast expanse of land, or, equally . . . a minute particle of earth drawn to scale"—Dubuffet goes on to explain others made in "a completely different mood . . . landscapes of the brain."

They are no longer—or almost no longer—descriptive of external sites, but rather of facts which inhabit the painter's mind. These are landscapes of the brain. They aim to show the immaterial world which dwells in the mind of man: disorder of images, of beginnings of images, of fading images, where they cross and mingle, in a turmoil, tatters borrowed from memories of the outside world, and facts purely cerebral and internal—visceral perhaps. . . . One will find also, among these pictures, certain ones called Stones of Philosophy, which represent only a large stone. These come from the idea, expressed before, that the movements of the mind, if one undertakes to give them body by means of painting . . . have something in common—are close relatives perhaps—with physical concretions of all sorts, as if there were not there two different orders, but rather two different modes of the same order, with possibilities of all combinations from one to the other. (In Selz, 1962: 71, 72)

Insisting exclusively upon external reality and denying internalities is another way of distancing from the very products of imagination that can unsettle so much. At the worst, we read pathology into art (another way of attacking the imagination for distressing us), and, at the least, we resist it by compartmentalizing into "two spheres of existence" where there is only one: "The quality which is completely unique and which characterizes surrealism most emphatically consists in the composition of its material, on one hand, of elements which correspond to empirical experience and, on the other, of a supernatural hallucinatorily unreal or unconsciously irrational reality. There are two spheres of existence here side by side—a world and a superworld—and two styles—realism of details and irrationality of a whole" (Hauser, 1983: 696). Irrationality is, of course, as real as rationality.

The power of the artist as social critic to "re-form" and "transform" our predicates, as Hogarth, Goya, Daumier, Picasso, the Dadaists, all have attempted to do, is not exercised mysteriously. They intend to upset us. More subtle is the relationship art bears to our daily replenishment of equilibrium. To be receptive to art requires an "expenditure of courage and decision," Arnold Hauser elegantly argues:

In an important work of art, existence is rid of its confusion and its provisional nature: its disconnected and dispersed fragments merge into a clearly structured, sensible pattern; if inner contradictions do not always modulate to satisfying harmonies, the contradictions and conflicts which fill the work are not suppressed and silenced but shown for what they are, and the crisis which underlies them comes to a head. This resolution of tensions and crises does not, however, merely mean that the artist has triumphed over agonizing chaos, that he has achieved a formal success which affects him alone; his triumph also affects the listener or the spectator with a purifying power and an imperative which no manipulation of mere forms could produce. Just as the creation of a significant work of art bears witness to power and the will to withstand the dangers of uprooting and disintegration which threaten life, adequate reception of the work presupposes a similar expenditure of courage and decision on the part of the audience. Whoever approaches the work properly feels inspired to measure up to its demands that he take his life and himself seriously, that he come to an understanding with himself to

order the circumstances of his life, to clean up all that is ambiguous and murky both in himself and in his environment, just as the artist has done with worldly things. The artist's "order" is apparently not just a formal aesthetic but a moral achievement. Order cannot be exhausted by a merely sensual experience of form. Every real work of art, as a formal structure, represents a refutation of l'art pour l'art theory. The moral appeal and the humanistic message which art conveys do not consist of special recommendations and express prohibitions but of calls to adopt a serious, calm, and reasonable attitude to the world, to life, and to everything which living together with other people implies. (Hauser, 1983: 323–324)

Reestablishing equilibrium with the help of artists' "resolution of tensions and crises" and our experience of its "purifying power" relies on art's associations with much else in our personal and social lives. But the irrevocable irony is that these associations lead us not only to "courage and decision," but, less nobly yet outside of awareness, to resisting and distancing.

RECEIVING ART'S RESONANCES

Understanding art by means of its reception implies understanding culture itself. For what people find meaningful determines what will make them curious and pleased, anxious and fearful, distant and hostile. The reception of new, unusual, and difficult art—in all the arts—depends on interpreters who will speak as much to the culture as to the works of art, as much to their implications for shared concepts and experience as to their emotional singularities and their positions within current aesthetic systems. The number of such interpreters is small, and those who have taken Marx and Weber to new ground smaller still; self-contained readings have won the day (signs of distancing, perhaps). The public's "bad ways" will persist until critics cushion the resonances of new and difficult ideas by situating and relating them to the socially shared predicates we take so much for granted that they are rarely taken apart, even by critics themselves.

The artists who live alongside us, enmeshed in the same systems of meaning, are dedicated both to celebrate them, and, in some degree or another, to doubt them with contradiction, discontinuity, deviation, and novelty. Speaking to us in signs, artists can only invite us to enter into their doubts, and we can accept only insofar as our own "capacities" for deciphering them permit.

The artist works with his audience's capacities—capacities to see, or hear, or touch, sometimes even to taste and smell, with understanding. And though elements of these capacities are indeed innate—it usually helps not to be color-blind—they are brought into actual existence by the experience of living in the midst of certain sorts of things to look at, listen to, handle, think about, cope with and react to; particular varieties of

cabbages, particular sorts of kings. Art and the equipment to grasp it are made in the same shop. (Geertz, 1983: 118)

Why shared meanings in general are so important to us I have suggested. Our American meaning systems, in all their "particular varieties," are constituted by nothing less than the history and archeology of Western social thought and the cumulative experiences of the peoples of this continent. While the anthropology of American predicates qualifies as a less-developed country, I hazard a few provisional and speculative ideas about what some of our "equipment" is—the cultural apparatus—with which we "grasp" art.

Abstract art flourishes through our contemporary capacity to have no doubt that there is more to it than meets the eye. We have witnessed atoms; we do not doubt that they are real enough to come apart. Models of DNA come to life; we can see genes splicing. The metaphors of formulae (and black holes) will turn out to be no less real, we are likely to think, than the plain facts of smiles and frowns. What Expressionists were earlier said to have deformed, violated, and distorted we would today suggest reveals their emotional essences and inner structures. We might even be skeptical that there are in the first place "phenomena" unconstituted by imposed meanings, and acknowledge that ours are but a few among many possibilities.

Our accelerating enchantment with technologies surely accounts for our capacity to be so overwhelmingly engaged by technique. So it is that the academicism of artists' experiments with pure color and pure form can also flourish. The appeal of "primitive" artists and of some of the work in the Prinzhorn Collection is due to their pyrotechnics.

Reason does indeed remain the supreme predicate by which we insist on distinguishing ourselves from animals and from those among us who are emotionally and mentally deranged, but its urgency in the context of this end of the twentieth century has far different sources than it had in the middle of the last. Then, reason was urgently required to calm the distress of the confrontation between familiar Genesis and novel Darwin: Were human beings made by God in one day or by millennia of apes' couplings? The overriding concern of both creationists and evolutionists was to set this species apart from other animals as uniquely masters of our instincts. Now we are hoping against hope to master what reason has wrought. Rationality and logic are supposed to save us from both the wild aggression that could make nuclear holocaust and the ordinary human imperfections that may cause nuclear accident. Yet each time our own or our bank's computer crashes, we have no choice but to contemplate the perils reason cannot banish from the social systems that weapons and all technical systems are implicated in. Reason's priority needs to be put into greater jeopardy, if only to open up space for acknowledging understanding and knowledge as socially mediated.

The presumed incompatibility of reasoned and intuitive knowledge is often used in accounting for the differences between artists' and scientists' natural capabilities,

as well as those of men and women. Yet why do we consider reason superior to intuition?

> To use one's reason is to formulate a body of principles that is independent of, and yet common to, every human activity. One shows that one knows something by being able to subsume the important points in a neat system of laws. . . . If one cannot systematize one's insights, either one is considered incapable or non-rational or, if one's skills are really exceptional, it is assumed that one's understanding is derived from intuitive knowledge. The formulation of a body of principles is said to depend on the use of reason and is thoroughly systematic, while intuitive understanding, although it is sometimes capable of achieving much, is attained by an act of divination, as it were; and since it depends primarily on the *individual's* powers of perception, cognition, and so on, it is deemed unreliable. . . . [But] science is not an absolute gauge of what counts as knowledge . . . [for] a preoccupation with laws and theories—with scientific method— may reveal lack of intelligence and deep thought. . . . I suggest that the real difficulty is the inveterate conviction of our culture that a man has not thought hard about an issue unless his thought has culminated in a sophisticated system of laws and theories. (McMillan, 1982: 34, 42, 44, 45)

The possibility that the unconscious and its products are as valuable as reason leaves unresolved, Gregory Bateson suggests, "the problem of grace." He sees it as "fundamentally a problem of integration . . . [of] the diverse parts of the mind— especially those multiple levels of which one extreme is called 'consciousness' and the other the 'unconscious.' For the attainment of grace, the reasons of the heart must be integrated with the reasons of the reason" (Bateson, 1972: 235). Is it this very problem of grace, then, that these mentally ill artists are seeking to solve, as they reveal their struggle to integrate in painting and drawing minds shattered into pieces and hearts broken by disease?

Only if artists, humanists, and scientists strike out in search of the new, unusual, and difficult can they bring the work of the world to higher ground. They must act without fear, yet they leave others trembling. We call their fearlessness creativity. Our own, for receiving their messages, needs no less cultivation and courage.

AUTHOR'S NOTE AND ACKNOWLEDGMENT

A version of this essay first appeared in the catalog prepared for the first United States tour in 1984 and 1985 of selections from the Prinzhorn Collection of the Art of the Mentally Ill at the University of Heidelberg: *The Prinzhorn Collection* (Champaign, Ill.: Krannert Art Museum, University of Illinois at Urbana Champaign, 1984). There, I commented on German and Swiss critics' responses to the collection's first European tour in 1980 and 1981, and here, I add commentary on the exhibition's reception by United States critics and make editorial changes as well.

The United States tour of the Prinzhorn Collection of the Art of the Mentally Ill was organized by Stephen Prokopoff, then Director of the Krannert Art Museum of the University of Illinois-Urbana/Champaign. The exhibit opened there and traveled to the Lowe Art Museum at the University of Miami, the David and Alfred Smart Gallery of the University of Chicago, and the Herbert E. Johnson Museum of Art, Cornell University. Support was received from the National Endowment for the Humanities, the McCloy Fund of the American Council on Germany, the Illinois Arts Council, and The Goethe Institute. I am grateful to Stephen Prokopoff for insisting that the catalog should bring my concerns to bear.

BIBLIOGRAPHY

Ashbery, John. 1985. "Visions of the Insane: A Haunting Treasure Trove of 'Mad' Art Goes on Tour." *Newsweek*. February 11.

Bateson, Gregory. 1972. *Steps to an Ecology of Mind*. San Francisco: Chandler Publishing Co.

Brehm, Jack W., and Arthur R. Cohen. 1962. *Explorations in Cognitive Dissonance*. New York: Wiley.

Brenson, Michael. 1985. "The Need to Communicate in a World That Does Not Listen." *New York Times,* June 23.

Clifford, James. 1981. "On Ethnographic Surrealism," in *Comparative Studies in Society and History,* Vol. 23.

Cole, Michael, and Sylvia Scribner. 1974. *Culture and Thought: A Psychological Introduction*. New York: Wiley.

Devereux, George. 1968. *From Anxiety to Method in the Behavioral Sciences*. The Hague: Mouton.

Fabian, Johannes. 1983. *Time and the Other: How Anthropology Makes Its Object*. New York: Columbia University Press.

Folk Art Finder, 1985. Vol. 5, no. 5. January/February.

Geertz, Clifford. 1983. "Art as a Cultural System," in *Local Knowledge: Further Essays in Interpretive Anthropology*. New York: Basic Books.

Goodman, Nelson. 1983. "The End of the Museum?" *New Criterion,* Vol. 2, no. 2

Gray, Jeffrey A. 1971. *The Psychology of Fear and Stress*. Cambridge: Columbia University Press.

———. 1982. *The Neuropsychology of Anxiety: An Inquiry into the Functions of the Septo-Hippocampal System*. New York: Oxford University Press.

Hauser, Arnold. 1983. *The Sociology of Art*. Translated by Kenneth J. Northcott. Chicago: University of Chicago Press.

———. 1951. *The Social History of Art: Naturalism, Impressionism, the Film Age*. Volume 4. New York: Vintage Books.

Hebb, Donald O. 1946. "On the Nature of Fear." *Psychology Reviews*, Vol. 53.

———. 1955. "Drives and the C.N.S. (Conceptual Nervous System)." *Psychology Reviews*, Vol. 62.

Konner, Melvin. 1982. *The Tangled Wing: Biological Constraints on the Human Spirit*. New York: Holt, Reinhart & Winston.

Lévi-Strauss, Claude. 1962. *The Savage Mind*. Chicago: University of Chicago Press.

Lyon, Christopher. 1985. "From Disturbed Minds Come Creative Treasures." *Chicago Sun-Times*, April 14.

McMillan, Carol. 1982. *Women, Reason, and Nature*. Princeton: Princeton University Press.

McNamara, Katherine. 1982. "Paris Primitive." *Cultural Survival*, Fall.

Meyer, Leonard. 1956. *Emotion and Meaning in Music*. Chicago: University of Chicago Press.

Moehl, Karl. 1985. "Selections from the Prinzhorn Collection of the Art of the Mentally Ill." *New Art Examiner*, January.

Peckham, Morse. 1965. *Man's Rage for Chaos: Biology, Behavior, and the Arts*. Philadelphia: Chelton Books.

Peirce, Charles S. 1978. Quoted in Milton Singer, "For a Semiotic Anthropology," in *Sight, Sound and Sense*, ed. Thomas Sebeok. Bloomington: Indiana University Press.

Prinzhorn, Hans. 1972. *The Artistry of the Mentally Ill*. Translated by Erich von Brockdorff. New York: Springer: Verlag.

Schulze, Franz. 1972. *Fantastic Images: Chicago Art Since 1945*. Chicago: Follett Publishing Co.

Selz, Peter. 1962. *The Work of Jean Dubuffet, with Text by the Artist*. New York: Museum of Modern Art.

Tomkins, Calvin. 1983. "The Art World: Seasons' End." *New Yorker*, July 18.

THE HISTORY AND PREHISTORY OF THE ARTISTS' HOUSE IN GUGGING

Leo Navratil

Translated by Agnès and Roger Cardinal

When I was working as a young psychiatrist in London in the winter of 1951–52, I came across a book by Karen Machover entitled *Personality Projections in the Drawing of the Human Figure: A Method of Personality Investigation* (1949). This discovery proved to be the starting point for my interest in the field of psychiatry and art, an interest which has lasted for decades. What Karen Machover deals with is the topic of figure drawings which people produce spontaneously at the instigation of the psychologist, and her argument is that such unprogrammed images constitute samples of genuine creativity wherein the individual's problems and conflicts find their distinct expression. The drawing activity she describes does not correspond to a psychological test in the strict sense, and Machover herself speaks simply of a method of investigation. Yet the investigation is carried out exactly like an experiment, under precise and constant conditions.

Early in my professional work as a doctor in the psychiatric hospital at Gugging-Klosterneuburg outside Vienna, I got into the habit of asking each new patient, after our initial interview, to do a drawing of a human being for me. If the figure turned out to be male, I would then ask the patient to draw a female figure on a second piece of paper. I kept up this practice over many years, so that many hundreds of such drawings accumulated in my files. The normal thing was for patients to produce their work in my presence. The materials used were rather basic: an ordinary pencil of medium hardness and a sheet of thin white cardboard of postcard size (4″ × 6″). The patients were given neither an eraser nor color pencils.

I soon began to ask patients to make drawings at regular intervals during their stay at the hospital, and always under the same conditions. Striking mutations would

often emerge in the sequence of such drawings. These were often unmistakably linked to alterations in the patients' clinical condition, but at other times were more difficult to account for. The drawings proved to be a valuable complement to the usual methods of clinical observation. They offered a picture of the patient which was quite different from the one derived from conversation, which in any event revealed the personality and the psychological state from a different angle. These findings were particularly helpful in the therapeutic approach to cases of psychosis.

I devoted several technical articles to the link between the healing process and the drawings, and became increasingly fascinated by the possibility of using such drawings as an investigative tool. Now it was that I came across the key texts by Walter Morgenthaler (1921) and Hans Prinzhorn (1922); I also read a good deal about art, notably the studies of mannerism by Gustav René Hocke (1957), and began a book of my own on schizophrenia and art (1965). While working on this, I came across an article in a medical journal by the Swiss psychiatrist Alfred Bader, called "Bilder von Irren—Spiegel der menschlichen Seele" (Drawings of the deranged—mirrors of the human soul) (1958). It made a big impression on me, and I at once wrote to the author, telling him of my project for a book. There ensued a correspondence which became the cornerstone of a friendship and a working relationship which have lasted to this day (Bader and Navratil, 1976). Bader was instrumental in transforming my initial interest in the drawings as a diagnostic tool into a wider interest in general issues of creativity and the relationship between art and mental disorder.

In 1965, in my book *Schizophrenie und Kunst* (Schizophrenia and art), I made this statement about my patient Franz: "The artist inside him *was* his psychosis." In light of his psychotic condition, I was able to demonstrate that whereas the aptitude for drawing remained constant, conventional representations were being replaced by new and extraordinary images corresponding to an altered and heightened interpretative experience. To exemplify this, I show here three drawings made by Franz. one produced in the normal state, the other two during his illness [12.1].

The spirit of the time seems to have been particularly receptive to my ideas, and in 1966 I published *Schizophrenie und Sprache* (Schizophrenia and language), in which for the first time I brought before the public the poems of my patient Alexander (whom we now know by his true name, Ernst Herbeck). The people most attracted to this subject matter proved to be practicing artists, and thus it was that I got to know the Viennese painters Georg Eisler, Ernst Fuchs, Alfred Hrdlička, Oswald Oberhuber, and Arnulf Rainer; of the younger generation, the most enthusiastic were the members of the group which Otto Breicha had exhibited at the Vienna Secession Gallery in 1968 under the title *Wirklichkeiten* (Realities)—notably Wolfgang Herzig, Kurt Kocherscheidt, Peter Pongratz, Franz Ringel, and Robert Zeppel-Sperl. I also got to know the painters Eduard Angeli and Loys Egg. Among contemporary writers, it was Peter Handke, Ernst Jandl, Gert Jonke, Friederike Mayröcker, Reinhard

12.1a

12.1b

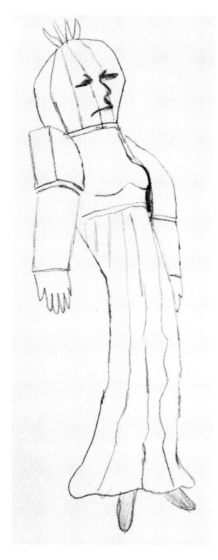

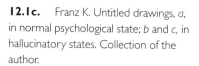

12.1c. Franz K. Untitled drawings, *a*, in normal psychological state; *b* and *c*, in hallucinatory states. Collection of the author.

Priessnitz, and Oswald Wiener who came to visit us at the Gugging hospital in those early days.

Had I not made the acquaintance of such prominent Viennese painters at that time, I fear there would today be no artistic production at Gugging. It was they who inspired me; it was from them that I learned to select what was artistically relevant. Their interest and enthusiasm gave me the perseverance and strength to persuade my patients to write or draw every day, and even to produce books about what they were doing and to organize their own exhibitions.

From the outset it was the patient Johann Hauser who inspired everyone's admiration. But my painter friends also found items of artistic interest among the many "test drawings" I had collected. They did not seem to mind that these were really

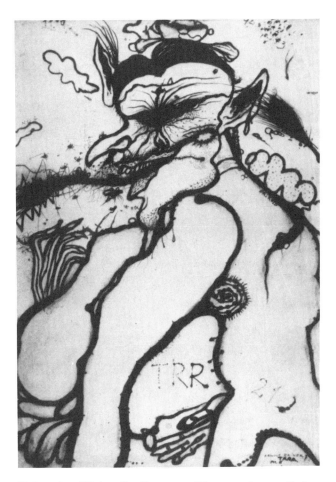

12.2. Arnulf Rainer. *Der Fliegenesser* (The man who eats flies), 1966, offset lithograph, 36 in. × 25 1/2 in. Collection of the author.

unpretentious pencil sketches. The artist particularly taken by the works of my pa-
tients was Peter Pongratz, who presented me with me a copper plate and an etching
needle, thereby launching me into the medium of etching. However, the greatest in-
fluence was Arnulf Rainer. He already had considerable knowledge of the field, hav-
ing assembled an important collection of works by mental patients, and was always
most assured in his judgments. (Even Rainer was apt to be subjective; he tended to
prize the drawings of those artist-patients with whom he felt a certain affinity. Apart
from Hauser, he favored Franz Gableck, Fritz Koller, and Max. He had respect for
draughtsmen like Otto Prinz and, later, Johann Garber, but personally he was not so
taken by their work.)

On May 18, 1966, I received in the mail a color lithograph by Arnulf Rainer
entitled *Der Fliegenesser* (The man who eats flies) [12.2]. As I unrolled the large

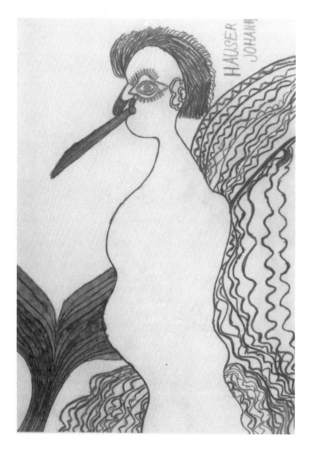

12.3. Johann Hauser. *Devil,* 1966, pencil and red felt pen, 17 1/4 in. × 12 1/4 in. Collection of the author.

sheet, Hauser, who was standing next to me, exclaimed: "Oh, how ugly! Fancy painting such an ugly picture! Isn't that the devil?" Hauser could scarcely have laid eyes on the image for more than a moment before I rolled it up again, replacing it in its cardboard tube and taking it home. On August 17, 1966, I asked Hauser to draw me the picture of a man. He was in a hypermanic mood and came up with an image of the devil [12.3]. What is so striking about his picture is its uncanny resemblance to Rainer's *Fliegenesser.* The receptivity to physionomic impressions, which was highly developed in Hauser, along with his manic excitement, had enabled him—probably without his recollecting the image at all clearly and possibly even quite unconsciously—to reproduce in his own drawing the highly provocative features of *Der Fliegenesser.* In my 1978 study of Hauser, I describe the connection between his creative impulse and his manic and depressive states, illustrating this with many examples from his work (Navratil, 1978). Later on I became acquainted with the drawings of the schizophrenic Heinrich Anton Müller, who had been in the Waldau Asylum near Bern at the same time as Adolf Wölfli. I was struck by the similarity between Rainer's *Der Fliegenesser* and Müller's portraits [12.4]. Whether Müller's

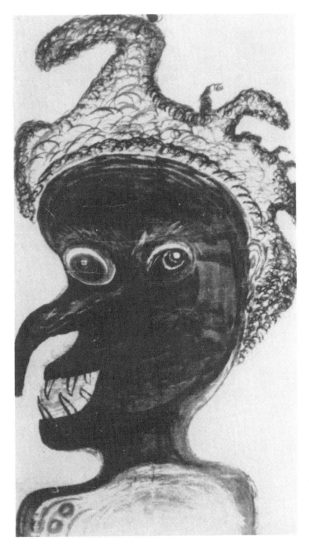

12.4. Heinrich Anton Müller. *Personage with Long Hooked Nose,* ca. 1917–1922, gouache, crayon, and pencil, 19¾ in. × 31½ in. Collection de l'Art Brut, Lausanne, Switzerland.

drawings had previously been unconsciously and unintentionally absorbed into the work of Arnulf Rainer, I do not know; but in any case I consider this an issue of secondary importance insofar as all three drawings seem to me works of exceptional artistic merit.

Through Alfred Bader I came into contact with the Société Internationale de Psychopathologie de l'Expression, which had been launched in Verona in 1959 by Dr. Robert Volmat, Bader, and others. In 1965, I helped to establish its German-speaking section, and in 1969, organized the society's conference in Linz. My publications had already wakened the interest of a considerable number of Viennese artists, and I was able to entice those I had come to know personally to take an active part in the society's conferences. Thus in September 1969 many artists—Ernst Fuchs,

Alfred Hrdlička, Arnulf Rainer, Walter Vogt—gave papers, and several prominent Viennese writers were in the audience. In this way, a highly significant boundary had been breached in what had hitherto been a topic dominated by medicine. Art and psychiatry had begun to develop a mutual influence which was also of mutual benefit.

In 1969 I began to correspond with Jean Dubuffet, the coiner of the term *Art brut*. Dubuffet was to take a most lively interest in the twelfth issue of the publications of the Collection de l'Art Brut, which came out under the editorship of Michel Thévoz in 1983, with the title "Gugging" (Thévoz and Roulin, 1983).

Walter Morgenthaler and Hans Prinzhorn are the true pioneers who inspired my work, though I have to admit that I felt much closer to the former than to the latter. Morgenthaler's monograph on Adolf Wölfli, *Ein Geisteskranker als Künstler* (A madman as artist), which had to wait half a century before achieving its due recognition, had first appeared in 1921. Luckily, I was able to correspond with Morgenthaler, and he was kind enough to suggest amendments to the essay on Wölfli which appeared in my *Schizophrenie und Sprache*. Toward Prinzhorn's extraordinary achievement—in less than three years he had established his collection and written his masterpiece—I felt less of a spontaneous affinity, given his geographically distant relationship to the patients whose work he had accumulated. It seemed to me that my position had been correctly understood when the curators of the Prinzhorn Collection, Inge and Ferenc Jádi, wrote that "many decades later, Morgenthaler's approach was to be perfectly reconstituted in the thoughts and deeds of Leo Navratil" (Jádi, [1986]).

I have never made a secret of the rather painful fact that my work (not unlike that of Morgenthaler) has excited exceedingly little response within psychiatric circles. Psychiatrists have just not become interested in the art of their patients. There is one exception: Professor Manfred Bleuler, who succeeded his father Eugen Bleuler as the longtime director of the University Psychiatric Clinic in Zurich.

On July 18, 1970, Monsignor Otto Mauer, director of an art gallery next to the Cathedral of St. Stephan, came to visit us. In the postwar years his gallery had become the outstanding forum for avant-garde artists in Vienna. Mauer was much impressed by the drawings of the Gugging patients and had no qualm at all about exhibiting them. He insisted on setting things up on a proper commercial basis, since he thought it axiomatic that any artistic endeavor deserves proper remuneration. Our first exhibition, and also our first attempt to offer works for sale, took place in the St. Stephan Gallery and ran from September 29 to October 25, 1970. Fourteen patients had produced etchings which fetched good prices, and there were also sales of hand-colored etchings. The Gugging artists visited the exhibition on its second day, together with their relatives and friends. The exhibition was commercially very successful and was favorably reviewed. The director of the Albertina, the Viennese Graphics Collection, acquired a complete set of the etchings. The gallery itself was honored with a prize relating to this and other exhibitions.

Many Gugging artists—among them, Josef Bachler, Franz Gableck, Johann Hauser, Johann Korec, and August Walla—were featured in an exhibition entitled "Zeichnen Heute" (Drawing today), organized by Alfred Hrdlička and held at the Vienna Secession Gallery during the 1971 Vienna Festival. In 1972 there was another exhibition of drawings in the St. Stephan Gallery. In 1975 and 1976 Gugging artists were to show their work in the Kulturhaus in Graz, in the Neue Galerie in Linz, and at the Theater am Kornmarkt in Bregenz, for which itinerant exhibition Otto Breicha compiled a catalogue with the title *Der Himmel Elleno* ("Elleno heaven," a phrase taken from a poem by the Gugging patient Ernst Herbeck) (Breicha, 1975).

In 1977 a substantial body of poems by Ernst Herbeck appeared under the title *Alexanders poetische Texte* (Alexander's poetic texts); the volume included critical contributions by Otto Breicha, Roger Cardinal, André Heller, Friederike Mayröcker, Ernst Jandl, Reinhard Priessnitz, and Gerhard Roth (Navratil, 1977). The artist Friedensreich Hundertwasser sent us a postcard to say that he was "deeply impressed by Alexander's texts."

For twenty years I lived with my family in the Gugging hospital outside Vienna. Among my own son's paintings can be found portraits of Otto Prinz, whom my son had known since childhood, as well as several paintings of Ernst Herbeck [12.5], whom he particularly revered.

In 1979 our draughtsmen were invited to participate in the "Outsiders" show sponsored by the Arts Council of Great Britain and held in the Hayward Gallery in London. Johann Hauser, Dr. Josef Bittner, and I flew to London, where we met Victor Musgrave and Roger Cardinal, the exhibition curators, as well as Monika Kinley, who later became director of the Outsider Archive. Between 1979 and 1981 Hauser exhibited in the Lenbachhaus in Munich, in the Kunsthalle in Cologne, in the Collection de l'Art Brut in Lausanne, in the Kulturhaus in Graz, in the Neue Galerie in Linz, and in the Museum of Modern Art in Vienna.

Because of the extraordinarily cramped conditions in the hospital, it had for a long time been very difficult for me to receive visitors who wanted to meet our artists. The department of which I was director was housed in a building about a hundred years old. It had once been intended to accommodate fifty patients, but during my time it often housed one hundred beds and more. In this building, known as Pavilion Number Two, I had my office, a small and sparsely furnished room. I had moved a table near to the window so that two patients sitting on either side could work there [12.6]. Everyone would sit around this table when I was introducing artists to visitors. At these gatherings, Ernst Herbeck might read some of his poetry aloud, or the artists would sign and present their catalogue; I encouraged each to assert his individuality and his art in an appropriate way.

By the end of the 1970s the reputation of the Gugging artists had made its way far beyond the frontiers of the province of Lower Austria. Our progressive director, Dr. Lois Marksteiner, undertook to transform Pavilion Number Eleven, which had fallen empty, into an art center and to place it at the disposal of the Gugging artists

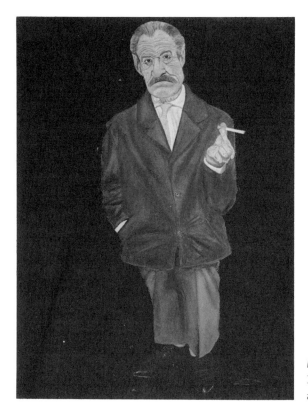

12.5. Walter Navratil. *Portrait of Ernst Herbeck*, 1983, oil on canvas, 31 1/2 in. × 25 1/2 in. Collection of the author.

as both a working and a living space. By spring 1981 this had been accomplished. The old pavilion was renovated and newly furnished, and we were able to move in and start decorating it with pictures. We invited Kurt Steyrer, at that time Austrian health minister, to formally open the center on June 9, 1981, on which solemn occasion Dieter Ronte, director of the Museum for Modern Art in Vienna, gave an address.

I consider it almost a miracle that our center ever saw the light of day. As a rule, reforms tend to materialize because of public pressure inspired by examples from abroad. However there was no precedent elsewhere for this Haus der Künstler, our Artists' House; it was something entirely unique. Naturally there were plenty of voices which spoke out in protest at the idea of making over an entire pavilion to such an extraordinary and, in many people's eyes, superfluous enterprise. It was Dr. Marksteiner who, to counter those skeptics who sought to place obstacles in our way, presented them with a *fait accompli* by ensuring that the center was launched in such a public and official manner. It is he also who appointed in 1983 Dr. Johann Feilacher, who, following my retirement in 1986, has continued to run the establishment in the spirit of its inception.

12.6. Joseph Bachler and Johann Hauser at work in the author's office.

There are in the Artists' House no draughtsman's studios or regulated timetables for artistic activity. Drawing and writing take place in an entirely individualistic way in response to personal disposition or external stimulus. The corridors and rooms are decorated with several hundred works by the Gugging artists. On the ground floor there are two small permanent sales rooms. The hospital sells the paintings for the patients who have made them, in strict accordance with the stipulations of their legal representatives. The institution and its employees are merely go-betweens and derive no financial or economic profit from any transaction. Since the artistic activities are unsubsidized, patients who have earned money through the sales of their work can buy their own drawing materials. They also have more pocket money and, in some cases, use substantial amounts for personal acquisitions. Johann Hauser, for one, contributes to his own upkeep. But the marketing of the work also has ideological implications for the hospital. If drawings it considers to possess artistic value fetch a commensurate price, then it has confirmation that such work is being considered on a par with work by other artists. Moreover, it sees here a sign that in the outside world the creators of such works are recognized as true artists and can therefore aspire to the same rights and expectations as the professionals.

In front of the Artists' House flies a flag with a blue star. This blue star on a white field, a favorite motif of Johann Hauser, has become the symbol for the enter-

prise. In 1983 and 1984 the south-facing façade was repainted. The workmen erected an enormous scaffold and covered the wall with a white undercoat, whereupon each of the twelve artists painted one of his typical motifs onto the wall of the house.

The Artists' House is situated at the far end of the hospital complex, indeed somewhat "outside" its actual boundary. This situation should also be understood figuratively. In a certain sense, the artists, as well as the nursing personnel, remain outsiders. The Artists' House, that old pavilion covered in individualistic images, represents a sort of contrary pole to the ordinary departments housed in the modern buildings. Whereas in other parts of the hospital the principle of "normalization" holds sway, associated with notions of healing, resocialization, and rehabilitation, the creative efforts of the artist-patients thrive precisely because of their deviation from the norm, drawing sustenance from those very psychological conditions which psychiatry ordinarily attempts to eliminate. What the hospital is doing in the Artists' House is not preparing patients to re-enter society in the role which once was theirs, but rather offering them a new social identity and, as Alfred Bader has put it, affirming their identity *as artists* after all the years of anonymous institutionalization.

The fact that the Artists' House does not fit too easily into the hospital framework has had its positive side. Patients who have been interned for many years no longer feel they are prisoners. They are looked after within a family setting such that the psychological effects of institutionalization gradually fade away. Visitors and friends alike no longer feel they are visiting a hospital and are at ease within the environment. In this sense the Artists' House has become a "Noah's Ark" and a "domistic form of communal life," that is to say, a community which in many ways corresponds to that "domistic" philosophy described by Horst von Gizycki in his book on "lived utopias." The terms *domistic* and *domism,* coined by Gizycki, are derived from the Latin *domus,* meaning house, dwelling place, sojourn, home, and also, as the author points out, in a wider sense, peace (Gizycki, 1983).

I have always strongly felt, and have declared as much to the outside world, that the Artists' House is not a model case. In its defiance of the norms of social psychiatry and social psychology it is historically unique. This is due to the fact that the people concerned seemed to me more important as individuals than for the characteristics they happened to share. It is also due to the fact that the Artists' House at Gugging had a prehistory much longer and favored by an even luckier star than its actual history. All in all, our house can be said to share many features with that ideal domistic community which Gizycki so memorably evokes [Pl. 10].

ACKNOWLEDGMENT

This essay originally appeared as "Zur Geschichte und Vorgeschichte des Hauses der Künstler in Gugging," in *Von einer Welt zur Andern: Kunst von Aussenseitern im Dialog,* edited by Roman Buxbaum and Pablo Stähli (Cologne: DuMont, 1990).

BIBLIOGRAPHY

Bader, Alfred. 1958. "Bilder von Irren—Spiegel der menschlichen Seele." *CIBA-Symposium,* no 6, 152–155.

Bader, Alfred, and Leo Navratil. 1976. *Zwischen Wahn und Wirklichkeit: Kunst-Psychose-Kreativität.* Lucerne and Frankfurt: Bucher.

Breicha, Otto, ed. 1975. *Der Himmel Elleno: Zustandsgebundene Kunst,* exhibition catalogue, Kulturhaus Graz.

Gizycki, Horst von. 1983. *Arche Noah '84: Zur Sozialpsychologie gelebter Utopien.* Frankfurt on the Main: Fischer.

Herbeck, Ernst. 1992. *Im Herbst da reiht der Feenwind. Gesammelte Texte, 1960–1991.* Edited by Leo Navratil. Salzburg and Vienna: Residenz Verlag.

Hocke, Gustav René. 1957. *Die Welt als Labyrinth: Manier und Manie in der europäischen Kunst.* Hamburg: Rowohlt.

Jádi, Ferenc. [1986]. "Wer? Was? Wo?" in *Hans Prinzhorn und Arbeiten von Patienten der Heidelberger Klinik aus der Prinzhorn-Sammlung.* Heidelberg: Prinzhorn-Sammlung.

Machover, Karen. 1949. *Personality Projection in the Drawing of the Human Figure: A Method of Personality Investigation.* Springfield, Ill.: C. C. Thomas.

Morgenthaler, Walter. 1921. *Ein Geisteskranker als Künstler: Adolf Wölfli.* Bern and Leipzig: Bircher. 1992. *Madness and Art: The Life and Works of Adolf Wölfli.* Translated by Aaron H. Esman. Lincoln: University of Nebraska Press.

Murken, Axel Hinrich, et al. eds. 1989. *Künstler aus Gugging: Zur Art Brut der Gegenwart.* Oldenburg: Universität Oldenburg.

Navratil, Leo. 1965. *Schizophrenie und Kunst.* Munich: Deutscher Taschenbuch Verlag.

———. 1966. *Schizophrenie und Sprache.* Munich: Deutscher Taschenbuch Verlag.

———. 1978. *Johann Hauser: Kunst aus Manie und Depression.* Munich: Rogner & Bernhard.

———. 1979. "'Prinzhorn heute," in *Psychopathologie als Grundlagenwissenschaft,* edited by W. Janzarik. Stuttgart: Enke Verlag, 167–171.

———. 1983. *Die Künstler aus Gugging.* Vienna and Berlin: Medusa.

———, ed. 1977. *Alexanders poetische Texte.* Munich: Deutscher Taschenbuch Verlag.

Prinzhorn, Hans. 1922. *Bildnerei der Geisteskranken.* Berlin: Springer.

Thévoz, Michel, and Geneviève Roulin, eds. 1983. "Gugging." *L'Art Brut,* no. 12.

13

FROM DOMINATION TO DESIRE

INSIDERS AND
OUTSIDER
ART

Eugene W. Metcalf, Jr.

Self-discovery through a complex and sometimes arduous search for an Absolute Other is a basic theme of our civilization, a theme supporting an enormous literature: Odysseus, Aeneas, the Diaspora, Chaucer, Christopher Columbus, *Pilgrim's Progress,* Gulliver, Jules Verne, Western ethnography, Mao's Long March. This theme does not just thread its way through our literature and our history. It grows and develops, arriving at a kind of final flowering in modernity. What begins as the proper activity of a hero (Alexander the Great) develops into the goal of a socially organized group (the Crusaders), into the mark of status of an entire social class (the Grand Tour of the British "gentleman"), eventually becoming universal experience (the tourist).

—Dean MacCannell
The Tourist

Cultural identity is inseparable from limits, it is always a boundary phenomenon and its order is always constructed around the figures of its territorial edge.

—Peter Stallybrass and Allon White
The Politics and Poetics of Transgression

There are two alternating and yet complementary pulsations in our century's involvement with primitive societies and the idea of the primitive: a rhetoric of control, in which demeaning colonialist tropes get modified only slightly over time; and a rhetoric of desire, ultimately more interesting, which implicates "us" in the "them" we try to conceive as the Other.

—Marianna Torgovnick
Gone Primitive

213

In 1945, French artist Jean Dubuffet discovered a new kind of primitive art. Searching, like many early twentieth-century artists, for forms to free him from established social and aesthetic norms, for an art disconnected from civilized artifice and imposed traditions, Dubuffet found in Swiss mental hospitals the raw and seemingly uncontaminated materials he sought. For, as art historian John MacGregor has pointed out, Dubuffet "arrived too late on the scene to make use of African or Oceanic sculpture, or even of naive art such as the painting of Henri Rousseau. The art of the insane was, therefore, Dubuffet's 'primitive art'" (MacGregor, 1990: 12). Yet Dubuffet's discovery was not too different from Picasso's or Gauguin's. As my opening epigraphs suggest, "primitive" is just one of the many names we ascribe to those people whom we assign to the periphery (or outside) of our social world, and it is through such assignments that we construct and control not only those Others, but ourselves as well.

I chose the quotations which open this essay because they begin to suggest what I have long believed about Outsider Art, that it is not as "outside" as we would like to think it is. As Marianna Torgovnick says about the art of so-called primitives, the art of outsiders "implicates 'us' in the 'them' we try to conceive as the Other" (Torgovnick, 1990: 245). For if there are primitives or outsiders, there must be, by definition, civilized people or insiders who first define the primitive-outside as that which the civilized-inside is not. Concepts like "primitive" and "outside" can exist only in binary terms; each implies, and determines the boundaries of, its opposite.

As a projection from the inside, the outsider, as well as the primitive, might best be understood as an example of the cultural Other, a symbolic device by which powerful groups in modern Western society measure and know themselves through their perceived contrast with people whom they consider to be unlike themselves. Imposed on people who are defined as deviant because they are different from the group who has the power to do the imposing, the concept of the Other supports as normative the attributes of the more powerful group, and is used by that group to maintain its cultural identity by comparing itself, as Stallybrass and White suggest, to "the figures of its territorial edge" (1986: 200).

The binary nature of the Other is not uncommonly considered in the discussion of such groups. For example, with regard to those people called primitive, Marianna Torgovnick has argued:

> Those who study or write about the primitive usually begin by defining it as different from (usually opposite to) the present. After that, reactions to the present take over. Is the present too materialistic: Primitive life is not—it is a precapitalist utopia in which only use value, never exchange value, prevails. Is the present sexually repressed? Not primitive life—primitives live life whole, without fear of the body. (Torgovnick, 1990: 8–9)

The definition of the folk and their art has been considered similarly. According to folklorist Henry Glassie:

Our art, as described by its historians ... , as evaluated by its keepers ... , concentrates upon certain virtues. Folk art becomes its shadow. If we characterize our own art as more personal than collective . . . then folk art will appear to be more collective than personal. . . . If our art centers through pictorial or psychological realism upon the material world, appearing to be at least secular, then folk art will center through abstraction upon the spiritual universe, appearing at last to be sacred. (Glassie, 1986: 271)

Finally, as Edward Said has pointed out, even the concept of the Orient was developed as a designation for the Other. Defined by Occidentals, "the Orient has helped define Europe (or the West) as its contrasting image, idea, personality, experience" (Said, 1978: 2–3).

Outsider Art, however, has seldom been studied in terms of its relationship to the "inside." Still generally viewed in much the same way Dubuffet originally defined it in the 1940s, as the idiosyncratic, self-inspired product of bizarre social misfits and mental patients, Outsider Art, and the people who produce it, are thought to exist somehow apart from culture, in a state unaffected by the influences and pressures of normal social interaction. This view was first widely popularized in the English-speaking world in 1972 when Dubuffet's ideas were presented by British art critic Roger Cardinal in his book *Outsider Art* (1972), and was recently reiterated in the 1990 exhibition and catalogue *Portraits from the Outside: Figurative Expression in Outsider Art* (Carr, 1990). In both of these presentations, as well as in most of the writing about Outsider Art, there is little recognition of the social factors or groups which influence the binary existence of "outsiderness," and emphasis is placed instead on the artworks themselves and their aesthetic merit.

The purpose of this essay is to suggest how the consideration of Outsider Art might begin to include the insider. Drawing on a variety of texts which can be related, in one way or another, to the idea of the Other, I hope to stimulate consideration of a new model for Outsider Art that emphasizes its binary nature, its social meaning, and its relationships. My comments are preliminary; they represent not so much a developed theory or coherent view as a series of observations which, when drawn together, may begin to suggest a new way to approach this art form. For, it seems to me, in order to begin to understand Outsider Art, we must view it not as the solely aesthetic creation of individual eccentrics disconnected from culture, but as the symbolic product of a complex and ambiguous relationship between more- and less-powerful social groups, a relationship which helps map the boundaries and chart the nature of cultural identity.

A good place to begin a reexamination of Outsider Art as a social phenomenon is with the idea of the art world, a concept which, in recent years, has significantly influenced the study of another art of the Other, American folk art (Becker, 1982; Vlach and Bronner, 1986). According to this concept, the meaning of a work of art is not innate to the object itself. Instead, this meaning emerges through the process in which the object serves as a focus for the beliefs, ideas, and interactions of the

people and institutions which define and support the object as art. Thus, art is more fruitfully conceived as the result of a cooperative *activity* rather than as an unchanging *thing*. It is the product of a group of people, not an individual. Seen in this perspective, the meaning of Outsider Art is not to be found, as most critics and collectors of the art form believe, in Outsider Art objects themselves, or even in their makers, but in the interactions of those who support various objects as this kind of art, and in the social and cultural processes that underlie these interactions. Indeed, in this view, by maintaining the justifications according to which objects are called Outsider Art, perhaps supporters of the art form are themselves significant contributors (as insiders) to the interactive social system which gives meaning to the art.

While the concept of the art world suggests how Outsider Art can be viewed as a social entity and a part of social activity, sociologist Dean MacCannell's theory of tourism presents a model which illuminates a kind of social activity Outsider Art might be. In his book, *The Tourist* (1989), MacCannell shows how tourism, as a model for modern behavior and a means by which modern identity is established, is fundamentally concerned with establishing relationships between insiders and outsiders. According to MacCannell, mass tourism and its support institutions first developed as an international institution about the turn of the present century, at roughly the same time the modern idea of the Other was emerging through the development and professionalization of anthropology. The development of both anthropology and tourism was prompted, in part, by the emerging belief that the progress of modernity had come at a terrible cost. Modern society was thought to be overcivilized, repressive, and inauthentic. Modern people came to believe that naturalness and authenticity existed only in other places, periods, or cultures, and the discovery (and preservation) of these places and people became a desperate, modern preoccupation. According to MacCannell, this concern for a lost authenticity and nostalgic search for real experience is at the center of modern consciousness. "The deep structure of modernity is a totalizing idea, a modern mentality that sets modern society in opposition both to its own past and to those societies of the present that are premodern or un(der)developed" (MacCannell, 1989: 3, 7–8, 59). Because of this, MacCannell claims:

> The best indication of the final victory of modernity . . . is not the disappearance of the nonmodern world, but its artificial preservation and reconstruction in modern society. The separation of nonmodern culture traits from their original contexts and their distribution as modern playthings are evident in the various social movements toward naturalism, so much a feature of modern societies: cults of folk music, adornment and behavior, early American decor, efforts, in short, to museumize the premodern. . . . These displaced forms, embedded in modern society . . . establish in consciousness the definition and boundary of modernity by rendering concrete and immediate that which modernity is not. (MacCannell, 1989: 8–9)

In such a world, tourism has developed as a primary preoccupation of the middle class. A central ritual in modern, technological societies where leisure is displacing work as a means of self-identity, where experience seems fragmented and discontinuous, and where the individual often feels atomized and disconnected from previously sustaining traditional institutions and relationships, tourism has become a way of attempting to reconnect the now seemingly disparate and unrelated pieces of modern experience. Yet it is not just other people and places that are touristically experienced. As MacCannell mentions, both history and tradition have become tourist attractions as the past and earlier life-styles are scavenged and pieced together as antidotes to, and measures of, the present.

The social activity which supports Outsider Art can be illuminated by considering it in terms of MacCannell's model of tourism. In this perspective, one can suggest that through celebrating and viewing Outsider Art, some of its proponents may touristically journey, if only emotionally, to what they perceive as the farthest and most exotic reaches of human experience. Leaving behind the mundane world of objectivity, rationality, and even sanity, they can travel to a place beyond the dulling strictures of social expectation, beyond culture itself, to where, it is believed, one can glimpse images of the strange, frightening, and powerful forces that arise from the depths of human consciousness. Perhaps this explains why the outsider has long been envisioned in spatial terms, as the inhabitant of a place apart. To use Roger Cardinal's famous description, the outsider is an "isolated squatter" who lives in the "vast space" of the "territories which lie beyond [and] are off-limits to those who inhabit the . . . Cultural City." In this place the outsider is "enclosed in a radiant space of his own creativity. . . . Within the private space of the individual imagination, an alternative reality can be conjured up on which external facts can't encroach" (Cardinal, 1979: 21, 29). Indeed, as it is often popularly understood and presented by its proponents, Outsider Art might be seen, itself, as a kind of metaphor for modern touristic experience. Just as Dean MacCannell asserts that sightseeing is an attempt to pull together and unify the differentiated and disconnected experiences and things of modern life, so, one could argue, the critical and collecting activities which flourish around Outsider Art can be seen as an attempt to unify aesthetically a variety of modern symbolic gestures which are so radically different from each other that they can barely be contained. (Because works of Art Brut are thought to be so radically different from each other, they cannot, claims John MacGregor, even be said to make up a style, a school, or a movement. "Despite Dubuffet's sociological criteria, in every case the decision as to what is or is not Art Brut must be made on the basis of the work. . . . The decision is always very difficult!" [MacGregor, 1990: 12–13].)

Yet in attempting to contain different expressive forms by designating them Outsider Art, proponents of this art might be said to display another aspect of touristic behavior, that of controlling the lives and artifacts of others. For just as the tourist's

capacity to organize and integrate other people, places, and things into a touristic experience is related to the ability to control and subordinate those people and places, so, perhaps, the ability of cultural insiders to identify the diverse activity and artifacts of Others as "outsider" depends on a relationship of power.

Within their binary relationship, *inside* and *outside* are never equal terms. There is always an interaction of domination. As Peter Stallybrass and Allon White have argued in their book *The Politics and Poetics of Transgression,* in modern society the inside is normally associated with the most powerful socioeconomic groups existing at the center of cultural power. They demonstrate, exercise, and preserve their power through their ability to create and enforce the dominant definitions of normal and deviant, superior and inferior (Stallybrass and White, 1986: Introduction). The outside, on the other hand, is represented by the marginalized and colonized. Such groups do not have the power to define themselves within the system that marginalizes them and are known instead in the terms of the insiders—terms like *savage, primitive,* or *folk.* Indeed, in his book *Orientalism,* Edward Said has shown how the term *Oriental* was created as a consequence of the power differential between Europeans and the people of the Middle East.

> To believe that the Orient was created—or, as I call it, "Orientalized"—and to believe that such things happen simply as a necessity of the imagination, is to be disingenuous. The relationship between Occident and Orient is a relationship of power, of domination, of varying degrees of a complex hegemony . . . The Orient was Orientalized not only because it was discovered to be "Oriental" in all those ways considered commonplace by an average nineteenth-century European, but also because it *could be*—that is, submitted to being—*made* Oriental. There is very little consent to be found. (Said, 1978: 5–6)

Viewed from this perspective, the designation of the art of certain people as "outsider" can be a result (and even, perhaps, a cause) of their social disempowerment. Touristically seeking authentic experience beyond the boundaries of social convention through confrontation with the antimodern Other, some supporters of Outsider Art, it can be argued, transform mentally disturbed, impoverished, or simply isolated and unusual people into willful, antisocial heroes. To the extent that they symbolically celebrate the very people they have, by implication, socially disempowered by defining them as deviant, many supporters of Outsider Art romanticize and trivialize the marginalization of these people. Most reprehensibly, for those individuals suffering from mental illness, supporters of Outsider Art can seem to deplore the very therapies which might make these so-called outsiders better socially adjusted. According to Sam Farber, a collector and specialist in Outsider Art, in the case of institutionalized artists, because of the repressive nature of modern society, it is often the *removal* of an individual from "the pressures of society" which triggers "spontaneous outpourings of creative expression. [Consequently] these works [of

Outsider Art are] not examples of 'art therapy' as practiced today . . . where therapeutic intent is the primary motivation" (Farber, 1990: 7). Indeed, laments John MacGregor, in the case of the art of the severely mentally ill, "most images made by such individuals, especially now that treatment involves the use of anti-psychotic and mood altering drugs, and the procedures of art therapy, [are] simply amateur art; mediocre, cliche-ridden and dull" (MacGregor, 1990: 12).

One of the most common means by which the outside is subordinated to the inside is through the use of the modern, naturalized concept of time. How this relates to Outsider Art can be best understood by first examining the work of anthropologist Johannes Fabian, who, in his book *Time and the Other* (1983), shows how the modern concept of time became connected to our understanding of the Other, as this idea developed in modern anthropology.

According to Fabian, the development of anthropology must be understood as a political process in which the colonialist expansion of Western nations secured control over people who then became the subject of anthropological studies which justified Western domination by interpreting the dominated as primitive and savage. As important, however, is the fact that such studies also helped establish a general epistemology of domination, "an ideological process by which relations between the West and its Other, between anthropology and its object were conceived not only as difference, but as distance in . . . time" (Fabian, 1983: 147). Assigned to a separate temporal zone apart from that of the anthropological observer, the Other was distanced from contemporary activity and thus removed from the process by which he or she was represented.

Fabian's work shows how the modern, naturalized concept of time developed largely as a consequence of the influence of social evolutionary theory on anthropology in the late nineteenth century. According to this concept, time was no longer viewed as a structure to encompass the unfolding of Biblical history, as it had been in previous centuries, or even as a neutral way to order the geological and paleontological record according to the recently developed theory of uniformitarianism. Rather, it was viewed as a story of the progressive, evolutionary development of the social stages leading from savagery to civilization, a development which was now thought to be "natural," the outcome of the operation of scientific laws. This story temporally separated the Other from "civilized" researchers by suggesting that the Other existed in a prior developmental stage (Fabian, 1983: 12–15). Such a view of time would not only support colonialist ventures but also politicize all relationships between Westerners and their Others.

It promoted a scheme in terms of which not only past cultures, but all living societies were irrevocably placed on a temporal slope, a stream of Time—some upstream, others downstream. Civilization, evolution, development, acculturation, modernization (and their cousins, industrialization, urbanization) are all terms whose conceptual content derives . . . from evolutionary Time. . . . A discourse employing terms such as primitive,

savage (but also tribal, traditional, Third World, or whatever euphemism is current) does not think, or observe, or critically study the "primitive"; it thinks, observes, studies *in terms* of the primitive. *Primitive* being essentially a temporal concept, is a category, not an object, of Western thought. (Fabian, 1983: 17–18)

Although the social evolutionary theory which prompted the new naturalized time was eventually discarded, the view of time it spawned has remained in place and become widely diffused in Western society. As a basis for the way Westerners understand and relate to people whom they consider to be different than themselves, it maintains an "objective distance" from the subject of study. It found particular application in the developing passion for tourism and eventually, it seems to me, in the interest in Outsider Art.

According to Fabian, a variety of time frames are used anthropologically to conceptualize (and enforce) different relationships between the self and the Other. One of the most widely used of these, and one which has found frequent application outside the professional field of anthropology, is typological time. Typological time measures time not in terms of a period elapsed, but rather as the temporal interval between socioculturally meaningful events or things. Underlying such conceptions as traditional vs. modern, folk vs. fine, or primitive vs. civilized, it is not as much a measure of movement as it is an assessment of the meaning of relationships (Fabian, 1983: 23). Thus the high quality of civilization is assumed because it is temporally conceptualized in terms of the interval which is between it and the low quality of the primitive. The same epistemology determines the conception of the outsider. Conceived in terms of a relationship which establishes the meaningful quality of its opposite, the outsider is epistemologically assumed to be inferior, and is distanced to a time apart from that of the observer. Consequently, to paraphrase Fabian's previously quoted remarks about the discourse on primitivism, one might say that the discourse on Outsider Art does not really think about, observe, or critically study the outsider. It thinks, observes, and studies in *terms* of the outsider. The outsider being essentially a temporal concept, it is a category, not an object, of Western thought.

It is because the outsider may be a category, and not an object, of thought that it, and the other temporal concepts which describe the Other, are so difficult to understand as social rather than aesthetic phenomena. For, in this view, they are not *things* at all, but *epistemologies* which create and enforce certain types of hierarchical relationships. Thus the temporal (and spatial) conceptions by which outsiders are known, and for which they are celebrated, may be the very conceptions that distance and disempower them. Indeed, of all the Others conceptualized by modern Westerners, the makers of Outsider Art are the only group that are overtly celebrated, and even named, for their "distance apart," making them, perhaps, among the most disempowered of all Others. For example, not only does the language used to describe the outsider (which includes words like *primal* and *uncultured*) enforce temporal distancing, but the outsider is even said to be entirely disconnected from time. Ac-

cording to Farber, the outsider is cut off not only from the present, but from the "source of tradition" in the past as well (1990: 7).

Viewed in terms of values and ideas that are not their own, those designated as the makers of Outsider Art are, not surprisingly, generally characterized as socially disadvantaged. Thus, according to MacGregor, in addition to mental patients and eccentrics, outsiders also include those said to be "desperately poor and illiterate" (1990: 12). Yet despite this characterization, the suffering and difficulty that may be part of such peoples' lives are never considered when they are described as *artists*. "The outsider is jubilant: he really enjoys what he does," says Cardinal, referring to the artistic activity of the outsider, an activity which, Cardinal admits, because of the artist's social situation, may be "the only thing he enjoys." Yet by adopting the idea that the often terrible personal and social circumstances which may influence the production of Outsider Art are extraneous to understanding the art, and thus by celebrating Outsider Art as something which validates itself, critics of Outsider Art not only risk obscuring important ethical questions about the personal and social cost of the production of this art, but also risk seeming to valorize and romanticize those costs as the stimulus of the production of great art. Thus, we are told, when outsider artists sometimes complain about their situation, they may not really mean it. A possible explanation for the "occasional cases where an outsider complains of feeling himself under a compulsion . . . is that . . . the complaint is advanced as a species of alibi" to be blamed on society, suggests Cardinal. "Those who produce so prolifically encounter a social pressure to justify the absorption in their art. Since other people can be insistently curious or unconsciously jealous, it serves as a defense to maintain one is actually unhappy about one's creativity, and not responsible for it." Moreover, continues Cardinal, commenting on the art of Martin Ramírez, Ramírez "was at once a hospitalized schizophrenic and a mute. Yet, so it seems, deprivation can function as a mysterious prelude to enrichment. The 'have nots' can suddenly become the 'haves'" (Cardinal, 1979: 28, 30–31).

Characterizations such as these can occur only when the people being described are silenced. However, this is routinely the case in the study of Outsider Art, where the people who make the art are often dismissed as unimportant. "We must be constantly aware," says Farber, "that it is the work that is important. It is art. The lives of the artists are merely an outward manifestation of the obsessions and inner struggle that the artist brings to his art, and that influence the final example of the creative act" (Farber, 1990: 8). When creativity and art matter so much more than people, there is no need to attempt to communicate with the makers of Outsider Art about what they think their art and lives are really about. Perhaps this is why, according to Cardinal, Dubuffet believed that "creativity was [not only] incompatible with social approval, [but also] . . . with communication" (1979: 22). And this, finally, may be the most terrible problem with the epistemology utilized to define and study Outsider Art. It is an epistemology which has little place for the views or values of those whom it represents as outsiders. Thus the problem of the representation of

the outsider in Outsider Art is not one of intent. It is more fundamental and perni-cious. As Fabian has observed, "Bad intentions alone do not invalidate knowledge. For that to happen it takes bad epistemology which advances cognitive interests with-out regard for their ideological presuppositions" or, I would add, their social effects (Fabian, 1983: 33).

As a statement from the inside which excludes the voices of those deemed to be outsiders, the conception of the outsider in Outsider Art reveals little about the real people and artifacts on which it is imposed, but it may reflect much about those doing the imposing. Understood as an example of the process by which the Other is created and maintained in modern Western culture, the outsider and Outsider Art can be compared to other examples of this process in order to study how modern middle-class identity is related to concerns with contrast, hierarchy, and the mainte-nance of boundaries.

For example, one of the best-known and most-influential studies of the contrast between groups at the center of cultural power and those on the periphery is Mikhail Bakhtin's study of carnival in his book *Rabelais and His World* (1968). An examina-tion of the popular and folk sources in Rabelais' writing, Bakhtin's book develops a view of the carnival which presents it as a contrast to dominant society and social norms. As a critical inversion of the hierarchies of official culture, carnival was used by Bakhtin, and subsequently by other scholars, as a model for all types of social inversions in which a symbolic contrast to dominant society is represented by the existence of a subordinate culture whose values, ideologies, and practices contradict, and present alternatives to, commonly accepted norms. According to Peter Stally-brass and Allon White, who brilliantly analyze the meaning and cultural politics of Bakhtin's work, carnival can be understood as a "festival of the Other," which codi-fies and represents all that a properly socialized bourgeois individual must not be in order to maintain an acceptable sense of self. For in Bakhtin's book a model of culture is developed in which the symbolic polarities created by the binary relationship be-tween the official world and its inversion are mutually dependent. Thus, "the 'carni-valesque' mediates between [the dominant group] and its negations, its Others, what it excludes to create its identity as such" (Stallybrass and White, 1986: 16, 26, 178). Seen in this way, carnival can become a remarkably useful model for understanding the relationships involved in Outsider Art.

As Stallybrass and White have noted, Bakhtin's view of carnival is similar, in important ways, to more recent work by anthropologists Barbara Babcock and Victor Turner who have also commented on the social meaning and process of symbolic hierarchical inversion (Babcock, 1978; Turner, 1978 and 1982). In her edited vol-ume, *The Reversible World*, Babcock presents a number of studies on the significance of negation in symbolic processes. Calling such negation "symbolic inversion," and defining it as "any act of expressive behavior which inverts, contradicts, abrogates, or . . . presents an alternative to commonly held cultural codes" (Babcock, 1978:

14), Babcock argues that it is central to the devices by which people communicate and understand themselves.

> Symbolic inversion . . . is closely related to the dynamics of classificatory systems. . . . According to [a] "structuralist" line of thought, the central categories of culture are dialectically defined by the positing of an opposite—that is, systems of classification are constructed according to the principle of binary opposition, which structuralists generally regard as an innate faculty of the human mind.

Furthermore, she continues, quoting anthropologist Rodney Needham,

> an especially important form of symbolic inversion is "that used to mark a boundary, between peoples, between categories of persons." This means that group membership is determined not only by what members share, but by what the members recognize that "significant others" do *not* share. Thus develops . . . the definition of those outsiders "on the periphery" in terms of how they depart from insiders. (Babcock, 1978: 27–28)

Turner designates the relationship which Babcock calls symbolic inversion as "liminoid." In the last chapter to Babcock's book, and in another essay published later, Turner points out that while inversion is often associated with the liminal, or transitional, rite-of-passage phase in traditional societies, it is more properly understood as liminoid (or only "resembling" the liminal) in modern, industrial culture (Turner, 1982). According to Turner, in traditional, preindustrial cultures the symbolic systems and genres such as inversion, which take place in rituals like rites of passage, are generally associated with work, since they are part of required, necessary, and regularized activities participated in by all for the purpose of effecting important collective ends. In modern, industrial societies, where life is not governed by common ritual obligations and where "how one earns a living" has been arbitrarily set apart from other activities, human life and time is fragmented in a way that makes possible a distinction between work and leisure. Now important symbolic activities, especially inversion, are often associated with leisure instead of work and, as such, take on a different meaning. Instead of being collectively created and experienced, they are now often individual products. Also, while liminal phenomena are well integrated into the whole social process, liminoid activities develop apart from central social processes, "along the margins—they are plural, fragmentary." And finally, while liminal phenomena utilize symbols which represent common meanings for all members of society, thus reflecting collective experience, liminoid symbols tend to be affiliated with particular groups—"schools" or "coteries"—and compete with one another on the open market as commodities (Turner, 1982: 53–55).

Considering Outsider Art in terms of Babcock's and Turner's analyses helps to suggest why this art form has such symbolic resonance in modern, industrial culture.

As a form of symbolic inversion, Outsider Art may help not only to map the boundaries between groups of people, but to do it in a modern way. For, as Turner suggests, the liminoid inversions characteristic of industrial leisure in large-scale, complex societies take on a different character than do the liminal ones which operate in traditional cultures. Responding to societies characterized by a high degree of social and economic division of labor, class stratification, technological sophistication, and rapidly changing (and widely varying) social practices and values, liminoid inversions, such as the activities associated with Outsider Art, lack the "comprehensive, pan societal, obligatory qualities of tribal and agrarian ritual. . . . Rather they are piecemeal, sporadic, and concerned with the setting of one segment of society, one product of the division of labor, against another." In short, they "respond . . . to contemporary circumstances" (Turner, 1978: 281–82).

Viewed in this light, it is understandable why Outsider Art is understood by its proponents in the way it is. For like Turner's model of the liminoid phenomenon, the appreciation of Outsider Art, as my analysis of Dean MacCannell's work has shown, is engendered by modern, mass leisure. Moreover, in common with Turner's model, Outsider Art is not only thought to be an individual, and not a collective, product, but it is understood in a way which glorifies the plural and fragmentary nature of modern experience that is said to exist at society's margins. Finally, like other modern liminoid phenomena which exist in a world driven by the forces of the marketplace, Outsider Art is increasingly treated as a commodity.

The connection between Stallybrass and White's conception of Bakhtin's carnival, Babcock's theory of symbolic inversion, and Turner's definition of the liminoid process to the concept of Outsider Art allows us to consider this art form in an expanded way, as one of the many symbolic cultural devices by which social groups in modern, industrial societies come to know, measure, and control their world by considering its inversions. For the ideas of Stallybrass and White, Babcock, Turner, and the proponents of Outsider Art are all, in a way, different examples of the same process. They all deal with, to use Stallybrass and White's term, "transgressions" against the norm. Stallybrass and White amplify this point, quoting Babcock:

> The classificatory body of a culture is always double, always structured in relation to its negation, its inverse . . . "What is socially peripheral is often symbolically central, and if we ignore or minimize inversion and other forms of cultural negation, we often fail to understand the dynamics of symbolic processes generally. . . ." The most powerful *symbolic* repertoires [are always located] at borders, margins, and edges, rather than at the accepted centers, of the social body. (Stallybrass and White, 1986: 19–20)

Viewing Outsider Art as a transgression further clarifies and helps demonstrate the implicit relationship between its major social functions in dominant culture—self-definition and social control. For, in situations of transgression, the more powerful group is often imaginatively attracted to, and attempts to define itself in terms of,

precisely those people and practices which, because they seem to those in power to be the inverse of all that is personally and socially acceptable, the powerful group is working to marginalize and destroy. Both repelled by and attracted to those groups it defines as Other, the dominant group displays a profound ambivalence with regard to them. "They exist for us in a cherished series of dichotomies," says Torgovnick, talking about primitives, "by turns gentle . . . or violent . . . what we should emulate or . . . what we should fear; noble savages or cannibals" (Torgovnick, 1990: 3).

The Other is really no more than an eroticized fantasy projection of those who define and thus control it. The Other and its maker are therefore the same, separated only by the maker's unwillingness, or inability, to acknowledge, accept, or take responsibility for those qualities it projects on its Others. Consequently, those designated as Other are symbolically desired for the very reasons they are socially reviled, and instead of accruing to their benefit, the celebration of them as Other insures their continued marginalization (Stallybrass and White, 1986: 4–5). This is why, according to Outsider Art enthusiasts, the artifacts venerated as Outsider Art are not to be confused with the products of art therapy. Such a confusion might constitute the makers of these objects less marginal and more socially acceptable to those who would otherwise label the makers "outsiders." This outcome would upset the delicate balance between fear and fascination, domination and desire, which fuels the conflictual insider fantasy of Outsider Art.

It is for these reasons that issues of power and control, as they manifest themselves in Outsider Art as well as in the other symbolic relationships by which modern Westerners know their Others, are never simple or straightforward. As Torgovnick has perceptively observed:

> The emphasis on *control over others,* while accurate to a point, remains incomplete. That a rhetoric of control and domination exists in Western discourse on the primitive is beyond question. And it exists in at least two senses; control and domination of primitives . . . and a parallel control of the lower classes, minorities, and women . . . who are linked, via a network of tropes, to the primitive. But the rhetoric of domination and control of others often exists alongside (behind) a rhetoric of more obscure desires: of sexual desires or fears, of class, or religious, or national, or racial anxieties, of confusion or outright self-loathing. Not just outer-directed, Western discourse on the primitive is also inner-directed—salving secret wounds, masking the controller's fear of losing control and power. (Torgovnick, 1990: 192)

It is the inner-directed rhetoric which accompanies the rhetoric of domination, the rhetoric of "obscure desires" which is aimed not at the control of others but at the transformation of the defining group or self, which finally, and fully, completes the relationship that engenders Outsider Art. For in modern, industrialized society, the identity and position of those in control is never comfortably established. As the masters of a seemingly fragmented, alienating, and overcivilized world where many of the traditional foundations of identity and status in work, the family, religion,

and community no longer seem fixed and secure, modern elites search the world for nonmodern people, places, experiences, and artifacts with which to have "natural" and "authentic" relationships that give substance and meaning to their lives.

Such experiences can be had with outsiders, it is believed, through Outsider Art. By involvement with this art its promoters can hope to somehow break through the civilized isolation and artifice which, they fear, encumbers them, to experience the dazzling insight and emotion of those who live beyond static social borders, and to feel both confirmed and enlarged by this encounter. This is what Stallybrass and White mean when they suggest that transgression is ultimately a key process of the "cultural imaginary" in which binary opposites and things normally assumed to be incompatible can mix, resulting in the production of a "complex hybrid fantasy" that defines and transforms the collective and individual experience of those in power (Stallybrass and White, 1986: 51). It is also what Sam Farber means when he says in the catalogue to a recent Outsider Art exhibition: "If we can allow our own cultural bonds and blinders to slip away, we can become a fellow traveler with the [outsider] artist on his creative explorations; if we will brave the emotional risks and anxieties, we can find ourselves on an exciting and mysterious journey" (Farber, 1990: 7). Yet this is a journey engendered by domination as well as desire, and we need to carefully reexamine its real destination and purpose.

ACKNOWLEDGMENTS

I would like to thank Robert St. George, who made suggestions which initially helped me conceptualize this essay. Sally Harrison-Pepper, Michael Hall, and John Vlach read and commented on various drafts, and Joanne Cubbs's numerous suggestions helped me rethink my own epistemologies with regard to the Other. Peter Stallybrass and Allon White's book *The Politics and Poetics of Transgression* has challenged and influenced my thinking about the topic of this essay, and I have relied on it in developing parts of my argument. Finally, Roger Cardinal's thoughtful and very valuable criticisms forced me to carefully consider the tone, targets, and intentions of my essay, which remains, of course, the result of my own analysis and views.

BIBLIOGRAPHY

Babcock, Barbara A. 1978. "Introduction." In *The Reversible World: Symbolic Inversion in Art and Society*, edited by Barbara A. Babcock. Ithaca: Cornell University Press.

Bakhtin, M. M. 1968. *Rabelais and His World*. Translated by H. Iswolsky. Cambridge, Mass.: Harvard University Press.

Becker, Howard S. 1982. *Art Worlds*. Berkeley and Los Angeles: University of California Press.

Cardinal, Roger. 1972. *Outsider Art.* London: Studio Vista; New York: Praeger.

———. 1979. "Singular Visions." In *Outsiders: An Art Without Precedent or Tradition.* London: Arts Council of Great Britain.

Carr, Simon, et al., eds. 1990. *Portraits from the Outside.* Dalton, Mass.: Studley Press.

Fabian, Johannes. 1983. *Time and the Other: How Anthropology Makes Its Object.* New York: Columbia University Press.

Farber, Sam. 1990. "Portraits from the Outside: Figurative Expression in Outsider Art." In *Portraits from the Outside,* edited by Simon Carr et al. New York: Parsons School of Design.

Glassie, Henry. 1986. "The Idea of Folk Art." In *Folk Art and Art Worlds,* edited by John Michael Vlach and Simon Bronner. Ann Arbor, Mich.: UMI Research Press.

MacCannell, Dean. 1989. The Tourist: A New Theory of the Leisure Class. 2d. ed. New York: Schocken Books.

MacGregor, John M. 1990. "Marginal Outsiders: On the Edge of the Edge." In *Portraits from the Outside,* edited by Simon Carr et al. New York: Parsons School of Design.

Said, Edward W. 1978. *Orientalism.* New York: Pantheon Books.

Stallybrass, Peter, and Allon White. 1986. *The Politics and Poetics of Transgression.* Ithaca: Cornell University Press.

Torgovnick, Marianna. 1990. *Gone Primitive: Savage Intellects, Modern Lives.* Chicago: University of Chicago Press.

Turner, Victor. 1978. "Comments and Conclusions." In *The Reversible World: Symbolic Inversion in Art and Society,* edited by Barbara A. Babcock. Ithaca: Cornell University Press.

———. 1982. *From Ritual to Theatre: The Human Seriousness of Play.* New York: PAJ Publications.

Vlach, John Michael, and Simon Bronner. 1986. *Folk Art and Art Worlds.* Ann Arbor, Mich.: UMI Research Press.

FRENCH CLINICAL PSYCHIATRY AND THE ART OF THE UNTRAINED MENTALLY ILL

Mark Gisbourne

It was not the nineteenth or twentieth centuries which discovered that the mentally ill possess an imaginary and personal view of the world that can find artistic expression. The hapless inmate who, in Hogarth's "Bedlam" print from *The Rake's Progress,* drew a diagrammatic projection of a chained sphere on the prison wall reflects an early recognition that creative aspiration did not end with claustration. Yet for Hogarth the inmate's image was little more than one of a series of delusional categories evident in the print as a whole, a theatrical ensemble of lunatic clichés that reflect the limited understanding of madness that prevailed in his time. While the eighteenth century saw insanity in the largely penal terms of manacled restraint, the illness nonetheless still retained some public accessibility,[1] an example of otherness in which "madness borrowed its face from the mask of the beast"[2] [14.1]. The Age of Enlightenment depicted the lunatic as a theatrically visible counterpoint, an emblematic means of representation linked to a moral regimen of restraint, a transparent dualist stereotype of "otherness" born of what was imagined to be the fruits of unreason.

When in the nineteenth century the insane ceased to be associated with criminality and were understood as hospital patients—moving from the public visibility of the prison hospital to the invisibility of the asylum—certain translations also took place. There developed a legacy of moral systems of treatment, which, while more humane, established that the creative mental patient could never be seen in the same way as a creative person outside the asylum. Unlike the art of the sane, in which general aesthetic values were inferred from the work of art or literature (the creative text), inferences drawn from the art of the insane were determined by context: the artists' state of confinement and of being mad. The social and cultural otherness

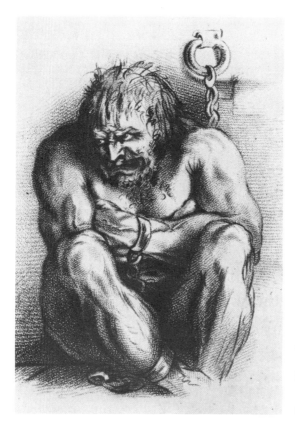

14.1. Sir Charles Bell. "Madness," in *The Anatomy of Madness: Essays in the History of Psychiatry,* volume 1, eds. W. F. Bynam, Roy Porter, and Michael Shepherd (London: Tavistock Publications, 1985). Photo courtesy Library of Congress.

of the confined mad patients determined the means of expression and the content, narrowed the possibilities of interpretation, and made light of anything they might have produced.

In an age when theories of facial expression, physiognomy, and phrenology were commonplace, how the insane were seen and depicted became a necessary corollary to evaluating their creative aspirations. The perception of the sane artist's creative context was merely of a particular relatedness, but the perception of the insane artist's was absolute, and this was true regardless of whether his or her condition was diagnosed in pathological or psychological terms. In this way, and in keeping with the development of a scientific method, the patient became an object of study. Inmates' subjective experiences, revealed through writings or graphic forms of expression, were seen largely as illustrative of their status as object; their images and words were a basis for diagnosis.

The legal and medical status of madness and the development of clinical psychiatry in the nineteenth century gave to the alienist-physician an increasing power to isolate the insane from the public at large. Paradoxically, it was often the invisibility of the insane that made them such a potent influence on the literature of the century, their absence from public sight giving impetus to all manner of literary speculations.

To understand the fragmentary visual or written materials that survive from the period, we have to be aware that they were mediated through a series of discourses which denied them the status of art. This was always true of drawings or writings of the untrained mentally ill; such materials were seen either as symptoms of illness or as amusing curiosities.

Through the late nineteenth and early twentieth centuries, artists like Richard Dadd and Jonathan Martin, who were legally confined, and voluntary patients like Vincent van Gogh (a trained artist who became mentally ill) were differentiated from those who were given medical case numbers or simply known by a pseudonym. For trained artists the works produced after the onset of mental illness were compared to those made prior to incarceration. By virtue of a comparative psychopathological assessment of means and content, art began to be understood as having a useful application in legal medicine, an application greatly extended with the advent of criminal anthropology in the second half of the nineteenth century. Indeed, in France it was in this context that Dr. Ambroise-Auguste Tardieu first suggested that the drawings of the insane might be used as evidence of insanity. They were considered as an outer, material documentation of an inner reality—prescriptive examples of medical and/or moral insanity.[3]

It is worth reiterating that the nineteenth century nearly always spoke *of* the insane and never *for* the insane. This *speaking of* (by inference as object) was shaped by three dominant discourses. These were grouped around systems of clinical classification, ideas concerning automatism, and theories of degeneracy and atavism, added to which was the later and rather unsystematic development of experimental psychology. In retrospect, the lateness in the development of the experimental life sciences, traditionally ascribed to Helmholtz, explains why the boundaries of these nineteenth-century discourses became so often blurred.[4] A semantic minefield was created, as language from Romantic philosophy and medicine vied with the new and more systematic methodologies of medical science and anthropology. Romantic ideas of genius and insanity, revivified by Diderot, were appropriated and substantially changed along biological lines as the experimental sciences established greater control in the areas of physiology and the neuro-sciences.[5]

Any consideration of the artistic productions of the insane in the nineteenth century must closely examine these discourses, since insane artists rarely spoke, and if they did so, it was almost always through a determining intermediary voice, that of the doctor. For to control discourse is to control the power to speak, to include and exclude from consideration, to exact what Foucault has called "enunciative modalities."[6] The statements were similarly circumscribed by the changing "institutional sites" of the hospital or the experimental laboratory, intensely assertive and largely autonomous places of observation. Writings appeared for the most part in the specialized publications of medical science, journals of societies, intellectual spaces where theoretical constraints and professional discourses were both shaped and determined. It was also true that the alienist-physicians who made the statements

felt few inhibitions in appropriating values from areas where they often possessed little expertise, namely, art and aesthetics. Their now professional understanding of art was deemed sufficient to analyze and evaluate visual materials. For the purpose of this essay these issues will be considered largely as they related to France, which in most respects serves as a model for the historical development of the art of the insane elsewhere.

When Philippe Pinel symbolically struck the chains off the insane at the Bicêtre asylum in Paris, a more humane view of madness was initiated.[7] Traditionally seen as the founder of clinical psychiatry, Pinel was the first to observe the creativity of the mad patient: "A celebrated watchmaker at Paris was fascinated with the chimera of perpetual motion, and to effect this discovery he set to work with an indefatigable ardour. . . . The method best calculated to cure so whimsical an illusion appeared to be that of encouraging his prosecution of it to satiety. His friends were accordingly requested to send him his tools, with materials to work upon, and other requisites, such as plates of copper and steel." The significance of Pinel's observation went beyond merely acknowledging that creative aspiration continued after the onset of mental illness, for in this instance it possessed a psychotherapeutic role, since the patient eventually saw the futility of his quest and a cure took place, the man "decided to devote himself to his business," and he was released from the asylum. There was no worked-out principle of psychotherapy on the part of Pinel; the decision to let the man pursue the course of his delusion was simply founded on the alienist's convictions of observation and description. In another respect Pinel was also responsible for translating into early psychiatry the philosophical issue of the heightened creative abilities of madness: "I have frequently stopped at the chamber of a literary gentleman, who during paroxysms appeared to be so above the mediocrity of intellect which was habitual to him, so to admire his newly acquired powers of eloquence."[8]

Sporadic references occur in Pinel about inmates drawing on walls, though he attached no significant meaning to them. The supposed neutrality of his observational method was directed toward the classification system evident in his medical writings. ("Nothing has more contributed to the rapid improvement of natural history than the spirit of minute and accurate observation which has distinguished its votaries."[9]) The nosology he developed has no importance today and was rapidly superseded by the work of his followers Jean Étienne Dominique Esquirol and Etienne Georget. It was Georget who was the artist Gericault's doctor and connected to that painter's famous portraits of the insane.[10] The portraits followed the same basic idea of clinical types and reveal little by way of establishing a subjective existence for the sitters. Similarly, Esquirol's medical atlas of nosological illustrations depict patients wrapped in toga-like garments, which said more about the neoclassical taste of his day than it did about the patients themselves.[11] However, an important legacy of Pinel was that he established that "derangement of the understanding is

generally considered as an effect of an organic lesion of the brain, consequently as incurable, a supposition that is, in a great number of instances, contrary to anatomical fact." [12] From this point of view, madness was no longer derived from ideas of possession, or absolutely determined by pathology. The hypothesis emerged that mental disorder might be of purely psychological origin and, as such, susceptible to remedy. This distinction between somatic and psychological causes was an important part of the psychiatric debate in France for the remainder of the nineteenth century. For the artistic undertakings of the insane it had specific implications, since their drawings or writings could either be interpreted as examples of disease or, alternatively, as mere examples of sporadic derangement.

No works of art by the insane as such exist in France for the first half of the nineteenth century, a situation in marked contrast to England, where works by James Tilly Matthews, Jonathan Martin, and Richard Dadd, have survived. Nor was there a collector of materials comparable to Dr. W. A. F. Browne in Scotland. [13] However, we can establish a partial insight into the permitted level of art and human creativity in the French asylums at mid-century. In a lengthy article written in a populist vein by the journalist and writer Alphonse Esquiros and entitled "Les Maisons des fous de Paris," we find not only a list of the sundry causes of madness but also an example of the social and cultural constructs of "otherness'" at the time. For Esquiros, "all intense passions were capable of deranging our faculties," and this was particularly true of political activity: "The Revolutions of 1789 and 1830 produced a great deal of madmen in the years that followed." This was why there were thirteen or fourteen Napoleons at Bicêtre, he explained. An excessive interest in the arts, speculations, conversations, public discourses, and sermons, all were capable of triggering forms of mental illness. "Sects, new ideas, have been through all periods the foyer of several mental illnesses. In recent years the doctrines of Saint-Simon, of Fourier, and humanitarians have moved the living intelligence of a number of madmen." [14]

Esquiros offered no clinical observations and referred only to a large number of interactive external causes for insanity. His article was published in a popular journal intended for a largely bourgeois public, and laid great emphasis on the role of a moderate life-style over and above what he called non-normative behavior. Homosexuality, narcissism, transvestism ("there exist men-women" and "women-men") were all features which pushed a pregiven disposition over the edge into madness. Most important of all, the article reflected as a subtext the newly established middle-class hegemony and its quest for a constituent normality, such a strong feature of the second half of the nineteenth century in France. Excess was the key evil—an excess of artistic interest, narcotics, alcohol, and sex—all the more pronounced when it was connected to specific ages of life, atmospheric conditions, or motions of the moon.

The article looked both forward and backward, preceding as it did the rise of experimental biology. It contained many of the key words of later psychiatric and anthropological discourses, such as *degeneracy*, and it emphasized statistics which, it was claimed, provided solid evidence that madness was more often found among

the illiterate poor and the overbred aristocracy. The latter half of the century saw the establishment of normality as a social and cultural construct, and of a middle-class self in which that class's supposed moderation and reason was incarnated.

While Esquiros rejected outright any connection between genius and insanity, he observed that the creative impulse was sustained and was even changed from one artistic mode to another by confinement. "At Montmartre, in the establishment of Doctor Blanche, there are traces of a chalk drawing on a wall; these half-effaced figures, of which one represents the Queen of Sheba, the other some king, were executed by a young distinguished writer; today he has regained his reason and the illness has developed in him a talent that did not exist in a state of health or at least played only an insignificant role."[15] The unnamed writer was in fact Gérard de Nerval, who began to draw in Dr. Emile Blanche's private clinic.

Any creative undertaking within an asylum therefore carried a sharp double edge. If it mirrored something like the prevailing artistic standards of middle-class taste, it could be seen as mildly therapeutic. If on the other hand it wandered from this narrow path, it reinforced the idea of deviance from a socially accepted but undefined normality and was therefore seen as the product of madness.

Social class had played a part in the commerce and politics of madness in France from the very beginning of the medicalization of insanity. In his article Esquiros pointed to the three estates transcribed into three modern insane classes. The poor insane were to be found at Bicêtre (men) and Salpêtrière (women), and the middle classes at Charenton; the new private hospitals, called "maisons de santé," one of the earliest of which was open at Varvres in 1833, were for the well-off and aristocrats. Esquiros's description of the reformed Bicêtre gave the public a vivid picture of life in an asylum in mid-nineteenth-century France. The population had burgeoned to three thousand inmates, who consumed large quantities of beef, mutton, and veal. In keeping with the work-motivated ethics and self-help philosophy of the time, Bicêtre tried hard to finance and sustain itself, employing four to five hundred inmates as manual workers. They washed sixteen to eighteen thousand pieces of linen a week. These small towns of the mad often had working farms, the animals of which were fed by the food slops sent from the larger city-based hospitals. "The farm of Sainte-Anne was in the middle ages a leprosarium. We find in this colony of the insane, masons, carpenters, tilers, painters, in a word, all the trades necessary to transform the ruins and make the place habitable."[16] The communities of the insane at Paris generated some fifty thousand francs a year. Yet, inevitably, the increasingly large-scale confinement of the mad was an inward-looking system that functioned to contain every aspect of daily life. This was even true of those artistic pursuits which were thought a benefit to the moral health of the patients. At Bicêtre there were frequent theatrical performances, and we must assume the patients assisted with the making of sets, the painting of scenery, and perhaps even the making of costumes. Usually the works were light comedies, for anything of a tragic nature was thought detrimental to the moral health of the patients.[17]

It was only in the last thirty years of the nineteenth century, once the insane had been completely isolated beneath the subordinating gaze of the alienist, that the first surviving records of drawings by untrained mental patients emerged. The impetus to record the materials was probably due to an increased use of experimental methods in French science as a whole. The localization of certain brain functions, first proved by Paul Broca, undoubtedly motivated an interest in the possibility that the characteristics of the art of the insane could be similarly localized, or at least attached to more precisely defined types of mental illness. There was already a long-established interest in the writings of the insane.[18] However, graphic images were considered impenetrable and only of value for the purposes of legal medicine.

It was in the context of a rejection of Tardieu's legal medical determinism that Dr. Max Simon, chief superintendent of the asylum at Bron, first claimed that there was in fact an art of the insane.[19] He was the first to use the word *art* in this context, though it must be said he did not consider it art in the conventional sense, his own aesthetic taste being determined by the prevailing academic standards of his day. As a médecin-philosophe, novelist, literary critic, and Swift scholar, he was concerned to show that there was quite literally a method in the madness, and he wanted to distinguish between somatic and psychological motivations. In this respect it appears he was indebted to the long medical-philosophical tradition that descended from Locke. "Madmen, having joined together some Ideas very wrongly, . . . mistake them for Truth. . . . The difference between Idiots and mad Men [is] that mad Men put wrong ideas together, and so make wrong Propositions, but argue and reason right from them: But idiots make very few or no Propositions, but argue and reason scarce at all."[20]

In his first article Simon immediately dismissed the congenital and pathological categories of insanity as sources of any real creative value, claiming that patients in these groups hardly ever drew or painted. "It is in the chronic state of affections, in partial delusions, principally in the delusions of ideas of persecution, that we meet the richest harvest, . . . and within the delusions of persecution we find ideas of grandeur." He therefore firmly located the artistic expression of the insane within the mental (as opposed to somatic) state that motivated it. There was a correlation between the ideas and the art; they were not the random products of madness. He spoke of "small compositions of doubtful value assuredly from the point of view of drawing, but very interesting for the doctor and psychologist. In these compositions they depict their misfortunes, the tortures they believe they have endured, the persecutions to which they imagine they have been the object. Sometimes these are represented by emblems, the lion as a sign of strength, the balances of justice, symbols of deliverance, etc."[21]

Having placed them in a delusional category, Dr. Simon did not criticize or ridicule his patient's works, recognizing that they were meaningful expressions. He was the first to observe the diversity of materials appropriated by patients, and, since he was also interested in literature, the elision of boundaries between written and

graphic elements. What was significant was that in his first long article on the subject he chose not to illustrate any of the works, though when he returned to the subject in 1888, he gave a whole series of illustrative examples [14.2].[22] He also changed the general direction of his argument, laying greater emphasis on hereditary features; he stressed the frequency of obscene subject matter, and separated the writings of the insane from their drawings. In the intervening period he had encountered the degeneracy theories of Dr. Cesare Lombroso, and as a result became far more biologically determined in his approach.[23] Further occasional articles appeared through the late nineteenth century which discussed both the writings and drawings of the insane, though they added little to the general view established by Simon.[24]

My emphasis here on classification may seem disproportionate but is intentional. Classification remained the dominant preoccupation of writings on the art of the insane up to the advent of art therapy in the 1940s, and was clearly at odds with any notion of the work's artistic autonomy. However, alongside the sweeping determinism of nineteenth-century science ran the more inchoate discourse of automatism.

An interest in spontaneous forms of artistic production first became evident during the period of Romanticism. Alexander Cozens had developed imaginary landscape works from chance-shaped inkblots in the late eighteenth century, an idea that was taken in another direction by Dr. Justinus Kerner in his *Klecksographien,* a collection of inkblots that inspired accompanying poems. Kerner was a parapsychologist and the biographer of Franz Anton Mesmer, first exponent of "mesmerism," or animal magnetism, later dubbed "hypnotism" by James Braid.[25]

At a time when automatism and general autonomic functions had been barely separated, automatic drawing and writing was seen as an aberration. It was hardly surprising, therefore, that the first theory of automatism should emerge in the context of the spontaneous writings of the insane. Dr. Jules Baillarger first used the term to explain the development of delusional states and the mental alienation which followed. He saw it as a second consciousness breaking through the normally rational conscious faculty. More significantly still, his close friend Dr. Jacques-Joseph Moreau (de Tours) extended this into areas of dream psychology, stating in his delightful epithet that "madness is the dream of man awake." Moreau rejected somatic insanity; he believed that physical manifestations stemmed from "the real nature" of madness, namely, hallucinatory and delusional phenomena. Moreau's interest in altered mental states had already led him into the first psychopharmacological experiments with hashish. As a member of Le Club des Haschichins (The Hashish-Takers' Club), which met in Paris at the Hotel Pimoden in the 1840s and 1850s, he undertook experiments, including chance-directed, or automatic, drawing with fellow members in drugged states. The members of the club included Honoré de Balzac, Charles Baudelaire, Gérard de Nerval, Théophile Gautier, and Alexandre Dumas *père*, among others of an "Orientalist" persuasion. Moreau's close connection to Gérard de Nerval was particularly important at this time, since the poet's famous *Aurélia:*

14.2. Anonymous patient at the Bron asylum. "Emblematic Drawing of Patient Suffering with Persecution," reproduced in "Les écrits et dessins des aliens," *Archives de l'anthropolie criminales et des sciences penales,* volume 3, 1888, pp. 318–55.

ou le réve et la vie, supposedly an automatic novel, closely followed the doctor's theories on the relationship between dream and consciousness—so much so that at times it seemed almost prescriptive.[26]

The debate concerning automatic forms of drawing among the insane, drug-induced mental states, and neo-Romantic ideas of spontaneous creativity that derived from essentially poetic concerns, remained obscure for some time. While at the private asylum of Dr. Blanche at Montmartre, Gérard de Nerval executed a series of drawings, a few of which survive. Even as a young man he had been interested in the invention of imaginary worlds and the construction of a projected genealogy for himself, a preoccupation he shared with psychotic artists. It was true also that from the 1850s there was an expanded interest in mediumism and the drawings and writings that resulted from trancelike states. The most famous examples of these were executed by Victor Hugo in the mid-1850s, and are not dissimilar to the blot drawings of Alexander Cozens.[27]

What became apparent in automatic forms of drawing was the fact that they could not be easily contained within the simple categories of clinical psychiatry. This led to two distinct traditions addressing automatism in France in the latter part of the nineteenth century, with an emphasis on either internal or external factors. Jean-

Martin Charcot (1825–93), the superintendent at the Salpêtrière, placed automatism in the context of neurophysiology. His famous experiments with hypnotized hysteria patients at the Salpêtrière hospital were pursued to this end. However, in the Salpêtrière journal which Charcot jointly edited with Charles Richer and entitled *Nouvelle Iconographie de la Salpêtrière,* we find nothing to suggest that Charcot was interested in the actual *art* of the insane.[28] This was particularly odd since he was reasonably well-known as an amateur artist himself.[29] On the other hand, among the neurological writings published by this journal were a large number of articles that appeared over some twenty years. The articles dealt with many historical depictions of the insane by a vast assortment of artists. These images were given postdated diagnoses based upon the symptoms thought to have been depicted. The articles, which in retrospect can be seen to have played an early role in the history of psychiatric medical illustration, tended on the whole to reinforce many of the older nineteenth-century stereotypes of "seeing" the insane.[30]

The second area of automatism that concerns us was that of psychical research (today called parapsychology), a prolific source of automatic writings and drawings in the years from the 1880s to the First World War. With the founding of the Society of Psychical Research in London in 1883, psychical research spread rapidly to France and even claimed among its followers the French philosopher Henri Bergson. The French *Annales des Sciences Psychiques* was founded in 1891.[31] Undoubtedly the greatest influence on the whole movement both in England and France was Frederick W. H. Myers, who wrote extensively upon graphic automatism. Myers sought to determine whether " 'mind acts on mind,' otherwise than by the recognised organs of sense." Today this whole idea seems little more than a complicated pseudoscience, doubly so when we understand that Myers used a planchette (a board supported on three legs, one of which was a pencil) and spoke of telepathic communication "automatically written and supplied by spirits or extra human intelligences."[32]

What was most significant about Myers's research, distinct from the experiments of so-called telepathic transfer of drawings from one person to another, was that it marked a return to theories dealing with the workings of the mind and therefore to psychology. The almost tyrannical somatic determinism brought about by the rise of experimental biology in the twenty years after Broca's localization discoveries was again challenged.

In the new context the person who most seriously investigated automatism was the French philosopher and psychologist Pierre Janet (1859–1947). In his famous *L'Automatisme psychologique,* published in 1889, he finally established that automatic drawing was the product of motivated unconscious processes, or the subconscious (a term he invented).[33] He set automatism within a hierarchy of psychic functions some of which produced automatic writing and drawing, and claimed that they were the result of partial catalepsy or distractions, types of absentmindedness, common to the waking state. These emergent doodles expressed fragmentary ideas from the subconscious, he claimed, and they could function as a therapeutic tool for the

psychologist. In this respect Janet tentatively unearthed in his experiments some of the subconscious conflicts that Freud was later to systematize in his psychoanalytic method.

While an interest in classification and automatism represented an attempt at a positive and, on the whole, progressive evaluation of the artistic products of patients, the same could not be said of the third major discourse that dealt with the materials. The theorists of degeneracy claimed the same works to be the result of atavism and regression. Increasingly within medicine there lurked the men of a new discipline, criminal anthropology, thoroughgoing materialists who saw the artistic products of the insane as a threat to the civilizing forces at work in positive reason. A theory of degeneracy emerges in France with the medical writings of Dr. Benedict Augustin Morel (1809–73), where the theory was directed largely toward congenital illnesses such as idiocy and imbecility.[34] It took on a particularly pernicious and biologically determined character in the years after the Darwinian revolution.

The man who fostered the ideas of a degenerate or atavistic nature in a vast outpouring of writings over some forty years was Dr. Cesare Lombroso (1835–1909). Lombroso was a positivist who believed in rationally determined thought allied to experimental verification. He developed a system of physical measurement, called anthropometry, which purported to show that criminality was an inherited disposition.[35] Given the opportunity, he claimed the same dispositions could be found in so-called men of genius. He also used the system for female prostitutes by traveling to Italian prisons and measuring women's physical characteristics and anomalies in order to build up a statistical explanation of why they were inevitably drawn to an immorality.[36] Most important of all, he developed the idea of degeneracy and set it against certain aesthetic and artistic undertakings. In his association of genius with insanity and degeneracy, he purported to show that members of the late nineteenth-century avant-garde were degenerate, and to do so he drew upon the spontaneous drawings and writings of the insane.[37]

For Lombroso the inspirational powers of genius shared with degeneracy tendencies toward a double personality—a giftedness in one area and a stupidity in practical areas of common sense. There was an excessive desire to be original and a fondness for glossolalia and hermeticism. Lombroso claimed that all forms of excess were evidence of degenerate traits, the most obvious of these being overactive imaginations prone to delusions and hallucinations. He looked back through history to show that the most gifted people fitted into what he called the "mattoid" category, a group of people at the borders of sanity and insanity. Since Lombroso himself was an atheist, charismatic religious figures (St. Francis of Assisi, Savanarola, Luther, St. John of the Cross) were obvious historical examples of mattoids. The same was true of philosophers, particularly those of a metaphysical persuasion. Lombroso's mattoids also included a vast number of people in the arts—painters, musicians, and writers from all periods of history. For Lombroso the interesting aspect of these mattoid types was that they could be illustrated by the art of the insane, in whom he thought the traits

were most evident. He argued that it was more novel for insanity "to transform into painters persons who have never been accustomed to handle a brush, than for it to improve skilled artists." [38] In fact, it was only in very few instances that he knew the creators of the works he used for illustration, many of the works having been simply forwarded to him by other doctors or evaluated from illustrations. Notwithstanding, Lombroso confidently listed a whole series of graphic degenerate characteristics, which included eccentricity, symbolism, minuteness of detail, absurdity, and an excessive "originality." "Disease often develops (as we have seen already in the case of insane authors) an originality of invention which may be observed in mattoids, because their imagination, freed from all restraint, allows of creations from which the more calculating mind would shrink, for fear of absurdity, and because intensity of conviction supports and perfects the work." [39]

Although the basic premises of Lombroso's ideas have been rejected today, these intensely imaginative qualities are what made the art of the insane and the outsider valued in the twentieth century. In Lombroso's *Man of Genius,* where each trait was developed through a detailed description of works and set against a pseudostatistical pattern established by the author, we find a formal determinism that could be applied to almost any end. And the fact that Lombroso had no training in art and aesthetics served as no inhibition.

> Perhaps the study of these peculiarities of the art of the insane, besides showing us a new phase in a mysterious disease, might be useful in aesthetics, or at any rate in art criticism, by showing that an exaggerated predilection for symbols, and for minuteness of detail (however accurate), the complications of inscriptions, the excessive prominence given to any one color (it is well known that some of our foremost painters are great sinners in this respect), the choice of licentious subjects, and even an exaggerated degree of originality, are points which belong to the pathology of art. [40]

Even though he is now largely forgotten, the influence of Lombroso in the late nineteenth century was enormous. As the founder of criminal anthropology, he had incalculable influence, and he attacked and labeled almost every avant-garde figure of his day. He can be seen as an early contributor to the process of the peripheralization of modern art for the public at large. An enduring legacy was the particular grouping of what he considered physical or moral degenerate types, which included the child (not yet fully formed by the moral universe), the prisoner (through physical features, drawings, and tattoos), the primitive (due to inferior brain and evolution), the insane, and the artist (drawn into an excess of originality). It may be no coincidence that these forms were appropriated by artists in the early part of this century when they began to invert the negative labels associated with the materials. The followers of Lombroso were numerous and many of them far less scrupulous. Among the most notorious was Max Nordau, whose book *Degeneration* went through numerous editions in all major European languages in the period up to the First World

War. Indeed, members of the literary avant-garde were still fighting to counter these ideas well into this century.[41]

With the increasing appropriation of the art of the insane, the art of mediums, and spontaneous visionary art by those in the mainstream of cultural art in the twentieth century, these discourses do not totally disappear, for they have colored in one way or another nearly all subsequent writings on the subject. An interest in degeneracy theory declined in France before the First World War, as theories of mind and psychology took hold. It was, however, given new life in Germany under the National Socialists, where, in the series of Entartete Kunst exhibitions that traveled through German and Austrian cities in the years from 1937 to 1941, Prinzhorn's psychiatric materials were used to compare modern art to that of the insane.[42] An analysis of automatism was extended by Janet and later still by Freud's ideas as they spread to France, and it became the cornerstone of Surrealism from 1924 to 1929. Fittingly perhaps, the journal *Annales des Sciences Psychiques* ceased publication in the very year (1919) that André Breton and Philippe Soupault published their automatic text *Les Champs Magnétiques*, coincidentally taking up the issues of psychical research and automatism that had appeared regularly in the journal. Nevertheless, clinical classification continued to be the dominant discourse concerning the art of the insane, and it was against this trend that Jean Dubuffet began seriously to gather materials for his art brut collection in the 1940s.[43] Dubuffet's antipsychiatric position was motivated by a new aesthetic he had formed, one which strongly opposed conventional cultural art while at the same time rejecting all notions of legal-medical insanity. Dubuffet's ideas in some respects foreshadowed a subsequent development by R. D. Laing, David Cooper, and Thomas S. Szasz, who returned them to psychiatry in the 1950s and 1960s. Their conception of psychiatrically defined mental illness sprang from a sociopolitical and conspiratorial view of institutionalized madness.

Undoubtedly, the most important text on the art of the insane in France before the First World War was that by Marcel Réja, called *L'art chez les fous*, which was published and quickly reprinted in 1907. Marcel Réja was the pseudonym of Dr. Paul-Gaston Meunier, a friend and colleague of Dr. Auguste Marie of the asylum at Villejuif. Dr. Marie also had a committed interest in the art of the insane, since he had set two rooms aside to exhibit works by his patients; works from this collection were used for the most part to illustrate Réja's text.[44] Réja's book, developed from earlier articles on the subject, was significant insofar as he compared the art of the mentally ill to popular art, notably to such things as popular prints ("images d'Epinal"), and not to the familiar illness categories [14.3]. This was particularly important since the anarchist playwright Alfred Jarry championed this form of popular art at the time. Jarry went so far as to cite Réja in his almanacs prior to the doctor's published writings on the subject.[45] Réja's writings served as a contrast at the time to the writings of his colleague Dr. Rogues de Fursac, who was forcing the same materials into the ever-changing disease categories, the most common being dementia praecox, later to be called schizophrenia.[46]

14.3. Théophile Leroy. "Metaphysical Drawing," reproduced in *La Littérature des fous,* Revue universelle, volume 3, 1903, p. 133.

In the period before the First World War, while clinical attitudes remained dominant, there was an increase in the reproduction of the works of the insane in medical journals.[47] This was largely due to advanced techniques in photographic reproduction. The increase was also evident in reproductions of works by mediums as a serious analysis of the workings of the human mind got under way; in the case of so-called psychic phenomena, these inquiries also led to many fraudulent manipulations. With the development of a modern art in which artists began to appropriate these materials, the dominant academicism of the nineteenth century was superseded, which meant that narrow localized theories of explanation no longer seemed tenable. In psychology the sum of local parts could no longer be equated to a whole, and simple causal readings were invalidated. What the nineteenth century had seen as the shared characteristics of the art of the insane, the child, the prisoner, and the primitive, far from closing down discourse, opened them up to advances in ethnography and child psychology.[48] In Germany artists like Klee and Kirchner actively championed the art of the insane. In France artists before the First World War were more reticent, and, initially at least, more drawn to primitive art forms.[49] How-

ever, there was an entrenched fascination in France for mediumism, and artists like Modigliani and Utrillo frequently attended seances, where occasional automatist-spiritist drawings emerged.

The war and interwar years that followed saw a marked shift among the avant-garde toward an interest in psychotic or psychopathological art, as it was subsequently called, as well as other marginal forms of production. Guillaume Apollinaire, the great modernist critic, wrote an article on the subject. André Breton, a young admirer of Apollinaire, and the later leader of the Surrealists, had firsthand experience of the disturbed when he worked as an intern at Saint-Dizier in 1916.[50] The traumatic results of the first large-scale mechanized war moved events decisively toward psychology and away from clinical forms of determinism. This may be seen as the historical moment when psychological theories began to triumph in France in the face of the protracted tendency to classify materials. With the advent of Paris Dada and Surrealism, André Breton and his fellow *chasseurs d' images* of the Surrealist movement pursued a poetic psychologism, a delight in the characteristics of the irrational set against the so-called rational determinism of the nineteenth century.[51] The pseudoscientific approaches of Surrealists gave prestige to the art of psychotics, mediums, and visionaries while stripping away any connotations of the spiritual or mysterious; its atheistic humanism balked at any suggestion of a metaphysical reality. The "period of sleeps," with its dream recitation and graphic automatism, and Paul Eluard's advocacy of the poetic role of madness[52] supported the Surrealist ideology of the power of spontaneously generated unconscious images. Max Ernst appropriated psychotic sources and also found interpretive strategies of madness. Ernst was particularly motivated by psychotic art, having begun to collect it prior to the First World War, when he studied psychology and psychiatry at Bonn University.[53]

The adaptation of these sources by the Surrealists (sometimes with ambivalent and idiosyncratic results) and others elsewhere, in the 1920s and 1930s, would have been less evident were it not for the fact that psychiatric attitudes were also changing. With the publication of Hans Prinzhorn's *Die Bildnerei der Geisteskranken (The Artistry of the Mentally Ill)* in 1922, psychotic art made another advance in general understanding.[54] Whereas Réja had grounded such art by comparisons with popular art forms, the German psychiatrist took things a stage further and proposed the autonomous status of psychotic art. Prinzhorn's notion of what he called "schizophrenic masters" implied that insane art possessed unique aesthetic merit. This assertion stood alone regardless of the fact that his analysis sought to distinguish between the origins of psychology and psychopathology in configuration. In any case, when Ernst brought the book to France, the Surrealists were less drawn to the psychiatrist's analysis (few of the Surrealists read German) than to the extraordinary diversity of its illustrations. It was at this time that Dubuffet, who also read no German, first discovered the book when it was sent to him by his friend the Swiss poet Paul Budry, though over twenty years were to elapse before the artist seriously pursued this interest.[55]

While the absorption of Prinzhorn was typical of the deliberately subversive French Dadaist and Surrealist appropriation of things German in the years immediately following the First World War, the same shift was also discernible in French psychiatry.[56] In a whole series of articles throughout the 1920s, Dr. Jean Vinchon moved the debate on psychotic art forward.[57] Vinchon's book *L'Art et la folie,* though less scholarly than the work of Prinzhorn, produced more materials and commented on the earlier text of Réja. By this time the writings of Vinchon can be seen to fit into a continuous literature on the subject of psychotic art initiated at the Salpêtrière in the wake of Charcot. Dr. Auguste Marie was a student of Charcot, Paul-Gaston Meunier was an assistant to Marie, Jean Vinchon was a student of Marie, and Dr. Gaston Ferdière was a student of Vinchon and made his internship at the Villejuif before going to the hospital of St. Anne. Ferdière, later the doctor of Antonin Artaud, was to go on and write about psychopathological art and call for a museum for the materials.[58] With the exception of Réja, each of them had followed Charcot and been drawn toward a neurophysiological determinism. Réja was the exception in taking a psychological line that went back to Moreau (de Tours), which probably also explains why he had used a pseudonym to hide his identity; his medical writings under his real name of Meunier are of distinctly neurophysiological cast.[59] The strangest aspect of Réja's life was that he lived until 1957, long after Dubuffet had discovered art brut, and never chose to write again on the subject or reveal his identity.[60]

Through the 1920s and 1930s several commercial exhibitions of psychotic art were held in Paris.[61] The most important was probably that of the schizophrenic Oskar Herzberg, held at the Galerie de la Pléiade in 1934, where there was an accompanying lecture on the issues of schizophrenia and art.[62] Such exhibitions finally secured the status of art for the materials, as the works passed from mere curiosity to autonomy.[63] At the end and immediately after the Second World War, psychotic art began to be liberated. André Breton wrote a famous essay on the subject. The return of Antonin Artaud from the asylum at Rodez, an exhibition of his drawings and portraits, and his antipsychiatric essay in defense of Van Gogh, brought the issues of madness in postwar France into the foreground.[64] Jean-Michel Atlan and Jean Fautrier, who both spent the wartime period hiding inside asylums, gave a further impetus.[65] Jean Dubuffet, who like Paul Eluard had visited Artaud at Rodez in 1943,[66] was also avidly collecting the materials that would eventually form his art brut collection. In 1949, two years after the founding of the Compagnie de l'Art brut, his anticultural and antipsychiatric positions were established by the major exhibition "L'Art Brut préféré aux arts culturels" at the Galerie René Drouin.[67] In parallel to these artistic manifestations French psychiatry was making a major reevaluation of psychopathological art.[68] In 1950, after two years of preparation, a major exhibition of psychopathological art was held at Sainte-Anne to coincide with the First World Congress of Psychiatry.[69] It included over two thousand works from seventeen countries and forty-five collections and was a great success. Its impact on Cobra artists

like Karel Appel and Asger Jorn remain another story.[70] Jean Vinchon's *L'Art et la folie* was updated and republished for the occasion, and Dr. Robert Volmat, the main organizer, subsequently published a large book concerning the contents of the exhibition. While classification and the anonymity of the patient artists remained in evidence, the position of an art of the insane, with all its inventiveness, had finally been acknowledged by the psychiatric establishment.[71]

The spontaneous outsiders emerged from the marginal sphere of "otherness" by a paradox, that is, from "inside" the confinement of public institutions.[72] The mediums and compulsive visionaries whom Dubuffet accepted joined them in the sphere of art brut and, as a result, were also able to obtain a forum to show their imaginative inventions. In certain respects this is where the story of Outsider Art begins. The wonderful and uniquely personal view of the world the outsiders have presented has continued unabated.

AUTHOR'S NOTE

Unless otherwise stated, the translations in this text are by the author.

NOTES

1. The practice of exhibiting the lunatic to public scrutiny was common in the eighteenth century. For a small fee (a penny in the case of "Bedlam") you could gain access on specific days to see the mad. The practice was abolished in the years following the reforms of Pinel in France (1793) and Samuel Tuke at York in England (1792). In Germany the practice seems to have hung on longer (see P. Miller, ed., *An Abyss Deep Enough: The Letters of Heinrich von Kleist* [New York, 1982], pp. 58–60).

2. Michel Foucault, *Madness and Civilisation: History of Insanity in the Age of Reason*, trans. Richard Howard (London, 1971), p. 72.

3. Ambroise-Auguste Tardieu, *Etudes medico-legales sur la folie* (Paris, 1872). The distinction between medical and moral insanity is no longer an issue today. However, it may be seen broadly as the distinction between somatic and psychological ideas of the causes of insanity. Medical insanity was considered somatic, internal, and largely a legal and medical issue. Moral insanity may be considered consequential; a moral regime could conceivably affect a cure.

4. Hermann von Helmholtz, *Handbuch der physiologischen Optik* (Leipzig, 1856–66).

5. Denis Diderot (1713–84) claimed that in the creative moment a writer or artist passes into an uncontrollable state which must be classified as pathological insanity, only to emerge again into the clear light of reason (see *Pensees philosophiques: Oeuvres complétes de Diderot* [Paris, 1875]). Diderot's essay *Salon of 1767* expounds many aspects of his theories on genius and insanity.

6. Foucault, pp. 50–55.

7. Philippe Pinel, *Traité medico-philosophique sur l'aliénation mentale ou la manie* (Paris, 1801). The English translation by D. D. Davis, *A Treatise on Insanity* (Sheffield, 1806), omits Pinel's introduction; the 1962 reprint is the edition cited hereafter.

8. Davis, trans., pp. 68–70, 29.

9. Quoted in ibid., p. 1.

10. J. E. D. Esquirol, *Des Maladies mentales* (Paris, 1838); E. Georget, *De la Folie* (Paris, 1820). For a general summary of the literature relating to the insane portraits, see Lorenz Eitner, *Géricault, His Life and Works* (London, 1983).

11. The medical atlas that accompanied Esquirol's *Des Maladies mentales* (1838) depicted all the different insane types in pseudoclassical robes with appropriate facial expressions and body language.

12. Davis, trans., p. 3.

13. John Haslam, *Illustration of Madness: Exhibiting a Singular Case of Insanity* (London, 1810); N. Gillow, *Jonathan Martin: Life and Drawings,* exhibition catalogue, York City Art Gallery, York, England, July 1971; Patricia Allderidge, *The Late Richard Dadd, 1817–86,* exhibition catalogue, Tate Gallery, September 21–October 20, 1974. The role of Dr. W. A. F. Browne (b. 1805) and his advanced views on the therapeutic role of art in asylums has been little investigated. He remains, however, the earliest known collector of patients' art (see *Art Extraordinary,* exhibition booklet, Glasgow Print Studio Gallery, August–September 1978).

14. A. Esquiros, "Les Maisons des fous de Paris," *Revue de Paris* (November 1843):pp. 5–24, 102–28, 243–65; (January 1844):pp. 37, 20.

15. Ibid., p. 118.

16. Ibid., p. 37.

17. The practice of performing plays in asylums and hospitals of the insane was not uncommon in the nineteenth century. Dr. W. A. F. Browne at the Crichton Royal Hospital in Scotland even went so far as to encourage his inmates to produce their own newspaper and to write plays and poetry. The newspaper was begun in 1844 and entitled *The New Moon;* it ran for several years (see *Art Extraordinary*).

18. Paul Broca, "Remarques sur le siège de la faculté articulé, suivi d'une observation d'aphémie," *Bulletin Societe d'Anatomie,* 2nd series, no. 6, (1861):pp. 330–57. For a nineteenth-century view of the writings of the insane, the following works will serve as a starting point: Pliny Earle, "The Poetry of Insanity," *American Journal of Insanity,* no. 1 (1845):pp. 193–224; A. Brigham, "Illustrations of Insanity Furnished by the Letters and Writings of the Insane," *American Journal of Insanity,* no. 3 (1847):pp. 212–26, 333–48, and no. 4, (1848):pp. 290–303; G. Mackensie Bacon, *On the Writings of the Insane* (London, 1870); Victor Louis Marcé, "De la valeur des écrits des aliénés," *Journal de médécine mentale,* no. 4 (1864):pp. 85–95, 189–203; H. Sentoux, *Figaro Charenton: Les fous journalistes, et les journalistes fous: Morceaux de prose et de poésie composés par des aliénés* (Paris, 1867); R. G. Brunet, *Les fous littéraires* (Brussels, 1880).

19. Paul Max Simon, "L'Imagination dans la folie: étude sur les dessins, plans, descriptions et costumes des aliénés," *Annales médico-psychologiques,* 12th ser., vol. 16 (1876):pp. 358–90.

20. John Locke, *Essay Concerning Human Understanding,* vol. 2, ch. 2, quoted in Klaus Doerner, *The Madman and the Bourgeoisie: A Social History of Insanity and Psychiatry* (London, 1981), p. 31 (German original, 1969).

21. Simon, *L'Imagination dans la folie,* p. 360.

22. Paul Max Simon, "Les Ecrits et dessins des aliénés," *Archives de anthropologie criminale et des sciences pénales,* vol. 3 (1888):pp. 318–55.

23. Lombroso came into contact with Simon through Maxime du Camp and drawings by patients were forwarded to the Italian doctor (see Maxime du Camp, in *Souvenirs Littéraires,* 2 (Paris, 1883): pp. 160–61.

24. See E. Regis, "Les Aliénés peints par eux-mêmes,"*Encéphale,* no. 2 (1882):pp. 184– 98, 372–82, 547–64; no. 3 (1883):pp. 642–55; Anon. [Dr. Pierre Hospital], "L'art chez les aliénés: curieuse sculpture sur bois, par un pensionnaire de l'asile d'aliénés de Montredon," *Annales médico=psychologiques,* n.s., 7, no. 18 (1893):pp. 250–55.

25. See Alexander Cozens, *New Method of Assisting the Invention in Drawing Original Compositions of Landscapes* (London, 1785); Justinus Kerner, *Klecksographien: Mit Illustrationen nach den Vorlagen des Verfassers* (Stuttgart, 1857); James Braid, *Neurhypnology, or the Rationale of Nervous Sleep Considered in Relation with Animal Magnetism* (London, 1843).

26. Jules Baillarger, "La théorie de l'automatisme: étudiée dans le manuscrit d'un monomaniaque," *Annales médico-psychologiques,* 3rd ser. (January 1856):pp. 54–65; Jacques-Joseph Moreau (de Tours), *Du Haschisch et de l'aliénation mentale* (Paris, 1845); English translation: *Hashish and Mental Alienation,* trans. Gordon J. Barnett; ed. Hélène Peters and Gabriel Nahas (New York, 1973). The complex history of Gérard de Nerval's novel *Aurélia,* including the last few pages found on his body after he had hanged himself, are dealt with by Jean Richer, ed., *Aurélia: Ou le rêve de la vie* (Paris, 1965).

27. J. Richer, *Nerval: Expérience et création* (Paris, 1963); also *Nerval par les témoins de sa vie* (Paris, 1970) and "Nerval devant psychanalyse," *Cahiers de l'association internationale des études françaises,* no. 7 (1955):pp. 51–64. See Mark Gisbourne, "I disegni di Victor Hugo: caso e spiritismo" in *Victor Hugo Pittore,* published by Edizioni Mazotta as both a book (Milan, 1993) and an exhibition catalogue for the Museo D'Arte Moderna, Venice, March 22–May 16, 1993; also published in a French edition.

28. Jean-Martin Charcot, *Leçons du mardi à la Salpêtrière* (Paris, 1889); see also Paul Richer, *Etudes cliniques sur l'hystéro-épilepsie ou grande hystérie . . .* (Paris, 1881). The earliest journal, *Iconographie de la Salpêtrière* (1877–80), showed no particular interest in art, being generally devoted to neurological matters. However, with the publication of the *Nouvelle Iconographie de la Salpêtrière* from 1888 onward, the whole history of the depictions of the insane in art began.

29. Henri Meigé, "Charcot artiste," *Nouvelle Iconographie de la Salpêtrière,* 11 (1898):pp. 489–516.

30. The articles led to a series of books on the subject by Charcot and Richer (see Jean-Martin Charcot and Paul Richer, *Les démoniaques dans l'art* [Paris, 1887]; Richer, *Les difformes et les malades dans l'art* [Paris, 1889]; Richer, *Physiologie artistique de l'homme en mouvement* [Paris, 1895]; Richer, *L'art et la médécine* [Paris, 1903]).

31. This journal ran continuously from 1891–1919 and contains numerous articles on

graphic automatism. After 1901 it reproduced many examples of automatic works of art by mediums and spiritists.

32. F. W. H. Myers, "On a Telepathic Explanation of Some So-Called Spiritualistic Phenomena," *Proceedings of the Society for Psychical Research,* vols. 1–2, 1885, pp. 217–37.

33. Pierre N. Janet, *L'Automatisme psychologique* (Paris, 1889). The text was dedicated to Drs. Gibert and Powilewicz, who had supplied Janet with the patients for his research.

34. Benedict Augustin Morel, *Traité des dégénérescences physiques, intellectuelles, et morales de l'espèce humaine* (Paris, 1857), with 37 figures.

35. Cesare Lombroso, *L'uomo del inquente studiato in rapporto all antropologia, alla medicina legale, ed alle discipline carcerie . . . con incisioni* (Turin, 1876, and four updated and extended editions to 1889). The book was translated into every major European language.

36. Cesare Lombroso, *La donna delinquente, la prostituta e la donna normale* (Turin and Rome, 1893). This book was translated into English, German, French, and Spanish.

37. Initially called *Genio e Follia* (1864), the book went through six Italian editions. There were three French translations entitled *L'Homme de génie* (Alcan, 1889; Carré, 1896; Reinwald, 1903). The first English translation was *Man of Genius* (London, 1891). The German edition was *Genie und Irrsinn* (Leipzig, 1887).

38. *Man of Genius,* p. 180.

39. Cesare Lombroso and Maxime du Camp, "L'arte nei pazzi," *Archivo di psichiatria scientifico, penali, antropologia e criminale,* vol. 1 (1880):pp. 424–37; *Man of Genius,* 18, 184.

40. Ibid., p. 208.

41. The most famous example was George Bernard Shaw's *The Sanity of Art: An Exposure of the Current Nonsense about Artists Being Degenerate* (London, 1908). See also *Regeneration: A reply to Max Nordau* (London, 1908).

42. Stephanie Barron, ed., *"Degenerate Art": The Fate of the Avant-Garde in Nazi Germany,* exhibition catalogue, Los Angeles County Museum of Art, February 17–May 12, 1991. Also see my essay dealing with effects on artists in Germany of the exhibition and the rediscovery of the Prinzhorn collection and insane art after the war: "Playing Tennis with the King: Visionary Art in Central Europe in the 1960s," in Maurice Tuchman and Carol S. Eliel, eds., *Parallel Visions: The Modern Artist and the Outsider,* exhibition catalogue, Los Angeles County Museum of Art, October 18, 1992–January 3, 1993 (Princeton, N.J., 1992), pp. 174–97.

43. It is clear that the initial emphasis of Dubuffet's collecting of art brut materials was directed toward psychotic art, and it was only later that he began to incorporate works by mediums and other visionary artists. The extent to which we can believe he intended to write a book on the subject for the publishing house of Gallimard remains uncertain. What is clear is that he had been interested in the materials for twenty years, at least since his acquisition of Prinzhorn's book on the subject in 1923. In 1924, after giving up painting, he went to visit his friends René Auberjonois and Charles Albert Cingria in Switzerland; it was at this time that he was first attracted to the artistic expressions of the mentally ill.

44. Marcel Réja, *L'art chez les fous: le dessin, la prose, la poésie* (Paris, 1907); Auguste Marie, "L'art et la folie," *Revue scientifique,* vol. 67 (1929):pp. 393–98; B. Pailhas D'Albi,

"Projet de creation d' un muséé resérvé aux manifestations artistiques de aliénés," *Encéphale,* no. 2 (1908):pp. 426–27.

45. Marcel Réja, "L'art malade: dessins de fous," *Revue universelle,* vol. 1 (1901):pp. 913–15, 940–44; and vol. 3 (1903):pp. 129–133. Alfred Jarry and Rémy de Gourmont, in their jointly edited review L'Ymagier, championed the tradition of popular prints called "images d'Epinal." The name Réja appeared among those listed in the *Almanach de Pere Ubu* of 1899. The context was significant, since it was placed within an imaginary conversation between Père Ubu and a M. Fournil, on the nature of the future avant-garde.

46. Rogues De Fursac, *Les Ecrits et les dessins dans les maladies nerveuses et mentales* (Paris, 1905). The term *schizophrenia* replaced *dementia praecox,* or precocious dementia (first coined by Morel in 1852 and referring at that time to rapid mental impairment after the onset of mental illness). The confused use of the term *dementia praecox* in the later part of the nineteenth century came to mean "dementia at an early age." See Eugen Bleuler's "Dementia Praecox, oder Gruppe der Schizophrenien," in Aschaffenburg, *Handbuch der Psychiatrie,* (Vienna, 1911).

47. For a list of these, see the bibliography to chapter eleven, "Marcel Reja: Critic of the Art of the Insane," in John MacGregor, *The Discovery of the Art of the Insane* (Princeton, N.J., 1989).

48. The use of graphic and written forms of expression for the purposes of intelligence testing in children began in France after the turn of the century. The leading figure in this field was Alfred Binet (1857–1911).

49. See the chapter "Expressionism and the Art of the Insane," in MacGregor, and the relevant essays in William Rubin, ed., *Primitivism in Twentieth-Century Art,* exhibition catalogue, 2 vols., Museum of Modern Art, New York, 1984.

50. Guillaume Apollinaire, "Une série sur les fous," *Les Arts* (June 22, 1914). See *Andre Breton: La Beauté convulsive,* Musée national d'art moderne, Centre Georges Pompidou, April 25–August 26, 1991, pp. 87–90.

51. The expression "hunters of images" was coined by Louis Aragon in *Une vague de rêves* (Paris, 1924).

52. Paul Eluard, "Le génie sans miroir," *Les Feuilles libres,* no. 35 (1924) pp. 301–308.

53. While at the university, Max Ernst made several visits in 1912 to the Provinzial Heil und Pfleganstalt (Provincial Healing and Care Hospital), at 20 Kaiser-Karl Ring, Bonn, where he saw patient drawings and sculpture. He even suggested later that he had intended to write a book on the subject. Though the institution still exists, no trace of these works has subsequently been found. It is possible but still unverified that works from this hospital were later forwarded to Hans Prinzhorn.

54. Hans Prinzhorn, *Bildnerei der Geisteskranken: Ein Beitrag zur Psychologie und Psychopathologie des Gestaltung* (Berlin, 1922 and 1923; repub. New York and Berlin, 1968); Eng. trans. by Eric von Brockdorf, *The Artistry of the Mentally Ill* (New York, 1972). The text was not translated into French until 1984.

55. It was not coincidental that when Dubuffet first began to collect psychotic art, it was from Swiss psychiatric sources, and that the earliest patient artists' works in his collection were by Heinrich Müller, Aloïse Corbaz, and Adolf Wölfli. The Swiss commitment to these

materials was also a major contributory factor in Dubuffet's decision to donate the whole Collection de l'art Brut to Lausanne in 1972.

56. Of the large number of German influences appropriated by Breton and the Surrealists in the period immediately following the First World War, the most telling example was their choice of Freud (see "Interview du Professeur Freud" in *Les Pas perdus* (Paris, 1924), pp. 99–100) over Janet, particularly when the latter was the genuine conduit of automatist theory in France. However, from Breton's later references, we are able to descry a distaste for the nineteenth-century rationalist tradition of *médecin-philosophe* that Pierre Janet so immaculately embodied.

57. Jean Vinchon, "Essai d'analyse des tendances de l'art chez les fous," *L'Amour de l'art*, vol. 7 (1926):pp. 246–48; "L'art dement," *Aesculape*, vol. 17 (1927): pp. 163–67; "Sur quelques modalités de l'art inconscient," *Revue Métaphysique* (1928).

58. Jean Vinchon, *L'Art et la folie* (Paris, 1924); Gaston Ferdière, *Les Fréquentations mauvaises: Mémoires d'un psychiatre* (Paris, 1978); J. Vie and G. Ferdière, "Appel en faveur d'un Musée d'art psychpathologique," *Annales médico-psychologiques*, no. 1, 1939, pp. 130–31.

59. Paul-Gaston Meunier and N. Vaschide, "Analogies du rêve et de la folie d'après Moreau de Tours," *Archives générales de médecine* (1903). See also *Les Rêves et leur intérpretation: Essai de psychologie morbide* (Paris, 1910). Marcel Réja's novels and criticism are very different in tone from the physiological conformism of his medical writings like *Mesures de quelques modifications physiologiques provoquées chez les aliénés par alitement thérapeutique* (Paris, 1900). The nature of his writings on the insane would have been highly criticized had he not used a pseudonym, since they went totally against the classificatory tendencies of his day. It was also the case with Hans Prinzhorn that though his 1922 book was revolutionary in advancing psychotic art, it did his career no good at all; before his premature death in 1933, of typhus, he had been passed over several times for seniority.

60. Michel Thévoz, "Marcel Réja: Découvreur de l'art des fous," *Gazette des Beaux-Arts*, vol. 107 (May–June 1986): pp. 200–218.

61. There was an exhibition of Dr. Marie's collection at the Galerie Vavin in 1928, followed a year later by one at Galerie Max Bine, avenue Iéna, Paris, entitled "Manifestations artistiques des malades du cerveau." For a discussion of a general Surrealist interest in the materials, see "Psychosis and Surrealism," in MacGregor, pp. 271–91. For a more situational account of the ambiguous relationship to the materials within Surrealism, see Roger Cardinal, "Surrealism and the Paradigm of the Creative Subject," in Tuchman and Eliel, eds., *Parallel Visions*.

62. *Peintures d'un Fou: L'Art schizophrénique*, lectures and small exhibition leaflet, Galerie de la Pléiade, Paris, January 11–30, 1934.

63. For a general discussion from the late 1930s onward, see Sarah Wilson, "From the Asylum to the Museum: Marginal Art in Paris and New York," in Tuchman and Eliel, eds., *Parallel Visions*.

64. Andre Breton, "L'art des fous, la Clé des champs," in *La Clé des champs* (Paris, 1953), pp. 270–74; Paule Thévenin and Jacques Derrida, *Antonin Artaud, Dessins et Portraits* (Paris, 1986). For the writings of Antonin Artaud, see *Oeuvres Complètes*, vol. 1, and vol. 2 (Paris:

1956 and 1961). For a translation of *Van Gogh: The Man Suicided by Society*, see Jack Hirschman, ed., *Antonin Artaud Anthology* (San Francisco: 1965), pp. 135–63.

65. For a general orientation to these artists and the issues of primitivism, madness, and cultural margins in France after the war, see *Aftermath: France, 1945–54*, exhibition catalogue, Barbican Art Gallery, London, March 3-June 13, 1982.

66. See Wilson.

67. Jean Dubuffet, Preface to *L'art brut préféré aux arts culturels*, exhibition catalogue, Galerie René Drouin, Paris, 1949; reproduced in Jean Dubuffet, *Prospectus et tous écrits suivants* (Paris, 1967), vol. 1, pp. 198–202. Dubuffet's position concerning the prevailing art culture was best expressed by his lecture "Anticultural Positions," given in English at the Arts Club of Chicago, December 20, 1951.

68. This was evident from the fact that the first medical dissertations devoted solely to the artworks of psychotic patients now began (see Jean Dequeker, *Monographie d'un psychopathe dessinateur: étude de son style* (Toulouse, 1948). It is significant that in France, monographs on insane artists postdate German writings by twenty years. Dr. Walter Morgenthaler's monograph on Adolf Wölfli, *Ein Geisteskranker als Künstler* (Bern and Leipzig), dates from 1921.

69. The organizers of the exhibition were Drs. Jean Delay and Robert Volmat. The idea of a large psychopathological art exhibit accompanying the Psychiatric Congress probably came from the fact that an exhibition of works by patients had been held at the Saint-Anne Hospital in 1946. Dr. Gaston Ferdière opened the exhibition with a lecture, and a small catalogue was also published with prefatory essays by Professor Henri Mondor and the art critic Waldemar George. "L'Exposition Internationale d'Art Psychopathologique," Paris, September 21–October 14, 1950.

70. For a general survey concerning these issues within Cobra, consult Jean-Clarence Lambert, *Cobra* (Paris and London, 1983).

71. Robert Volmat, *L'Art psychopathologique* (Paris, 1956). There is a vast outpouring of literature dealing with psychotic-schizophrenic art (or psychopathological art, as it was sometimes called) from the late 1940s. A reader would be best served by consulting Norman Kiell, ed., *Psychiatry and Psychology in the Visual Arts and Aesthetics: A Bibliography* (Madison, Wis., 1965). For a complementary volume dealing with literature, see Norman Kiell, ed., *Psychoanalysis, Psychology, and Literature* (Madison, Wis., 1963).

72. Art therapy becomes an important issue in the context of the postwar period. For the situation of art therapy in France immediately after the war, see Adrian Hill, *L'Art contre la maladie: Une histoire d'art-thérapie* (Vigot, 1946). In the 1950 exhibition, Robert Volmat did not distinguish between art therapy and spontaneously generated works. However, Jean Dubuffet totally rejected works that were motivated and directed by art therapy. Art therapy in relation to art brut stands rather like Charcot's hypnotherapy experiments at the Salpêtrière in the 1880s, which were criticized by the Nancy School led by Hippolyte Berhheim; that is to say, they are open to being directed by the suggestibility of the therapist. Dubuffet's famous quotation on the power of art brut has meaning only in this context. "Art does not lie down on the bed that is made for it; it runs away as soon as one says its name; it loves to be incognito. The best moments are when it forgets what it is called" (quoted in *Outsiders*, exhibition catalogue, Hayward Gallery, Arts Council of Great Britain, 1979, p. 1).

OUTSIDE OUTSIDER ART

Kenneth L. Ames

This essay is an invitation to reflect on the condition of Western society's collective soul. A strange way to begin a discussion of so-called outsider art perhaps, but strange only because we have become accustomed to looking at and thinking about art in isolation from the larger world. It is neither quaint nor passé to think that art and ethics, art and morality, art and spirituality, might be linked. While art itself need not be explicitly ethical, moral, or spiritual, a society's definition of art, its uses of art, and its hierarchy of arts all provide valuable if often unintended testimony to its ethics, morality, and spiritual state.

Responsible exploration and assessment of art in any society mean asking questions about the functions and ramifications of that art. This responsibility increases rather than diminishes when we turn to art in our own society. Of all arts, our own most needs to be subjected to such questions, for it is our responsibility to keep our own house in order.[1] And that means so-called outsider art must be the focus of inquiry. The brief exploration of outsider art I offer here moves outward from the art and what is said about it to the wider surrounding field of Western contemporary high culture art and the values and ethics implicit in that art. The exploration makes two facts perfectly clear. The first is that profoundly important social and cultural struggles are taking place on the terrain called art. The second is that it is impossible not to take sides.

In this essay I take sides. I take a stand. I believe that outsider art is a flawed and injurious concept that promotes and perpetuates a dehumanizing conception of art. In these pages I explain the reasoning behind my stand.

My view is in part a reflection of the growing tendency within American society

to be critical of the claims made for high culture art and its various colonial manifestations, of which outsider art is a prominent example. Today, if high culture art has not exactly embraced life, life has at least invaded high culture art. A decade or two ago, we were willing to believe that art could exist in a vacuum, apart from and somehow unsullied by the world. And that is the way art and art history were taught.[2] But that stance now seems touchingly innocent and naive [15.1]. Today when we look at art or visit art museums or galleries, we are likely to wonder about social and political agendas, power relations, ideological orientations, or social impact and ramifications. Regardless of its form, regardless of its alleged content or lack of content, we now recognize that art is a piece of the world, a product of the world, and necessarily plays a role in that world.

For those who have been trying to bring art back in touch with life, renewed attention to content and context is welcome. After all, only the most extreme self-delusion, the most exaggerated Platonism, could sustain the fantasy that art had been created in some utopian void apart and insulated from the coercive forces of the

15.1. Works of art always invite the same questions: What do they mean? Whom do they serve? What are their ramifications? Sometimes answers to these questions are obvious; sometimes they are more elusive.

Cornelius Krieghoff. *An Officer's Trophy Room,* 1846, oil on canvas, 17 1/2 in. × 25 in. Royal Ontario Museum, Sigmund Samuel Collection.

larger world. Yet that delusion has not vanished into the obscurity it deserves. It has only resurfaced to thrive anew in the cultural construction called outsider art.[3] In this relatively recent product of romantic fantasy, total solipsism reigns. Or perhaps I should say that total solipsism is the goal. It seems to me that proponents of outsider art have constructed a largely imaginary domain in which artists are liberated from everything that might conceivably impinge on them in a negative way. In the constructed land of outsider art and outsider artists, all mundane, banal, crass, or commercial demands, constraints, and considerations characteristic of modern civilization have been swept away. Artists have total creative freedom and no responsibilities.

This imaginary land of outsider art has been populated, largely without their consent, by a mixture of minority, marginalized, and unempowered people. Prominent among them are many who are emotionally disturbed or mentally impaired, people who are out of touch with the larger world in a variety of ways and for a variety of reasons. But the more we examine outsider art, the more it becomes apparent that the entire enterprise is out of touch with the larger world and suffers from a kind of myopia associated with overspecialization.

The peculiarities of modern abstract art and the ideology that sustains it have obscured the truth that most of the world's art has always been part of life [15.2, 15.3].[4] Because it was integrated into life, much of art necessarily served social, political, or other agendas, but it has taken us a long time to acknowledge this truth. Hegemony works best when we don't know it is working.[5] Falsified formalist histories dominant a couple of decades ago neatly sequestered art from the messy concerns of life. Romantic ideologies and appropriate cultural beliefs limited the ways we saw, thought about, and even acknowledged art. Naming played, and continues to play, a critical role in shaping or impeding understanding.

The very designation, outsider art, may on the surface suggest separation from social and political engagement. Indeed, we may once have been willing to assume that outsider art really was outside of or oblivious to such considerations. Yet the evidence suggests quite the opposite. Perhaps some of the makers of the objects called outsider art were or are truly indifferent to worldly matters, although surely not unaffected by them; but those people did not invent the designation or make outsider art a cause in the art world. They did not call themselves outsiders or issue manifestos proclaiming the triumph of outsider art. Indeed, whatever the claims, outsider art is not really about alleged outsiders or the things they make. The key players are really the namers, the advocates, the apologists. If we make the effort to see through the clouds of mystification that surround them, we will find that they are often very interested in matters of the world.

What I am suggesting here is that we make a mistake if we think of outsider art as primarily an aesthetic phenomenon. While it has aesthetic dimensions, its political and social dimensions are just as critical. For studying outsider art leads us also to explore power relations and the ways some people use other people for their own

15.2. Most of the world's artists have been engaged in their society at some level, working under implicit or sometimes even explicit social contracts. And most of the world's art has had social purposes and served social agendas.

Christmas postcard, United States or Germany. Sent to Frieda Sippel, West Albany Shakers, from Pittsfield, Massachusetts, December 23, 1908. New York State Museum.

ends. Outsider art shows how obsessive fixation on a single set of goals or values grotesquely distorts reality. It reveals yet another instance of the way people, men in particular, are too often inclined to value idealizations and abstractions over living human beings.

A critical exploration of the idea of outsider art engages many of the most pressing concerns of our time. Gender, class, and ethnic equity; the relationship of high culture art to social and political structures and agendas; the values and consequences of bureaucratized societies; the cult of specialization; conflicting claims to cultural authority; divergent visions of the functions and purposes of art; the gulf between, as well as the confluence of, scientific and romantic world views; ethical and moral blindness; Western capitalism's insatiable appetite for novelty; the dominance of market values—all these and more can be found here. Studying the alleged outside necessarily and inevitably leads to studying the inside. Studying "them" really means studying us.

The exciting thing about the phenomenon called outsider art is that it has pushed art so far, and into such an extreme posture, that questions about art's relationship to all of these issues become impossible to avoid. Outsider art makes it

15.3. Abstraction as macho swagger, with the same negative effects? Abstraction leads away from life, not toward it; away from people, not toward them; away from communication, not toward it. Abstraction leads away from experience, from sympathy, from empathy, and from situational sensitivity.

Franz Kline. *Charcoal Black and Tan,* 1959, oil on canvas, 9 ft. 4 in. × 6 ft. 10 1/2 in. State of New York, Governor Nelson A. Rockefeller, Empire State Plaza Art Collection.

painfully clear that there is no need to fear that all strange and exotic cultures have been swept from this world by the forces of modernization. One of the strangest cultures of all still flourishes. And that is our own. Of that culture, the part called art culture seems particularly strange [15.4]. In no other society, that is, nowhere outside the Western capitalist world, has art taken quite the same configuration. Nowhere else is it quite as specialized, quite as self-contained, quite as removed from daily life. The distinctive peculiarities of the Western system of elite art are thrown into high relief when one begins to explore the area called outsider art.[6]

Studying outsider art brings us face to face with questions about fundamental human values and appropriate relationships of people to other people and to their cultures. It pushes us to think about compassion or the lack of it; about empathy or the lack of it. It requires us to decide whether we will work to make a better world in whatever small ways we can or will exploit the world as it now exists for our own gain and aggrandizement. Others may describe the issues and questions provoked by outsider art in different terms. But only the narrowest inquiry into these goods and their content and contexts will be able to avoid the realization that outsider art is tightly bound up in a web of social and political ramifications.

Outsider art is positioned at the edge of the elite or high culture art world and for that reason throws into high relief contemporary elite or high culture art values. For that matter, the entire genre of high culture art is peripheral to much of American life but—or, more exactly, therefore—it remains an important repository of cultural values. The art itself may or may not matter. What does matter is the belief system it sustains and embodies. That is why looking at and, even more important, reading about and reflecting on outsider art is much more than a dilettantish exercise. This double edge, this double margin where outsider art teeters, is exactly the place where those interested in the symbolic life of modern society and its central cultural values should look.

I have bandied about the terms *insider* and *outsider* without explanation. Both terms are heavy laden with meaning, yet at the same time they are almost meaningless. From some perspectives, all of us are insiders and all of us are outsiders. It is all a matter of point of view, and point of view is always affected by where you stand. What I want to introduce here is a slightly different interpretation of the two terms than is usually used, for I would maintain that the fragmentation and specialization characteristic of modern life have created a society where we are all both insiders to our own specialized area of activity or expertise and outsiders to virtually every other area all of the time. This is not the way the insider-outsider dichotomy is used by proponents of outsider art, but it nonetheless allows us to better understand what those people say and how they think. For they position themselves within the art culture and conform to and perpetuate its rules. Many of us who are outside that culture think its rules are not merely odd but sinister. The insider's world is in serious need of what we call nowadays a reality check.

Over the course of the last two centuries, the art world has grown increasingly

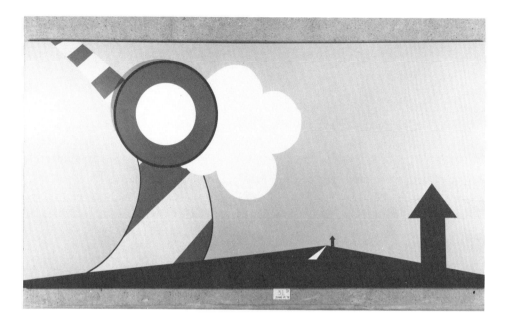

15.4. Enigmatic modern abstract art. It makes sense to art culture insiders, but to millions of others it is nearly unintelligible and virtually meaningless, except perhaps as a gesture of exclusion and elitism.

Allan D'Arcangelo. *American Landscape,* 1967, acrylic on canvas. State of New York, Governor Nelson A. Rockefeller, Empire State Plaza Art Collection.

specialized. While doing so, it has developed its own values, its own jargon, its own ideology, and its own hierarchies. All these are not merely unfamiliar to people outside the world of elite culture art but very strange as well. What the configuration of the high culture art world currently reveals is how peculiar and self-absorbed a specialized part of a larger society can become when it is disconnected from that society.[7]

This problem of specialization or overspecialization is not peculiar to the fine-art world. It exists in many of the professions, in the sciences, in technology, in bureaucracies, in academe in general. In the latter, specialization has often seemed so extreme that I sometimes suspect that the audiences for many scholarly monographs consist mainly of the authors of those monographs. Increasingly in recent years academic conferences seem to feature more and more scholars talking about smaller and smaller subjects to fewer and fewer listeners. All fields are susceptible to this specialization, but literary criticism and, even more, philosophy, seem to have drifted particularly far off into their own rarefied, jargonistic dream worlds, ever more distant from the world of real speaking, acting, touching, living people and their concerns.[8]

We see similar negative effects in the realm of politics. We now commonly speak

of politicians who are out of touch with those they are supposed to represent. Political life and thought seem to have acquired their own internal structure and logic, which bear remarkably little resemblance to the world as the rest of us see it, and assuredly little to our sense of genuinely pressing government priorities [15.5]. To witness what passes for political discourse these days is to invite severe depression, rage, cynicism, or hilarity, depending on your style of coping.

Isolation and intellectual inbreeding of a similar sort afflict art culture. What makes sense or passes for normal inside seems very strange outside. From the outside, art seems deliberately unrelated to issues and concerns of ordinary people. Art is a closed system, a segregated world. Artists living in this segregated world not only make art but control the definition of art. For that matter, artists seem less and less to make art, and more and more to define art. Found art, folk art, outsider art. All made by others. All named and anointed by high culture artists who talk increasingly to themselves, who live in their own world.

This is not the place for an extended critique of late twentieth-century high culture art. But it is the place to call attention to particularly problematic dimensions of outsider art as it is conventionally defined and to remember that many of those problematic dimensions stem from outsider art's colonial relationship to high culture art. And it is the place to note that, from a holistic social perspective, the values sustaining outsider art seem both bizarre and dangerous. Although its apologists will surely disagree, their understanding and interpretation of outsider art strike me as pathological products of modern society.

That the works incorporated under this mischievous rubric may be variously beautiful, provocative, terrifying, depressing, perplexing, or yet something else I do not deny. But that is not the point. What is the point and what troubles me deeply is that proponents of outsider art 1) make a fetish out of classifying humans and forms of human creativity; 2) valorize formalistic imperialism, male hubris, and what can most charitably be called sloppy thinking; and 3) show near total disregard for human context and extra-aesthetic meaning.

Classification is one of the major legacies of the so-called Age of Reason. Classification is also one way people, usually men, make order out of the chaos that surrounds and threatens to engulf them. Classification has its benign aspects. It is reassuring to be able to give names to the various birds that frequent our backyards and to the plants and flowers we attempt to grow there. But when classification turns to people and the things people make and have made, the situation becomes more difficult [15.6]. Anyone familiar with museums will recall that the biologists and geologists seem to have a much easier time classifying their respective materials than the curators of history. For that matter, have you ever tried to apply stylistic labels to every building or every piece of furniture you encountered? It just doesn't work. Things don't fall into easy patterns. All the edges are blurred. And many of the alleged centers don't hold up under close scrutiny either.

People are even more difficult to classify than the things they make. Who really

I5.5. As in art culture, some in the political culture live in their own circumscribed world, pursuing their own group's interests without regard for the larger society or for the enduring ramifications of their actions. From an outsider's perspective these insiders may seem deluded at best, at worst, evil.

Larry Rosing. *Flag Over White House*. First day cover (envelope specially decorated to mark the first issue of the twenty-nine-cent "flag over White House" stamp), 1992.

knows how to assign someone to the correct social class, whatever that might mean? Differences in education, wealth, and values surely exist, but how to evaluate them? Most classifications of people are usually based on biases, overt or concealed. And if the truth be told, most classifications of people are invidious. Many are little more than strategies to rationalize or formalize preexisting prejudices. Classification systems applied to people frequently assign high rank to those who most resemble the classifiers and low rank to those most unlike the classifiers. People tend to spend relatively little time classifying those they think are better than or superior to themselves but much more time classifying those they think are inferior. It is much easier and more satisfying to classify people who seem to be inferior in some way. In actual practice, classifying people often means assigning people to various but usually low ranks, then transforming those arbitrary, assigned ranks into fixed and immutable social positions. It also goes without saying that with assigned ranks also comes a host of assigned characteristics that further pigeonhole people and limit their options.[9]

The most basic form of classification of people is into two groups, male and female. Feminists and students of gender relations can recite the almost endless litany of invidious pairings that accompany and inform this classification [15.7]. The next most basic form of classification, an extension of the first, is also into two groups: we and they. This dichotomy is invariably weighted. We are good and superior in some way. They are bad and inferior in some way. The most egregious examples of this crude dichotomization are promulgated to mobilize people to destroy other

15.6. Classifying is a way to control. To a point, it is necessary, for people cannot exist without finding or imposing some order on the world around them. Recognizing patterns is a valuable survival skill. But pushed too far, classifying becomes pernicious, exaggerating distinctions and limiting opportunities and freedoms.

"Arabian" design motifs. From *The Grammar of Ornament*, by Owen Jones (London: Day and Sun, 1856). Courtesy the Winterthur Library, Printed Book and Periodical Collection.

15.7. Women are the world's perennial outsiders. Women and their accomplishments have been systematically devalued by the males who control and perpetuate definitions and hierarchies.

Anna A. Taylor Cubberly. *Crazy Quilt* (detail), ca. 1880–1899, silk and cotton, 63 in. × 81 in. New Jersey State Museum Collection, Trenton: Museum purchase.

people. Think of any nation in wartime, when the enemy is dehumanized into an inferior, subhuman "them."[10]

One of the problems with this dichotomous classification is that it comes all too easily. Anthropological literature suggests that it may even be a human universal.[11] All people do it, imagining themselves as the superior or inside group and some other group as the inferior or outside group. Notions of the real people, the chosen people, the people with the only true religion are too well known to be belabored here.

In writings on outsider art, classification takes a variety of forms and is complicated by some intriguing inversions or reversals. Shaping the ideology of outsider art are romantic assumptions about the enviable freedom or liberation of outsider artists. From this perspective, outside becomes superior. Yet even while this view is being asserted, those very outsiders are denied voice and an active role in defining themselves. Thus, from a functional perspective, outsider artists remain in an inferior posi-

tion. It becomes clear that while outsiders play important symbolic roles, as Babcock and Stallybrass and White have already reminded us, their parts are largely, perhaps even entirely, written by insiders.[12]

Classification may be, then, misleading. Above all, however, it is mischievous. It reduces human complexity and diversity to a few oversimplifying words. It conceals authentic ambiguity and fluidity behind a rigid and reductionist mask. It dehumanizes. My sense is that, in general, those most concerned with classifying are also most concerned with formalism, with the nonhuman dimension of the works they call art. And those who avoid or critique classifying are more focussed on people and the human dimensions, both affective and cognitive, of the things people make.[13]

The second aspect of the prevailing understanding of outsider art that I find particularly troubling is sloppy thinking about art and the smug and arrogant assumption that art is anything artists declare it to be. In making this argument I want not to be misunderstood. My intent is not to denigrate the people who have been involuntarily assigned the label of outsider or the things called outsider art. It is critical to recognize that the inventors of outsider art have put under that rubric a remarkable array of works, performances, statements, gestures, and expressions. Some are artful. Others are apparently artful. By that I mean they correspond to or resemble things that have been dubbed art. Their formal qualities conform to the guidelines determining what might appropriately be called outsider art. But to call them art is either sloppy thinking, hubris, or blindness to other ways of looking at and responding to the world and the things in it.

These objects have a formal dimension to them because it is impossible to make objects without a formal dimension. But they are not intended to be about form. Reading them as form, as though they were the creation of a high culture modern artist is a strange and in some ways a hostile or insensitive act. Here I speak most explicitly about the goods made by people with emotional disorders so severe that they cannot function in the outside world. There is no doubt that these people find significant outlet for some of their inner anguish in the act of drawing or painting. Through these activities, troubled people objectify some of their inner conflicts and, possibly, gain some faith in their own ability to overcome them. There is a discipline or a profession called art therapy devoted to improving people's emotional health through providing the opportunity for such nonverbal expression.[14] For the truth is that many people find it easier to identify and work through some of their problems in media apart from words. Art therapy, then, shares a key tenet with material culture scholarship: that things—here largely drawings and paintings—carry content that people cannot or will not put into words.[15]

This is a key point because it underlines exactly where outsider art departs from both material culture studies and art therapy. For both studies recognize that most material culture and most art made as therapy are created for a purpose, are created to serve one or more functions, are created to communicate, at least at some level [15.8]. But in looking at outsider art, all of which is material culture and much of

15.8. Material culture is always a form of communication at some level. In this case, it celebrates lives, memorializes the dead, and heightens awareness of a spreading fatal epidemic.

Panels of the NAMES Project Memorial Quilt, created for victims of AIDS. On view in the New York State Museum, December 1990. Photograph by John Yost.

which can be described as therapy, the proponents of outsider art seem strangely unconcerned with whatever those goods might be trying to communicate, resolve, explicate, or expiate. This indifference is justified as necessary to advance the cause of formalism, in itself a bizarre and inhumane view of the world.

Even the humane profession of art therapy compounds the difficulty of thinking clearly about what we are seeing. Art therapy is misnamed. People in therapy are usually not making art. They are creating graphic expressions. They are wrestling in nonverbal form with internal demons. They are exploring parts of their own past through the jumbled records hidden or misfiled within their own cognitive structures. They are discovering or trying to discover earlier selves, the child within, the person they might become. Or they may be creating a graphic world that will never be cognitively accessible to anyone else. When we use the word *art*, we immediately rob this complex inner exploration of its deeper personal meanings.

Some people want to call the graphic explorations or expressions of troubled people art because these creations look like what they think art is or ought to be. They call them art because of their formalistic appeal. The screams of people in pain have form and tonal structure, but that does not make them music. Wounded people may squirm in distinguishable patterns and produce shapes and configurations, but we do not call what they do dance or performance art. Emotionally wounded or troubled people may express themselves graphically, they may inscribe gestures or create random, patterned, or structured markings on paper, but what they create may not be—probably is not—art. If it is, *art* is a meaningless term. If it is, we have reached a new level of dehumanization and insensitivity. If it is art, we need to abandon art. What is to be gained by concealing truth under the mystifying blanket of art?

I do not want to be misunderstood here, nor do I want to be doctrinaire. Some nonverbal expression based on or exploring one's inner self may be both art and artful. As I have been arguing, there are no easy rules, no facile ways to classify what people do. Consider the testimony of two distinguished women, Judy Chicago and Gloria Steinem. Judy Chicago defines herself as an artist and is recognized as such by the greater society. Much, if not all, of her art has had a profoundly auto-biographical element to it, as she has struggled to create a distinctive woman's art grounded in her own experiences, her own identity, her own sexuality, and her efforts to fully actualize herself in a male-dominated art world. Many of her works were products of a conscious and deliberate process of self-analysis and therapy through nonverbal, artful expression [15.9]. About the psychic benefits of one series of works, the *Pasadena Lifesavers*, she says:

> Through the "Pasadena Lifesavers," I was able to emerge from the many constraints of role conditioning, for as I symbolized the various emotional states that comprised my personality, I gave myself permission to experience and express more aspects of myself. When I finished the paintings, I felt like icebergs were breaking up inside me. By making images of my feelings, I was able to liberate myself from the guilt about my needs, my aggressiveness, my power as a person.[16]

Gloria Steinem is one of the most prominent feminists of the late twentieth century. She is an activist for human rights and not an artist. But in *Revolution from Within*, she talks about the benefits of self-exploration through painting, drawing, making pots, and related activities. Steinem approvingly quotes Goethe's dictum: "We talk too much; we should talk less and draw more." She reports on the importance of painting to singer Judy Collins and on the way Alice Miller used "painting as a path to reexperiencing and healing her own over-controlled, spirit-breaking childhood." Steinem stresses that these people and the others she discusses do not see themselves as making art (or Art). Rather, it is the act of using other materials, other senses, and therefore other parts of the brain that help them reach deep within themselves and heal psychic wounds.[17]

15.9. An outsider transforms perceived weaknesses into strengths. This prominent example of feminist art uses media traditionally associated with women to celebrate women of the past who overcame male oppression to make important contributions to humankind. Originating in one person's conscious and deliberate search for self-understanding, this object is therapeutic for an entire society.

Judy Chicago and Associates. *The Dinner Party,* 1979, mixed media, 48 ft. each side. Copyright Judy Chicago. Photo by Donald Woodman, courtesy of Through the Flower, Santa Fe.

Is the imagery produced in these processes of self-exploration art? For Judy Chicago, yes. For Alice Miller, no. For deeply traumatized or autistic people, we hardly know what to think. We cannot easily generalize. We cannot easily classify. Nor should we try to. Circumstances vary. Intentions vary. Self-awareness varies. Judy Chicago wanted to find her subject matter in her own experience. Others wanted to reach unknown parts of themselves and painted only for themselves. Regardless of whether they thought about art, however, all of these people found the images they made deeply meaningful or gratifying. And this issue of meaning brings me to the next point.

The third problem I see with so-called outsider art is the tendency of some of its advocates to separate, even sever, people from the things they make. This tendency seems related to the formalism that still stalks the land of art. Formalism means an insistence on privileging a formal reading or response to an object above all others.

It insists that form must always be the primary consideration. The potential for abuse and idiocy within such a rigid doctrine is obvious. Its potential for dehumanization, for insensitivity, for distortion of intent, for falsification, is all equally obvious [15.10].

Formalism is least offensive when it is applied to the work of elite culture artists who share formalist values. But when this modern sensibility is superimposed on things created in entirely different contexts by people apart from, ignorant of, or indifferent to formalism, the ugly spectre of cultural arrogance appears. Anything with the right formal properties may be wrenched out of context and appropriated as outsider art to meet the dominant culture's insatiable demand for formal novelty.

Formalism reveals the kind of tyranny that becomes possible when one idea drives out all others. Even allowing for the value of formalism within current Western high art, which is dubious, its application to random bits of the humanly made universe shows ethnocentrism at its worst, cavalierly revaluing and reinterpreting things made by known and knowable people living in other circumstances. The widespread abuse of formalism is a compelling argument for pluralism, for alternative visions and values to check and control ideological monopoly [15.11]. A great shortcoming of formalism is that it closes off much of the cognitive exploration complex artifacts may invite. In separating goods from people so that we may better view them through our own narrow formalist and therefore ethnocentric lens, we deny ourselves the opportunity to turn exploration of goods into a meaningful and rewarding learning experience. And we deny ourselves the opportunity for growth that seeing the world or a part of it from someone else's perspective provides. By superimposing our values, we only see more of ourselves. By trying to leave our own prejudices behind, we may indeed sail out into uncharted and threatening waters, but those waters may ultimately bring us to lands of enlightenment we never knew existed. But if we never relinquish our upper hand, we merely dominate—and remain ignorant.

The formalistic insistence on removing the people who make things from meaningful consideration of those things simultaneously cuts off two potentially rewarding routes: one to learning, as I have already noted, and the other to compassion. There are those who wish to mystify art and those who wish to understand it. My sentiments lie with those who want to understand whatever can be understood. Some of what is called outsider art is produced by people who pour their entire being into what they make. We shortchange not only those people but ourselves if we refuse to realize that the art is inseparable from the life, that the art cannot be understood without learning about the life. We lose much when we refuse to hear their voices. This seems common sense to me.

But apparently it is not for everyone. Some seem comfortable with the suppression of other voices, the suppression of empathy,[18] the suppression of compassion, fostered by extreme formalist stances. In this suppression we see the evils of modern specialization and its accompanying segregated consciousness. Aesthetics cannot be

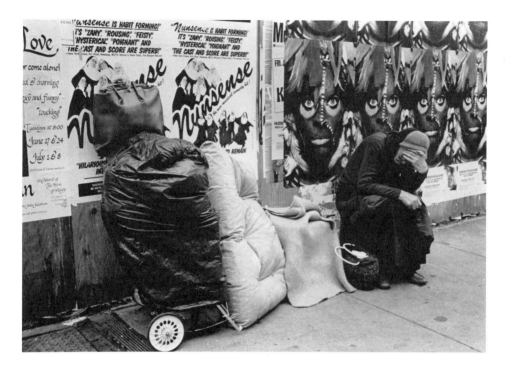

15.10. Formalists might complain that this image is a bit cluttered, or not a "clean" composition. But that is hardly the point. This was not conceived as art but as a record of human suffering and a document of an unjust social order. It urges us to see, feel, understand, and act. Art is not merely beside the point here, it is irrelevant.

Mel Rosenthal. Photograph of a homeless woman, 1990.

separated from ethics or morality. Intentions matter. Ramifications matter. Seeing the whole picture is critical to responsible living.

It is this disinclination to look at things people make in a broad and open-minded perspective that causes me to disagree with the proponents of outsider art. For in their narrow assessment of what matters and in their cavalier attitude to human involvement with objects, they mirror and perpetuate the worst features of our fragmented and bureaucratic world.

I have mentioned only a very few of the many important and compelling issues that outsider art raises. In doing so, I have expressed more of my own point of view than is customary in academic essays. But this is not a subject on which one can easily remain neutral. To assume a posture of scholarly objectivity would have made me complicit in advancing views I do not endorse. It would have perpetuated the tendency to self-distancing that I have critiqued here. Sometimes important matters are not well served by too much objectivity. Sometimes it is necessary to join the struggle.

15.11. A triumph of formalism and visual values. A grand vista Brunelleschi might have enjoyed. This visually imposing complex provides dramatic views and striking instances of the laws of perspective. But for much of the year the space is cold, barren, and windswept. The individual buildings are superhuman in scale and uninteresting at close range. Many interiors are shoddy and depressing. A wonderful design does not necessarily translate into a wonderful human environment.

View of the Governor Nelson A. Rockefeller Empire State Plaza, Albany, New York. W. K. Harrison, architect, 1972–77. Photograph courtesy of the New York State Office of General Services.

I began with a reference to Western society's collective soul. I have tried to show that the construct called outsider art threatens that soul by promoting inhumane values. If that soul is to be saved, we need to foster values that honor and empower more of humankind. We need to continually critique reigning ideas and ideologies and do whatever we can to promote authentic pluralism. We need to reconnect art to life and put humanity back into art. We need to foster art for people, not art against people. We need critical voices. We need people willing to question, people willing to explore ramifications. We need people who will challenge claims of cultural authority. We need people who will protect the vulnerable, who will resist oppression, disenfranchisement, marginalization of the unempowered. We need people who can see beyond the limited and limiting horizon of the dominant culture. And

we probably need to get rid of the whole idea of outsider art. It does more harm than good.

NOTES

1. On critiquing art in our own society, see Maurice Berger, *How Art Becomes History: Essays on Art, Society, and Culture in Post-New Deal America* (New York: HarperCollins, 1992).

2. If the study of art and art history were strangely detached from the world, the study of music seems to have become even more bizarrely estranged. See Kathleen Marie Higgins, *The Music of Our Lives* (Philadelphia: Temple University Press, 1991).

3. For the basic tenets of outsider art, see Roger Cardinal, *Outsider Art* (London: Studio Vista, 1972).

4. On art being integral to life, see Ellen Dissanayake, *What Is Art For?* (Seattle: University of Washington Press, 1988); David Novitz, *The Boundaries of Art* (Philadelphia: Temple University Press, 1992); and Higgins, *Music of Our Lives.*

5. On the workings of hegemony, see Harvey J. Kaye, *The Powers of the Past: Reflections on the Crisis and the Promise of History* (Minneapolis: University of Minnesota Press, 1991), 65–74, 130–135.

6. Dissanayake, *What Is Art For?*; Philip Fisher, *Making and Effacing Art: Modern American Art in a Culture of Museums* (New York: Oxford University Press, 1991). Much of modern elite culture art might be seen as a form of applied phenomenological musing and therefore closer to philosophy than to art as traditionally understood.

7. Specialization carried to extremes often leads to the separation of ends from means. This separation always carries with it the potential for great cruelty and suffering. For an extended analysis of these ideas, see Zygmunt Bauman, *Modernity and the Holocaust* (Ithaca: Cornell University Press, 1991).

8. For a view of recent literary scholarship, see Steven Watts, "The Idiocy of American Studies: Poststructuralism, Language, and Politics in the Age of Self-Fulfillment," *American Quarterly* 43, no. 4 (December 1991): 625–660.

9. For a thoughtful examination of the circular reasoning that often accompanies classification, and for an invitation to more rigorous thinking about thinking, see Elizabeth Kamarck Minnich, *Transforming Knowledge* (Philadelphia: Temple University Press, 1990). For further comments on the negative aspects of social classification, see Barbara Ehrenreich, *Fear of Falling: The Inner Life of the Middle Class* (New York: Pantheon, 1989).

10. On the way Nazis systematically dehumanized Jews, see Bauman, *Modernity and the Holocaust.* On the cost to survivors, see Lawrence L. Langer, *Holocaust Testimonies: The Ruins of Memory* (New Haven: Yale University Press, 1991).

11. Donald E. Brown, *Human Universals* (Philadelphia: Temple University Press, 1991).

12. Barbara A. Babcock, Introduction to *The Reversible World: Symbolic Inversion in Art and Society* (Ithaca: Cornell University Press, 1978), 15, and Peter Stallybrass and Allon White, *The Politics and Poetics of Transgression* (Ithaca: Cornell University Press, 1986), 26.

13. For a consistently humane approach to studying people and the things they make, see the work of Michael Owen Jones, including *Exploring Folk Art: Twenty Years of Thought on Craft, Work, and Aesthetics* (Ann Arbor: UMI Research Press, 1987).

14. For a recent summary of scholarship in areas of psychology relevant to art therapy, see Vija Bergs Lusebrink, *Imagery and Visual Expression in Therapy* (New York: Plenum, 1990).

15. For explorations of some of the basic tenets of material culture study, see Grant McCracken, *Culture and Consumption: New Approaches to the Symbolic Character of Consumer Goods and Activities* (Bloomington: Indiana University Press, 1988), and Kenneth L. Ames, *Death in the Dining Room and Other Tales of Victorian Culture* (Philadelphia: Temple University Press, 1992).

16. Judy Chicago, *Through the Flower: My Struggle as a Woman Artist* (Garden City: Doubleday, 1975), 57.

17. Gloria Steinem, *Revolution from Within: A Book of Self-Esteem* (Boston: Little, Brown, 1992), 170–173.

18. Formalism probably has multiple causes, but the possibility that it is at least partially an element of the backlash against women should not be dismissed. See Chicago, *Through the Flower.* On the social costs of the suppression of empathy, see Myriam Miedzian, *Boys Will Be Boys: Breaking the Link between Masculinity and Violence* (New York: Doubleday, 1991).

ARTISTS AND THEIR WORK

MISTAKEN IDENTITIES

MERET OPPENHEIM

Maureen P. Sherlock

This is not so much an academic paper as a meditation in honor of Meret Oppenheim, who died in 1985. Existing on the borderlines of philosophy, art history, feminist theory, and literature, it is a rumination on reading visual signs made by women within the horizon of meaning produced by a fundamentally male discourse. What does it mean for a woman to produce a sign whose meaning is transformed by a fetishizing gaze which leaves her original experience vacated and unacknowledged? What does it mean for other women viewers and critics to reproduce that gaze and fail to sustain the earlier meaning of the artist while they betray their own mother tongue? How can we as women in a professional and public world restore the voice of our own ruptured past? These questions are part of the complex issues facing all peoples whose lives and relationships have been marginalized by what Derrida calls the phallocentric hegemony of meaning. In tracing the historical and critical response to Oppenheim's two most famous sculptures, I will try to give a second reading according to what Nietzsche once called "kettle logic," a subversive sense in the very heart of reason, a subtext in the downstairs kitchen beneath the upstairs library of dominant texts.

In her essay, "This Sex Which Is Not One," Luce Irigaray describes the imaginary sexuality created by male desire:

> This sexuality offers nothing but imperatives dictated by male rivalry: the "strongest" being the one who has the best "hard on," the longest, the biggest, the stiffest penis, or even the one who "pees the farthest" (as in little boys' contests). Or else one finds the imperative dictated by sadomasochistic fantasies, these in turn governed by a man's rela-

tion to his mother; the desire to force entry, to penetrate, to appropriate for himself the mystery of this womb where he was conceived, the secret of his begetting, of his "origin." . . . in order to revive a very old relationship—intrauterine, to be sure, but also prehistoric—to the maternal. (Irigaray, 1981a: 100–101)

According to this text, men rival one another to wrest the secrets of their nature from a maternal source in biology before hawking their heroics in history. Two of the most prominent athletes in these Olympic games are Freud and Jung, each of whom sought the title of paternal author of the proper theory of psychoanalytic femininity. Their feuding acolytes chant their respondent choruses favoring now one and now the other to determine which *paterfamilias* offers the most rigorous, the stiffest reading; which one shoots the furthest toward liberating the essential meaning of woman. Each side claims to appropriate the womb, each announces the territorial acquisition of the "dark continent" for the fatherland, while cutting off the mother tongue.

Derrida correctly calls these anthropological war games "the battle of the proper names" (Derrida, 1976:107). Commenting on "the writing lesson" in Claude Lévi-Strauss's *Tristes Tropiques,* Derrida ironically notes the anthropologist's perception of violence in an argument between two little Nambikwara girls observed by the scientist in the Amazon basin and comments: "First a pure violation: a silent and immobile foreigner attends a game of young girls. That one of them should have "struck" a "comrade" is not yet true violence. No integrity has been breached. Violence appears only at the moment when the intimacy of proper names can be opened to forced entry . . . reoriented by the glance of the foreigner" (Derrida, 1976: 115). The anthropologist outsider usurps the system of names integral to the society here observed; physical violence is of small consequence when compared to the force of another who dares speak my name. After all, there is speech before the coming of the scientific colonizer, but it is robbed of its force only when placed in a new configuration by a different locus of power in Western science. In the contest of who has the right to speak the woman, Freud and Jung loose the space in which women "speak female" (*parler femme*) and speak to each other (*parler-entre-elles*) "without the interference of men" (Wenzel, 1981: 57).

The Freudian *femme* I initially speak of here is not so much that of Freud as of the Surrealist's reading of the "father" of psychoanalysis. This woman is the goal of André Breton's search for *amour fou,* and also a moment of Bataille's transgressive sexuality, the heart of de Sade's celebration of the libertine woman, Juliette. She is a certain populist Freudian flapper of the sexual revolution which saw its first manifestation in the Paris of the 1920s and 30s. Freed from the constraints of petit bourgeois culture, she becomes a polymorphously perverse and narcissistic woman-child who steps out to light up the night. She incarnates the eternal muse as the *femme passion-elle.* Her truth is received from a penetrating gaze which offers false liberty in the guise of a licentiousness sanctioned by patriarchal law. She is visualized in a vulnerable cruciform anal view of Lee Miller by her vengeful ex-lover, Man Ray, in Max Ernst's animal women, and in the valorization of Breton's hysterical heroine, Nadja,

who proclaims to her lover, "You are my master, I am only an atom respiring at the corner of your lip." She is also the young Meret Oppenheim.

It came to pass that her vision of sexual freedom paled in the moonlight, revealing a carnivorous corpse buoyed by the voracious myth of the *vagina dentate*. A rescuing missionary appeared, a familial Jungian shade rose from the dead and offered Oppenheim a more pacific principle resonant with light and love. Suddenly, the feminine libertine of Paris fled to the domesticity of the Jung Institute, populated by the burgers of Switzerland. Jung's mystification of the colonization of the mother's body seemed to valorize the feminine as a necessary moment of subjectivity. The promiscuous bitch was transformed into the eternal feminine, immortalized as art's guiding light. In the end she was just another animistic being christened by a Swiss priest as Earth Mother, just another silent, speechless goddess, someone else's myth who, once again, is without the possibility of history. Jung's paternal penetration produced only an essentialist *anima* named separate but equal, offering her eternity in exchange for life.

Jung's theories allowed Oppenheim, like many individual women after her, an imaginary solution to the all too real contradictions of being female. As if years of feminist struggle had never happened, in 1984, shortly before her death at seventy-two, she was still able to claim: "Concerning the theme of the 'Muse' I want to say: the 'Muse' is an allegorical representation of the *spiritual* female part of the creative male, the 'genius.' And the 'genius' represents the *spiritual* male part in the creative female, the 'Muse.' . . . Personally, I consider the problem of male versus female as solved. Although I know that many have not arrived at this point" (Chadwick, 1985: 23). The inherent sexual bias of the terms "muse" and "genius" in her abstract allegory do not interfere with her beliefs. The problem of the sexes is, for her, resolved on a purely personal and conceptual level without political or economic consequences for real life. Her freedom still rests on a male organizing discourse which demands personal acquiescence to a mystical and a historical model. The woman as subject is here replaced by woman as metaphor; the trials of existence are eradicated by rhetorical conceit.

At an earlier point in the same letter to art historian Whitney Chadwick's publisher, Oppenheim reveals, in my opinion, why she was such a consenting victim to both of these theories: "When I met the group, end of 1933, I was twenty years old and I was not at all sure about political opinions. I made my work and did not worry about these discussions. (After the war I met Man Ray again. He said to me: 'But you are speaking!' I asked him: 'Why do you say that?' He answered: 'You never said a word formerly.')" (Chadwick, 1985: 12). She perceived herself and her art production to be in a vacuum untouched even by the passage of the Jew laws in 1933 which would ultimately force her German Jewish father to exile in Switzerland with her mother's family. Throughout her life she continued to avoid political issues and repeatedly chose a metaphysics of myth in a very privileged social existence. We can only wonder what might have happened in her crisis period had she followed the lead of her maternal grandmother, an artist and writer whose work did not preclude

her political activism in the Swiss League for Women's Rights. Instead, the peace Oppenheim sought was only personal and therapeutic, like Echo listening to her father's Jungian archetypes.

Near the end of her life, she requests Whitney Chadwick to exclude her work from Chadwick's *Women Artists and the Surrealist Movement* (1985: 236). Apolitical to the last, she still claimed women were admitted to the Surrealist circle without prejudice and held that the "male centeredness" of the group was merely an inconsequential hangover from the nineteenth century. She insists: "There is no difference between man and woman: there is only artist or poet. Sex plays no role whatsoever. That's why I refuse to participate in exhibitions of women only" (Belton, 1990: 66). Claiming the spirit to be androgynous and the mind without sex, the gendering of all ideological apparatuses eluded her over the course of seventy years.

After years of Jungian analysis she can exclaim, "Woman is close to the earth" (Chadwick, 1985: 143). Identifying with another's discourse, she tattoos herself with the mask of Derrida's stranger-scientist, who studies "primitive" peoples as an "index to a hidden good Nature, as a native soil recovered, of a "zero degree" with reference to which one could outline the structure, the growth, and above all the degradation of our society and our culture" (Derrida, 1976: 115). This earth, this *en-soi* of the natural is a romance, a narrative of perfection not earned but determined by fate. This biology, however, is not without complications for the artist:

> I am ready to believe now that men and women are absolutely equal in their brains. Of course, women are generally less strong, slower than men in physical terms. Still, it's like dogs that are bred a certain way. So too are women. Now this is just a crazy idea of my own but suppose that in primitive societies, the slower women were caught by men, then raped and impregnated. The fast ones never had any children, so the slow were effectively "bred" by men so they would be subordinate. So that men could wield the power, whether it be the power of the arm, the tool, the weapon, the bomb, money, whatever. (Belton, 1990: 72)

Biological determinism thus positively binds women to nature in the face of an inherently evil technology, or negatively asserts a territorial imperative which naturalizes aggression. In both cases, women are exempted from history, law, economics, or politics. Are we to assume from Oppenheim that inexorably nature decrees "To the swift belong the race"?

In her own case, Oppenheim appears to subject her work, at different moments, to those two paternal desires which claim to speak the truth of feminine experience with all the authority once given either to god or nature. Breton's Freud and her father's Jung mark the two poles within which she allows her projects to be read. They are the two mistaken identities she elects to sustain at various points in her life. As Irigaray, in another context, puts it: "Taking one model after another, passing from master to master, changing face, form and language with each new power that dominated you. You/we are sundered; as you allow yourself to be abused, you be-

come an impassive travesty. You no longer return indifferent; you return closed, impenetrable" (Irigaray, 1985: 210). Oppenheim reads her life through the magisterial discourses of others; she vacillates between two different theories *of the mother* without addressing the questions of a history spoken *by the mother*.

As a young woman seeking to avoid what Kierkegaard once called "the well trodden path of mediocrity," she left Switzerland at nineteen to study in Paris. Bored by her academic art studies there, she drifts through the cafes where both her body and her work become named and colonized as a Surrealist text. Later she will flee the city and return to her father, who taught workers to spiritually overcome their economic lot through therapy rather than the organization of unions. After years of balancing her *anima* and *animus* at the Jung Institute, she finds herself rewritten as an alternate text by the competing father, and a fragile peace is won. Each of these two differing texts of Freud and Jung dispossess her speech and haunt the spaces where she lives and works.

The *confreres* of the Surrealist Manifesto will name her a *femme-enfant*, a natural wild child just like Keller's forest girl, Meretlein, in *Green Henry*, after whom her father named her. Man Ray once called her the most uninhibited woman he ever met, but was it she, or his projection of her as an icon of savage beauty? She was known for her outrageous and flamboyant behavior all over Paris. She thought nothing of peeing into a burger's hat or stripping off her clothes in the middle of a cafe (Chadwick, 1985: 105). These activities, witnessed by the circle, as well as her friendship with Giacometti and intimacies with Ray and Max Ernst, ensured her membership in the group. In 1933, at twenty, she was a Surrealist groupie; by 1937 she had produced her most famous works and returned home to Basel for a seventeen-year artistic crisis: Everyone gets to be famous for fifteen minutes.

I believe the seeds of Oppenheim's crisis were sewn in her two most important works from this period in Paris: *Dèjeuner en Fourrure* (1936) and *Ma Gouvernante, My Nurse, Mein Kindermädchen* (1936). The idea for the fur-lined teacup came while Dora Maar and Pablo Picasso were admiring a fur-covered brass bracelet Oppenheim had designed for Schiaparelli. Picasso remarked that almost anything could be covered in fur, and as her tea grew cold Oppenheim called to the waiter for "un peu plus de fourrure" (a little more fur). Later that day she bought a demitasse cup, covered it with fur from a Chinese gazelle, and presented it to Breton for the "Objects" show at Galerie Charles Ratton. According to Jacqueline Burckhardt, editor of *Parkett*, it was not Oppenheim, but Breton, who gave the piece its title. The right to give a "proper name" to her own work is here usurped by the primary legitimator of Surrealism with her permission. In Western history and mythology, this power to nominate is "equivalent to taking possession" (Todorov, 1984: 27). God gives Adam power over the earth by allowing him to denominate all its species. A more cogent parallel for our purposes is that of Columbus, who assumed possession of the "new world" by renaming sites already known, inhabited, and named by misnomered Indians. The colonizer's renaming transforms the terrain from the functional habitat of

indigenous peoples into an empty aesthetic landscape awaiting European economic exploitation. How fortunate for the tribal peoples, "civilization" at last came to the Americas!

To function as "art," Oppenheim's work must also be integrated into the iconography of the religion of art, consecrated through baptism by Surrealism's high priest. What is spoken here is the territory of male desire, which alone invests the object with significance. It must be named by those who have the right to speak in what Foucault has called "the discursive Fellowship," not by that which is spoken—the obscure object of desire. The piece becomes the quintessential Surrealist fetish in the true Freudian sense of the term: a site of both the recognition and disavowal of the mother's castration. While not denying the validity of this interpretation, the question remains as to why *only one* form of desire has the right to invest the site with its meaning?

Burckhardt ironically notes, "The title is poetic, witty, yet not a necessary means to understanding the object, whose essence lies in the tactile stimulus rather than in the title" (Burckhardt, 1985: 27). She suggests here a priority of haptic space over that place of male desire, that dominant Gaze of the visual field. Luce Irigaray holds that women's experience of sexuality arises not so much through the look as through the pleasure of touching. Underneath the discourse of the proper organ, of fetishism and oral sex, which dominates the traditional reading of Oppenheim's work, I claim a subtext to the work of the caress over the stare. Another citing of the work might pose the teacup, sign of a domestic comfort, as a moment of feminine *jouissance*. As I lift the cup, I might address it to these lines of Luce Irigaray: "the contact of *at least two* (lips) which keep the woman in touch with herself, but without any possibility of distinguishing what is touched from what is touching" (Irigaray, 1981a: 26) [16.1]. What would it take to rupture the text of sight with an improper reading of touch? Would I then see a woman who produces signs instead of a "femme-enfant" orchestrated by the colonial administrator of Surrealism's foreign and exotic territories? Would we then as women begin to articulate the poetry of our bodies lived, instead of our bodies viewed?

In the same "Objects" show at Ratton's, Oppenheim exhibited the other object for which she is most famous: *Ma Gouvernante, My Nurse, Mein Kindermädchen.* Consistently, sadomasochistic descriptions of the piece are put forth with little differentiation between male and female writers. If I might condense and paraphrase a survey of fifteen or so published descriptions: "Max Ernst supplied her with a pair of white high-heeled shoes discarded by his wife which Oppenheim bound up with string. The heels are shockingly splayed and ensconced with paper lamb crown roast frills. The titillating spread is served on a silver platter ready for the viewer's delectation." Burckhardt adds, it lampoons "the conventions of good society and conjures up the story of a young lady with a deliciously guilty conscience for toying with forbidden fruit" (Burckhardt, 1985: 27).

Whitney Chadwick offers a slightly more ambivalent reading:

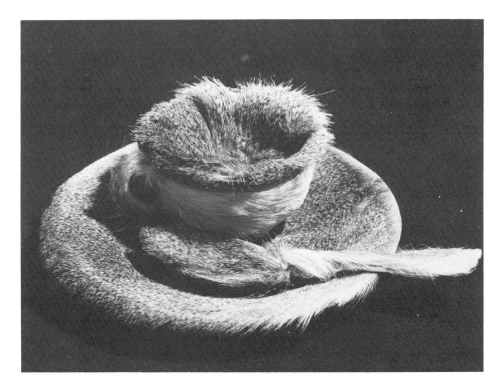

16.1. Meret Oppenheim. *Breakfast in Fur (Le Dejeuner en fourrure)*, 1936, fur-covered cup, saucer, and spoon, cup 4⅜ in. diameter; saucer 9⅜ in. diameter; spoon 8 in. length; overall height 2⅞ in. The Museum of Modern Art, New York.

> To Oppenheim, the piece was a way of "getting even" with a childhood nurse by tying her shoes together; to the public its content was titillating, erotic, and bordered on the obscene. The truth probably lies somewhere in between . . . but for Oppenheim they led to no new explorations into the use of objects as a means of subverting function and meaning. (Chadwick, 1985: 122)

Let us examine this quote more carefully. Earlier in her text, Chadwick had described the piece as

> a woman's shoes bound together on a platter in a position simulating that of a nude woman on her back with her legs spread and "dressed" with paper frills. (Chadwick, 1985: 122)

While the former quote may at least partially acknowledge the artist's narrative of her own experience, the latter quote documents Chadwick's preference for the magisterial male reading of sexual exploitation.

Is the artist's scenario so farfetched that only a fool would sustain its meaning? Perhaps Oppenheim is a native not used to the new "lay" of the colonized land. Perhaps, like Caliban in Shakespeare's *The Tempest,* she must learn a new language more adequate to the geography of her colonizer's experience, in this case an official lexicon of the perverse—as Caliban's was the curse. The work has been invaded by a system of signification not her own, and this poses a number of problems. Must she always wait for the dominant Other to produce the meaning of her work and thus legitimate it? Is she like the analysand incapable of constituting her narrative and therefore in need of the fictional thread of a male analyst to make sense of her life? If the answer is yes, then who could blame her for not continuing her futile efforts "to subvert function and meaning," since even women art historians and critics fail to listen to her and instead reproduce the prevailing discourse of the Gaze. Why should she weave another web to be undone by those Penelopes who wait patiently for the return of their legitimate husbands in the truth.

It is a great irony of history that *Ma Gouvernante* was actually destroyed by another woman, Marie-Berthe Auenche, Max Ernst's wife and another *femme-enfant.* Presumably jealous over the extramarital liaisons of her husband, she walked into the gallery and took back her shoes. She did no more damage to the piece than anyone else, including Oppenheim, who obligingly rebuilt it in the 1950s. It exists now, not so much a work of polyvalent meanings as a monument to the power of the single reading. If as women we always seek our legitimation within the discursive fellowship of men, will we only perpetuate the dominant ideology which denies all marginalized people the right to produce their own names and narratives? Then again, what would it mean to be outside that discourse entirely? Would it mean anything at all?

The danger in taking up our own mistaken identities within this system is that we ultimately render our own experience mute, like a landscape waiting to be inscribed with the names of foreign places. And within the system, Irigaray claims,

> if we keep on speaking sameness, if we speak to each other as men have been doing for centuries, as we have been taught to speak, we will miss each other, fail ourselves. . . . Words will pass through our bodies, above our heads. They'll vanish, and we'll be lost. Far off, up high. Absent from ourselves: we'll be spoken machines. Enveloped in proper skin, but not our own. Withdrawn into proper names, violated by them. Not yours, not mine. We don't have any. We change names as men exchange us, as they use us, use us up. (Irigaray, 1985: 205)

As speaking subjects, we women must insist that our relationships to our many nurses and mothers is not some dark and silent continent waiting to be claimed by others. We must learn to speak with our own dialect and not merely be spoken by a foreign tongue.

As an alternate strategy to the extremes of either a stultifying silence or a defining diatribe, I propose a different strategy for reading Oppenheim's work: listening

to a maternal speech through a fissure, a cleft in two parallel texts of eye and mind, of the flesh of the world and of the word. I seek to counter Oppenheim's visual subtexts of domestic items and kitchen metaphors with Luce Irigaray's prose poem to her mother "One Does Not Stir without the Other" (Irigaray, 1981: 60–67). It addresses the daughter's trial of sexuality, known in every woman's rite of passage, spoken here in a (M)OTHER TONGUE which speaks and eats and kisses. This sonorous space sounds more like the guttural stammerings of the voice reaching for the word in Luciano Berio's musical composition *Parole*. It is a breast which suffocates as it nourishes, a poetry which collapses and resurrects its self at a moment's notice.

To honor Meret Oppenheim *in memoria*, I ask you to imagine *Ma Gouvernante, My Nurse, Mein Kindermädchen* installed in the center of a quiet room barely lit from overhead [16.2]. On the four walls washed with a gentle light I have written in pencil (so it can be erased) these words of Irigaray:

> With your milk, Mother, I swallowed ice. And here I am now, my insides frozen. And I walk with even more difficulty than you do, and I move even less. You flowed into me, and that hot liquid became poison paralyzing me . . . I look like you, you look like me. I look at myself in you, you look at yourself in me . . . always distracted, you turn away. Furtively, you verify your own continued existence in the mirror, and you return to your cooking . . .

16.2.

> But then you seem to catch yourself, and once more you throw back at me: "Do you want some honey? It's time to eat. You must eat to become big." . . .

> You've gone again. Once more you're assimilated into nourishment. We've again disappeared into this act of each eating each other. Hardly do I glimpse you and walk toward, when you metamorphose into a baby nurse. Again you want to fill my mouth, my belly, to make yourself into a plenitude for mouth and belly. To let nothing pass between us but blood, milk, honey, and meat (but no meat; I don't want you dead inside me) . . .

16.2.

I want no more of this stuffed, sealed up, immobilized body . . . giving yourself to me only in an already inanimate form, abandoning me to competent men to undo my/your paralysis, I'll turn to my father. I'll leave you for someone who seems more alive than you. For someone who doesn't prepare anything for me to eat. For someone who leaves me empty of him, mouth gaping on his truth. I'll follow him with my eyes, I'll listen to what he says . . .

He leaves the house, I'll follow in his steps. Farewell, Mother, I shall never become your likeness . . .

16.2.

I can't tell you where I am going. Forget me, Mother. Forget you in me, me in you. Let's just forget us. Life continues . . .

But we have never, never spoken to each other. And such an abyss now separates us that I never leave you whole, for I am always held back in your womb. Shrouded in shadow. Captives of our confinement . . .

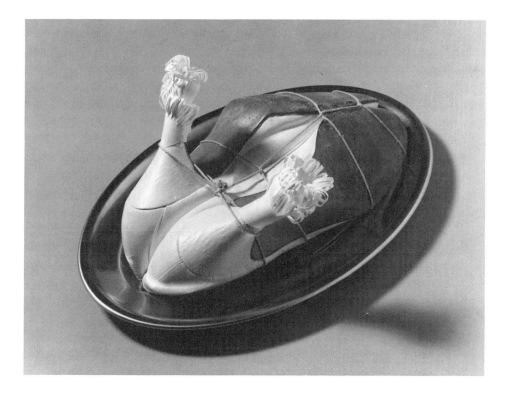

16.2. Meret Oppenheim. *Ma Gouvernante, My Nurse, Mein Kindermädchen,* 1936, mixed media, 5½ in. × 8¼ in. × 12 in. Statens Konstmuseer, Moderna Museet, Stockholm, Sweden.

And the one doesn't stir without the other. But we do not move together. When the one of us comes into the world, the other goes underground. And what I wanted from you, Mother, was this: that in giving me life, you still remain alive (Irigaray, 1981b: 60–67).

ACKNOWLEDGMENT

This essay is a revised edition of a speech-performance first given at the First National Women's Sculpture Conference in Cincinnati, Ohio, in May of 1987. Michael Hall, one of the few men who attended the conference, came to hear this lecture with his daughter, Rane. He asked me to save it for a publication he was planning and which has finally reached fruition with this book. I want to thank Michael for his patience and willingness to deal with an experimental form. It was really meant to be delivered vocally to an audience of predominantly women artists, historians, and critics, and I hope its merit has been preserved and augmented in this written form.

BIBLIOGRAPHY

Belton, Robert J. 1990. "Androgyny: Interview with Meret Oppenheim." In *Surrealism and Women*, edited by Mary Ann Caws, Rudolf Kuenzli, and Gwen Raabery. Cambridge, Mass.: MIT Press.

Burckhardt, Jacqueline. 1985. "The Semantics of Antics," *Parkett*, no. 4, pp. 23–29.

Chadwick, Whitney. 1985. *Women Artists and the Surrealist Movement*. Boston: Little, Brown & Company.

Derrida, Jacques. 1976. "The Battle of Proper Names." In *Of Grammatology*, translated by Gayatri Spivak. Baltimore: Johns Hopkins University Press.

Irigaray, Luce. 1981a. "This Sex Which Is Not One," translated by Claudia Reeder. In *New French Feminisms*, edited by Elaine Marks and Isabelle de Courtivron. New York: Schocken.

———. 1981b. "And the One Doesn't Stir without the Other," translated by Helene Vivienne Wenzel. *Signs: Journal of Women in Culture and Society*, vol. 7, no. 1, pp. 60–67.

———. 1985. "When Our Lips Speak Together." In *This Sex Which Is Not One*, translated by Catherine Porter. Ithaca: Cornell University Press.

Todoroz, Tzvetan. 1984. *The Conquest of America*. New York: Harper & Row.

Wenzel, Helene Vivienne. 1981. "Introduction to 'And the One Doesn't Stir without the Other.'" *Signs: Journal of Women in Culture and Society*, vol. 7, no. 1.

17

ELIJAH PIERCE, WOODCARVER

DOVES AND PAIN IN LIFE FULFILLED

<div align="right">

Gerald L. Davis

</div>

"Outsider art" seems to be one of those pleasantly unambiguous phrases intended to represent exactly what it describes, aesthetic creations produced by people trained outside of a fine arts tradition. Typically, outsider art products are described as "idiosyncratic," "primitivistic," "intuitive," "unbound by stylistic conventions," and "fundamentally symbolic." Catalogue introductions from two important exhibitions, both written by art historians, will serve to illustrate the ease with which these pronouncements or judgments delineating the meaning of "outsider" are made, and the tenacity of these notions as professional, academic categories.

The first was published in the 1974 catalogue *Naives and Visionaries*, produced by the Walker Art Center from the quite wonderful exhibition of large sculptural, architectural creations of people who would appear, on the surface, to be untrained in a fine arts tradition. Writes Martin Friedman, then director of the Walker:

> The scruffy curiosa bordering the American highway includes such wonders as reptile gardens, instant pioneer villages, agate shacks, zoos and freak shows—glaringly announced by fluorescent billboards and pulsating neon. Sometimes, modestly juxtaposed among the roadway heraldry promoting these blandishments, crudely lettered signs invite the dazed motorist and his car full of travel-numbed children to visit quite another kind of attraction: hand-made universes created by elderly individualists. These exotic manifestations are best described as idiosyncratic architecture. . . . These structures— we have no adequate generic term for them—are characterized by direct, primitivistic forms. . . . this is a wholly intuitive expression, as unbounded by stylistic conventions as by local building codes. . . . While it may be convenient to characterize these architectural manifestations as folk art, they are unique and isolated from each other: they

cannot be regarded as examples of widespread styles. . . . they are individualistic, not collective expressions; they are fundamentally symbolic, not utilitarian. . . . Their [the artists'] formal educations were practically non-existent and most were raised and lived their entire lives in the same region, relatively unaware of the world outside. They had no art training and if some of their building dimly suggests an awareness of historical prototypes—towers, columns, arcades, entablatures—the associations are fortuitous, inspired, perhaps, by gleanings from the encyclopedia or the *National Geographic*. (Friedman, 1974: 7)

The second introduction is found in the 1987 catalogue produced by the California Afro-American Museum as complement to its exhibition "Home and Yard: Black Folk Life Expressions in Los Angeles." Lizetta LeFalle-Collins, the Museum's visual arts curator and also the curator of the exhibition, is more guarded and circumspect, but the resonances with the Friedman perspective are clear:

The term "folk art" has been used when discussing decorative objects that are the products of these traditions because it refers to objects created by those outside of a fine art tradition. These objects are made by "everyday people" who have retired or who are no longer employed, and by those who have some extra time on their hands and are lead by their aesthetic sensibilities to develop their own style of expression or technique based on something taught them by a friend or relative. Folk art is also defined as a collective expression of cultural pattern that, in the hand of the individual, can be variously interpreted. The environmental sculptures, while outgrowths of the Southern Black folk experience, are not considered examples of folk art, but rather are loosely referred to as 'outsider' art. They are fundamentally symbolic, not utilitarian, and are made of many irregular and complex parts. . . . Similarities between the folk artists and the individual "outsider" artists . . . are apparent in their lives and their work. Parallels in educational backgrounds, lack of knowledge of the fine art traditions, socio-economic status and their ties to their neighborhood, community and the South, do exist. It is important that Southern Black folk art expression be recognized as a continuance of important cultural ties with a region from which many West Coast Blacks migrated and where many elements of Black culture were developed and cultivated. It is equally important to recognize a direct effect of that cultivation expressed in these individualized environmental sculptures. (Le Falle-Collins, 1987: 11–17)

While it may seem awkward to quote at such length, it is important to highlight some of the contradiction and confusion which attends this business of defining outsider art—complications revealed only through a detailed inspection of writings on the subject. Le Falle-Collins wisely if cautiously blurs the distinction between folk art and outsider art. As far as Le Falle-Collins is concerned, both forms arise from a distinct and identifiable cultural base. However, unable to completely set aside the hegemonous authority of the art history literature, which is, after all, simply another cultural tradition, Le Falle-Collins admits that some distinction between the two forms ought to be made, though that distinction is a matter of degree. And she

is concerned with the extent to which the created product is more rather than less an expression of an individual, therefore idiosyncratic, sensibility.

Friedman is not constrained by any manner of community ethos. He is writing for other art historians or certainly for a public which needs to separate itself from "everyday people." Friedman's frank elitism masks a thin professional condescension toward the artists untrained in a fine arts tradition. They produce curios and bizarre, primitivistic forms, but being unschooled, and therefore uneducated, they could hardly be expected to know a fine arts tradition! Indeed, Friedman confidently asserts that their "associations are fortuitous, inspired, perhaps, by gleanings from the encyclopedia or the *National Geographic*." Still, Friedman, like Le Falle-Collins, is uncomfortable and seeks to soften somewhat his otherwise unyielding perspective by recognizing that outsider art may bear some relationship to the more salient characteristics of folk art, an equally problematic category for art historians but a larger, more widely sanctioned rubric.

It is in this admission of the limitations of the professional category of "outsider art" that the most elemental problem for the art historian can be observed. These works are artistic and result from powerful aesthetic sensibilities. Further, in spite of attempts to label them individualistic, unrelated to any recognizable style, and symbolic—terms as common to the production and description of fine art as wheels are to automobiles—Friedman and Le Falle-Collins, and each of the scholars writing in both catalogues, take pains to situate the so-called outsider or folk artist in a cultural context. Each of the artists discussed in both catalogues are inextricably linked to some cultural community wherein they may have learned some or several of the salient elements of the form selected to represent aspects of their sensibilities.

The failure to locate the aesthetic product in a cultural context may significantly expose the folly of the art historian's predilection for object-centered analyses. Such an analytic structure does not permit the introduction or recognition of tradition as a formalized instructional element in the formation of the artist's aesthetic sensibilities. Nor does such a concern for the primacy of the object allow the sort of ethnographic intervention with which the folklorist, for instance, customarily frames his or her research reporting. Hence, while "outsider" art may be a necessary professional bulwark against incursions into the sacrosanct precincts of the "fine" arts by artists trained in anthropologically traditional systems, the term does not, after all, define the phenomenon it seeks to describe.

No folk artist is more emblematic of this seeming conundrum than Elijah Pierce, the Columbus, Ohio, wood-carver who, in his later years, began to find some favor among collectors. The dilemma for collectors and critics has been where to situate Pierce. His work seems too stylized and too idiosyncratic to be considered "folk." And yet he is too clearly tied to a discernible nonacademic cultural tradition—African-American Southern Rural—for the art historian to comfortably embrace him and his product. Moreover, as an artist who fully participated in the life of his community, his work has also been denied inclusion into the lexicon of outsider art.

While Pierce was justly proud of his wood carving and recognized that he was gifted, in a variety of ways, the "artist" mantle never sat comfortably on his handsome and broad shoulders. Perhaps for Pierce, as for many traditionalist African-American artists, the separation of artistic sensibilities from the business of living made little sense in the everyday scheme of things.

Whether art imitates life or life mirrors art is a discussion which has little applicability to most African-American traditional communities. In such communities life and art are inseparable, being so inextricably fused that the absence of expressive structures and forms would relegate daily living to hollow, uninteresting, textureless, marginal status. Life is exuberant, cautious, communal, patterned, brilliant, ordinary, necessary everyday stuff; art is aesthetic, sensate, dynamic, structured, textured, pragmatic. Whether it is a Sunday-go-to-meeting milliner's creation worn at an improbable jaunty angle with a regal grace, or an apparently idiosyncratic signature strut that seems to defy all laws of body mechanics; whether it is a system of language and argot virtually incomprehensible to the "outside" world but enormously seductive, evocative, powerfully compelling and empowering to the practitioners, or a household quilt apparently haphazardly pieced by a community member in which are embedded the most complex of philosophical judgments and which bears unmistakable linkages to utilitarian and decorative fabrics constructed in African communities many hundreds of years earlier;[1] whether it is a sermon performed in a church by a master preaching to a congregation that seems to the uninitiated on the verge of anarchy because the testimonies to faith and truth uttered concurrently by tens and hundreds of voices are so dense and expressive, or a reduction of the narrative units and symbols of the performed African-American sermon to the hallowed, reverential medium of wood, which inherently bears the elements of life and the enormous potentiality of expressive creativity and invention, African-Americans are surrounded by intentional constructions informed by daily existence and given sentience and sensual form through a generously endowed creative necessity.

The traditional African-American folk artist does not create, work, or invent in isolation. Standards of excellence for a chosen form are learned both formally and indirectly from family members and neighbors. That is, one can be formally selected as a master's apprentice in her or his community, or one can learn, seemingly indirectly, by observation and trial and error in the context of a native aesthetic (Davis, 1976: 177). One learns the technologies of craftsmanship, along with the more esoteric notions that complete one's mastery of a medium, to the satisfaction of established masters and through the recognition and acknowledgment of the general community.

One of the more interesting and academically useful notions is that of equivalences. While a folk artist may excel in one expressive structure—quilt tops, split-oak baskets, tale-telling—certain selected structural elements of one form or mode may be applied to other forms. These shared "expressive equivalences" provide to any community a sense of continuity and cultural unity that crosses genre bound-

aries, and their common occurrence among African-Americans may help to explain why a fine blues singer can be a reasonably accomplished folk sculptor, or a jazz performer can be a quite magnificent poet in formal and folk idioms, or a male fife player can be a wonderful quilt-top piecer and a glorious tale-teller and a passable basket maker—all, of course, identifiable in the contexts of traditional African-American aesthetics. By definition the folk artist is known to segments of his or her community. And whatever the quality of the affection, or dislike, for the artist's product, the community recognizes its form and may embrace its effect.

While the self-conscious creation of formal, literary poetry should not in any way be equated with the constructive processes of folk art, excerpts of a poem written by master wordsmith Gwendolyn Brooks, in which she intentionally approximates both the sound and structure of the African-American urban narrative idiom, may serve to illustrate in gross terms the workings of a "community aesthetic." In her poem "The Sundays of Satin-Legs Smith" (Brooks, 1973: 169–170), Brooks lovingly illustrates the complex expressive behaviors of an urban lover-hero and identifies something of the heady aesthetic of everyday living so many African-Americans manifest:

> Inamoratas, with an approbation,
> Bestowed his title. Blessed his inclination
> He sheds, with his pajamas, shabby days.
> And his desertedness, his intricate fear, the
> Postponed resentments and the prim precautions.
> ...
> Now, at his bath, would you deny him lavender
> Or take away the power of his pine?
> What smelly substitute, heady as wine,
> Would you provide? life must be aromatic,
> There must be scent, somehow there must be some.
> Would you have flowers in his life? suggest
> Asters? a Really Good geranium?
> A white carnation? would you prescribe a Show
> With the cold lilies, formal chrysanthemum
> Magnificence, poinsettias, and emphatic
> Red of prize roses? might his happiest
> Alternative (you muse) be, after all,
> A bit of gentle garden in the best
> Of taste and straight tradition? Maybe so.
> But you forget, or did you ever know,
> His heritage of cabbage and pigtails,
> Old intimacy with alleys, garbage pails,

Down in the deep (but always beautiful) South
Where roses blush their blithest (it is said)
And sweet magnolias put Chanel to shame.

Perhaps the poet will forgive a paraphrasing of her elegant lines for African-Americans who live parts of their lives "in the tradition" (most African-Americans participate at some level in the maintenance of traditional cultural forms, although those who are active, dynamic participants or who are artists are, of course, proportionately few). But "life must be [artistic], / There must be [aesthetic form], somehow there must be some." Even Mr. Smith's most mundane and gritty Monday-to-Saturday existence can be mediated by an aesthetic sensibility that flowers magnificently on Sunday and that is best interpreted in the context of African-American community history and social life.

From Monday to Saturday Mr. Smith, *Mr. Smith* is an ordinary African-American man. Little distinguishes him, perhaps, from millions of other men jailed in America's cities by social and economic circumstance. Certainly his is a life without fragrance during those six days when the expressive impulse rests, seemingly dormant. But on Sundays, "He wakes, unwinds, elaborately: a cat ... / ... he designs his reign ... /He sheds, with his pajamas, shabby days ... /Postponed resentments and the prim precautions." And should the point be missed that this is no mere "pretty" collection of phrases and words but a sociopolitical essay in verse that encompasses a whole, entire people and a sociohistoric migration, Brooks challenges her readers: "Now, at his bath, would you deny him lavender / Or take away the power of his pine? / ... But you forget, or did you ever know, / His heritage of cabbage and pigtails, / Old intimacy with alleys, garbage pails, / Down in the deep ... South / Where roses blush their blithest (it is said) / And sweet magnolias put Chanel to shame." "Life must be aromatic [artistic]."

Finally, Brooks offers her readers a motivation for the Sunday transformation of a commoner to a king preparing to meet his adoring public, *his* community, his "Inamoratas ... / Bestowed his title. Blessed his inclination." Brooks's narrative representation of a community aesthetic is best understood, or perhaps can only be fully appreciated, in the context of African-American sensate systems. Mr. Smith's lovers, *his* Sunday community, his intimate congregation, in recognition of his talents and product and genius, bestowed upon him the wholly sensual, delicious title "Satin Legs" that he is entitled to bear for twenty-four hours every seven days until breath leaves him.

The notion that brackets this prologue of sorts is the nettlesome business of discovery, intended here to mean the initial identification of a craftsperson or artist by an outsider and the attempt to bestow upon the discovered artist an "original" validation that derives from external and perhaps competing cultural sensibilities. The *sotto voce* supposition, of course, is that the "discovered" artist has no previous

validating recognition. A folk artist's aesthetic community is rarely given credibility by collectors or discoverers. So for purposes of this essay, the operative query becomes: By which evaluative set of standards and perspectives do we recognize the genius of traditional folk artists? This writer's perspective on the query, weighted in favor of native aesthetics, is phrased thus: Are there identifiable systems of artistic judgment and aesthetic structures vested in the peculiar and unique histories of communities that permit those communities to recognize and evaluate—pass artistic judgment on and maintain standards of excellence for—native expressive forms?

Pierce was, by age eight, or approximately by the year 1900, already carving. Pierce the "folk artist" was "*discovered* [emphasis added] quite unexpectedly in 1968 or 1971 at a YMCA exhibition in Columbus" (Connell, 1988: 122). Discovery by the world of museums and collectors can have a salutary effect on the traditional artist, of course. Travel, honors, enhanced income, documentation of the artist's life and thoughts, are certainly some of the benefits of discovery. And from all reports, Pierce enjoyed the exposure to the world of collectors and the benefits that came to him very late in his life, and he took them all in stride. He did not set aside his church, his community, or his beloved Masons.[2] These constituted his foundation, his lifelong base, the source of his artistic, moral, and spiritual sustenance and knowledge. He was nurtured and loved by his people, and in his turn Pierce embraced them and their corporeality with a gentle, abiding love and a towering, commanding sense of compassionate mission. Pierce was no stranger to the transient, seductive riches promised by the world, nor was he unaware of the vicissitudinous pathways traveled by so many of his friends and relatives. But it was to his moral, physical, spiritual, and aesthetic community that his allegiances were anchored.

Perhaps it was providential that external acclaim came so relatively late in Pierce's life. From his earliest years, this man of God-inspired talent and steely determination negotiated a pathway between his terribly onerous religious calling, prophesied by the terms of his birth, and his single-minded passion to avoid the imprisonment of his venturesome soul and spirit by social and political circumstance. His art, his chosen interactive expressive form, became the mediator in this internal war. His community, easily recognizing the terms of his struggle and the quality of his gift, became his balm, his guardian, his lover, his mirror, his anchor, as he moved inexorably toward the inner peace and resolution that finally came to him. His wood became the vessel for his sermons, his *exempla,* his medium of discourse, and it served as his pulpit. The carvings were not generally the elements of Pierce's worldly persona. Rather, these were his several voices that resonated most fully within the intimacies of African-American life and history and his own very private soul. "With the knife and wood," wrote Mark Ellis in a *Columbus Dispatch* article on Pierce's funeral, "Pierce achieved a simple eloquence. He expressed visions inspired by the Bible and interpreted a world that revolved around his barbershop, home, and church" (Ellis, May 12, 1984). It is easy to feel comfortable with Ellis's summation;

at least one can feel warmly immersed in its quality. But the scale in his journalistic reduction of Pierce's life misses the grand, almost cosmic proportions of Pierce's place in the lives of *his* people.

During an interview with Aminah Robinson, a close friend and protegee of Pierce's and an acclaimed artist in her own right, I was cautioned against being too academic in examining facets of Pierce's life.[3] Yet I am both an African-American and an academic, and therefore doubly committed to fully understanding certain phenomena through means that may be more oppositional than complementary, since each arises from quite different cultural assumptions. And it is because of this that I am so drawn to this man Pierce and his very human contradictions and complexity. And it may explain why I am so compelled by the notion that Pierce's biography and the biography of his works called "sermons in wood" are mutually illuminating.[4] In all of this Aminah Robinson's caution is a methodological beacon. The logic or illogic of academic analysis is insufficient to probe the variety of queries that arise from even a cursory examination of the weft and warp of Pierce's life. One must also repair to the untidy environs of African-American religious faith and belief and social practice and custom to understand the compacted parallels between Pierce's reverential knife strokes in his wood and his reflections on his own pathways and the human condition of his community in Columbus, where he lived for over sixty years.

At first glance there would appear to be little relationship between Pierce's vocation as a barber, his avocation as a carver of wood, and his profound sense of calling as a religious. In several of his interviews in the years following his discovery by Boris Gruenwald, Pierce himself connects the tripartite elements suggested above, as in the following quotations attributed to him: "I've been barbering and carving so long they both come natural." And "I've been running from preaching for twenty years . . . and my second wife used to say I had to carve every sermon I never preached. I guess the good Lord put me on the woodpile." And "When I was about eight or nine, I would work all day for a pocketknife. Then my dog and I would go down to the creek bank and fish and whittle. I'd pick a tree that had soft bark, maybe a beech, and carve anything I could think of. Horses, dogs and cows, anything that came to mind. And if I got sleepy, I'd just lie down in the woods and my dog wouldn't let nothing come near me" (Marsh, 1975: 55).

It is difficult to know how to enter the universe of ideas represented above and reordered to suggest an implied and unified psychic continuity in Pierce. Certainly the first correspondence, between barbering and wood, is recognizable to many African-American religious traditionalists as fundamentally spiritual, although the term as we know it would rarely be employed in the sense that it appears here. *Mystical* may be a closer approximation of the attachment African-Americans form to the person who regularly does their hair—barber or hairdresser—and to that person's physical place of business.

More than mere ornamentation, hair and hair preparation are elements of an essential body of emic material referred to as African-American hair lore, and it can

be a near metaphysical index to one's very soul, being, psychology, and personal history, and, in the aggregate, a group's social history. To the person to whom one entrusts the "doing" of one's hair, sometimes discovered after a lengthy search and exhaustive conversations with friends and acquaintances, is yielded significant power. That power frequently transcends the relatively few moments a customer spends in a barber's or hairdresser's place of business [17.1]. If the church is the focus of a community's sacred or religious energies, the hairdressing salon and the barbershop are the secure environs of its secular rituals. The attributes shared by the personalities central to the healthy functioning of both environments, the preacher and the barber or hairdresser, can be interchangeable and can involve healing mechanisms perceived as spiritual: deep and intimate trust, and a sort of sustaining power in the social and political affairs of the community.

For many African-American traditionalist Christians, there can be a direct linear relationship between the persona of Jesus Christ the carpenter and those male African-American members of any community who are utilitarian carpenters or decorative or expressive wood-carvers. While all talent is perceived as God-given, those master carvers or workers of wood who are recognized as especially talented can be thought of as divinely inspired, a superordination of the "God-given" categorization. To push this concept a bit further, one can be fairly passive in the development of one's God-given talent, but to possess a divinely inspired talent means that one cannot run away from one's destiny. A person is under a deep and abiding obligation to realize such a gift in concrete terms and specific behaviors.

Whether Pierce recognized his early interest in fashioning aesthetically expressive objects from woods as divinely inspired, and therefore inescapable, is unclear. What is clear is that Pierce found respite from the demands of the outside world and his father's Baldwyn, Mississippi, farm in the ancient, solitary woods nearby, where he carved initials, the names of family members, and representational figures in standing trees or whittled animals and other small figurines from scraps he found on the forest floor.[5] And though Pierce described himself as "the black sheep, a little oddball who didn't play much with the other kids" (Marsh, 1975: 56), in his youth he began a practice that he continued throughout his life: giving carved pieces to people who admired his work or with whom he wanted to share a bit of himself. Apparently the sharing of this extension of the self was as important as the reverential fashioning of objects from the wood he both admired and needed. "I'd give the things I whittled to the kids in school. I just got a real joy out of whittling" (Marsh, 1975: 56).

Reports of wood-carvers' and carpenters' compelling love and compulsive, at times obsessive, attachment to wood abound in a variety of academic literatures. Some carvers ascribe to the wood anthropomorphic qualities, regarding the products they fashion as their "children." Frequently, carvers will tell interviewers that a piece of wood will sit in a corner for years until an appropriate image emerges, as in a privileged communication between two intelligences. Pierce was no stranger to this

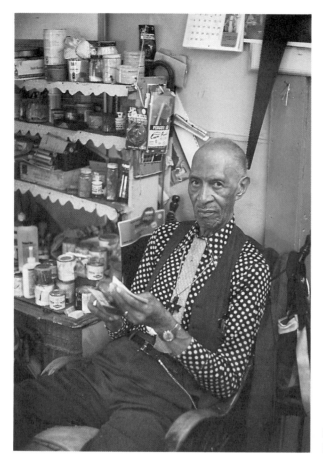

17.1. Elijah Pierce in his Columbus, Ohio, barber shop, 1978. Photo by Michael D. Hall.

manner of transcendent relationship with his woods and his carvings. As late as 1974, he reported to an interviewer, "Most of the carvings are from a *vision* I see. I *see* a picture in the wood or *hear* a sermon [in the wood]."[6] And in 1971, Pierce reported, "I usually pray over a piece of wood before I ever put a knife in it. I pray to Him for inspiration."[7]

While it would be foolish to conclude that all workers of wood feel this way about their medium, this peculiar deep respect for the "personalities" of woods lends to the wood-carver a quality that borders on the mystical. While working with Tennessee African-American wood-carver Alvin Jarrett, folklorist William Wiggins recorded this comment: "Jarrett sees 'an account of ancient days' etched in the growth rings of cedar trees—King Solomon, the settling of Tennessee, and his forefather's slavery are all wrapped up in this wood that he carves" (Wiggins, 1976: 29–34).

In his later years, after he settled in Columbus with his second wife, Pierce's practice of giving his carvings to members of the Gay Tabernacle Baptist Church

(formerly Gay Street Baptist Church), of which he was an associate pastor, seemed to be connected to a sort of divination process. According to several members of the church, Pierce would deliver a sermonette during the Sunday service; at the conclusion, he would present to some unsuspecting member of the church a recently completed wood carving, frequently of a religious subject, or a Masonic theme, if appropriate to the receiver.[8] How or by what special dispensation Pierce would arrive at a theme appropriate to a receiver does not appear to be explained anywhere in the sizable body of Pierce materials, but reportedly many of those who received his carvings in this way were surprised at the aptness of the carving and its relationship to the receiver. It may very well be that Pierce's vocation as a highly respected barber in the community gave him access to some of this information, which was perceived as personal by recipients of his carvings. But, no matter, by his middle years it was clear that the Gay Street congregation had accepted as legitimate Pierce's prophetic sensibilities.

Even if one were inclined to regard with some skepticism the traditional bases of these readings or the powerful confluence of symbols that marked Pierce as profoundly exceptional and spiritually gifted, one would find it difficult to dismiss the extraordinary circumstances of Pierce's birth and the particular character of the formation of his personality in the context of his deeply religious family, two factors that have a direct application to the nature of Pierce's "sermons in wood" carvings. There is a sense in all of this that Pierce understood the inevitability of his assumption of his personal destiny as an anointed Christian and quite intentionally used his aesthetic expressive form, his carving, as an instrument of negotiation between his religious destiny, which he regarded as onerous and vigorously attempted to deny for a time, and his embrace of a fully evolved secular life-style, replete with a love of dancing, an appreciation of elegant and splendid haberdashery, and the companionship of women. If this reading seems a bit expansive and perhaps wide of the mark, one has only to return to a quotation offered earlier: "I've been running from preaching for twenty years. . . . I guess the good Lord put me on the woodpile." The "woodpile" in traditional African-American Christian parlance means trials and tribulations, and holds the promise of the sweetness of salvation after the bitterness and disappointment of "worldly" travails.[9]

The following excerpt taken from an interview with Pierce conducted in the fall of 1971 by Michael Hall might well serve to illustrate metaphorically Pierce's time on the "woodpile" on his way to full acceptance of his destiny. Without apology for the length of the excerpt, I also suggest that this may be one of the few examples of the type of sermonette Pierce delivered preceding the bestowal of a carving. Clearly a Pierce sermonette had an expressly didactic function. Reflecting on his carved relief *The Man That Was Born Blind Restored to Sight* [Pl. 11], Pierce said:

And when I get a picture in mind I want to carve it. And as I carve it sometimes I get so lifted up in the spirit of God that I stop. These things haven't been cut with the sharp

instruments that I use because he's helping me to do that work. I just wish that you or others could see how he will use you when you give up and put him first in all your undertakings. He said "The greater work that we could do if you only obey him." Lot of people don't put enough trust in God, they try to do too much themselves. Well the world today, brother, wouldn't be in the condition it's in if we had love one for another as we should, as brothers. To me, my religion, I love you as though you were my own dear brother. Not only you, all people. I don't carry no hate in my heart against nobody. If I can do you any good, I'll do it. But I wouldn't lay one straw in your way. Anything I could do to help. My greatest joy is to make others happy. I believe that's my work that was assigned to my hands by the Heavenly Father above.

So that picture, I love it. It's a part of me. And as I've so often said when I sell a picture, I ask God's blessing upon that picture. Let it be a blessing in the home because it is a part of me. Trying to instill or leave a message in that home, representing my Heavenly Father.

He saw that man. He was born blind in his mother's womb. And he was crying. He was by the wayside and Jesus takin' time out to heal him and give him sight. He made a drug out of spittle in the clay and annointed his eyes and told him to go to the pools alone and wash [that] he may see.

Being obedient, he was told to do and he received his sign. He had been beggin' and had been seen by lots of people from his youth up. After he was received of sight, he went rejoicing in the streets and the people was amazed because they knew he was a blind man and now he sees. And they asked him who healed him? "Who gave sight to the blind?" He said, "a man came along. [I] didn't even know his name, but a man came along and told me what to do. Made spittle, stooped down and made spittle in the clay and anointed my eyes."

"Ain't you the one that was born blind? Why and how?" They went to his parents and asked about him. They told 'em "yes, he was born blind." "But how is it now that he see?" They said, "he is of age, ask him." One thing he said, "I was blind but now I see." [Pierce laughs, rejoicing.] You know that's wonderful! I was blind but now I see! He went on his way rejoicing. It ain't no secret what God can do.

Pierce's rejoicing near the conclusion of this segment of his interview with Hall indicated his regard for the profundity of the parable and its relationship to his own life, complementing Pierce's more generalized celebratory testimony to the power and the glory of God. The dynamism inherent in this reification of the sacred example illustrated by a secular application is at the heart of Pierce's translation of the biblical parable of the blind man into striking relief in his carving. This essential dynamism as a structural signature is apparent in most, if not all, of those works by Pierce now referred to as his "sermons in wood." It is a dynamism reflected as well in the unique structure of the performed African-American sermon, which requires that a preacher heavily weigh her or his message in the context of the secular world within an ontological framework of abstracted religious principles. Indeed, Pierce's own life embodies this tension, which, coupled with his gift and his inescapable sense of mission, is realized in the magnificent body of religious work for which he is

principally known. It is no wonder that Pierce's personal rejoicing in the interview comes as a transition between the end of the sacred example and Pierce's own reflective commentary, "You know, that's wonderful! I was blind but now I see. He went on his way rejoicing. It ain't no secret what God can do." [10]

Born to deeply religious Christian parents on March 5, 1892, Pierce was reportedly named Elijah by his mother, Nellie, in recognition of his blessed birth. Elijah Pierce was born "with a veil," a thin membrane that sometimes covers the child's head immediately following birth. [11] Among African-Americans, a child born with a veil is considered to be blessed with the ability to prophesy and is thought to be chosen or ordained by God to be a religious charismatic. So important is the veil as an index to a child's future personality and the manner in which he will be regarded—even if he does not appear to immediately manifest his calling—that parents and grandparents will frequently hold and cherish the veil as a keepsake, typically in a small wooden box.

Aminah Robinson reported that Pierce took his first name seriously. [12] Surely Pierce's mother had in mind Elijah, the ninth-century B.C. Hebrew prophet of 1 Kings of the Old Testament, when she named her son. The naming was, perhaps, far more apt than Nellie Pierce may have realized. A leader in both the secular and the sacred worlds, the biblical Elijah was a political activist of sorts, on God's side. And he, like Elijah Pierce, resisted his calling until a visitation from the Lord convinced him to become a religious champion. Pierce was born the second youngest, and the youngest boy, into a large family of eight siblings and a small and relatively close-knit community, and it is unlikely that as a youth he ever escaped interpretations of his religious destiny. The woods became a sanctuary for the bright, independent-minded, venturesome Pierce, and there he could indulge his dreams, strengthen his determination to leave his father's farm to seek the bright lights of points north, and generally construct a psychological secular existence unfettered by his family's powerful Christian centering.

This is not meant to suggest that Pierce was antagonistic toward his family's religious foundation. There is little in his materials to indicate that he was. Pierce was, in fact, profoundly influenced by the family's daily prayer sessions and Bible readings, by his father Richard's unbending independence and refusal to yield psychologically or physically to the system of enforced servitude into which he was born and from which he freed himself, and by his mother's apparently gentle humanity and abiding faith and strong resolve. [13] And each of these elements is found in abundance in Elijah Pierce the mature adult. Still, as a young adult Pierce struggled mightily to balance his sense of mission, greatly intensified by the quality of his family's religious life, his community's expectations, and his own needs as a young man. Interestingly, as the following anecdote testifies, this essential, appropriate, and necessary tension in Pierce's young life was frequently resolved in sacred contexts.

After I was a young man and had left home, I was up to a New Year's Eve dance. Something I had never did. The bells was ringing and we was on the floor dancing, people were hollering and singing, we were gliding over the floor. In fact I love to dance. But that night while I was dancing, the hall was singing and I heard my mother praying, just like she was in the dance hall. And when I heard her call my name, ask the Lord to take care of Elijah wherever he may be, I turned my girlfriend a-loose and ran and sit down and cried like a baby. This is something I never did, dance a New Year's in and the old year out. And over all that noise I heard her praying just like she was right there in the room and saw her with my eyes. I said she is broadcasting and televising to [me] and I will never dance anymore if the Lord will forgive me.[14]

Chronologically, this experience probably came after the more widely reported experience that may have led to Pierce's formal conversion as an adult and his decision to be ordained and licensed as a preacher, an event that took place at the Mt. Zion Baptist Church in Baldwyn on September 26, 1920. Pierce has summarized this latter experience, the subject of his *Obey God and Live* painted carving, numerous times in interviews [17.2]. The version of this critical experience offered below is taken from the 1971 Hall interview with Pierce and is probably the fullest text of the narrative ever published. The interview has been described by E. Jane Connell as "if not the earliest post-contact recording of Pierce's words, then one of the most candid and private interviews [of Pierce] ever recorded."[15]

The one where I was laid out for dead? . . . oohwee. . . . That picture kind of gets under my skin. . . . But it's kind of like this . . .

One day when I was down home in Mississippi where I lived, my mother and I and my sister stayed together after Father died. She [mother] moved to town and lived in my home. So one day I was doin' my evening chores and I was told to read a certain passage of scripture in St. Matthew. I think it's around the sixteenth chapter. And instead I went into the house and sit down in my chair beside a short table. Mother was on one side and I was on the other.

She and I used to read in the evenings the Bible—different passages of scripture. And that day Sears and Roebuck sent a catalogue. A brand new catalogue came in the mail. And I saw it on the table and I reached over the Bible with my left hand and picked up the catalogue to thumb through it lookin' at the sights and different things that were in the catalogue. And as I did so, the power from above—seems as though a hand touched my head. And when that happened, I began to fall out of the chair. And mother looked at me fallin' out of the chair on the floor. She jumped up and came to my rescue and asked me what was the matter. And as I was goin' through that fallin' out of the chair, I heard the voice God told you to read the Bible and you disobeyed him and I'm just showing you my power.

So my mother and sister drug me into the bedroom and laid me on the bed. And I went out just like the sun going behind a cloud. And they put camphor to my nostrils. Last thing I remember, mother asked me, "Honey, what's the matter?" And I couldn't say anything, although I didn't have any more pain than I have now. But I went on out, and they pronounced me as being a dead man.

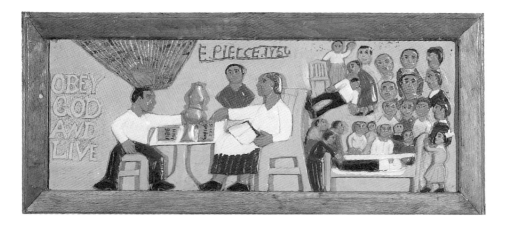

17.2. Elijah Pierce. *Obey God and Live,* 1956, carved and painted wood relief with glitter and marking-pen ink, 12⅞ in. × 29⁵⁄₁₆ in. Columbus Museum of Art, Ohio, Museum purchase.

And my mother and sister began to scream and cry and the neighbors heard them, came in to see what was the matter. And they said I was dead. I didn't have any pulse beat and neither my heart was beating or breathing or anything. And they said that I had passed away. And the house was filled with neighbors as I was laying there on the bed. And they made preparations to get the doctor and the undertaker . . . yes . . . [Pierce's voice breaks and he clears his throat].

So finally—I don't know how long I was in that condition—but finally I came back just like I went away, like the sun comin' from behind a cloud. And I heard the voice of God just showing you his power. He [Pierce] was disobedient, and I got a chance to speak. I said, "Hush Mother. I'll tell you what's the matter . . ." [pause, Pierce begins to sob]. She said, "Lord, honey, tell me." I said, "God told me to read the Bible and I reached over the Bible to look at a magazine and he just laid his hands on my head." I want to stop. [Here Pierce begins to cry uncontrollably. He asks Hall to turn off the tape recorder until he can regain his composure.]

And people was in the house looking frightened and some was backing toward the door as though they were afraid. And I stood up and walked around and they all were looking. I didn't have any pain, but I found out that it's bad to disobey God; that he will speak to you today just like he did in the days of old, that he spoke to the prophets and told them what to do. And he was showing me that it's bad to disobey. I thank you.

There are several points to be made from this intensely personal narrative. The first is to observe the structure of the iconographic representation of the narrative in Pierce's carving *Obey God and Live.* The second is to determine whether this structure approximates in any definitive manner the prototypical structure of the performed African-American sermon as defined in academic literature. Finally, it is appropriate to examine the means by which Pierce, as a traditional African-American folk artist, may have come by his knowledge of carving and preaching structure and transferred those technologies to the aesthetic rendering of images.

Elsewhere I have identified what I consider to be the "minimal requirements for the realization of an African-American sermon" (Davis, 1985: 46). It is amazing that this conceptualization holds true across African-American denominational boundaries. The minimal requirements are:

A. The preacher informs his congregation that his sermon is not his own, that he did not arbitrarily decide the text of his sermon. The African-American preacher must indicate to his congregation that the text of his sermon was provided by Divine intervention, by God (67–70).

B. The next obligatory step in the introduction of the African-American sermon is the identification of the sermon's theme. Usually theme identification is followed by a supporting Bible quotation (70–74).

C. The final phase of the obligatory introduction is the threshold of the sermon formulaic system. Following the Bible quotation, the preacher is obliged and expected to interpret, first literally then broadly, the quoted biblical passage (74–76).

D. The body of the African-American sermon is constructed of independent theme-related formulas. Each unit of the formula develops or retards a secular and sacred tension and moves between abstract and concrete example. Each generated formula is an aspect of the argument of the announced theme and advances the discovery and examination of the sermon theme (76–80).

E. There is rarely a closure to the African-American sermon. The sermon is open-ended and compares favorably with the open-ended nature of African-American performance forms generally (80–82).

In *Obey God and Live* it is clear the distinct elements in Pierce's carving approximate the narrative formulas in the African-American sermon. In some of his "sermons in wood," Pierce deliberately sets each of his elements apart from others through some form of bracketing, frequently using narrow frames or borders within the large carved or pieced border that frames the entire composition. It is instructive that Pierce has said of his carving, "Everything I carve, I want it to tell some kind of a story." Pierce continues, "It don't seem like nothing to me if it don't tell a story. I think that anything that don't have a story behind it, I don't know, I just don't understand it. I wouldn't call it junk. Beautiful work. Good work. But it don't tell nothing. It don't move me. It's not strong. I don't see nothing it tells." [16]

For Pierce, it would appear that there are equivalences between the episodic nature of sermons or tales as he may have heard them performed, and the structure of many of his "sermons in wood" carvings. While this may be regarded as an artist's organizing technique, a kind of mnemonic device, it is equally clear that a great deal of African-American narrative and material form seem to be composed of sequentially related elements.

In the case of *Obey God and Live,* a work in which each element is distinct, one has a handsome working out of a distinct cultural—African-American—aesthetic structure, which compares rather favorably to the organization of the African-American performed sermon summarized above. Moreover, Pierce's multiepisodic carvings are recognized and accepted as narratives, or as having a high narrative quality, by many African-Americans. Such a consistent recognition obviously requires a sound cultural base shared by the artist and his community.

There are seven distinct episodes or structural units in *Obey God and Live,* a couple of which hold dual properties. The first, of course, is the text "Obey God and Live," which has both sacred and secular applications. It is the abstract religious principle on which the secular Pierce experience is mounted. The next two elements are positioned by Pierce around the table on which the Sears and Roebuck catalogue and the Bible are located—the Sears and Roebuck catalogue located on the right side nearest Pierce's mother; the Bible positioned on the left in front of Pierce. This is the beginning of the narrative proper. Element two represents Pierce and his mother sitting at the table preparing for prayer and Bible reading; in a profoundly intimate, religious setting, element three captures Pierce's interest in the world, which unwisely causes him to flout well-established social custom and reach across the sacred Bible to pick up the secular merchandise catalogue. The fourth element is the representation of the heavenly power reaching down to touch Pierce on his head, rebuking him for his lapse. Pierce falls comatose from his chair in element five, and in element six is surrounded by people who think him dead. Element seven depicts the more generalized community watching the proceedings.

Without belaboring the correspondences, it would appear that element one satisfies phases A and B of the performed African-American sermon structure. The element is weighted heavily in Pierce's secular life but positioned against an abstract sacred principle well known in Baldwyn. This is both the secular theme of the carving and an acceptable religious text. Sermon phase C is accomplished by elements two and three, Pierce's setting up of the essential confrontation between his worldly needs and the religious nature of the family gathering. Sermon phase D is realized in elements four through six, and perhaps seven. In element seven, Pierce returns the import of the carving and the message to the secular world, and, as in all African-American sermons, he personally assumes responsibility for the impact of the message, even as he makes it clear that it is intended for a more general application in the daily lives of the people of his community.

While there may be some slight variance from religious carving to religious carving, in most ways this admittedly academic analysis is useful if one is to more fully appreciate the sermonic character and the distinct cultural provenance of Pierce's work. Pierce was an African-American folk artist who mined and trusted the rich stores of African-American traditional aesthetic systems to guide his hand and heart as he set knife to wood. Much has been made of the fact that Pierce considered himself self-taught. This is not to challenge the representation of idiosyncrasy in

causing Pierce's interest in wood carving, but his having been raised on a farm, which probably exposed the young Pierce to at least some rudimentary knowledge of carpentry and woodworking, and having a favorite uncle who was himself a carver, may have had a great deal to do with Pierce's choice of avocation. Certainly, he would have gathered his knowledge of African-American preaching structure from church attendance and from a familiarity with the variety of community narrative expressive forms which abound in any African-American traditional family environment [17.3].

A query was raised near the beginning of this essay concerning which of several competing standards of excellence should be used to evaluate the genius of a traditional African-American folk artist. One set of standards habitually denies the existence of community categories of excellence and thereby denies any linkages between an artist and his historical, social, and cultural foundations. The absurdity of such standards is most easily recognized in language that speaks of the folk arts as "quaint," or "idiosyncratic," or "dying out," or "the province of the old, the unlettered, the poor, the dispossessed, the marginal."

Elijah Pierce was a most excellent and respectful manipulator of steel against

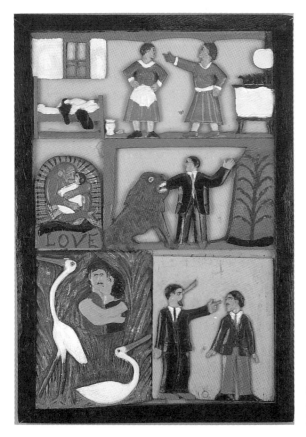

17.3. Elijah Pierce. *Monday Morning Gossip,* 1935, carved, assembled, and painted wood, 33½ in. × 24 in. Private collection.

wood; a preacher who was born in the rural South and whose soul found sweet rest in the urban North; a man who was saintly because he knew intimately the ways of the world; a most gentle spirit who treated his wood with respect and who welcomed all to his embrace; a man who could fix a person with one eye while the other roamed, seeking nuance—this man, this Reverend Elijah Pierce. The work of Elijah Pierce puts the lie to those who think the folk arts dead and simple and quaint, and folk artists marginal and anachronistic. Pierce, as are most folk artists, was dynamically aware of his world. Through his art, the rich complexity of daily, secular living finds momentary repose as we walk through the galleries of his personal quests, his wondrous visions of African-American ideas and heroes, his community perspectives on national events and political figures, his relationship with his God, and his elemental belief that his people are good people. This tall, elegant, superbly presented man was no mere simple soul. His life and his art were metaphors for the dynamism of life and the legitimization of the power of African-American aesthetic structures.

> And I usually pray over a piece of wood before I ever put a knife into it. I'm depending on Him for my inspiration and He give it to me. He said, "Ask and you shall receive." [17]

> So I think as long as you have lived and after you have died your work will live on. That's one thing I half-way believe. I've made some history and after I've passed off this old sinful world I'll live on. [18]

AUTHOR'S NOTE AND ACKNOWLEDGMENT

The title of this essay is taken from the title of a multimedia collage portrait of Elijah Pierce by Columbus artist Aminah Robinson, and it is used with her permission. The essay is adapted from an essay that originally appeared in *Elijah Pierce, Woodcarver* (Columbus, Ohio: Columbus Museum of Art, 1992).

NOTES

1. Many scholars, among them Gladys-Marie Fry, Steven L. Jones, Mary Arnold Twinning, John M. Vlach, Roy Seiber, and Lawrence Levine, have noted the historical connections and relationships between patterns in African fabrics and textiles and African-American quilt tops. But few commentaries have approached the precision and confidence of art historian Robert Ferris Thompson's *Flash of the Spirit: African and AfroAmerican Arts and Philosophy* (New York: Vintage Books, 1984), pp. 207–222, and collector-scholar Eli Leon's catalogue for his exhibit of the same title, *Who'd A Thought It: Improvisation in African-American Quiltmaking* (San Francisco Folk Art & Craft Museum, 1987), pp. 22–28 esp.

2. Pierce was an honorary member of Master Lodge No. 62 of the Ancient Free and Accepted Masons, Columbus, Ohio. Originally thought to have been a thirty-third-degree Mason, Pierce was in fact an eighteenth-degree Mason. Apparently Pierce may have been a

Mason earlier in his life and was reinstated to active membership in his later years. In any event, Masonry was a powerful force in Pierce's life, and Masonic symbols figure prominently in many of his works.

3. During an exceptionally intimate three-hour interview in her Columbus home on June 21, 1991, Aminah Robinson shared with E. Jane Connell and me some of her thoughts on Pierce's life and art. It was an extraordinary interview, and I am indebted to Ms. Robinson for her candor, trust, and grace.

4. The appellation "sermons in wood" may have originated, as Michael Hall suggests, as journalistic hype. The phrase appears on the Sunday, November 11, 1979, cover of the *Plain Dealer Magazine* and in an article inside the Sunday supplement, "Elijah Pierce, an American Original," by Jay Hoster, pp. 22–29. However, the conceptualization of "preaching" by carving religious images and narratives in wood Pierce attributed to his second wife.

5. *Artists Among Us*, 1977 television documentary film produced for WNET / Thirteen, New York. The audiotape of the program was supplied by Michael Hall, artist and Pierce biographer and collector.

6. From notes of a 1974 interview conducted by Jeff Wolf in Pierce's barbershop.

7. From a fall 1971 interview conducted by Michael Hall, accompanied by McArthur Binyon and Nancy Brett, in Pierce's home. E. Jane Connell has characterized this as one of the earliest "postcontact" interviews with Pierce. Estelle Pierce, his second wife, was also present during the interview.

8. From interviews with Isiah Holoman, Lonnie Cumberlander, and Dewell Davis, Jr., all members of Pierce's Gay Tabernacle Baptist Church. Both Davis and Cumberlander are thirty-third-degree Masons. I am deeply appreciative of their willingness to share with me their memories of Pierce. Davis was among those who received a Pierce carving in church.

9. In a personal correspondence, friend, general savant, and African-American literary theorist Erskine A. Peters supplied the following clarifying note on the meaning of the woodpile. "If you were living in a rural area down south and your father said 'If he doesn't straighten up I'm going to *put him on that woodpile* out there,' what it meant is that the subject would be *assigned* the task, the arduous and trying task, of chopping firewood."

10. Hall, 1971 interview with Pierce.

11. From a videotape interview of Pierce by Jeff Wolf at the opening of Corcoran Gallery of Art's *Black Folk Art in America, 1930–1980* exhibition.

12. Aminah Robinson, June 26, 1991, interview.

13. Ibid.

14. *Artists Among Us.*

15. Personal correspondence, July 19, 1991.

16. *Artists Among Us.*

17. Hall, 1971 interview with Pierce.

18. *Artists Among Us.*

BIBLIOGRAPHY

Brooks, Gwendolyn, reprinted in Stephen Henderson. 1973. *Understanding the New Black Poetry: Black Speech and Black Music as Poetic References.* New York: William Morrow & Co.

Connell, E. Jane. 1988. "Elijah Pierce, 1892–1984." In *The American Collections: Columbus Museum of Art,* edited by Norma J. Roberts. Columbus, Ohio: Columbus Museum of Art.

Davis, Gerald L. 1976. "Afro-American Coil Basketry in Charleston County, South Carolina: Affective Characteristics of an Artistic Craft in a Social Context." In *American Folklife,* edited by Don Yoder. Austin: University of Texas Press.

———. 1985. *I Got the Word in Me and I Can Sing It, You Know: A Study of the Performed African-American Sermon.* Philadelphia: University of Pennsylvania Press.

Ellis, Mark. May 12, 1984. "Famous Woodcarver Buried," *Columbus Dispatch,* Columbus, Ohio.

Friedman, Martin. 1974. "Introduction." In *Naives and Visionaries.* New York: E. P. Dutton & Co.

Le Falle-Collins, Lizzetta. 1987. "Home and Yard: Black Folk Life Expressions in Los Angeles." In *Home and Yard: Black Folk Life Expressions in Los Angeles.* Los Angeles: California Afro-American Museum.

Marsh, Betsa. June, 1975. "The Woodcarver of Long Street," *Columbus Monthly,* Columbus, Ohio.

Wiggins, William H. Jr., 1976. "The Wooden Chains That Bind: A Look at One Shared Creation of Two Diaspora Woodcarvers." In *Black People and Their Culture: Selected Writings from the African Diaspora.* Edited by Linn Shapiro. Washington, D.C.: Smithsonian Institution Press.

HOW DO YOU GET INSIDE THE ART OF OUTSIDERS?

Michael Owen Jones

Folklorists respond to the hoopla over "outsider art" with mixed reactions. They applaud the growing realization that art exists outside the mainstream of artists supported by a complex infrastructure of schools, galleries, and museums. But they shudder at the way the many varieties of this art are often indiscriminately lumped into the vague and meaningless category "outsider," and they dislike the statements often made about the makers of this art as mentally disturbed, self-taught, and disconnected from culture. Although several contemporary notions about outsider art resemble assumptions made about art and artists by early ethnographers, current folklore theory recognizes both traditional and aesthetic behavior as common to all people, not selected "others." In this essay I examine the implications of assumptions regarding art and outsider status. To do this, I consider some of the similarities and differences in terms of which art is defined and understood by folklorists and proponents of outsider art.

People have long been attracted to folklore because it seems indicative of ways of living, thinking, and behaving in the past. When he coined "Folk-Lore" in 1846 to replace "popular antiquities," William Thoms intended it to refer to "the manners, customs, observances, superstitions, ballads, proverbs, etc., of the olden time." (Thoms, 1965 [1846]: 5). "If the idea was, when expressed, conservative, the resultant object—the song or story or sculpture—can be called folk," writes a contemporary student of folk art. "Saying that a thing is 'folk,' then, implies that the idea of which it was an expression was old within the culture of its producer" (Glassie, 1972: 258).

Interest in documenting the old ways increased during the late eighteenth and

early nineteenth centuries (and continues today) because these ways were thought to be disappearing in the face of industrialization, urbanization, and formal education. The acceptance of the notion of the inevitability of progress motivated many to search for national and cultural roots, and to record ways that appeared to be changing or dying out (Georges, 1971). Folklore, then, was thought to be a historical artifact which was more common and widespread in the past than in the present, and hence was destined for alteration or extinction.

Not surprisingly, the search for old ways and ideas turned in the direction of "the others"—those least affected by the forces of modernization that threatened the ways of thinking, behaving, and living presumed to have been normative in the past. Folklore was "current among backward peoples, or retained by the uncultured classes of more advanced peoples" (Burne, 1914: 1).

Many researchers conceived forms and examples of folklore to be "survivals" in culture of earlier modes of thought and ways of life. As defined by E. B. Tylor, "These are processes, customs, opinions, and so forth, which have been carried on by force of habit into a new state of society different from that in which they had their original home, and they thus remain as proofs and examples of an older condition of culture out of which a newer has been evolved" (Tylor, 1958 [1871]: I, 16). He cites a Somersetshire woman using a handloom predating the flying shuttle, a newfangled appliance she refused to learn to use. Tylor writes that "this old woman is not a century behind her times, but she is a case of survival."

Researchers less influenced by the tenets of evolutionism have viewed examples of folklore as "continuities" through time rather than merely survivals from the past. For many, this has meant looking at the behavior of old people, rural dwellers, and immigrants. Although there are exceptions, it was really not until recent years that folklorists began to turn toward themselves, and their friends and families, in their inquiries about tradition (e.g., Adler, 1981; Daniels, 1985; Haring, 1974; Jones, 1980; Kalcik, 1975; Stahl, 1975; Zeitlin, 1979). In sum, researchers have often presumed their subjects to be isolated from the mainstream, members of a homogeneous and unchanging society or subgroup, and a class of people different from those who study them. This is particularly apparent in writings on belief. "The relentless climb of man from the primitive state to a life of increasing knowledge and culture has been marked by the retention of age-old folk beliefs—irrational ideas and superstitions that he has been unwilling or unable to discard" and that "spring from the . . . seedbed of misinformation, ignorance, and darkness," writes Wayland D. Hand (Hand, 1968: 215).

Explanations of folk behavior also present the subject of folkloric inquiry as alien and inferior. The folk perpetuate the old ways of thinking, behaving, and living because they are untutored, misinformed, unreflective, irrational. As members of a society or subgroup, they are culture-bound, unable or unwilling to break free from the stronghold of tradition. By making invidious comparisons between "them" and "us," researchers have ignored similarities between others and themselves which

might help explain the kinds of behavior they have studied (Jones, 1976). What has been true for folklore is likewise the case for outsider art.

Like other forms of the art of the "other," outsider art has become popular as an antidote to the seeming pressures of contemporary society. Thought to represent a condition or a place free from the strictures of overcivilized modern life, outsider art is said to have been created by people who are isolated and uncultured, untutored in common social and aesthetic norms. Much of the attraction to outsider art—as well as to those other arts of the "other" with which it is frequently confused and connected, such as grass roots, folk, or naive art—results from the same factors which drew early ethnographers to folklore: the seeming disconnection of these arts and their makers from the destructive, alienating forces of modernization.

Yet despite these similarities, many of the assumptions made about outsider art and other similar forms differ from the assumptions made by folklorists and ethnographers about the arts they study. For example, to begin with, virtually all the examples of outsider art which have been collected, exhibited, and published are painted or sculpted works. "Art," then, is limited to graphic representations, imitative of fine-art forms, which only some people sometimes produce. In this view, art is not aesthetic expression common in our lives, and it has nothing to do with utility or practicality. Moreover, art consists of objects or artifacts rather than both objects and activities. Some of these things are said to be produced by "compulsive visionaries" and the mentally disturbed, that is, individuals who are irrational and therefore incomprehensible to the average person. Other things are made by those who allegedly are self-taught. As mentally disturbed and/or untrained, these makers of paintings and sculpture are necessarily isolated—outside the art world, in the backwaters of the mainstream, even separated from community.

Such views of outsider art ignore several assumptions common to folkloric and anthropological practice. One is that much of human behavior, and its result, is aesthetic. Franz Boas put it best. "All human activities may assume forms that give them esthetic values. When the technical treatment has attained a certain standard of excellence, when the control of the processes involved is such that certain typical forms are produced, we call the process an art, and however simple the forms may be, they may be judged from the point of view of formal perfection" (Boaz, 1955 [1927]: 9–10).

There is an aesthetic dimension to the way we select our clothing, how we decorate our work space or homes (Faulds, 1981), the way we prepare and serve or eat food (Adler, 1981), the "manners" appropriate to interacting with others (Bronner, 1986: 44–55), how we orchestrate parties, the way we tell stories or use proverbs, and so on. Paintings and sculpture are not alone, much less primary, in evincing aesthetic concerns.

Another shortcoming of the popular conception of outsider art is that it views the art as simply an isolated oddity. Instead, much so-called outsider art reflects "the attempt [common to all people] to make beauty, or meaning, or perhaps just connec-

tions" with other people, times, or ways (Metcalf, 1986: 25). For example, "Seen" and other New York City "taggers" who "write" (spray paint grafitti) on subway cars "piece a train" in order "to try to produce something" (beautiful), "to get your name up for everyone to see," and "for people to get to know who I am." Radka Donnel, a Bulgarian immigrant in San Francisco, took up quilt making when her easel painting stalled, her children left home, and her marriage unraveled. Her quilts garnered praise. "I was suddenly being taken seriously by important others in my life," she said, indicating the activity's meaningfulness in her life.[1]

Tressa ("Grandma") Prisbrey, an often acknowledged "outsider" artist, created connections with others, even strangers, through her art. She began constructing an elaborate "Bottle Village" out of salvaged materials at age sixty after losing her husband, several siblings, and six of her children to heart disease and cancer. She often asked visitors, "Are you alone?" If the response was affirmative, she followed with, "Oh, that's too bad," and invited them in to the world she had created (Greenfield, 1986: 55–89). After years of wandering from one job to another in northern cities, a man named Aaron headed back to the hills of southeastern Kentucky where he was born. One day in 1962, after a week-long bout with the bottle, he signed up at a local shop to learn Appalachian-style chair making, which connected him to his heritage. By the time I met him five years later, his self-esteem had grown, and the empty half-pints lining the walk to his house like ruts in a road had accumulated years of dust (Jones, 1989: 210–222).

The common understanding of outsider art also implies that aesthetic behavior triggered by typical psychological processes such as grieving is abnormal. "I've heard it said lots of times; there's something about carving a piece of wood that you have in your hand—it quiets your nerves—just to keep your mind off something else," said Floyd Bennington, who took up chain carving when faced with the anxiety of retirement. Willie Hausmann carved chains after his wife's sudden death, helping him adjust to the loneliness he felt (Bronner, 1983: 72). Theora Hamblett once remarked, "I feel I can paint anything I want any day of the week except Wednesday. I paint visions and dreams on Wednesdays." A religious woman and former schoolteacher who produced memory paintings of her childhood as well as visionary images, she seemed at times to be working through emotional turmoil over her relationship with her father, who died when she was seventeen, and grappling with the death of her brother, of which she had a premonition.[2] Creativity for these people, and others, is hardly an aberration.

It is ironic that while the art world labels its artists and divides them into multiple groups based on values, style, and aspirations (e.g., Expressionists, Surrealists, Abstract Expressionists, or the Chicago Imagists), other artists who do not fit so neatly into fine-art conceptions are lumped together as "outsiders," in a single group which ignores their many differences. With no unifying criteria other than the often questionable assumption that these artists are naive, self-taught, or mentally disturbed, promoters and collectors of outsider art ignore the varied traditions, the dif-

ferent values, and the unique aesthetic concerns of these many artists. For there is considerable difference between the sensibilities of makers (and users) of cornhusk dolls in Iowa (Rikoon, 1981), the values of Mennonite memory painter Anna Bock of Elkhart County, Indiana (Bronner, 1986: 124–143), the Indian heritage inspiring California painter Dalbert Castro (who would have preferred being an herb doctor but was born too late to "have the teachings of the old timers"), and the Northwest Coast's logging traditions that inform the chain saw sculpture of Skip Armstrong.[3]

Another problem with our understanding of outsider art is that it fails to ac- knowledge experiences on which nonacademic artists draw. Many who appear "self- taught" (because they didn't study their art in an art school or university) are not, however, untutored. Moving away from rigid art models tied to painting and sculp- ture, we find that some quilt makers learned quilting from spouse, relative, or neigh- bor. Chair makers worked as apprentices until they had perfected the craft. Cane makers and chain carvers apply general woodworking skills learned in youth. Chain saw carvers rely on knowledge acquired in the construction business or logging in- dustry. Moreover, once they become involved in an aesthetic behavior, people seek out others to observe their techniques, whether the activity be crocheting, tie-dyeing, or cooking. No one is truly unlearned in a craft, or entirely self-taught.

Yet one more fact ignored by proponents of outsider art is that (with the excep- tion of some who are institutionalized) the artists grouped into this category are not without community. Indeed, it is a sense of communion or communitas that often results from their artistry or that motivates it. Minnie Evans's paintings of angels, prophets, and chariots connect her to the local community of Fundamentalists who believe in the literal Second Coming of Christ. Suzanna Calderon, who worked on quilts at the local school board meeting, discovered that quilting served first as a bridge and then a bond between herself as a self-professed radical and the conserva- tives of the community. Leaf Hillman, who learned the old ways of his people from the last elder, Lew Wilder, helped preserve tribal integrity and distinctiveness by teaching Kurok art, customs, and language to the children.[4]

Not only are these artists connected to others, but also many of them function quite well within the mainstream of society, even though their aesthetic specialities fall outside the boundaries of the art establishment. Saul Hill, Abram Joseph, John Curtis, and other yard decorators appear to be integrated into their community in south central Los Angeles (Le Falle-Collins, 1987). Marlene Zimmerman, a painter of nostalgic scenes, seems well-adjusted to modern life in Beverly Hills. The late Texas quilt maker and painter Martha Mitchell did not evince alienation. Baltimore screen painters Tom Lipka, Ben Richardson, and Frank Cipolloni just want to beau- tify the neighborhood in which they and their customers live.[5]

Finally, those who promote outsider art often ignore the fact that all human beings express themselves through traditional forms and processes and that all people exhibit aesthetic sensibilities in many aspects of their lives. All people tell stories. They take part in rituals, customs, and ceremonies. They tell jokes, use prov-

erbs, and sing songs. They make things by hand, whether objects from discarded materials (Lockwood, 1984), toys for their children, cards or other gifts at holidays and anniversaries (Daniels, 1985), or flower beds and herb gardens. Even arrangements of trash cans may be aesthetically driven (Jones, 1987: 81–95). In these endeavors, people follow models (tradition), often imbuing the precedents with special value. And they also attempt to perfect form, thereby giving the performances or objects aesthetic qualities (Jones, 1987).

In what follows I discuss in some depth two examples of artistic activities which might be considered to be outside normal art-making purposes and histories—two activities that seemingly exist outside both folkloric visions of art as tradition and connoisseur notions of art as aesthetics. The first involves the making of chairs by Chester Cornett, an iconoclastic craftsman whose work often seemed to push far beyond traditional norms. The second activity involves decorating the work place, an aesthetic behavior which takes place outside of the normally considered range of art-making activity. Despite their seeming disconnection from standard art-making procedure, these two activities, closely inspected, reveal both traditional and aesthetic impulses at work.

Of the dozen chair makers in southeastern Kentucky whom I studied in the mid-1960s, Chester Cornett stood out. In the chair-making business for more than forty years, he obviously was dedicated to this craft. He had the greatest store of traditional knowledge; he also was the most innovative. As I worked with him for several years, many questions arose about how he used particular techniques, why he chose certain materials, who his customers were, the extent to which he anticipated and acceded to others' wishes regarding chair design, what his relationship to family members and neighbors was, what his aspirations and values were, and so on (Jones, 1989).

Most of his life Cornett cut the timber himself and shaped it into chairs using an ax and drawing knife [18.1]. He constructed chairs without nails, screws, or glue; following tradition, he relied on differential rates of seasoning. He "cooked" slats and posts (or legs) in boiling water, then drove them into presses; when dry, they retained their curved shape. He seasoned the rounds (or stretchers) by placing them in a wood-burning stove for several days. Because the slats and rounds had less moisture than posts into which they were driven, over several months' time the posts slowly shrank around them forming a lasting joint.

Like other chair makers, Cornett put pegs in the slats to help hold them. Unlike others who relied on a single peg inserted in the back of the chair, he eventually put pegs at each end of a slat from the front, using them for decoration (often making them of a wood darker or lighter than the wood of the slats). Typically it took two weeks to build a mountain-style "settin'" chair and a month to construct a rocker.

Because customers expected chairs to sell cheaply, most were simply designed and quickly constructed. Even at the beginning of his career, however, Cornett's chairs differed from those by his grandfathers and uncle, from whom he learned the

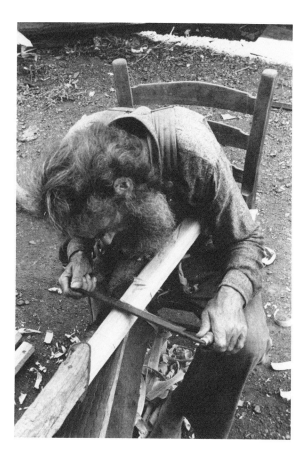

18.1. Chester Cornett, at drawing horse, "shaving" a "post" (leg) for a chair, August 1965.

craft. He bent the back posts both backward and outward rather than leaving them straight, and he curved the slats for greater comfort. He experimented with the seats. Some he made of wood, carved to conform to one's posterior. Others he wove of hickory bark, following precedent, but he used summer bark as well as bark stripped from trees in the winter, and he wove seats with varying widths of bark (the wider the bark, the quicker the weaving but the less comfortable the experience of sitting).

He altered the shape of the "foot" on settin' chairs, making some pointed for appearance's sake and others broad so as not to puncture linoleum floors. Using a handmade, foot-powered turning lathe like the one he had worked on with his grandfather, Cornett made a rocking chair in 1935 on which every piece has "spools." The sets of turnings on the back posts, front posts, rounds, and arms all differ from one another (Jones, 1989: fig. 66). Rather than settling on one form and repeating it throughout as other craftsmen did, Cornett experimented with variations on a theme, exploring the very notion of turnings. A panel-back rocking chair that he made in 1942 and sold for $2.50 consists of maple panels, ash posts in back that are square, oak posts in front turned on a lathe, turned hickory rounds, and woven

hickory-bark seat (Jones, 1989: fig. 67). In Cornett's words, the chair is "a mixed-up proposition," but effective nonetheless and evidence of his propensity to experiment with one or another concept about chairs and chair making.

This conceptual approach informs a rocking chair Cornett made in the 1950s as a companion to a love seat, both of which he shaped entirely with ax and hatchet. Constructed of mulberry (and painted light green by the owner), the chair's rockers are 20½ inches apart in front but only 4¼ inches apart at the back [18.2]. It was one of Cornett's favorites. The man using it in the 1960s spoke highly of its comfort. You can rock backward with no fear of tipping over, he said several times. He demonstrated, rocking vigorously. He invited me to sit in the chair and challenged me to try to tip it over.

The chair typifies Cornett's style. He characteristically shaped posts and stretchers eight-sided with a drawing knife, ax, or pocketknife. The seeming "organic" quality was distinctive, a result of his concern about making a chair that "sets good." An examination of nearly one hundred of his chairs reveals that he tended to focus on some aspect of chair design, construction, or purpose and to develop it—as a concept—on one or another chair.

By the late 1950s Cornett was beginning to imagine a "dining chair" which differed from settin' chairs in having a higher back and seat as well as more decorative elements and constructed of more costly wood than sassafras or hickory. He finally made such a chair about 1961 [18.3]. Built of black walnut, it has a high seat, five slats, and overwhelming ornamentation, all of which preclude its being used to just sit in and tip back or lean against the wall. "My brother said he wouldn't give me fifteen cents for that chair, but I like it," said the woman who bought it. "I was going to have Chester make me a table and chairs till I got this other table" (a factory-made piece).

Each slat has a heart carved in the center. Cornett hand-rubbed the chair with oil and then finished it with varnish, refinements he infrequently bestowed on any chair, but this was one of his favorites. He had made the chair for his daughter, Brenda, vowing never to sell it. She told me that it was her favorite of all the chairs her father had built. She no longer had it, however. Her father had sold it several years earlier because winter was setting in and young Brenda needed shoes.

Sometimes Cornett created chairs and then sought buyers. On other occasions he made chairs on order, according to customer specifications. He preferred the former. Even when he accepted orders, he often modified them to fit his techniques or design preferences. This independence assured originality and personal expressiveness, albeit with respect to models from the past.

In addition to traditionality and a conceptual approach to chair making, there were two other themes in Cornett's behavior and the things he made. One was a self-conscious old-fashionedness that exceeded mere appreciation of precedent. For example, in the spring of 1965, only a few months before I met him, he created a maple rocking chair with very thin posts, little more than an inch in diameter [Pl.

18.2a. *a.* A mulberry rocker made by Chester Cornett in the mid-1950s, using only an ax and hatchet. Mulberry wood with hickory seat, height 42 in., width of rockers 20½ in. in front and 4¼ in. in back. Whereabouts unknown.
b. Back view of Cornett's mulberry rocker.

18.2b

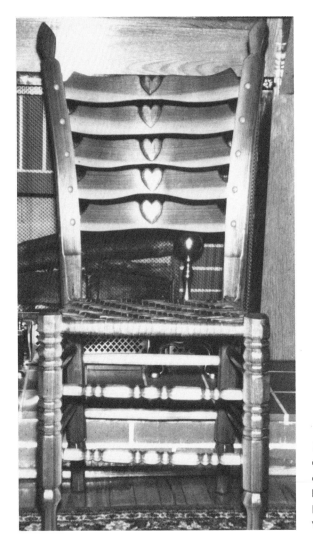

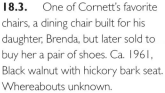 **18.3.** One of Cornett's favorite chairs, a dining chair built for his daughter, Brenda, but later sold to buy her a pair of shoes. Ca. 1961, Black walnut with hickory bark seat. Whereabouts unknown.

12]. Allegedly the posts were thin because he had no more substantial material. To strengthen the chair, he added a brace in back. He also mortised through the posts so the slats and rounds extend through them, projecting half an inch or so beyond. "Some people called it the 'Washington chair,'" said Cornett, "cause it looked like somethin' George Washington might a' set in. But I call it my Abner chair. Called it that b'fore I ever made hit." He had been inspired by the Li'l Abner comic strip in the Sunday edition of the *Louisville Courier-Journal* a dozen years earlier, in the mid-1950s. In the cartoon chair, the pieces of wood project beyond the posts because they have been haphazardly nailed to the backs of the legs. At the time that he noticed this furniture in Al Capp's cartoons, his wife had left him in an effort to force him

to move from a mountain hollow to live by the highway. He began growing a beard, gave up using a turning lathe, and constructed chairs with four legs.

In the early 1960s his wife left for a longer period. In 1963, he built a chair he called the "Old Timer" for an elderly woman, without her knowledge, and she died before he completed it. The chair had a tall back with nine slats so wide they nearly touched one another, a high seat that "made you sit way up high like a king or somethin'," and a leg rest extending from beneath the seat. With the help of an FHA loan in 1966, Cornett built a shop and purchased modern woodworking equipment. He adapted a router to cut rough notching on the chair posts corresponding to spools he had previously cut by hand. If rubbed with oil, the darkened notches were supposed to give the chair more of an antique appearance, which would make them "better lookin'" than those notched with a pocketknife, Cornett claimed.

In the spring of 1965, Cornett composed a song to the tune of "Man of Constant Sorrow." Called "My Old Kentucky Mountain Home," it refers to a man at war, "Fer, oh, fer o'er the deep blue sea, whar the sun hardly ever shines." He longs to return to his "ole Kentucky mount'n home, whar the whippo'wills are so lonely and lonesome, and I wonder if they ever think of me." Cornett was born and raised on top of Pine Mountain, where he built a cabin for his mother. He often said he wished he could return there to live, asking my wife and me as well as a local journalist to take him there to visit several times. Like the narrator of his song, Cornett was drafted during World War II and sent to the Aleutian Islands, a place where the sun hardly ever shines, where he was put on KP and guard duty. Less than three years later he was discharged, having suffered a 30 percent disability for "nervousness." One can understand how a southern mountaineer, away from his old Kentucky mountain home for the first time, would very likely suffer. But Cornett did not compose his song until twenty years after the war ended.

Another theme in his chairs is that of a sense of enclosure, even security. In the mid-1950s, when his wife left him the first time, he created several settin' chairs with eight legs. In the early 1960s, after Ruth left him again, he built several two-in-one rocking chairs with eight legs and four rockers. He claimed that the chair in Fig. 18.4 (the second of about nine) took 356 hours to make. Given the hand tools he used, plus the more than eighty pegs with grooves and ridges (each of which required at least thirty minutes to carve) and the many pieces of dowelling that he had to shape eight-sided using a drawing knife to shave off tissue-thin pieces with each stroke, his estimate may be understated. No one had requested such a chair, of course. No one seemed to want it as Cornett trudged through town with the chair strapped to his back, stopping at shops and homes in an effort to sell it. Finally, the owner of an automobile franchise bought it for seventy-five dollars and finished it with paste wax.

Cornett told me several times how difficult it was to build such chairs, to drill all the holes at the proper angle and in the correct place, and to bend the slats double the usual amount. These deeply curved slats, however, were "just like somebody hug-

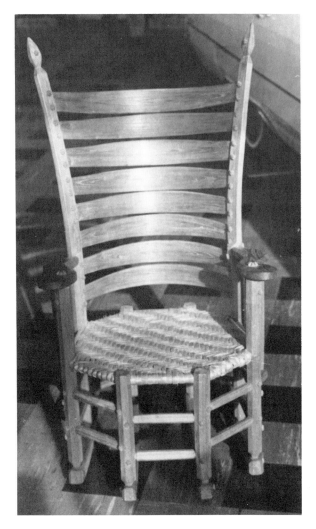

gin' you." In the spring of 1967, he "revised" a settin' chair he had made in the late 1950s and used at home. He cut off the top, replaced the long, narrow slats with shorter, wider ones, added decorated pegs to the slats, replaced the thin arm rests with thick ones, and generally made it less expansive and more enclosed and secure like his two-in-one rocking chairs.

Cornett coped with multiple problems in his adult life. He and his wife, Ruth, had different aspirations, he to make chairs and she to socialize. Poverty contributed to marital discord. In January of 1965, for example, he sold a rocking chair for only $12, one that had taken two to four weeks to build. He had asked $25, and dreamed of one day receiving $90. His rent was $10 a month, his electric bill about $10 every other month. At his wife's insistence Chester had tried various jobs but always

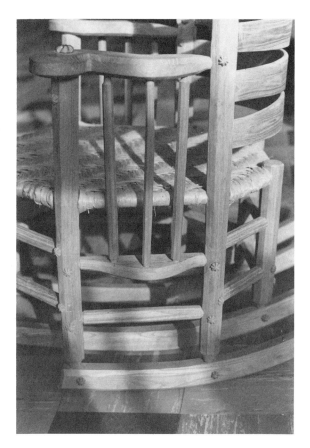

18.4b. *a.* Cornett's second two-in-one rocker allegedly required 356 hours to make. Early 1962, redbud with hickory bark seat, height 47 in., maximum width 23½ in., length of rockers 30 in. Whereabouts unknown. *b.* Detail of Cornett's second two-in-one rocker shows spokes under the arms and the hand-carved pegs with grooved heads.

returned to chair making. The Cornetts had four sons. As each entered his teens, he quickly deteriorated physically and intellectually. By 1967 the oldest, then twenty-two, could only lie in bed flailing his arms and making buzzing sounds. The next, aged seventeen, could still walk, but his speech was incoherent. The third, aged fif-teen, had fallen the year before and broken his hip, which did not mend properly; he was confined to a wheelchair. Much of what he said was incomprehensible. The same fate awaited the Cornetts' youngest boy, Billy, then about six years old.

Cornett's coping entailed the process of grieving, in which one idealizes the past—hence, his wishing to return to Pine Mountain, his composing the song "My Old Kentucky Mountain Home," his adopting the hillbilly image popularized by Al Capp, and his becoming preoccupied with old-fashionedness in his tools, techniques of construction, and many chairs. He was also trying to insulate himself from others, having moved to the noisy highway at Ruth's insistence and being forced to deal with visitors' inquiries and interruptions of his work. Because chair making is expressive behavior and an art form, Cornett projected many of his feelings and needs into the

things he made. Some of his chairs, and even his immersion in building them, afforded him protection and helped him create a world in which he could control a few things in his life (Jones, 1989).

A second example of artistic activity, how people decorate and personalize their work space, is so far outside popular art world conceptions of the aesthetic that it is seldom considered to be art at all, even by proponents of outsider art. In 1987, with the help of a research assistant (Scheiberg, 1990), I conducted a study of several units in a university. One was a large basement area of a library, out of sight to the public, devoted to the processing of books. With management approval, many employees had extravagently and exuberantly decorated their work areas, which were makeshift spaces created with "walls" of used bookcases, old desks, and carts. Some people taped posters on bookcases. One woman who had hung a forest scene above her desk slightly above eye level said that she would lean back and look at it when she was feeling particularly stressful. Another put cartoons around the edges of her desk, which she glanced at occasionally to lighten her mood. A third person cut out pictures from book jackets, creating a collage expressing his aesthetic appreciation of the books he had processed. Employees emphasized awareness of their surroundings, designing their space with elements to help relieve tension or express positive emotions associated with work. They also recognized continuities and consistencies in behavior, that is, the traditionality of personalizing the work space in this unit. One woman pointed out that a co-worker, whose desk was sparsely decorated, was "new—she's not depressed"; she had not had time to personalize her work area like others had done, although she intended to do so.

In another unit, three teaching assistants occupied a single office (Jones, 1988). Each had a desk facing a wall. All had put items on the wall. For example, one teaching assistant had taped policy memos and other work-related information to the right of the desk where the information was accessible when needed but not constantly in sight. She covered the wall in front of her and part of her desk below it, which she viewed directly and often, with postcards of places she had visited; a photo of her brother and sister-in-law, whom she missed; and other memorabilia, including a handmade greeting card from a prior teaching assistant wishing her the best. She was extroverted and gregarious; sometimes these items around her desk were topics of conversation and also, I eventually realized, familiar items of comfort when her self-assurance faltered.

Another person in the office had found teaching to be a trying experience, particularly since the course was a far cry from her specialty. She was introverted, uncomfortable in the classroom, and perhaps somewhat impatient with students. On the wall directly in front of her at eye level was job-related information, as if she had to focus on what she must do. To her left on the side of a filing cabinet was a piece of photocopy-machine lore dominated by the image of a menacing grouch, below which was a caption warning others not to speak until he had had his morning cof-

fee. A student sitting on the chair at the end of the desk would have been aware of the image while conferring with the teaching assistant.

On the wall immediately to her right was another example of photocopier lore in the form of the cost to answer questions, from "no charge" for "dumb answers" to the greatest charge for "right answers." Although a seated student would block it from her sight, the teaching assistant would have known it was there; certainly she saw it before a student was seated in front of it and after the student had left. On the wall in front of her desk and above eye level when seated was a poster depicting a fanciful scene from medieval mythology (her field of specialization) of a dragon and its slayer. To look at the image from her desk, she would have to lean back in her chair, head tilted back, eyes up (behavior associated with reverie).

The personalization of work space, viewed as artistic behavior, is outside the purview of management science and organizational theory. Viewed through the lens of folklore, however, this activity raises important issues. In what ways do examples of folklore express positive feelings and to what extent do they communicate negative ones? How do they reinforce attitudes and values? How do some examples of folklore function in helping people cope; and what does this suggest not only about human behavior but also about management policy and organizational design (Jones, 1991; Jones, Moore, Snyder, 1988)?

Decorating their work areas and other kinds of artistic behavior can help individuals fantasize, project their anxieties and emotional turmoil, deal with the vicissitudes of organizational life, and provide an aesthetic satisfaction to those who engage in it. Tolerance of such behavior can lead to greater satisfaction and better performance.

For collectors and curators, the furniture and decorated work spaces described above fall outside the boundaries even of outsider art. Although the chairs can be purchased and exhibited, the fact that they are utilitarian objects renders them difficult to appreciate for their artistry. Decorated walls at work cannot be purchased; neither do they lend themselves to waxing nostalgic over a simpler way of life. Both chair making and the personalization of work space, however, illustrate the human urge to create aesthetic gestures and the equally human propensity to express one's self through traditional forms.

Although outsider art tends to be presented as oddities made by untutored or psychotic individuals isolated from society, a different picture would emerge in exhibits and publications if more collectors and curators really got inside the art of outsiders. An emic or insider approach would reveal that much of people's behavior is traditional. Individuals' activities evince continuities through time and consistencies in space because of a propensity to model behavior and to replicate precedents. Such an approach would also discover that as human beings we seek positive aesthetic experiences, we attempt to perfect form in some aspects of our lives, and we admire things well made or pleasingly executed. Instead of a collection of oddities

by those who are abnormal, the art of outsiders is really a window onto what makes us human, including the need for tradition and the urge to create aesthetic forms in our everyday lives.

NOTES

1. "Seen" and other writers, taggers, and bombers display their skills and talk about their art in Tony Silver and Harry Chalfant's film *Style Wars* (1983; color, 69 min.), distributed by New Day Films. Information about Radka Donnel and other women is from Pat Ferrero's film *Quilts in Women's Lives* (1981; color, 30 min.), available from Ferrero at California State University, San Francisco. For other excellent films and videos about American folk art, see *Grandma's Bottle Village* (1978; color, 28 min.), and *Possum Trot: The Life and Work of Calvin Black* (1977; color, 28 min.), both of which are distributed by Light-Saraf Films; Marjorie Hunt and Paul Wagner's *The Stone Carvers* (1985; color, 28 min.), distributed by Direct Cinema; Scott Crocker's *Bone Shop of the Heart: Folk Offerings from the American South* (1990; color, 50 min.); Jack Ofield's *Ralph Fasanella: Song of the City* (1979; color, 25 min.); and Barbara Attie, Nora Monroe, and Maureen Wellner's *Skin and Ink: Artists and Collectors* (1990; color, 28 min.), distributed by Women Make Movies, Inc.

2. For information about Hamblett, see the film *The Art of Theora Hamblett* (1966; color, 22 min.), distributed by University of Mississippi Extension; and Bill Ferris and Judy Peiser's *Four Women Artists* (1977; color, 30 min.), distributed by Center for Southern Folklore.

3. For information about Castro and others, see Donna Reid's video *Carved Visions, Painted Dreams: A Glimpse of Four California Artists* (1986; color, 35 min.), distributed by UCLA Folklore and Mythology Center. See also Sharon Sherman's *Spirits in the Wood: The Chainsaw Art of Skip Armstrong* (1991; color, 33 min.), distributed by Sherman at University of Oregon.

4. For further information about Evans, Calderon, and Hillman, respectively, see the following films: *The Angel That Stands By Me [Minne Evans]* (1985; color, 30 min.), distributed by Light-Saraf; Ferrero's *Quilts in Women's Lives,* mentioned in note 1, above; and James Culp's *Preserving a Way of Life: People of the Klamath, Part II* (1989; color, 28 min.), distributed by New Day Films.

5. For information about Zimmerman, see the video *Carved Visions, Painted Dreams,* cited in note 3 above. Regarding Mitchell, see Melvin R. Mason's video *Martha Mitchell of Possum Walk Road: Quiltmaker* (1985; color, 28 min.), distributed by Mason at Sam Houston State University. For information about screen painters, see Elaine Eff's *The Screen Painters of Baltimore* (1988; color, 28 min.), distributed by Direct Cinema.

BIBLIOGRAPHY

Adler, Elizabeth Mosby. 1981. "Creative Eating: The Oreo Syndrome." *Western Folklore* 40:4–10.

Boas, Franz. 1955 [1927]. *Primitive Art.* New York: Dover Publications.

Bronner, Simon J. 1983. "Links to Behavior: An Analysis of Chain Carving." *Kentucky Folklore Record* 29:72–82.

Bronner, Simon J. 1986. *Grasping Things: Folk Material Culture and Mass Society in America.* Lexington: University Press of Kentucky.

Burne, Charlotte Sophia. 1914. *The Handbook of Folklore.* London: Sigwick & Jackson.

Daniels, Theodore. 1985. "The Grammar of Kindness: The Exchange of Homemade Gifts in Folklife." Ph. D. dissertation, University of Pennsylvania.

Faulds, Sara Selene. 1981. "The Spaces in Which We Live: The Role of Folkloristics in the Urban Design Process." *Folklore and Mythology Studies* (Los Angeles) 5:48–59.

Glassie, Henry. 1972. "Folk Art." In *Folklore and Folklife: An Introduction,* ed. Richard M. Dorson, pp. 253–80. Chicago: University of Chicago Press.

Georges, Robert A. 1971. "Models of Inquiry in Folkloristics: The Nineteenth Century." Paper given at the American Folklore Society meeting, Washington, D.C.

Greenfield, Verni. 1986. *Making Do or Making Art: A Study of American Recycling.* Ann Arbor: UMI Research Press.

Hand, Wayland D. 1968. "The Fear of the Gods: Superstition and Popular Belief." In *American Folklore,* ed. Tristram Coffin, III, pp. 243–55. Washington, D.C.: Voice of America Forum Lectures, United States Information Service.

Haring, Lee. 1974. "' . . . And You Put the Load Right on Me': Alternative Informants in Folklore." In *Conceptual Problems in Contemporary Folklore Study,* ed. Gerald Cashion. Bloomington, Ind.: Folklore Forum Bibliographic and Special Series, No. 12.

Jones, Michael Owen. 1976. "The Study of Folk Art Study: Reflections on Images." In *Folklore Today: A Festschrift for Richard M. Dorson,* ed. Linda Dégh, Henry Glassie, and Felix J. Oinas, pp. 291–304. Bloomington: Research Center for Language and Semiotic Studies, Indiana University.

———. 1980. "L. A. Add-ons and Re-dos: Renovation in Folk Art and Architectural Design." In *Perspectives on American Folk Art,* ed. Ian M. G. Quimby and Scott Swank, pp. 325–63. New York: W. W. Norton.

———. 1987. *Exploring Folk Art: Twenty Years of Thought on Craft, Work, and Aesthetics.* Ann Arbor: UMI Research Press.

———. 1988. "How Does Folklore Fit In?" Paper given at Academy of Management meeting, Anaheim, Calif.

———. 1989. *Craftsman of the Cumberlands: Tradition and Creativity.* Lexington: University Press of Kentucky.

———. 1991. "What if Stories Don't Tally with the Culture?" *Journal of Organisational Change Management* 4, no. 3:27–34.

Jones, Michael Owen, Michael Dane Moore, and Richard Christopher Snyder, eds. 1988. *Inside Organizations: Understanding the Human Dimension.* Newbury Park, Calif.: Sage Publications.

Kalčik, Susan. 1975. "' . . . Like Ann's Gynecologist or the Time I Was Almost Raped': Personal Narratives in Women's Rap Groups." *Journal of American Folklore* 88:3–11.

Le Falle-Collins, Lizzetta. 1987. *Home and Yard: Black Folk Life Expressions in Los Angeles.* Los Angeles: California Afro-American Museum.

Lockwood, Yvonne C. 1984. "The Joy of Labor." *Western Folklore* 43:202–11.

Manley, Roger. 1989. *Signs and Wonders: Outsider Art Inside North Carolina.* Raleigh: North Carolina Museum of Art.

Metcalf, Eugene W., Jr. 1986. *The Ties That Bind: Folk Art in Contemporary American Culture.* Cincinnati: Contemporary Arts Center.

Rikoon, J. Sanford. 1981. "'I Mean It's Almost Unreal': Categorizing a Creative Folk Art Object in a Folk Aesthetic Network." *Folklore and Mythology Studies* (Los Angeles) 5:34–47.

Scheiberg, Susan L. 1990. "Emotions on Display: The Personal Decoration of Work Space." *American Behavioral Scientist* 33:330–38.

Stahl, Sandra K. D. 1975. "The Personal Narrative as Folklore." *Journal of the Folklore Institute* 14:9–30.

Thoms, William. 1965 [1846]. "Folklore." In *The Study of Folklore,* ed. Alan Dundes, pp. 4–6. Englewood Cliffs: Prentice-Hall.

Tylor, Edward Burnett. 1958 [1871]. *The Origins of Culture.* New York: Harper & Row, Vol. I of *Primitive Culture.*

Zeitlin, Steven J. 1979. "An Alchemy of Mind: The Family Courtship Story." *Western Folklore* 39:17–33.

19

OUTSIDE IN THE CITY

STREET PERFORMERS
IN NEW YORK'S
WASHINGTON
SQUARE
PARK

Sally Harrison-Pepper

Step up! Step up, everyone! The turtles are on the track! These are great thoroughbred racing turtles, come from far away to be with you this afternoon.

Come forward everyone. Come on up—especially you, my dear. Step up, step up, everyone!

Turtles? He's going to race turtles? Is this what he's really doing? And to what end, here in this New York City square?

Right now they're doing their wind sprints, their setting up exercises, getting loose, getting limber. Anything to break the tension that always accompanies the running of a major event.

His style is reminiscent of the old carnival pitchmen, enticing an audience to gather 'round for a dubious event. The turtles perform in a "handy dandy break-down do-it-yourself portable Turtle Drome"—basically a hexagonal table. Drawing the curious toward his turtle-racing arena, Mitchell Cohen welcomes the crowd, announcing that the day's race is the "feature race of the afternoon," the famed "Twin Tiara," or perhaps the famous "Washington Square Futility." The satiric basis of his show is quickly established.

Cohen then introduces the turtles. He presents Sublime Shalimar, "once the jewel of the Shah's stable, she is today a political exile—banished by the Aya-Turtle"; Ivan the Terrapin, the "first professional racing turtle to defect from the Soviet

Union"; Slime-O Greeno, "with more victories lifetime than any turtle now competing"; Maximillian Shell, returning from "near fatal" knee surgery to make a spectacular comeback as that year's "Reptile of the Year"; and Lana Turtle, formerly known as Engleburt Hump—turtle racing's "first transsexual turtle." Cohen announces that the winner will be declared "under the rules of the New York State Turtle Racing Authority, Joseph T. Noonan, Commissioner." He points to his "official" T-shirt [19.1].

Cohen tells his growing crowd that they will be allowed to bet on the turtles for *free*, explaining: "This my contribution to your afternoon's exposure to cultural events." He moves around the circle, asking people to call out their "bets," advancing toward the quiet ones and threatening to *assign* them a turtle if they won't bet. Cohen shouts to the people in the back of the crowd: "Don't worry if you can't see the turtles. There are no turtles here!" Or he may call out: "You've got to take this more seriously, like those folks over there!"

Exchanges between Cohen and his audience are fluid and spontaneous, and more predictable audience remarks are met with what Cohen calls "canned ripostes." One such riposte emerged because of a fortuitous error. Originally, the turtles were numbered sequentially, from one to five, with little plastic numerals stuck on their backs. One day, however, Cohen could not locate the numeral two. He instead labeled the turtles from one to six, with the two missing. During the betting, however, someone called out "Number Two." Cohen quickly responded, "Oh, Number Two has been scratched due to a drug inquiry." The retort was met with such laughter that the gap in numbering remains in the act, waiting to prompt an unwitting spectator's remark.

Once the betting has been completed, Cohen will look about the crowd with a somber expression. "I would like to say a word about why I'm doing this," he says. The absurdity of the situation is so well defined at this point that the remark is met with even more laughter. "We're trying to build a new wing at the St. Elmo's home for Retired Racing Turtles in Galapagos, New Mexico," he explains. "I'm the Director. And folks, I'm here to tell you, those retired racing superstars need little turtleneck sweaters to guard them against the chill night air! And they need Shell . . . *Oil!* And Turtle . . ." Often the audience joins him at this point: "Wax!"

Cohen shows the crowd the back of a poster, explaining that on the other side is a picture of that year's "Poster Turtle." He advises those "close to the emotional borderline" not to look and then, adopting the tone of a reverent sportscaster, continues: "But for the rest, especially you old-time sports fans, I'm sure you'll remember him with a tear in your eye [revealing a drawing of a bandaged turtle sitting in an armchair]: Old Number Fourteen, Mr. Y. A. Turtle!" (The name is a pun on the retired New York Giant's quarterback, Y. A. Tittle.) Cohen quickly adds: "Now if you get the very generous impulse to throw gold, wristwatches, heirloom quality pewter flatware, I urge you not to do that because you might concuss the turtles. Then again, *paper money* is not hazardous to their health!"

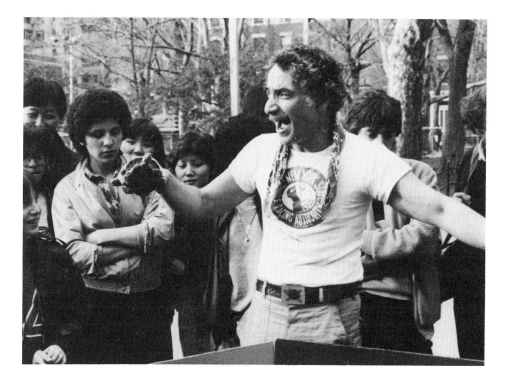

19.1. Mitchell Cohen introduces a turtle, Washington Square Park, 1982.

Cohen proceeds to the next segment of his act: He asks for a volunteer, stipulating that the person must be male, courageous, and strong. He pauses briefly and then drags someone out of the audience. The volunteer is given a battered brass helmet, an aluminum pot lid "shield," and a silly rubber finger puppet for his index finger. "And now, my friend, this is your important task: At great peril to your upper torso, you must lean over the track during the race and shout 'Wooga Wooga!' while waving your finger puppet at the turtles! This is necessary," Cohen says soberly, "in order to get the turtles to move." (Actually, it rarely seems to make any difference, but of course, that's not the point.)

Cohen begins to blow part of the familiar racetrack melody on a kazoo. He stops abruptly, commenting, "Well, you know how it goes." He then places the turtles behind the "central barricade" (a set of folding plastic walls in the center of the track) and shouts: "It's Post Time! The turtles are on the track, pawing the turf, ready to begin their run to glory! Are you ready, Ed?," Cohen asks the volunteer. Ed nods, laughing. "Try to get hold of yourself, man. This is dangerous work." More laughter. The pace is building.

Cohen grabs a windup toy of a boy riding a bicycle, announcing: "The field is in the hands of the Official Starter!" Releasing the toy, he raises the "central barri-

cade," and the turtles begin to slowly crawl toward the outer walls. The audience laughs and cheers, Ed waves his finger puppet shouting "Wooga Wooga!," and Cohen, adopting the tone of a racetrack announcer, drones: "And moving up on the outside, it's Number Three, Sublime Shalimar. As they round the Clubhouse Turn, here comes Ivan the Terrapin . . ." [19.2].

Finally, one of the turtles will meander across the finish line. Cohen grabs a large checkered flag and waves it high, yelling, "And it's Number Five, ladies and gentlemen! Number Five—Maximillian Shell!" He places a eucalyptus wreath on the back of the victorious turtle. The audience cheers and applauds.

Cohen now tries to hold his audience's attention for one more comic routine— the awarding of the "totally worthless *tchachkalas*" (Yiddish for "little bits of junk") to the winners in the audience. "You lucky devils," he says, "you are going to receive replicas, in living fake cheap stuff, of the greatest racing turtle of all time! Ladies and Gentlemen, a turtle of the people! Turtle Kamen!" He reveals a small plastic turtle; the crowd groans at the pun on Tutankhamen. Cohen moves through the crowd, passing out the awards while shouting: "Okay, that's the show, ladies and gentlemen. I hope you enjoyed it, and I do hope you remember those retired racing superstars at the St. Elmo's home. You've been a terrific audience, *so far!*" He moves around the departing audience with his hat. "You're losing ground!" He continues to move through the crowd until all have left. Another voice is calling from across the square, ". . . Show time! Next show starting now!"

Though he performed in the square for only two years before moving on, Charlie Barnett's routines were legendary [19.3]. Each Saturday evening, several hundred people would gather in the center of the square, waiting for Charlie—"Seen him yet?" "He's coming, isn't he?" "Where's Charlie at?" He performed in the natural amphitheater formed by an inoperative fountain in the center of the square. Its steplike ledges provided seating for three hundred or more spectators, while a raised metal disk in the center provided a platform from which Barnett could deliver his opening remarks. In the first few months of his performances in the square, he enticed the crowd with a few jokes; thereafter, however, Barnett simply began by shouting: "Y'all know me and my show, and y'all know what to do. When I count to three, everybody's gonna yell, cheer, applaud, whistle, scream, and make so much racket that everybody else'll think I'm getting killed over here and they'll come to watch!" The noise usually ended in a chant: "Charlie . . . Charlie . . . Charlie . . ." as Barnett swaggered around the ring. As the show proceeded, he would fling himself around the center, strutting, dancing, rapping, smoking, and absorbing his power from the crowd. Though his attitude became increasingly intimidating, his energy held the spectator's attention throughout the performance.

Primarily a stand-up comedian, Barnett possessed a type of humor that was topical and specific to New York City. After introducing himself, for example, he would say, "One thing I like about New York. Everybody has the same fuckin' name—'Yo!' . . . Yeah, and we can always spot you tourists, too. You guys look at

19.2. Coming down the home stretch, Washington Square Park, 1982.

stuff we don't give a fuck about anymore. [Pointing to the nearby Washington Arch] 'Oh look, Myrtle, the Washington Arch.' [To audience] Who cares, right?"

Unlike Cohen, Barnett relied on a stylized rudeness and a series of rapidly delivered insults, usually based on stereotypical prejudices. He insulted everyone—African-American, gay, wealthy Upper East Side, tourists, Puerto Rican—with carefree enthusiasm. "I do a lot of ethnic humor," he would remark, "and people ask me if I'm prejudiced. . . . Well, let me be honest with you all: I'm not black! This is a birthmark! . . . But really, I do *everybody*—'cause what interests me is how everyone does stuff different." Often, while imitating one group, he would say, "Don't worry, I'm gonna do blacks." He would mimic his victims' behavior on the streets (impersonating homosexuals was a favorite) or in the bedroom (demonstrating, for example, the lovemaking styles of Asian, Jewish, or southern women). He would point to representatives from the parodied group and ask, "Isn't that right?"

One popular segment of Barnett's show concerned the large transistor radios black adolescents carried on the streets and subways. "White folks hate it when niggers get on the subway with them goddam radios. Honkies just get mad as shit. And niggers don't get on with no itty bitty boxes. When they get on the train, everybody's gotta wait for them to put the speakers up in the corners!"

Barnett would locate a white man in the audience wearing a tie and perhaps a

19.3. Charlie Barnett instructs the audience, Washington Square Park, 1982.

jacket and, pulling him into the circle, would announce: "Okay, listen. This is your chance to get us niggers back. I'm gonna be you. And *you* can be *me*" [raised eyebrow glance to the audience]. He would borrow the man's coat and tie (on one occasion, Barnett even took the man's briefcase and an expensive pen) while convincing his volunteer/accomplice to wear a backward baseball cap, roll up one pant leg, and carry a large radio borrowed from another audience member.

"Okay, I'm on the train. It's 5:00, I've had a hard day at the office, and I'm trying to read my *Wall Street Journal* [another prop taken from the audience]. Then you get on the car."

His volunteer often needed coaching—"Don't you know how to turn that radio on? . . . No, niggers don't walk like that. It's like this." Finally, the man would enter the scene. Soon, he would be strutting about the imaginary subway car, relishing the opportunity to turn up the volume and wave the radio in Barnett's face. Barnett would look up and say, in a prissy voice, *"Will* you turn that thing off!" The audience would break into laughter and applause at the spontaneous "psychodrama" taking

place before their eyes. The man would try to be even more obnoxious until actors and audience were laughing so hard that the skit usually broke apart.

Joyfully abusive of everyone in his audience, Barnett would ridicule their clothing, lover, job, apartment—whatever he suspected was important to his quarry. The pace of his performance reflected the tempo and pressure of its urban existence. He used gestures, postures, walks, leaps, and a shouted delivery, "constantly breaking into hostile absurdity and forcing audiences to laugh, maybe a little harder than they would like to, about the desparateness of their own lives" (Smith, 1981: 15).

"A lot of people say I'm offensive," he would remark, "but I don't give a fuck!" He imitated the way different groups go to work (the Polish walk backward, Asians take tiny steps). He would mimic a Caucasian tourist encountering an African-American New Yorker ("Will you mug me, while my husband takes a picture?") and ridicule African-American teenage fashions ("If you were a cab driver, would *you* pick this person up?"). He'd twist his face into a caricature of a Japanese tourist and, moving around the circle with tiny steps while holding an imaginary camera around his neck ("You don't never see a Jap without a camera"), he'd pepper the audience with a complex combination of prejudices, truths, and fantasies, all propelled by the force and rhythm of Barnett's oddly charismatic energy. "I never get bored with his delivery," a fan remarked. "But he's the only one who can do it and get away with it. If anyone else tried his routines, they wouldn't live through it!"

Barnett, too, was armed with "canned ripostes." "If I want any shit from you, I'll squeeze your head," he'd retort, or "Give to the United Negro College Fund, folks. As you can see, a mind is a terrible thing to waste." Audiences admired his *chutzpah* (a descriptor offered by many I interviewed), and Barnett relied on this combination of brass, insolence, and self-assurance for his income. Frequently, he would stop in mid-routine and ask, "How many people like my show so far?" Most would respond with applause. "That's good," he would say, "'cause I'm going to collect *now*. You all always *leave* later on." Amazingly, he'd stop the show to collect his money, moving around the circle with a paper bag, hurling insults to prompt greater contributions. Though this segment might last ten minutes or more, everyone remained in the fountain, watching each other put money in the bag ("Don't put that change in there, it's too heavy! *Paper* money!"). Sometimes, Barnett repeated the routine at the end of the show, collecting twice from the same people. But his fame and bravado enabled him to accomplish this feat. Barnett performed, demanded money, and spectators complied. He averaged about three hundred dollars per show.

THE STREET AS STAGE

Since 1981, I have watched, followed, interviewed, and photographed street performers. I began by simply documenting the performers' shows, but I was soon impressed by the variety of ingenious strategies these performers had devised to do theatre *out-*

side, both literally and metaphorically. New York City performers emphasize the messages of freedom that are embedded in their acts, and describe their ability to be "outside the system," self-employed and self-sufficient. "I didn't want a regular life . . . and this was my way out, my way of living outside society," explained storyteller Asche. "My purpose on this planet is to instill a homesickness for freedom in the lives of ordinary men," declared Jim Gardner. "It's a way of saying, 'I don't have to live my life the way most people do'—there are alternatives," said Cohen.

Street performers also feel that they are communicating a message which is fundamentally different from that of commercial (or what street performers call "inside") performers. Their performances function in contrast or opposition to official culture, especially theatre and its values. Street performance is an arena for the unexpected, for innovation, even chaos. It operates, along with carnival, festival, and play, as a form of "symbolic inversion," a phenomenon broadly defined by Barbara Babcock as "any act of expressive behavior which inverts, contradicts, abrogates, or in some fashion presents an alternative to commonly held cultural codes, values, and norms be they linguistic, literary or artistic, religious, or social and political" (Babcock, 1972: 14).

Mitchell Cohen's act, for example, is essentially an extended monologue, perhaps fifteen minutes long, with less than one minute actually devoted to the turtles' "race." The commentary, in fact, is what is truly important to Cohen. He feels that his turtle racing presents alternatives to the frantic, sometimes violent environment of the city. "I'd always felt that I'd like to be one of those who's kind of symbolic of the fun that can just sort of serendipitously happen on a nice warm spring day," Cohen once told me. "That makes me feel good." He described his act as a "vehicle that makes some satirical comments on America's reverence for muscle and skill and athletic prowess at the expense of all else." "It always rankled me somehow," Cohen explained, "that the second violinist of the New York Philharmonic makes about ten percent of what the average rookie baseball player makes during his first year with the New York Mets."

No society can function without an "outside" and an "inside." The inside is what anthropologists often call the dominant worldview of a culture. The outside, on the other hand, is everything the inside is not. It is the shadow. The outside is the domain of the street performer. It is also the domain of the comic.

Comedy is the site of struggle between the "inside" and the "outside." It may be used to face disorder, to contemplate issues of survival and the possibility for failure, or to confront the oppressions of everyday life, but the joke is always connected to social relations. Often it is used as a blunt instrument for debunking. Invariably, it deals with power.

Both Cohen's and Barnett's humor, for example, is based on an inversion of the basic ("serious") uses of language and behavior in daily life. Cohen offers a comic inversion of horseracing, and discusses the ways in which he feels our culture overem-

phasizes athletic rather than artistic skill. Barnett ridiculed his audience's hopes and fears, focusing principally on the contextual culture of New York City. Yet Barnett's humor never entirely reflected the "actuals" of whatever ethnic group he was abusing at the moment. Instead, the material was based on the dominant (white, male, middle-class) culture's ethnocentric image of the parodied group. His jokes were concerned with delineating boundaries: binary oppositions between "us" in the audience and "them" outside the performance, "us" in New York and "them" in the rest of the country, "us" the residents of the United States and "them" the foreign tourists.

Barnett's binarism was critical yet familiar to New York audiences, for, as anthropologist Edmund Leach observes: "Local custom is quite often organized not simply on the basis that 'we, the X people, do things differently from the Y people,' but on the principle that 'our X customs are correct; those lousy Y people just across the valley are obvious barbarians, they do everything back to front!'" (Leach, 1976: 63). Joking thus provides a useful vehicle for the demarcation of boundaries between inside and outside, couched in terms of a covert communication on taboo topics.

A TRADITION OF HOSTILITY

Perhaps, then, it is understandable that so few cities would welcome the street performer. Indeed, the prejudice against street performance is centuries long. It has been described as "a kind of oral graffiti" (Cohen and Greenwood, 1981: 5). It has been dismissed by theatre historians as an "irregularity" or an "unpredictable element [which] seems both to transcend period and to run independently of any phase" (Southern, 1961: 34). The laws prohibiting it date at least as far back as the 421 B.C. Roman "Laws of the Twelve Tables," which outlawed the performances of street singers under penalty of death. Louis IX banned outdoor tumblers and sleight-of-hand artists "through whom many evil habits and tastes have become engendered in the people" (Clark, 1929: 14). Henry VIII ruled that beggars—a category in which he included "pardoners, fortune-tellers, fencers, minstrels, and players"—who were found without licenses "should be punished by being tied naked to the end of a cart and beaten with whips" (Clark, 1929: 20). The Church equated the itinerant performer's solicitation with prostitution.

In the American colonies, a 1612 law in Jamestown, Virginia, outlawed conjurors and actors. A 1699 ruling of the Massachusetts Bay Colony banned all "rogues, vagabonds, idle persons [and] persons using any subtle craft, juggling or unlawful games or plays" (Collins, 1973: 401). A 1773 Connecticut "Act for Suppressing of Mountebanks" stated, in part, that "no mountebank, or person watsoever under him, shall exhibit or cause to be exhibited on any publick stage or place watsoever within this Colony, any games, tricks, plays, jugling or feats of uncommon decs-

terity and agility of body, tending to no good and useful purposes, but tending to collect together numbers of spectators and gratify vain or useless curiosity" (McNamara, 1976: 8).

More recently, Mayor Fiorello La Guardia canceled the licenses of New York's street performers, declaring that the city would no longer go into "partnership with this concession in mendicancy" (*New York Times*, 1935: 23). Chicago police lieutenant Robert Wagner remarked, "If you have an individual out there who is unkempt, dirty and has an untuned instrument, he's obviously not a performer, he's a panhandler" (*New York Times, 1983: 2*). In the 1990s, street performers prompt civic concerns about an appropriate public "image," and most cities respond by prohibiting street performance entirely. In New York, San Francisco, New Orleans, Chicago, outdoor entertainers are charged with vagrancy, unlawful soliciting, willfully blocking the street, or disturbing the peace. The performers are jailed or fined, their props confiscated by the local police.

Elsewhere, I have argued that street performers function as folk heroes of the urban environment (Harrison-Pepper, 1990). It it essential, in fact, for street performers to remain outside licensing structures and commercial theatrical norms. Their unauthorized position in the civic environment is a key to their attractiveness; audiences recognize and admire their heroic import. The street performer, one New Yorker said admiringly, "is a self-made man." [1] He seems a close cousin to Jerome Rothenberg's postmodern artist: a "surviving non-specialist in an age of technocracy" (Benamou and Caramello, 1977: 14). The street performer is outside, in all the ways that term can mean—outside the law, outside the power, outside the conventions, outside rather than inside.

THE FOLK IMPRINT ON THE BUILT ENVIRONMENT

Street performance is thus part of a larger urban phenomenon Barbara Kirshenblatt-Gimblett has called "the folk imprint on the built environment" (Kirshenblatt-Gimblett, 1983: 195), that is, the unauthorized, unofficial expressions of the folk superimposed on the anonymous, mass-produced cityscape. This is an important dimension of street performance. Performers in the streets are responding, directly and concretely, to a wish to "bring the theatrical event into the world outside the theatre building" (Schechner, 1982: 29).

But urban space is not an already written text. The street performer must inscribe his meaning upon it. Working essentially in a "found" environment, the performer must transform the space as part of his performance. The urban environment—its noise, traffic, and garbage—often becomes a performer in its own right, but not a predictable one, nor one that can be re-created indoors. Theatres have become tamer places than the streets.

The city therefore exerts a primary influence on both the perception and recep-

tion of street performance. The shape, texture, and uses of urban space determine behavioral expectations, performance structures, and the theatrical frame. The width of a sidewalk or shade from a tree, the noise surrounding the performance space, the proximity of other performers, the civic regulations concerning performance activities—all are part of the street performer's daily, even minute-to-minute negotiations with a fluid and vital urban environment. The setting may even influence an audience's contributions. Buses rumble by; helicopters hover overhead; hecklers interrupt the rhythm of the performance; rain, cold, or police can defeat the performer entirely. The audience surrounds him, restless, waiting, impatient.

Courage is always necessary. Cohen, for example, compared his performance preparations to those of a soldier preparing for battle. Barnett used to shout during his act: "Let's hear it for all the New Yorkers who are brave enough to go out and entertain other New Yorkers!" For some, this is part of the exhilaration of the streets. Philippe Petit, for instance, said in a 1982 interview, "Finding a spot, waiting for the rain to stop, hiding from a cop is part of what street performing is about, and I hope that that doesn't change." Earlier Petit declared: "The artist who chooses this formidable ground of expression faces a tough and savage school. It is the total and constant encounter—*l'affront*. . . . I defend my one-night territory: a corner of sidewalk, a circle of chalk" (Petit, 1979: 58). The street performer creates his own inside.

Cohen also says that when his act is at its best, it is "absolutely transporting":

> Every pause, every joke, every nuance is responded to. And it reaches a point where everything I say is funny. The timing is crisp and I can just ride the laugh. . . . This chemistry is just somehow produced. . . . It is almost as if I'm not doing it. . . . And then at the end, the climax is a real climax, a whole purgative and catharsis for everybody—which is of course the crux of why people perform. *That* is the reward.

This feeling is heightened on the street, where a very direct experience of the momentary interactions of performance is possible. Street performers are attracted to the energy, the conflict, the chaos, of the *outside*. They describe again and again their act in terms of a contrast to the inside. Observed Pat Olesko, for example, a New York performance artist who worked outdoors in the late 1970s:

> It is far more cogent to attract people in the public way (e.g. when art walks down the streets and actually competes with the common hustle-bustle) than it is in the arid, austere space of an art emporium. Not only does it force a closer understanding between artist and audience, but it also forces the art to be tougher, more demanding of itself. Street performance affects 90% of the population that may never view art except through the T.V. (Boyle, 1978: 71)

When a performer begins to prefer the fluid urban environment over the walled theatre space, street performers say that he has "become the street," and this is an exalted position among veteran performers. Explained Asche: "When I become the

street, I'll have really made it. No grants from the government. I don't want them. I don't want the government to know I exist. This is theatre of the people, by the people, and for the people."

For many New Yorkers, the streets are a kind of tunnel, leading only from home to office, or home to shopping, and back again. A good street performer can surprise these tunneling individuals, drawing them into a temporary world of wonders, encouraging interaction and participation. Street magician Jeff Sheridan explains: "The street entertainer is a visitor from a world of no appointments. What he offers the audience is not only a moment of entertainment, but also a moment of calm, the chance to pause and share an experience while escaping tensions created by an inhospitable environment" (Claflin and Sheridan, 1977: 127).

AUTHENTICITY AND THE OUTSIDER

The street performer nevertheless relies on the most fundamental contract of the theatre—the central yet unspoken agreement between the solo performer and the individual spectator. "I will watch," the spectator's presence implies, "as long as you are worth watching." "I will be worth watching," the performer's actions respond, "as long as you watch." [2] Together, spectator and performer define the relationship that is performance. Thus the performance is both outside (of larger cultural sanctions and controls) and inside (based as it is upon a new social contract). The contract is fleeting, however. Twenty minutes at most. And it is usually the presence or absence of the spectator that prompts and sustains street performance. No spectators = no performance.

Thus, while civic authorities argue about sidewalk congestion, the street performer simply learns to work within the fundamental theatrical pattern of gathering, performing, and dispersing. As city planners ponder the appropriateness of certain kinds of performance, or the locations for the shows, street performers manage to construct a highly functional self-regulating activity. While mayors contemplate licensing strategies, street performers receive permission to perform from the laughter and contributions of their audiences [19.4].

Street performance restores theatre's ability to communicate with pure forces, and the transformations which occur in street performance may, in fact, be more "real" than those which take place in indoor theatres. The street performer's show, happening here and now, using us and our shared environment as props for its action, both entertains and enchants us largely because it takes place so directly within our space. Its transcendent power is achieved using the real people, objects, smells, sounds, and restrictions of the built environment. The heat from the fireblower's flames is *really* hot—audiences lean back in fright as the fireballs near their faces. The noise from an approaching police siren is not a taped sound effect. The nearby sidewalk vendor hasn't been sent by central casting; the smell of hot dogs and sauer-

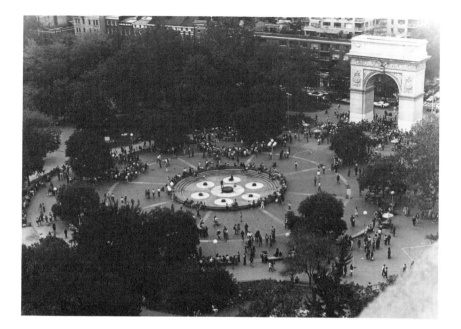

19.4. The performance ring, Washington Square Park, 1982.

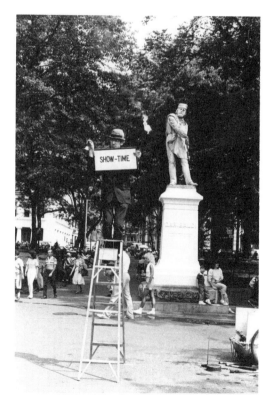

19.5. Milo Max starts his show, Washington Square Park, 1984.

kraut is real, authentic, present. I believe, as performance theorist Antonin Artaud once declared, that "it is not upon the stage that the true is to be sought . . . but in the street" (Artaud, 1958: 76) [19.5].

NOTES

1. With the possible exception of San Francisco's outdoor entertainers, the vast majority of contemporary American street performers are male. The few women who perform outdoors do so primarily in teams or with male partners. The solo outdoor performer is therefore discussed in the masculine gender, not as a generic pronoun, but as an accurate portrayal of the field.

2. The phrasing for this contract was first presented by Hollis Huston, a former street performer (now a professor of theatre), in a guest lecture at the University of Texas at Dallas. Huston added, on the other hand, that his idea for the fundamental performance contract arose from his reading of one of my articles on street performance (Harrison, 1984).

BIBLIOGRAPHY

Artaud, Antonin. 1958. *The Theatre and Its Double*. New York: Grove Press.

Babcock, Barbara. 1972. *The Reversible World: Symbolic Inversion in Art and Society.* New York: Cornell University Press.

Benamou, Michel, and Charles Caramello. 1977. *Performance in Postmodern Culture*. Madison, Wis.: Coda Press.

Boyle, Wickham. 1978. *On the Streets: A Guide to New York City's Buskers*. New York: New York City Department of Cultural Affairs.

Claflin, Edward, and Jeff Sheridan. 1977. *Street Magic: An Illustrated History of Wandering Magicians and Their Conjuring Arts*. New York: Dolphin Books.

Clark, Sidney Wrangel. 1929. *The Annals of Conjuring*. London: George Johnson.

Cohen, David, and Ben Greenwood. 1981. *The Buskers: A History of Street Entertainment*. North Pomfret, Vt.: David and Charles.

Collins, Sherwood. 1973. "Boston's Political Street Theatre: The 18th Century Pope Day Pageants." *Educational Theatre Journal* (December): 401–3.

Harrison, Sally. 1984. "Drawing a Circle in the Square." *Studies in Visual Communication,* Vol. 10, No. 2 (Spring): 68–83.

Harrison-Pepper, Sally. 1990. *Drawing a Circle in the Square: Street Performing in New York City's Washington Square Park*. Jackson: University Press of Mississippi.

Kirshenblatt-Gimblett, Barbara. 1983. "The Future of Folklore Studies in America: The Urban Frontier." *Folklore Forum*, Vol. 16, No. 2: 175–234.

Leach, Edmund. 1976. *Culture and Communication: The Logic by Which Symbols Are Connected*. Cambridge: Cambridge University Press.

McNamara, Brooks. 1976. *Step Right Up*. New York: Doubleday and Company.

New York Times. 1935. "Hurdy Gurdy Fees Abolished by Mayor," March 8:23.

———. 1983. "Chicago Considers Permitting Artists' Performances in Streets," April 15:2.

Petit, Philippe. 1979. "The Vagabond Theatre." *Village Voice*, July 2:58.

Schechner, Richard. 1982. *The End of Humanism*. New York: Performing Arts Journal Publications.

Smith, Howard. 1981. "Wild in the Streets." *Village Voice*, September 10:15.

Southern, Richard. 1961. *The Seven Ages of Theatre*. New York: Hill and Wang.

NOTES ON THE CONTRIBUTORS

LUCY R. LIPPARD is a critic and activist who has published numerous books on contemporary art, including *Get the Message: A Decade of Art for Social Change.* Her most recent books are *Mixed Blessings: New Art in a Multicultural America* and *Partial Recall: Photographs of Native North Americans.*

ROGER CARDINAL is professor of literary and visual studies at the University of Kent at Canterbury, England. Cardinal wrote the influential book *Outsider Art* and the major essay for the 1979 catalogue *Outsiders,* which generated much of the current American interest in outsider art.

DANIEL ROBBINS is Baker Professor of the History of Art at Union College, Schenectady, New York, and is the former director of the Fogg Museum at Harvard University. He is the author of *Albert Gleizes, Jacques Villon,* and numerous articles and catalogues.

MICHEL THÉVOZ is curator of the Collection de l'Art Brut in Lausanne, Switzerland. He is the author of numerous books including *Art Brut.*

JOANNE CUBBS is a writer and curator whose publications include *Hmong Art: Tradition and Change* and a monograph on artist Eugene Von Bruenchenhein. Cubbs is currently completing a book on major environments by self-taught artists in Wisconsin to be published by the John Michael Kohler Arts Center.

LAURENT DANCHIN is a writer and animator. He has engaged in the study of outsider environments in France and is the author of *Jean Dubuffet*.

DAVID MACLAGAN is a writer, artist, and art therapist who teaches at the University of Sheffield in England. He has written widely on outsider art and has also published *Creation Myths*.

MICHAEL D. HALL is an artist, critic, and collector. He has been a pioneer in the field of contemporary American folk art. Among his many writings is the book *Stereoscopic Perspective: Reflections on American Fine and Folk Art*.

CHARLES G. ZUG III is professor of English and folklore at the University of North Carolina. An authority on southern arts, Zug's best known book is *Turners and Burners: Folk Potters of North Carolina*.

RICHARD NONAS is a sculptor who was once an anthropologist. His work has been widely exhibited and collected in America, Europe, and Japan. He has been awarded a Guggenheim Fellowship and several National Endowment for the Arts Fellowships.

CONSTANCE PERIN is a cultural anthropologist in the research program of the Sloan School of Management at the Massachusetts Institute of Technology. Among her publications are *Everything in Its Place: Social Order and Land Use in America* and *Belonging in America: Reading between the Lines*.

LEO NAVRATIL is the founder and former head of the Artists' House at the Gugging psychiatric clinic near Vienna. Among his books are *Schizophrenie und Kunst* and *Zwischen Wahn und Wirklichkeit* (with Alfred Bader).

EUGENE W. METCALF, JR. is associate professor of interdisciplinary studies at Miami University in Ohio. Metcalf has written widely on American folk art and its social meanings. Among his essays are "Black Art, Folk Art, and Social Control," and "The Politics of the Past in American Folk Art History."

MARK GISBOURNE has taught at London's Courtauld Institute of Art and currently teaches a postgraduate course for Sotheby's Education Studies and the University of Manchester. He has extensively researched the relationship between art and psychopathology and is currently writing a book on conceptions of psychotic art in Europe up to the 1920s.

KENNETH L. AMES is chief of the Historical Survey for the New York State Museum. A specialist in aesthetics as a cultural and political phenomenon, Ames has published many writings, including *Beyond Necessity: Art in the Folk Tradition* and *Death in the Dining Room and Other Tales of Victorian Culture*.

MAUREEN P. SHERLOCK is a visiting associate professor of critical theory in the Film Department of the School of the Art Institute of Chicago. She is a regular contributor to *Art Papers* and a number of other American and European journals and magazines.

GERALD L. DAVIS is associate professor and chair of the Department of Africana Studies at Rutgers University. Included in his many writings on African-American culture and religion is the book *I Got the Word in Me and I Can Sing It, You Know: The Performed African-American Sermon.*

MICHAEL OWEN JONES is chair of the Program in Folklore and Mythology at the University of California, Los Angeles. Among his numerous publications on craft, creativity, and the arts is the recent book *Exploring Folk Art: Twenty Years of Thought on Craft, Work, and Aesthetics.*

SALLY HARRISON-PEPPER is associate professor of interdisciplinary studies at Miami University in Ohio. Harrison-Pepper's research has focused on the activities of street performers, and her book on the subject is entitled *Drawing a Circle in the Square: Street Performers in New York's Washington Square Park.*